YALE PUBLICATIONS IN THE HISTORY OF ART, 7

MANET

and his CRITICS

by *GEORGE HEARD HAMILTON*

Yale University Press
New Haven and London

To the memory of Marguerite
and Henri Focillon

Library of Congress catalog card number: 54-5083
International standard book number: 0-300-03759-7 (paper)

10 9 8 7 6 5 4 3 2 1

CONTENTS

ILLUSTRATIONS

Illustrations are grouped at the back of the book. The source is indicated in parentheses wherever the photograph has been supplied by a firm or institution other than the owner of the painting.

PREFACE TO THE 1986 EDITION

A FEW months after this book was published, in May 1954, Nils Gösta Sandblad's *Manet: Three Studies in Artistic Conception* appeared in an English translation. Sandblad's searching analysis of the historical as well as formal structures of Manet's work to a large degree encouraged the investigations of other than formal problems that over the past thirty years have so greatly enlarged our understanding of Manet's art.

My own analysis as set forth in the introduction was more limited and was, I thought, implicit in the epigraph by Georges Braque. I wanted to record what those who first encountered Manet's work in public thought they saw. The task was not easy. Verbal expressions cannot, by their nature, duplicate visual perceptions. Critics of contemporary art have to work at the cutting edge between the present and the future, but their criteria and vocabularies inevitably were developed in the past, even if that was only yesterday. Since the critic can more easily say what a new painting is not rather than what it is, contemporary criticism more often than not is negative. This does not excuse, but it may partially account for, the reactions that Manet's art, so very "new" in his own present, provoked.

If such was my purpose—to look at Manet as he appeared to his contemporaries—it has been puzzling that the book, although occasionally commended as useful, has been taken as an exercise in formalist criticism. Had I really been a formalist I could not have dedicated the book to the memory of Henri Focillon, under whom I was proud to be a student and very junior colleague from 1936 until his death in 1943. Focillon taught that a work of art

has, separately and simultaneously, two different aspects. It is a physical object existing in our own space, but because it has been shaped by the conditions within which it was created, it is also a fact in time and, we can add, in all the subsequent times through which it lived and lives. We diminish one of these aspects if we slight the other.

I think that every method scholars use to help us understand a work of art deserves consideration, but I am too much a product of another generation to think that either art or history is well served if a work is examined so exclusively in other than artistic terms that its formal character is ignored. If it really is a work of art it must have form, and the more excellent the form the more significant the work will be, historically as well as artistically. I am not trying to revive Clive Bell's doctrine of "significant form." Bell thought representation, subject matter, and content were irrelevant. I believe that content, if not subject matter as such, has a form, as it is certainly a forming element in a significant work of art.

Had there been all the time to spare thirty years ago, it might have been interesting to contrast the works that Manet did or did not send to the Salons with those that the state saw fit to honor. But that task has become very difficult now that so many of the most admired masters of the mid-nineteenth century have faded into obscurity, if not oblivion. To take only two instances, in 1863 when Manet's three entries were rejected—among them the *Déjeuner sur l'herbe*—the Grand Prix du Salon was awarded to a sculptor, Jean-Josephe Perrand (1819–1876), and the first class medal in painting went to Michel Dumas (1812–1885). In 1876, when *Nana* and *The Artist* were turned down, medals of honor were given to the sculptor Paul Dubois (1829–1905) and to a painter, Joseph-Noël Sylvestre (1847–1926). Dubois enjoys a kind of half-life as the ablest of the mid-century *néo-florentins*, but the others are little more than entries in the dictionary where I found their dates. Manet's rejected paintings hang in the great museums of Paris, New York, Hamburg, and São Paulo. How well he chose the legend for his bookplate: *Manet et manebit*.

G. H. H.

April 1986

GEORGES BRAQUE: *The artist should not be asked for more than*

he can give, nor the critic for more than he can see.

INTRODUCTION

THIS BOOK is neither a biography of Edouard Manet nor a critical examination of his entire work. It is a study of the kind of criticism published about Manet and his art during his lifetime, with some mention of the critical reaction after his death. The plan of the book has been shaped by the historical conditions which determined the origin and character of this criticism.

It is not the historian's function to revive dead passions, nor is it proper for him merely to record the existence of such issues. The study of the criticism of Manet's work during his lifetime must be justified on other grounds than those of the archivist or the polemicist. Manet's art has taken its place among the sources of contemporary painting, and one may presume that his position is assured in the total continuity of the European tradition. Therefore, contemporary attitudes toward his work are useful as they help us to establish his historical position in the development of modern painting, and also as they concern recurrent problems of criticism today.

Since the late eighteenth century the relation of the artist to contemporary society has become increasingly ambiguous. With the destruction or decline of guild and workshop training, and with the disappearance of societies which supported such systems, the artist in the course of the nineteenth century lost contact with the traditions of craftsmanship and patronage. The enlarged and enriched middle classes created by the industrial revolution had little artistic experience or sense of the responsibility of patronage. Although they required works of art as symbols of their newly won

1

position, they preferred familiar forms conventionally treated. The art created in accordance with such tastes was inevitably traditional in the sense that its practitioners relied upon previous formulae for subject and technique, and it is usually described as academic because the artists themselves so often rose to places of honor in the conservative academies and schools. From these positions, as will soon be seen, they could dominate the supply and distribution of such art through their control of the schools and public exhibitions. The progressive artists could do little more in the face of such organized opposition than assert their right to work as they pleased and to have their productions judged by the public, freely and on their own merits.

Meanwhile the important task of evaluating the vast quantity of contemporary art was assumed by a comparatively new figure, the art critic. Ideally, we might think, he should have seen his duty to help the public understand the best art of the day and to defend the right of the artist to achieve self-expression whenever, for other than reasons artistically relevant, such rights were questioned or denied. But in practice there were soon as many kinds of critics as there were different interests, social, governmental, and artistic, to be defended or opposed. The result has been a century and more of confusion, misunderstanding, and mutual intolerance. The individual artist has often suffered almost unbelievable hardship in his attempt to reach the public; the public has frequently lost the opportunity of enjoying the greatest contemporary art at the time of its creation.

Today we sometimes seem closer to a solution of the difficult problem of safeguarding public claims while guaranteeing the artists' rights. The establishment in many cities of museums devoted to contemporary art, more systematic art instruction in schools and colleges, and the occasional appearance of liberal government-sponsored programs have notably increased the public's use and understanding of modern art. Yet the study of the historical relations among artists, public, and critics in the past is still appropriate. It may suggest how we should phrase the answers to some of the most persistent and difficult questions of modern criticism. Why has almost every progressive artist during the past two cen-

turies encountered an adverse reception when his work was first exhibited to the public? Is continual antagonism between artist and public inevitable in the creation of modern art? Can it be explained on artistic principles alone or does it require an understanding of other cultural factors peculiar to historical time and place? If these questions are not completely answered in the following pages, perhaps this particular enquiry may point toward the resolution of the general dilemma.

The criticism of Manet's work by his contemporaries affords unusual opportunities for such an examination, because of the circumstances attending his encounters with the public. In almost all European countries during the nineteenth century an annual exhibition of fine arts, sponsored by the government under the nominal direction of the state-supported art school or academy, provided a clearinghouse for the study of contemporary art. If by the very nature of the academic process the selection of work to be exhibited was more often than not influenced by the prevailing taste and interests of the middle classes which supported the government—if, in other words, the exhibition stood for generally conservative tendencies—it nonetheless served to throw into sharp relief the activities of those artists devoted to other ideals. Of all the various national exhibitions the annual or biennial exhibition in Paris, the official Salon, was the most important. Its honors and awards were the most coveted, for from the ranks of the elect were chosen the painters to execute important governmental commissions. Since France led the world in the quantity and material value of such commissions, painters came to Paris from every continent hoping to study with the most famous academicians and to exhibit their work in the Salon. For most of them even the least medal from Paris was a passport to prestige at home.

Of more enduring importance was the temper of the Parisian artistic environment. In no other country was public interest so widespread or criticism so extensive and vociferous. Not only were handbooks of explanations issued by individual critics for each Salon and lengthy reviews carried by many periodicals and newspapers, but the more influential writers republished their annual reports in collected volumes. So it is possible not only to follow

the reactions of individuals to separate Salons but, through the works of a Castagnary, a Claretie, or a Thoré-Bürger, to trace the development of a critical point of view over a decade or more.

Throughout the twenty-four years of his active artistic life Edouard Manet continually sent his paintings to the Salon, where he met criticism which in constancy and bitterness surpassed that directed against any of his nineteenth-century predecessors. Unlike Delacroix and Millet, who were certain of the validity of their artistic programs, or Courbet, who welcomed dispute, Manet resented public hostility and wanted the honors the others despised or learned to do without. Here is a paradox of criticism and character, for Manet never deviated from the artistic goal he had set himself, however much he might otherwise seek official if not popular favor. Year after year he profferred his best to a jury he knew detested his work. Six times in twenty-one his work was wholly or partially rejected, while of rewards his first mention came too early and his last, as he himself said, too late.

In restricting this account to the criticism of those paintings which he submitted to the Salon I hope that I do Manet no disservice. These were the paintings which were best known to his contemporaries; these were the works he thought most of himself, since it was to them that he entrusted his reputation. Indeed, in a quite literal sense we can know this man only by studying his work; we can penetrate his feelings only by imagining what our own reactions might have been to the criticism his work received. Unlike many of his contemporaries, his life was almost without incident apart from his painting. His conversation, except for a few epigrams, has been unrecorded; his letters are rare and insignificant; and he wrote nothing else which could serve as a clue to his ideas. The materials for his spiritual biography consist of a few reminiscences by his friends and a mass of contemporary criticism, some of it scrupulous and sympathetic, but much more all too thoughtless and derogatory.

For Americans there is a special interest in Manet's contributions to the Salon; of the thirty-eight paintings he presented to the juries between 1859 and 1882 no less than eighteen have entered public and private collections in this country. Yet, curiously, this

concern with Manet's art has not been matched by comparable critical or historical research by English or American writers. The principal studies, in French and English, which are described in the bibliographical note, are for the most part out of print or inaccessible to the general reader. Under these circumstances the present work, although limited to the history of Manet's criticism, contains some biographical details for the reader unfamiliar with the artist's life. For those critics whose significance for the history of French art is of some consequence, I have provided brief biographical annotations. When such are lacking the critics may be considered of interest solely for their quoted contributions.

I have rendered all French prose texts into English as directly as possible. If the translations are sometimes inelegant, the translator is bold enough to think the faults not entirely his. Much of this criticism was hasty, on-the-spot reporting, written without much concern for literary style. The texts of French poems have been left in the original language.

Translation of the titles of Manet's paintings presented obstacles only to be solved by rule of thumb. For many, such as the *Déjeuner sur l'herbe* or *Chez le père Lathuille,* no English equivalent is relevant; for others such as *Le Repos* a translation would be ungainly or would fail to suggest the shade of meaning expressed in the subject. Yet to refer constantly to the *Christ Scourged* as *Jésus insulté par les soldats* is as awkward, if not as misleading, as it would be to render *Déjeuner sur l'herbe* as *The Picnic.* Therefore titles have been translated whenever the English counterpart was appropriate.

The study of the contemporary reaction to Manet's art was first undertaken by the late Adolphe Tabarant whose two books, *Manet —histoire catalographique* (1931) and *Manet et ses oeuvres* (1947), contain many examples of contemporary criticism. I count it a privilege to acknowledge my obligation to his work and to confess that my own research has depended upon his. When I have added to Tabarant's materials I have used the resources, and I have had the unfailing assistance of the staffs, of the following libraries: the Library of Congress; the Frick Art Reference Library; the library of the Metropolitan Museum of Art; the New York Public Library;

the Vassar College Library; and the libraries of Yale University. I am grateful to the private collectors and museum officials, whose names and institutions appear in the list of illustrations, for permission to reproduce paintings by Manet in their possession. For information on numerous matters concerning Manet and his art I wish to thank the following individuals: Wayne Andrews; P. M. Bardi; Franklin M. Biebel; W. G. Constable; Mrs. Richard E. Danielson; Charles Durand-Ruel; Ima N. Ebin; Mrs. Albert Ten Eyck Gardner; Mrs. Henry W. Howell, Jr.; Macgill James; E. Coe Kerr, Jr.; Henri Marceau; Violette de Mazia; Agnes Mongan; Henri Peyre; Vagn Poulsen; John Rewald; Albert J. Salvan; John Davis Skilton, Jr.; Joseph C. Sloane; Charles Sterling; Frederick A. Sweet; Mrs. George Vernadsky; Georges Wildenstein; Otto Wittman, Jr. Margot Coffin (now Mrs. Franklin A. Lindsay) prepared several preliminary translations and typed the earlier drafts of the manuscript. Lewis Perry Curtis and Sumner McKnight Crosby scrutinized the final manuscript with scholarly perception; for their interest and attention, which smoothed many rough places, I am most grateful. To Edgar S. Furniss, the Provost of Yale University, and to the officers and staff of the Yale University Press, I acknowledge my gratitude for their help and consideration.

George Heard Hamilton

EDOUARD MANET

Qu'un destin tragique, omise la Mort filoutant, complice de tous, à l'homme la gloire, dur, hostile marquât quelqu'un enjouement et grâce, me trouble—pas la huée contre qui a, dorénavant, rajeuni la grande tradition picturale selon son instinct, ni la gratitude posthume: mais, parmi le déboire, une ingénuité virile de chèvre-pied au pardessus mastic, barbe et blond cheveu rare, grisonnant avec esprit. Bref, railleur à Tortoni, élégant; en l'atelier, la furie qui le ruait sur la toile vide, confusément, comme si jamais il n'avait peint—un don précoce à jadis inquiéter ici résumé avec la trouvaille et l'acquit subit: enseignement au témoin quotidien inoublieux, moi, qu'on se joue tout entier, de nouveau, chaque fois, n'étant autre que tous sans rester différent, à volonté. Souvenir, il disait, alors, si bien: "L'oeil, une main . . ." que je ressonge.

Cet oeil—Manet—d'une enfance de lignée vieille citadine, neuf, sur un objet, les personnes posé, vierge et abstrait, gardait naguères l'immédiate fraîcheur de la rencontre, aux griffes d'un rire du regard, à narguer, dans la pose, ensuite, les fatigues de vingtième séance. Sa main—la pression sentie claire et prête énonçait dans quel mystère la limpidité de la vue y descendait, pour ordonner, vivace, lavé, profond, aigu ou hanté de certain noir, le chef-d'oeuvre nouveau et français.

<div align="right">MALLARMÉ, Divagations (1897)</div>

THE SALON IN THE NINETEENTH CENTURY

In the history of nineteenth-century French art the annual or biennial official exhibition of painting and sculpture constitutes a focal point for the study of the major issues in the relation of the artist to his public and to the state. This exhibition, commonly known as the Salon, was provided for in the decree establishing the Royal Academy of Painting and Sculpture in 1663. The first exhibition occurred in 1673, and from then until 1791 the entries were limited to works by members of the Academy itself. This discrimination against artists who were unwilling or unable to join the Academy caused such dissatisfaction that in 1791 the National Assembly decreed the exhibition should henceforth be open to all artists, Frenchmen and foreigners alike, and should be directed by a committee appointed by the government. That successive French governments, revolutionary or reactionary, maintained the Salon in unbroken sequence is sufficient evidence of the esteem in which it was held.[1]

In the course of the nineteenth century the Salon, which had been a small exhibition of painting and sculpture by the leading artists patronized by the court and nobility, was transformed into a vast public spectacle wherein large numbers of artists sought public as well as private favor, with a few asserting their right to paint as they chose regardless of official or popular approval. Here

1. A full if confused history of the Academy, the Salon, and the system of government patronage in French art appears in Mrs. C. H. Stranahan's *History of French Painting from Its Earliest to Its Latest Practice* (New York, 1888). See also Eleanor P. Spencer, "The Academic Point of View in the Second Empire," in *Courbet and the Naturalistic Movement* (Baltimore, 1938), 58–72.

many of the principles were established and the tactics developed which marked the aggravated relations between the progressive artists and official patronage. From the beginning the main issues were clear. On the one hand the government, because it supported the Salon, considered that it had the right to determine the character of the exhibition. With the emergence of a prosperous middle class, and later of a powerful popular electorate, the administration felt obliged to lend its support to those factions producing an art certain to secure wide public approval. Artistically this meant the continuance of the conservative traditions of the government-sponsored Ecole des Beaux-arts, whose professors were usually in the majority on the jury of selection and awards. The artists who opposed this tendency could only protest their rights, as citizens, to a free and unimpeded exhibition of their work. Even under the government of Louis-Philippe the jury's habit of suppressing so-called radical tendencies by excluding the work of such artists as Courbet, Millet, and Théodore Rousseau had been denounced. With the downfall of the July Monarchy the experiment of a free Salon without a jury was tried in 1848–49. But this expedient proved impossible, partly because of the large amount of work that was sheerly incompetent by even the most liberal standards, and partly because of the enormous number of items submitted. Between 1791 and 1831 the number of exhibitors had risen from 258 to 3,182. When the jury was abolished in 1848 no less than 5,180 artists were represented; obviously some limitations would have to be set. In 1849 the jury was elected by the exhibitors themselves, but the Salon of 1850–51 saw a return to the principle of selection by a jury, in part elected by the artists and in part appointed by the government.

During the Second Empire the Salon, like other French institutions, came increasingly under the control of the central government through the appointment of additional jurors sympathetic to the artistic ideals of the administration. But even a conservative policy can be carried too far. In 1863 the number of artists excluded by the jury grew so large that the government was compelled to open an exhibition of the rejected works, the famous

Salon des Refusés, an expedient tried again on a smaller scale in 1864 and then abandoned. Control by the administration was not broken even by the Franco-Prussian War of 1870–71. Conditions did not improve until in 1881 the government of the Third Republic, recognizing the existence of abuses, delivered the organization of the Salon into the hands of the artists themselves, who were empowered to select their own jury and to establish their own standards of admission. Since then the Société des Artistes Français has taken charge of the exhibitions, but the authority of the Salon has been undermined and its power to arbitrate in artistic matters curtailed by the establishment of rival organizations. The Salon of the Société des Beaux-arts was founded in 1890 to provide additional exhibition space for the ever increasing number of artists who were dissatisfied with the older organization. The more liberal independent exhibitions, the Salon des Indépendants (1884) and the Salon d'Automne (1903), which may be considered heirs of the series of private exhibitions organized by the Impressionists between 1874 and 1886, were until recently the sponsors of the truly progressive movements in contemporary art.

It is difficult, now that the prestige of the Salon has dwindled almost to nothing, to realize how important it once was. Until past the middle of the nineteenth century there were few established dealers prepared to promote the work of individual painters through one-man exhibitions and energetic salesmanship. Only at the Salon could the young painter hope to reach his prospective audience and thus sell his work. Only here could the mural painter display the studies which might lead to government commissions and the easel painter achieve, through a medal or an honorable mention, the stamp of approval which would recommend his painting to patrons who recognized no other mark of merit. As early as 1827 Eugène Delacroix's *Death of Sardanapalus* had been rejected by the jury and the artist warned by the director of fine arts that he would have to change his manner of painting if he hoped for further government orders, without which he could not support himself.

Today the history of nineteenth-century French painting is usu-

ally read as the illustrious succession of Ingres, Delacroix, Millet, Courbet, Manet, and the Impressionists. We have forgotten that these artists in their own times were often overshadowed by the notables of the Salon and appeared less significant than the men then honored by government and public alike. Even Ingres, so often regarded as the archconservative, was disgusted with the treatment which the critics accorded his work at the Salon of 1834 and refused to exhibit there again. Although frequently elected a member of the jury he consistently declined to serve. Had not Delacroix enjoyed the friendship of the House of Orléans it is entirely possible that his work would have been refused during the years of the July Monarchy. Both Courbet and Millet were the victims of mortifying rejections, and the former went so far as to hold his own exhibition on the outskirts of the Exposition Universelle of 1855 in protest against the actions of the government. Manet's experiences will be recounted in detail.

Although the Salon was the favorite proving ground for the academic artist, his position was consolidated by his acceptance of two other official institutions. In almost every case he had passed through the government art school, the Ecole des Beaux-arts, where he had taken part in the various competitive programs culminating in the annual competition for the Prix de Rome which entitled the winner to spend a term of years at the French Academy in Rome. Although posterity has forgotten almost all the winners of this prize, they were not ignored in their lifetimes.[2] As long as their work continued to meet official approval, they could look forward to numerous honors and government commissions for the decoration of churches and public buildings. For the more eminent and energetic there was the final privilege of election to the Institute, or more exactly to the Academy of Fine Arts. After its dissolution in 1792 the old royal Académie des Beaux-arts had been reconstituted in 1795 as the fourth section of the Institut de

2. The winners of the *grand prix* in painting from 1850 to 1865, the period corresponding to the student years of Manet and the younger Impressionists, were as follows: Baudry, Chifflard, Giacomotti, Maillot, Clément, Sellier, Henner, Ulmann, Michel, Lefebvre, Layraud, Maillart, and Machard. See Eugène Müntz, *Guide de l'École Nationale des Beaux-arts* (Paris, 1889), for these and other lists of prize winners.

France, and its forty members were charged with the progress of French painting, sculpture, architecture, the graphic arts, and music. Under later governments its function had changed to that of exercising a close, even restrictive supervision over the Ecole and the Salon. With the curtailment of its ancient privilege of electing associate, nonvoting members, the Academy's intellectual initiative was restricted to the interests of its regular members. From among the fourteen painters and eight sculptors in the Academy were usually chosen the artists who represented the government on the Salon juries. Since they were also the principal professors at the Ecole, the circle was closed to all but the most docile and respectable talents. If today we are puzzled by the store which Delacroix and Manet set by membership in the Institute or Legion of Honor, distinctions ignored by Courbet and Daumier, we must remember that these and many more awards were received by men whose work they despised. There was a moral as well as an economic issue involved, which we may best appreciate by trying to recall the men who could close the door to the painters whom the future has preferred. It is enlightening to consider merely the names of the painters who won the major honors and who served on the juries in Manet's lifetime. On twenty occasions between 1859 and 1882 Manet submitted his paintings for approval to a jury usually numbering twenty-four men. During those years the following painters served at least five times: Baudry, Bernier, Bida, Bonnat, Bouguereau, Gustave Boulanger, Jules Breton, Brion, Busson, Cabanel, Cabat, Cogniet, Delaunay, Dubufe, Français, Fromentin, Gérôme, Gleyre, Hébert, Henner, J.-P. Laurens, Jules Lefebvre, Meissonier, Pils, Robert-Fleury, and Vollon. During the same period the Grand Medal of Honor, which was not awarded at every exhibition, fell to Pils, Cabanel, Brion, Bonnat, Robert-Fleury, Breton, Gérôme, Laurens, Carolus-Duran, Morot, Baudry, and Puvis de Chavannes. In 1867, at the Salon held in connection with the Universal Exposition, the grand prizes were awarded to Cabanel, Gérôme, Meissonier, and Théodore Rousseau. As for the Academy, during Manet's active career the following were elected: Meissonier, Cabanel, N. A. Hesse, Muller, Lehmann, Gérôme, Cabat, J. B. Hesse, Pils, Lenepveu, Baudry,

Hébert, Bouguereau, Delaunay, Bonnat, and Boulanger.[3] Within
the same space of time Manet received one of the 110 honorable
mentions distributed in 1861, and another one twenty years later;
in between his work was rejected, either actually or implicitly, on
six occasions.

Many academic painters enjoyed a further privilege. Those who
had received major awards were considered *hors concours;* exempt
from the obligation of submitting their works to the jury, they
were able to exhibit without hindrance year after year. Under
such circumstances it is less surprising than scandalous that the
names of several members of the jury who had arranged each Salon
usually reappeared at its conclusion among the list of prize win-
ners. And it is no wonder that the painter who did not care to
execute acceptable subjects in the approved technique had scant
hope of admission to the Salon and even, if admitted, of recogni-
tion. After 1870 the hopelessness of their predicament was acknowl-
edged by many of the younger generation of progressive painters.
The exhibitions of the Impressionists and the emergence of such
dealers as Durand-Ruel relieved them of the necessity of humiliat-
ing themselves before the jury.

The unfavorable physical conditions under which the Salon was
held were additional grounds for dissatisfaction. By the middle
of the century the exhibition had outgrown the space available
in the Louvre, already overcrowded with the collections of the
arts of the past. After 1857 the government installed the Salon in
a large building on the Champs-Elysées originally constructed to
house industrial exhibits and used for the International Exposi-
tion of 1855. This Palais de l'Industrie, although of architectural
interest as one of the first great exhibition halls erected in Paris
in the nineteenth century, was scarcely an ideal place for painting
and sculpture. Like the Crystal Palace of 1851 in London, it soon
served for the most varied entertainments, and the Salon merely

3. For the history of the Academy and biographies of the members elected in the
nineteenth century, see Albert Soubies, *Les Membres de l'Académie des Beaux-arts*
(4 vols. Paris, 1904–17). The lists of jurors may be conveniently consulted in Adolphe
Tabarant, *Manet et ses oeuvres* (Paris, 1947), henceforward cited as Tabarant.

interrupted for six weeks the busy succession of agricultural displays and horse shows.

The thirty-two galleries into which the barren interior was divided were poorly lighted, scantily decorated, and dirty. So numerous were the exhibits that they were customarily hung in rows reaching to the ceiling. If a painting were "skied" in the top row it could not possibly be seen to advantage, while both artist and public were at once aware that such work was considered inferior by the jury. One way for an artist to avoid such a calamity was to paint a picture so large it could not possibly be overlooked. Such huge "machines," by reason of their size alone, attracted critical and popular attention quite out of proportion to their merit. Finally, no better arrangement could be found than to install the paintings in alphabetical order by artist. These conditions prevailed until the end of the century when the Palais de l'Industrie was finally demolished to make way for the new buildings for the International Exposition of 1900, the Grand and Petit Palais, which provided better quarters for the Salons.

In two other respects, in the character of the visiting public and in the criticism which was written for that public, the Salons of the middle years of the nineteenth century differed from their predecessors of the eighteenth century. The earlier Salons had been comparatively small exhibitions visited by those members of the nobility and of the prosperous middle classes who had some knowledge and understanding of art. The importance of such an inherited fund of artistic experience becomes clear when one compares the enthusiasm excited by the first paintings of David with the storm of reprobation and incomprehension which met the early works of Manet. Yet the innovations in each instance were quite as much matters of technique as of subject. Although Daumier's caricatures of the bourgeoisie passing a Sunday afternoon at the Salon are typical of but one aspect of the nineteenth-century public, it is nonetheless true that most of the people who visited the exhibition were not immediately in search of strictly pictorial quality. Unlearned and unexperienced, they sought, even in historical and mythological painting, dramatic narrative and pic-

turesque anecdote. But the day had passed when for the Salon great
artists painted great events. The governments which succeeded
the First Empire had failed to provide, until the catastrophe of
1870, the stirring episodes which Gros and his pupils had popular-
ized in large historical canvases. The escapades of Louis-Philippe's
armies in North Africa or of Napoleon III's in Italy were petty
compared with the epic adventures of the first Napoleon. Even
the choice of mythological scenes showed a change from the amo-
rous subleties of Prud'hon or the moral dignity of David. History
and mythology alike were ransacked for scenes of terror and car-
nage. The change in classical painting is already apparent in Cou-
ture's *Romans of the Decadence* (1847). Gérôme's *Death of Caesar*
(1867) and *Pollice Verso* (1859) are only the more familiar exam-
ples of a host of canvases which treated the agonies of Oedipus
and Rizpah or, exaggerating the exotic qualities of Delacroix's
orientalism, illustrated scenes of torture and violent death in Islam.
Such paintings quickly became the sensation of each Salon, sur-
passing in public interest and esteem the contributions of the land-
scape painters of Barbizon, or in the 1860's the early work of Monet
and Pissarro. When, as usually happened, these melodramatic com-
positions were awarded the honors of the Salon, the public was con-
firmed in its opinion that they constituted the highest achievement
of contemporary French art.

To assist this new public to appraise correctly the development
of contemporary painting should have been the task of the critics,
yearly increasing in number and influence. Dailies and weeklies
alike carried long accounts of the Salon during the six weeks it was
open. Often these were not so much serious discussions of the
artistic merits of the works on exhibition as detailed descriptions
of the subject matter of the paintings most likely to attract popular
attention. Although much of this material was only journalistic
reporting, occasionally, when Théophile Gautier wrote his annual
Salon review for the official *Moniteur universel* or Thoré-Bürger
his for *L'Indépendance belge,* these writings must be treated as
considered opinion.[4]

4. For the history toward the middle of the Second Empire of such papers as the
Moniteur universel, the *Journal des débats, Charivari,* and *Figaro* see Jules Brisson

Two other kinds of art criticism became important during the Second Empire, the humorous caricatures which appeared in the illustrated papers and the serious reviews in periodicals devoted exclusively to art. Of the former, the daily *Charivari* and the weekly *Journal amusant* were widely read and probably influenced, quite as much as they reflected, public opinion. During the Salon the cartoons of Cham, Bertall, and Stop ridiculed, usually in the form of childish pen-and-ink drawings, the paintings which were attracting the greatest amount of public interest. While the caricaturist spared neither the academic great nor the obscure newcomer, inevitably persons who were inclined to laugh at Manet's work laughed all the more when they remembered the witty cartoons they had seen earlier that day. Negligible for the most part as criticism, such cartoons were a powerful factor in creating and maintaining public opposition to new work.

The periodicals devoted exclusively to art were not many in the 1860's but they were important. The two most considerable, the *Gazette des beaux-arts* edited by Charles Blanc and *L'Artiste* edited by Arsène Houssaye, were fundamentally conservative. The *Gazette*, owing to the scholarly interests of Blanc, published for the most part historical studies. Its annual review of the Salon was usually written by someone sympathetic to the administration, such as Paul Mantz or Léon Lagrange. If *L'Artiste* devoted more space to contemporary painting, common sense as well as the taste of the editor saw to it that academic painting received the larger measure of attention.

Lastly, there were a few critics especially gifted with discrimination and taste, more often than not men of letters, who had themselves been baffled and distressed by public misunderstanding. They cut to the core of the critical confusion and resolved it in terms which can stand as a permanent evaluation. Through these three kinds of criticism—the first rude shock of public bewilderment recounted in the pages of the official *Moniteur universel* or

and Felix Ribeyre, *Les Grands Journaux de France* (Paris, 1862). The growth of Salon criticism through this period appears in the annual lists compiled by Maurice Tourneux in his *Salons et expositions d'art à Paris (1801–70), essai bibliographique* (Paris, 1919).

Charivari, professional appraisal according to prevailing critical standards in the *Gazette des beaux-arts* or *L'Artiste,* and finally the discernment of Baudelaire or the penetration of Mallarmé—were enacted the stages of Manet's long struggle for the acceptance of his program as a valid expression of modern painting.[5] The forces arrayed against the recognition of individual progressive painting during the Second Empire and early Third Republic were indeed formidable. Under such circumstances it is perhaps less remarkable that Manet's first works were received with disfavor than that they aroused so much attention. The continual outbursts of protest over his later work appear to be the inevitable result of such a system of exhibiting and examining objects of art.

Manet's work and its criticism by his contemporaries are divided into two parts, separated historically by the Franco-Prussian War of 1870 and artistically by the emergence of Impressionism. In the paintings offered to the Salon between 1859 and 1870 Manet was working generally within the limits of mid-century realism. If his subjects, so frequently Spanish in costume and composition, reflected the "romanticism" which Baudelaire considered an integral aspect of his personality, yet in technique and expression he was attempting to reconcile the modern subject with the conventional Salon composition, large in size and formal in design. In the twelve years between 1871 and 1882 he made his enduring contribution to modern art, modern both in relation to the progressive painting of his own day and in the sense of providing a body of work to which future painters would look for solutions to their own problems in discovering a truly modern expression. In picture after picture during the 1870's Manet worked with an increasingly broader and more spontaneous stroke, with more brilliant and analytic color, and with an unequivocal acceptance of the Impressionist subject, the motif from contemporary life. Even when we acknowledge his debt to the Impressionists, who may be shown to have anticipated his themes in many instances, Manet constantly reiterated his position in relation to the Salon and the European tradition by retaining the figure as the dominant theme of his large

5. See Joseph C. Sloane, *French Painting between the Past and Present* (Princeton, 1951), for a detailed analysis of kinds and qualities of criticism from 1848 to 1870.

canvases. Contemporary critics failed to see his paintings in their relation to that tradition. They mistook the change in locale, from the cathedral and palace to the theater and boudoir, for the rejection of tradition. Far from that being the case, Manet's paintings are more nearly related to the compositions of Ingres and Delacroix than to those of Monet and Degas.

In the history which follows, this general division and these narrower discriminations form the structure of the book. The more important critics, such as Baudelaire and Zola, are discussed separately and in detail; the attitudes of less important writers have been grouped generally around some important event, such as the Salon des Refusés of 1863. This arrangement perhaps avoids the arbitrary monotony of a strictly chronological arrangement. If it involves occasional repetitions or anticipations of paintings not at that time achieved or exhibited, the reader may gain additional familiarity with Manet's work as this record traverses his times.

MANET AND BAUDELAIRE: 1859-67

1859

EDOUARD MANET was born in Paris on January 29, 1832, the son of a prominent magistrate, Auguste Manet, and of Eugénie Désirée Fournier whose father had assisted Bernadotte to the throne of Sweden. Later two other sons were born, Eugène the following year and Gustave in 1835. Eminently respectable and moderately well-to-do, the family had exemplified for several generations the upper-middle-class virtues of moral probity and intellectual conservatism. Manet's father intended him to be an attorney, but the boy, who had been encouraged to draw by his maternal uncle, Col. Edmond Fournier, an accomplished amateur, wanted to become a painter. In school, where he did poorly in all subjects except gymnastics, drawing, and history, his developing personality, so strangely compounded of inner spiritual intransigence and outward social conformity, can be sensed in the reports which describe him as having a "caractère difficile." Since his scholastic record handicapped him for the law and his father insisted on a profession, he applied for the naval college. When he failed the examinations, he enlisted in the merchant marine which promised a naval career after six months' service. In December 1848 he put to sea as a cadet on the training ship *Havre et Guadeloupe* bound for Brazil.[1] In his letters home he wrote of drawing caricatures of the officers and of reddening some Dutch cheese which had spoiled during the voyage. As he said himself, this was his "first bit of painting." Apart from such youthful pranks the long Atlantic voyage and the nine

1. Manet's letters written aboard ship have been published as *Lettres de jeunesse, 1848–1849. Voyage à Rio* (Paris, 1928).

weeks' sojourn in Rio de Janeiro confirmed for the future painter his love for the sea and for Spanish life, soon to become important factors in his art.

After his return in June 1849 and second failure in the naval examinations his father relented and permitted him to enter, in January 1850, the studio of Thomas Couture, where he worked at intervals for the next six years.[2] Couture, who had won a medal at the Salon of 1847 with his vast *Orgie romaine* (Paris, Musée du Louvre), may well have seemed the painter who could best set young Manet on the path to official honors and financial success. But between Couture and his pupil there seems to have developed a lasting antipathy, the result of differing temperaments accentuated by fundamental artistic disagreements. Manet was not interested in learning how to paint the elaborate historical and mythological subjects invariably set for prize competitions and almost alone acceptable to the Salon jury for large paintings. With the remark that "we must accept our own times and paint what we see" he had, even in the studio, scoffed at Diderot's contention that since contemporary clothing becomes in time unfashionable only historical costumes should appear in a serious painting. Now, in the face of Couture's disapproval, he preferred to draw from a model posed naturally and even completely clothed rather than conventionally nude. He insisted that he painted objects as he saw them and not as others would like to have seen them. One day, when he dared to tell the model to pose in ordinary shirt and trousers, Couture exclaimed that he would never be more than the Daumier of his day, to which Manet scornfully retorted that to be such was better than to be the Coypel. Antonin Proust, his classmate in school and in Couture's studio, who set down his memories of this period many years later and so may unintentionally have exaggerated the usual differences between master and pupil, reported a remark that summarized Manet's discouragement and impatience with academic routine: "I don't know why I'm here. Everything we see around us

2. Although Thomas Couture (1815–79) failed to fulfill the promise of his earliest success as a historical painter, he was an able, conscientious, and gifted teacher. His personality and methods may be studied in his *Méthodes et entretiens d'atelier* (Paris, 1868). For a sympathetic examination of his studio practice and relations with Manet, see Gotthard Jedlicka, *Edouard Manet* (Zurich, 1941), ch. 3.

is ridiculous. The light is false. The shadows are false. When I come to the studio, it seems to me that I'm entering a tomb." [3] Yet for all that, he remained with Couture six years, inwardly rebellious, outwardly content to learn what he could.

In spite of his impatience Manet must have understood that he had much to learn and Couture much to teach. It is no wonder, then, that Couture's influence is apparent in his early work. The sharp oppositions of light and shade, the simplified distribution of color, and the occasional passages of delicate brushwork, so characteristic of Couture at his best, occur in Manet's paintings for a decade after he left the studio. Something of his attitude toward modern life and of his concentration on the visual rather than conceptual properties of the subjects he painted may have been learned during those years. Often Couture's advice seems inseparable from Manet's practice, as in such a remark as this: "If we directly and simply copy what nature offers us, we shall soon perceive that what we do is very much better than what we dreamed." [4] Perhaps he respected his master more than he wished to acknowledge: in 1859 he invited Couture to visit his studio to see the *Absinthe Drinker* (Fig. 1), his first considerable achievement as an independent painter. Couture was not persuaded, and his bitter comment reflected an older man's conservative position: "An absinthe drinker! And they paint abominations like that! My poor friend, you are the absinthe drinker. It is you who have lost your moral faculty."

Couture's opinion was sustained by the jury which rejected the painting for the Salon of 1859. Some consolation came to Manet when he heard that Delacroix was said to have voted for it. Manet admired the older romantic painter, whom he once had visited with Proust to ask permission to copy Delacroix's first Salon contribution, the *Dante and Vergil in Hell* of 1822.[5] Like Delacroix's,

3. Antonin Proust's recollections are the principal source for the anecdotes about Manet's schooldays and his years with Couture. They were published serially in the *Revue blanche* in 1897 and in book form as *Edouard Manet, souvenirs* (Paris, 1913).

4. See Jean Alazard, "Manet et Couture," *Gazette des beaux-arts*, Series 6, *35* (1949), 213–18.

5. Although Delacroix received the young men coldly, he granted permission. Two small sketches after Delacroix's *Dante* may be related to this episode; reproduced in Jamot, Wildenstein, and Bataille, *Manet* (Paris, 1932), *1*, Nos. 1, 2.

Manet's first sizable work was a pastiche wherein future promise was mixed with memories of tradition and recent school practice. What probably disgusted Couture in the *Absinthe Drinker* was just that insistence on the validity of the artist's choice and personal interpretation of a contemporary subject irrespective of its moral or aesthetic implications.[6] The subject of his picture, a man by the name of Colardet, was a ragpicker by profession who used to frequent the galleries of the Louvre and who had caught the artist's eye by his picturesque costume, even then somewhat exaggerated in its dilapidation.[7] Manet had proclaimed his acceptance of the fundamental principle of contemporary realism as it had been defined four years before by Courbet. In the manifesto distributed in his Pavillon du Réalisme, Courbet had declared that his intention had been "to represent the customs, the ideas, the appearance of my own era according to my own ideas."

On the other hand, what might have pleased Couture and what was indeed to become almost compulsive with Manet for the next few years was his contradictory dependence on the masters of the past for conventional designs into which he fitted his contemporary subjects. In the *Absinthe Drinker* Manet, to be sure, had gone to the seventeenth-century realist Velasquez rather than to the idealist compositions of the Italian High Renaissance which were more sympathetic to the conservative painters. The debt to Velasquez was paid by the bottle lying on the ground, so similar to the still-life attributes at the feet of many of the Spaniard's full-length figures. More distracting from the conventional point of view were the double shadows cast by the bottle and by the figure itself. Although illogical in one sense, they served to throw bottle and drinker into greater relief, emphasizing the gloomy pictorial space.

6. In painting the *Absinthe Drinker* Manet placed himself in opposition not only to the idealizing academic subject but also to the typical Romantic subject with its overtones of imaginative escape from present time and place. Only two years before, Delacroix had noted in his journal (January 13, 1857) that "modern subjects are difficult to treat in the absence of the nude and the poverty of modern costume."

7. In costume if not in mood the *Absinthe Drinker* appears not unrelated to Daumier's sculpture of the raffish *Ratapoil* (1850) which satirized the down-at-heels Bonapartists agitating for the extension of the powers of the Prince-President. Manet, in a letter from shipboard in 1848, had expressed his distrust of Napoleon's ambitions.

And, in taking from the brooding philosophers of Velasquez the general scheme for his own treatment of contemporary misery, Manet commenced a practice that would soon entail considerable difficulties, critical as well as technical, for himself and for the public. After the rejection of the painting Manet stated his intention and his dilemma in a few words: "I painted a Parisian character whom I had studied in Paris, and I executed it with the technical simplicity I discovered in Velasquez. No one understands it. If I painted a Spanish type, it would be more comprehensible."

1 8 6 1 – 6 2

TO THE next Salon, held in 1861, Manet sent two paintings which were accepted. In the *Portrait of the Artist's Parents* (Fig. 2) Couture's schematic scale of values plays against Manet's feeling for a predominantly black-and-white tonality relieved by the green table cover and variegated balls of wool. Even more characteristic of a tendency soon to dominate his figure painting is the curiously awkward composition in which the two figures are neither coherently related, formally or psychologically, nor isolated as separate elements. Yet Manet had tried to create a new kind of portraiture, one that would show the contemporary individual as he appeared to be, in surroundings neither abstracted from nor idealized beyond those he occupied in ordinary life. In these terms the portrait of his parents is the first of that modern group to which belong not only his own later studies of men and women but also the family portraits by Degas in the 1860's and even those by Renoir and Monet. The most compelling aspect of the painting, even now, may be the sense of suppressed anxiety in the elderly couple, a certain constitutional nervousness which Manet exhibits himself in photographs and in his portraits by Degas.

For the *Spanish Singer* (Fig. 3) a Spanish model posed in native costume singing to his own accompaniment on a guitar. As with so many realist works the passage of time has mitigated the original effect. The color scheme of black and grey against olive green, the still-life pottery jar, and the onions, to say nothing of the costume and subject, are now more reminiscent of Velasquez' peasant paint-

ings than of Parisian or even Spanish life a century ago. But to the spectators at the Salon, where Gérôme's *Phryne* was the success of the year, the subject and technique appeared far removed from contemporary practice and provoked the first popular and critical reaction to Manet's work.

The painting had at first been "skied," but public interest was so great that it was eventually moved to a better position and at the conclusion of the Salon won for Manet an honorable mention. Official opinion was expressed on July 3 by Théophile Gautier, romantic poet and critic, in the government paper, the *Moniteur universel,* to which he had contributed articles on the yearly Salon since 1845: [8]

> *Caramba!* Here is a *Guitarero* who hasn't stepped out of a comic opera, and who would cut a poor figure in a romantic lithograph. But Velasquez would have given him a friendly wink, and Goya would have asked him for a light for his *papelito.* How heartily he sings as he plucks away at his guitar! We can almost hear him. This bold Spaniard in his *sombrero calanes* and short southern jacket wears pants. Alas! Figaro's knee breeches are now worn only by the *espadas* and *bandilleros,* but the *alpargates* atone for this concession to civilized fashions. There is a great deal of talent in this life-sized figure, broadly painted in true color and with a bold brush.

Whatever Gautier would later write about Manet, these first encouraging words were surely sincere, perhaps the more so since he may well have been aware that Manet was a protégé of Baudelaire, who had dedicated to the older poet his *Fleurs du mal.* Yet the comments show how little Gautier understood either the traditional or novel qualities of the painting. His glancing reference to technique was a commonplace of criticism, while his description of the subject, so heavily salted with his favorite Spanish expres-

8. For Gautier's criticism and critical principles see the collection of his articles published as *Théophile Gautier, critique artistique et littéraire* (Paris, 1929), with an introduction by F. Gohin and R. Tisserand. His interest in Spain and Spanish art has been considered by Gilberte Guillaume-Reicher in *Théophile Gautier et l'Espagne* (Ligugé, 1936).

sions, conveyed only his surprise that this Spaniard wore everyday trousers.

The reaction of the two most important art journals was less favorable. In the July 1 issue of *L'Artiste* Hector de Callias sarcastically dismissed the painting as another miscarriage of realism: [9]

> The *Spaniard Playing a Guitar* recalls the palmy days of Courbet. What poetry in the idiotic figure of this mule driver, in this blank wall, in the onion and cigarette, whose combined odors have just perfumed the room! The fine brush strokes, each separately visible, caked and plastered on, are like mortar on top of mortar.

That same month the critic of the *Gazette des beaux-arts,* Léon Lagrange, joined the attack without sparing even the portrait of the artist's parents: [10]

> An honest person cannot agree that a heavy hand is the last word in art. At least to this quality Manet adds good taste in color. By the choice of subject as much as by the way it is treated, the *Spanish Guitarist* recalls the methods of the school of Seville. But what a scourge to society is a realist painter! To him nothing is sacred! Manet tramples under foot even the most sacred ties. The *Artist's Parents* must more than once have cursed the day when a brush was put in the hands of this merciless portraitist.

In these criticisms of his first Salon paintings the lines were drawn for the battle which was not to end even with his death more than twenty years later. Gautier, then fifty years of age, indulged in the temporary enthusiasm of an essentially conservative man of letters, half regretful that the Spanish theme had failed to correspond to his own romantic vision of the Spain of Figaro and Count Almaviva. Of more consequence for the future were his references to the

9. Hector de Callias (dates unknown), art critic for *L'Artiste* and *Figaro,* author of *Mirages parisiens,* was the brother of the painter Horace de Callias whose wife posed for Manet's *Dame aux éventails* (Paris, Louvre).

10. Léon-Marius Lagrange (1828–68), critic and author of such works on earlier French art as *Les Vernet* (1863) and *Pierre Puget* (1868).

Spanish painters. Later critics would not hesitate to accuse Manet of plagiarizing Velasquez and Goya. The objections of de Callias and Lagrange created, quite as much as they reflected, the obstacles in the way of Manet's appreciation by the general public. In his choice of subject Manet had accepted the realist doctrine that no distinction, for artistic purposes, need be made between the beautiful and the ugly: any subject whatever was capable of artistic treatment. The validity of the painting would depend upon the craftsmanship and sensitivity of the artist himself, but in this respect Manet had offended established precedent by his bold and ostensibly slapdash brushwork. Of the two points for attack perhaps the choice of subject seemed in 1861 more serious. Only Gautier had enjoyed the lifelike character of the *Guitarero,* as it came to be known from his description. If for de Callias he was only an "idiotic mule driver" and if for Lagrange the artist's parents had been mercilessly caricatured, their reactions were based on the traditional attitude toward idealizing the subject as it is found in nature. Truth in art, then, differed from truth in nature to just that extent by which the artist succeeded in ennobling or imparting moral values to the subject. Artist and public alike could measure the degree of artistic truth in almost exactly inverse proportion to the amount of natural truth in a given painting. This was the latest development of the academic formula which at the beginning of the century had been used to condemn such dissimilar accomplishments as Ingres' *Odalisque* of 1814, Géricault's *Raft of the Medusa* of 1819, and Delacroix's *Dante and Vergil* of 1822. In each the truth, whether the searching observation of natural appearance or the projection of intense personal experience, had not been subjugated to conventional canons of design.

In spite of the generally unsympathetic treatment of his first Salon contributions, the attention given the *Spanish Guitarist* brought Manet new friends among the younger painters and another opportunity to exhibit his work. Two years later Fernand Desnoyers, a young man of letters and a friend of Courbet, told how a group of artists, including Alphonse Legros and Fantin-Latour, had been amazed by the *Spanish Guitarist.* It was painted "in a certain strange new way, of which the astonished young painters

thought they alone had the secret, a kind of painting midway be-
tween that called realistic and that called romantic. . . . It was
decided then and there by this group of young artists to go in a body
to Manet's. This remarkable manifestation of the new school oc-
curred. Manet received the deputation very graciously and replied
to the spokesmen that he was no less touched than flattered by this
proof of sympathy. He told them all they wished to know about
himself and the Spanish musician (the model for the painting).
They learned, to their amazement, that he was a pupil of Thomas
Couture. They did not limit themselves to this first visit. The
painters even brought a poet and several art critics to see Manet." [11]

In the autumn of the same year Manet was invited by Louis
Martinet, one of the few Parisian dealers of the day, to exhibit in
his showroom on the Boulevard des Italiens.[12] Here during Sep-
tember and October were shown at intervals in a changing group
exhibition the *Guitarist*, the *Reader* (St. Louis, City Art Museum),
and the *Boy with Cherries* (Gulbenkian Collection), in color and
expression reminiscent of Murillo's urchins. In August 1862 he
had found new inspiration for his Spanish subjects in the perform-
ances of a troupe of Spanish dancers and singers who appeared for
a season at the Paris Hippodrome. The Spaniards served as models
for such works as the *Spanish Ballet* (Washington, Phillips Me-
morial Gallery) and *Lola de Valence* (Paris, Musée du Louvre),
which were exhibited at Martinet's early the next year. That same
month Manet was invited to join the Société des Aquafortistes, a
collaborative undertaking to promote etching as a form of artistic
expression independent of reproductive engraving, sponsored by
Charles Baudelaire, Alphonse Legros, and Félix Bracquemond
with the assistance of the publisher Cadart. To the Society's first

11. Fernand Desnoyers (1828–69), author of *Chansons parisiennes* (1865). The quo-
tation is from his review of 1863 published as *La Peinture en 1863 . . . le Salon des
Refusés par une réunion d'écrivains*, pp. 40–1.

12. Louis Martinet (1810–94), painter and etcher, became a successful entrepreneur
as a picture dealer. At his gallery he presented recent work by such older masters as
Delacroix as well as by such newcomers as Manet. Occasionally he arranged symphony
concerts in his showrooms, and from 1861 to 1863 issued his own publication, the
Courrier artistique, which was full of lively news. He was also the founder of the
short-lived Société Nationale des Beaux-arts.

publication in September Manet contributed an etching, *Les Gitanos*, after a painting on a Spanish theme, the *Gypsies*. This plate, with the painting which was later destroyed by the artist, led to the first public mention of Manet by Baudelaire, his first great critic.[13]

The poet and painter had apparently been friends for several years. If Antonin Proust's memory served him right, Baudelaire had been with them in 1859 when Manet learned that the *Absinthe Drinker* had been refused by the jury, and he joined them in frequent summer visits to the Tuileries Gardens: Baudelaire and Gautier are thought to appear obscurely in profile at the left of the painting *Concert in the Tuileries Gardens* of 1862 (London, Tate Gallery). About this time the poet must also have been a frequent visitor to the studio. The prose poem *La Corde*, which he dedicated to Manet, is an account of the startling suicide of the youthful model for the *Boy with Cherries*. The warmth of his affection for Manet appears in a letter to the painter's mother written in 1863: "It seems difficult for me not to admire his character quite as much as his talents." [14]

If proof of their association were needed the color and mood of the *Absinthe Drinker* are unmistakable indications of the admiration which Manet felt for the author of the *Fleurs du mal*. This enigmatic, black-clad figure might have been painted to demonstrate Baudelaire's contention that modern dress had a beauty all its own. In his review of the Salon of 1846 he had asked if it were not "the necessary costume of our long-suffering age, which bears upon its black and narrow shoulders the symbol of perpetual grief." [15] And a few lines further on he enjoined the painters to accept the prevailing hues of modern costume: "Great colorists know how to get an effect of color with a black suit, a white neckcloth, and a grey background." In Baudelaire's verse the color black

13. Reproduced, Marcel Guérin, *L'Oeuvre gravé de Manet* (Paris, 1944), No. 21. Later in the year Cadart issued a portfolio of eight etchings by Manet including versions of the *Absinthe Drinker* and *Guitarist,* and two etchings after paintings in the Louvre then attributed to Velasquez.

14. Baudelaire's letters to and concerning Manet will be found under the appropriate dates in *Charles Baudelaire, variétés critiques* (Paris, 1924), 2, 223–5.

15. Charles Baudelaire, *Curiosités esthétiques* (Paris, Aubry, 1946), pp. 194–5.

constantly recurs as a descriptive and expressive adjective, even at
times associated with the presence of light rather than with its
absence:

> Et tout, même la couleur noire,
> Semblait fourbi, clair, irisé.

In Manet's work of the 1860's much of his particular quality de-
pends upon his habitual reference of a few "clear" colors to black
areas and accents. Even in his last Impressionist work the colors
were never completely freed from a dark ground. More than that,
the tone—that elusive element which is more than merely the
subject—of his early paintings, especially of the *Absinthe Drinker,*
is Baudelairean.[16] It communicates the mood of discouragement
and disgust in which the poet so often projected his attitude toward
contemporary urban life. Exact concordance between word and
colored shape is less significant than the feeling common to the
painting and to such a typical image as that with which Baudelaire
introduces the fourth "Spleen" among the *Fleurs du Mal:*

> Quand le ciel bas et lourd pèse comme un couvercle
> Sur l'esprit gémissant en proie aux longs ennuis,
> Et que de l'horizon embrassant tout le cercle
> Il nous verse un jour noir plus triste que les nuits.

For Baudelaire Manet's early works may have promised what
some years before he most wanted in modern art, a depiction of
contemporary life which should express its inherent grandeur and
beauty. In the conclusion to his review of the Salon of 1845 he had
called for a kind of painting which the *Absinthe Drinker* almost
exactly supplied: "To the wind which will blow tomorrow no one
pays any attention; and yet the heroism of modern life surrounds
us and urges us on . . . He will be truly a painter, *the* painter who

16. The relation between Manet's painting and Baudelaire's poetry has been noted
since their lifetimes, but there have been few attempts to reach a deeper understand-
ing of their mutual exchanges. Jens Thiis, in his "Manet et Baudelaire," *Etudes d'art*
(Algiers, 1945), *1,* 9–23, considers the similarity between the *Absinthe Drinker* and the
stanza in Baudelaire's "Le Vin de l'assassin" beginning: "Me voilà libre et solitaire!
Je serai ce soir ivre-mort." However, the tone of the poem is too macabre and melo-
dramatic to accord with the muted expression of the painting.

will know how to draw out of our daily life its epic aspect, and make us see and understand, in color and design, how we are great and poetic in our neckties and polished boots."

It might have seemed that Courbet could have fulfilled this wish, but although in his review of the Exposition Universelle of 1855 Baudelaire had recognized Courbet's "savage and patient intention," he had also condemned his "feud with the imagination."[17] Now, on September 14, 1862, in a review in the *Boulevard* of the portfolio just published by Cadart, Baudelaire explained Courbet's success as a necessary reaction against academism and merely commended his contribution "toward re-establishing a taste for simplicity, for freedom, and for an absolute, disinterested love of painting." He followed this comment by a discussion of the contributions of Legros and Manet, of the latter remarking that

> Manet is the painter of the *Guitarero* which caused such a lively stir at the recent Salon. At the next we shall see several of his paintings, touched with the strongest Spanish savor, which leads us to believe that Spanish genius has taken refuge in France. Manet and Legros join to a pronounced taste for reality, for modern reality—which is indeed a healthy symptom—that active and spacious imagination, both sensitive and bold, without which it must be said even the best talents are only servants without masters, agents without authority.

What Baudelaire wanted was possibly as difficult to define as it was, for any lesser artist than he or Manet, to achieve. A subject selected at random from contemporary life could well be trivially chosen or inadequately presented. The work of art must, if it were to incorporate that accent which Baudelaire recognized as "modern," be chosen with care and executed with the utmost artistic discrimination, not with Courbet's crudity but with Manet's taste. From this point of view Manet's predilection for Spanish subjects was far from a hindrance to his modernism; in the movements of

17. The extent of Baudelaire's disillusionment with Courbet and the Realist movement as exemplified by Champfleury may be read in the draft of a projected article, "Puisque réalisme il y a," discovered among the poet's papers. See Jacques Crépet, ed., *Oeuvres complètes de Charles Baudelaire. Oeuvres posthumes* (Paris, Louis Conard, 1939), *1*, 296–9, 579–80.

the Spanish dancers modern life acquired the accents of beauty and
especially of imagination, that quality which Baudelaire prized
above all others. In this sense perhaps his most enduring tribute
to Manet's art was the quatrain he composed for the portrait of the
Spanish dancer, Lola de Valence:

> Entre tant de beautés que partout on peut voir,
> Je comprends bien, amis, que le désir balance;
> Mais on voit scintiller en Lola de Valence
> Le charme inattendu d'un bijou rose et noir.[18]

Although the notice of 1862 was the only occasion upon which
Baudelaire spoke out publicly on behalf of Manet's work, his en-
couragement never failed. In 1864 he intervened privately to repair
what he considered an unjust attack on the artist. The critic Théo-
phile Thoré (W. Bürger) had mentioned, in an otherwise compli-
mentary description of Manet's *Incident in the Bull Ring,* his
dependence on such Spanish masters as Velasquez and El Greco.
Baudelaire resented the inference and addressed to Thoré the long
and interesting letter on Manet's painting which will be examined
in the discussion of the Salon of that year. By then Baudelaire's
support of Manet was well known, not only to the narrower circle
of the artist's friends but to the wider public as well. In a certain
sense it was encouragement which could do quite as much harm as
good. The author of the *Fleurs du mal* was already notorious in his
own right. Upon the publication of that volume in 1857 he had been
brought to trial and six of the poems had been suppressed as in-
decent. Some indication of popular opinion of poet and painter
alike can be read in Louis Leroy's labored satire in *Charivari* on
June 15, 1864.[19] Although the humor, if any, has long since evapo-
rated, and we should scarcely recognize Baudelaire in such an idiotic

18. The verses were first published on the margin of the third state of Manet's
etching after *Lola de Valence* (Guérin, 1862), No. 23. So suspect were Baudelaire's
poems that his contemporaries understood an obscene meaning in the phrase "bijou
rose et noir," a reading which Zola endeavored to correct in his article on Manet in
1867.

19. Louis Leroy (1812–85), engraver, genre painter, and popular playwright, was a
frequent contributor to *Charivari.* In 1874 he coined the term "Impressionist" in his
review of the first Impressionist exhibition.

temper, the presentation of Manet as an aloof figure is a more accurate characterization than those by the contemporary cartoonists who depicted him as a disorderly Bohemian. The scene purports to represent the distribution of awards at the conclusion of the Salon of 1864 where Manet's bull in his *Bullfight* had been considered ridiculously small. A vulgar voice is heard calling for the painter:

> The young artist, hoisted on a shield carried by Messrs. Baudelaire, Champfleury, and de Broglie, father and son, stops in front of the judges' bench.
>
> *The President.* This pose of a conquering hero is unbecoming. Get down!
>
> *Baudelaire* (beginning to gnash his teeth). If we could have found a bronze chariot in the square, we would have hired it at once in order to bring the only painter of our times to you in proper fashion. Hurray!
>
> *The President.* Baudelaire, it's not your turn to speak.
>
> *Baudelaire* (giving full rein to his roars). Onh! . . . ffowt! . . . rhooh! . . . fowt! . . . fowt! . . .
>
> *The President.* This poet is frightfully raucous.
>
> *Manet* (calm and slightly disdainful). I should like very much to know what my prize consists of.
>
> *The President.* Make your attendant keep quiet; he bothers me with his interruptions, borrowed from the language of the beasts. (Messrs. de Broglie, father and son, succeed in calming the author of the *Fleurs du mal.*) . . .
>
> *The President.* We were talking about your prize, weren't we?
>
> *Baudelaire* (escaping from his keepers). Rrauwft! . . . fowt, fowt!
>
> *The President.* I repeat, Baudelaire, you haven't the right to be so noisy here.
>
> *Manet.* I'm still waiting.

The President. Where was I? The Butchers' Union, rightly astonished that a man of your ability knows so little about modeling horned beasts, has unanimously decided that a special box shall be reserved for you in all the slaughterhouses of the city of Paris. The union hopes that through excessive use of the favour you will, some day or other, be able to give bulls the thickness, the relief which nature has so generously given to this reproductive animal, relief which you cannot ignore any longer without trampling on the sacred rights of the defense, inalienable rights at whose service justice, truth and *The Right* [the court newspaper] habitually put themselves.

Baudelaire (once more a gentleman). This prize seems to imply a criticism on the part of the committee of award and, no matter how decrepit the members may be, how corrupt, how brutish, how idiotic they appear, I must admit I should never have expected such a filthy decision. Be proud, gentlemen. You have just gained an advantage over the molluscs, the zoophytes, the most spineless products of the social and humanitarian flora. Many thanks, you beasts.

The President. We joyfully hasten to acknowledge the fact that the illustrious poet has brought to his protest tact, taste, and seemliness which cannot be overpraised. It is so true that a soul so choice as his could not always stop at the first rudiments of childish and honest civility. Gentlemen, the meeting is adjourned.

But Thoré's reservations and Leroy's sarcasm were as nothing to the torrent of abuse which was unleashed the following year when Manet exhibited the *Olympia* and *Christ Scourged* at the Salon of 1865. Even the most self-assured would have been disconcerted. In his dejection Manet turned to Baudelaire, now near the end of his own creative activity in Brussels where, beset by similar public abuse and misunderstanding, he would shortly suffer the paralytic strokes which were to destroy him. Manet wrote: "I could wish you were here. Insults pour down on me like hail. I should so much like to have your opinion of my paintings, for all this outcry irritates me, and it is evident that someone or other is at fault." Baudelaire's

reply on May 11 conveys something of the tone of Manet's appeal, which must have been written when the first shock of public outrage was still fresh:

> I thank you for the good letter which Chorner brought me this morning, as well as for the piece of music . . . If you see Rops, don't attach too much importance to certain violently provincial mannerisms. Rops likes you, Rops has understood the value of your intelligence, and has confided to me certain observations which he made about the people who hate you (because it seems that you have the honor of inspiring hatred). Rops is *the only real artist* (in the sense in which I, and perhaps I only, understand the word *artist*) that I have found in Belgium.
>
> So I must speak to you of yourself. I must try to show you what you are worth. What you demand is really stupid. *They make fun of you; the jokes aggravate you; no one knows how to do you justice, etc., etc.* . . . Do you think you are the first man put in this predicament? Are you a greater genius than Chateaubriand or Wagner? Yet they certainly were made fun of. They didn't die of it. And not to give you too much cause for pride, I will tell you that these men are examples, each in his own field and in a very rich world; and that you, *you are only the first in the decrepitude of your art.* I hope you won't be angry with me for treating you so unceremoniously. You are aware of my friendship for you.
>
> I wanted to get a *personal* impression from this Chorner, at least insofar as a Belgian can be considered an *individual.* I must say that he was kind, and what he told me fits in with what I know of you, and with what some imaginative people say of you: *There are some faults, some failings, a lack of balance, but there is an irresistible charm.* I know all that, I was one of the first to understand it. He added that the painting of the nude woman, with the negress and the cat (is it really a cat?), was far superior to the religious painting.

Considering the welter of conflicting opinion, the poet's analysis was eminently acute and just. Yet he must have felt that Manet,

already exacerbated almost beyond endurance, would resent even
the slightest reservations, and Baudelaire's were not slight. Two
weeks later he wrote to Paris again, this time to Mme. Paul Meurice,
advising her:

> When you see Manet, tell him this: that torment—whether
> it be great or small—that mockery, that insults, that injustice
> are excellent things, and that he should be ungrateful were he
> not thankful for injustice. I well know he will have some dif-
> ficulty understanding my theory; painters always want im-
> mediate success. But really, Manet has such brilliant and facile
> ability that it would be unfortunate if he became discouraged.
> He will never be able to fill completely the gaps in his tempera-
> ment. But he has a *temperament,* that's the important thing.
> And he does not seem to suspect that the greater the injustice,
> the better the situation—on condition that he does not lose
> his head. (You will know how to say all this lightly, and without
> hurting him.)

The following day, May 25, in an even more confidential letter
to Champfleury, he noted again what worried him most in Manet's
case, the near failure of will:

> Manet has a strong talent, a talent which will resist. But he
> has a weak character. He seems to me disconsolate and dazed
> by the shock. I am also struck by the delight of all the idiots
> who think him ruined.

Baudelaire's fears were groundless; his friendship with Manet was
uninterrupted. In October he acknowledged another communica-
tion from the painter in a letter which is the last surviving one ex-
changed between them. Since it is entirely taken up with an account
of Baudelaire's difficulties with his publishers and his distrust of
Victor Hugo, then living in exile in Brussels, it is of no immediate
concern to this account.

One may regret that Baudelaire's influence was so soon to cease.
In April 1866 he was stricken with paralysis and died in September
of the following year. At first reading the relations between the two
men may seem of small account compared with the total criticism

of Manet by others. Baudelaire has even been accused of having done less than his share to support his friend against the public. But the brief published notice of 1862, the reply to Thoré quoted by the latter in his published criticism, the stray remarks in letters to friends which gradually circulated throughout Paris, and most important, the increasing public awareness of Baudelaire's significance as a poet and as a gifted critic of the greater painters of his time—of Delacroix and Courbet, of Daumier and Guys—persuaded more than one reluctant admirer of Manet's achievement. Echoes of Baudelaire's attitude recur with increasing frequency until now his name is inextricably linked with Manet's. As early as 1873 Théodore de Banville suggested the position the future would assume. Commenting on that "intense quality of modernity" in Manet's *Repos* of that year's Salon, he remarked that "Baudelaire was indeed right to esteem Manet's painting, for this patient and sensitive artist is perhaps the only one in whose work one discovers that subtle feeling for modern life which was the exquisite originality of the *Fleurs du mal*." [20] And as will presently appear, more, possibly, than subsequent or even contemporary critics realized, the "exquisite originality" of Manet's early work from 1859 through the decade of the 1860's may be considered the result of his admiration for the poet.

20. For de Banville's statement in full see below, p. 172..

1863

EARLY IN 1863 Martinet, encouraged by the attention Manet's work had attracted at his gallery, arranged the painter's first one-man exhibition. In itself such an occasion was unusual at a time when dealers were few and these few hesitated to commit themselves to relatively unknown younger artists. The date, March 1, just a month before the first meeting of the Salon jury, was carefully chosen in the hope that if the reviews were encouraging the three large canvases Manet was sending might be accepted. Fourteen recent works were on view including, in addition to the paintings previously seen at the gallery, the *Street Singer* (Boston, Museum of Fine Arts), the first painting for which Victorine Meurend had posed, the *Boy with a Sword* (New York, Metropolitan Museum), and the *Old Musician* (Washington, National Gallery of Art, Dale Collection). The last is a large canvas containing an assortment of gypsy-like characters, including a reprise of the absinthe drinker in the background. The isolated, fragmented grouping of the figures recalls Velasquez, but the bright, clear colors prove that Manet was beginning to move away from the darker tonalities of his earlier Spanish works.

Although the critics now had an opportunity to examine more than isolated examples of the young painter's work, their comments only emphasized the division of opinion which the *Guitarist* had provoked. In his review in *L'Artiste* on April 1, Ernest Chesneau showed that he detected the originality of vision and conception which other critics failed to see, but his own taste led him to prefer a painting which more than any other betrayed Manet's earlier

dependence upon Velasquez, the dark but charming *Boy with a Sword*.[1]

> Until now his work has provoked more condemnation than sympathy. In spite of that I must confess that a certain amount of youthful daring is not distasteful to me and that, even if I willingly grant all that Manet still lacks to justify his audacity, I do not despair of seeing him triumph over ignorance to become a fine painter. In my eyes he has one great virtue: he is not commonplace and he does not stick in the rut which leads to easy rewards and cheap success . . . I shall only add that in addition to numerous figures wherein there is much to find fault with from the point of view of draftsmanship, he has created one very fine painting, of unusual sincerity and feeling for color. I mean the *Boy with a Sword*.

Unhappily for Manet and his dealer the unfavorable reviews were in the majority, and for the first time prominent conservative critics joined the attack. Paul de Saint-Victor, the most influential critic of art and drama after Gautier, remained a staunch opponent of modern painting throughout his long career, in the course of which he took every opportunity to slight or ignore Manet's work.[2] His irritable remark in the *Presse* on April 27, to the effect that Manet suggested "Goya in Mexico gone native in the heart of the pampas and smearing his canvases with crushed cochineal," was typical of his attitude. Paul Mantz, who usually sided with the government, had been even more severe in the *Gazette des beaux-arts* on April 1.[3] Where Chesneau had seen beneath the superficial discrepancies of draftsmanship to the underlying power and originality, Mantz was distracted by such aberrations. His objections

1. Ernest Chesneau (1833–90), critic and administrator, contributor to numerous Parisian journals, was especially interested in the relations between art and society and published several studies of nineteenth-century French and English art.

2. Paul Bins, Comte de Saint-Victor (1827–81), succeeded Gautier as critic of the *Presse* in 1855. He was for a time inspector-general of fine arts and was often appointed an official member of the Salon jury, notably in 1866, 1867, and 1878 when Manet's works were either rejected or ignored.

3. Paul Mantz (1821–95), journalist, critic, and administrator. Contributed to the *Gazette des beaux-arts* from 1859; director-general of fine arts, 1881–82. Author of *Hans Holbein* (1879) and *François Boucher* (1880).

to Manet's color and drawing were more specific and so more effective in influencing subsequent criticism:

> Manet, who is a Parisian Spaniard, related by some mysterious affinity to the tradition of Goya, exhibited at the Salon of 1861 a *Guitarist* which, we must confess, greatly impressed us. It was brutal but it was truthful, and in that rough sketch there was promise of a virile talent. Two years have passed since then, and Manet with his innate bravado has entered the realm of the impossible. We absolutely refuse to follow him. Form is lost in his large portraits of women, and especially in the *Street Singer* where, through a peculiarity which bothers us intensely, the eyebrows have been moved from their horizontal position to a vertical one parallel to the nose, like two dark commas.[4] There is nothing more there than the shattering discord of chalky tones with black ones. The effect is pallid, harsh, ominous. At other times, when Manet is in a good humor, he paints the *Concert in the Tuileries Gardens,* the *Spanish Ballet,* and *Lola de Valence,* paintings which disclose his abundant vigor but which in their medley of red, blue, yellow, and black are color caricatured, not color itself. In short, this art may be strong and straightforward but it is not healthy, and we feel in no way obliged to plead Manet's cause before the jury of the Salon.

The reference to the jury of the approaching Salon anticipated the immediate crisis of that month. When toward the end of April it became known around Paris that the jury had refused more than 4,000 paintings, an unusually large number, including some by men who had been admitted in the past or who had even won a

4. The description of the *Street Singer's* complexion and peculiar eyebrows brings to mind the first stanza of Baudelaire's 'Les Promesses d'un visage':

> J'aime, ô pâle beauté, tes sourcils surbaissés,
> D'où semblent couler des ténèbres;
> Tes yeux, quoique très-noirs, m'inspirent des pensers
> Qui ne sont pas du tout funèbres.

Since the poem was not published until 1866, it may be that Manet's vision had begun to influence Baudelaire's.

mention as had Manet, the complaints were so numerous that the government, on the initiative of the Emperor, ordered an exhibition of the rejected works in halls adjacent to the official galleries. This decision was announced in the *Moniteur* on April 24, one week before the opening of the official Salon:

> Numerous complaints have reached the Emperor on the subject of works of art which have been refused by the jury of the exhibition. His Majesty, wishing to let the public judge the legitimacy of these complaints, has decided that the rejected works of art are to be exhibited in another part of the Palace of Industry. This exhibition will be voluntary, and artists who may not wish to participate need only inform the administration, which will hasten to return their works to them. This exhibition will open on May 15. Artists have until May 7 to withdraw their works. After this date their pictures will be considered not withdrawn and will be placed in the galleries.

The wording of the decree left the rejected painters in an ambiguous position. If they withdrew their works it might be thought that they had accepted the jury's verdict. On the other hand, if they decided to remain it was to ask for the public's decision, not on the merit of their art but on the justice of the jury in rejecting it. Although many withdrew, the number of rejected artists exhibiting in the so-called Salon des Refusés came to more than 1,200, including among a large assortment of nonentities such promising and progressive painters as Jongkind, Bracquemond, Fantin-Latour, Legros, Pissarro, Cézanne, Whistler, and Manet.

This notorious exhibition of rejected paintings was more of a popular scandal than an artistic success. Many of the works were incompetent and had quite sensibly been refused on the grounds of inadequate craftsmanship. The paintings of the men cited above in some instances were crude and immature, like Cézanne's. Whistler and Manet, on the other hand, were attempting experiments in design and expression which ran counter to prevailing academic standards. But it is doubtful whether their work would have attracted quite the same amount of public derision had it been included without undue notice in the official exhibition. As

it was, shock and irritation rather than temperate and considered judgment characterized public and critical reaction to the exhibition as a whole as well as to Manet's work in particular. Sober appraisal of this new painting, which should have been the only critical issue, was lost in name calling. Perhaps the public could not be blamed for approaching in a spirit of prudery and ridicule work presented under such inauspicious circumstances, but unfortunately the critics, with rare exceptions, did nothing to clarify the situation and contented themselves with reiterating the public's sentiments. That the jury was determined not to let the occasion pass without some effort to disparage the intrepid exhibitors is apparent from a remark by Louis Leroy in *Charivari* on May 20: "The galleries are good-sized, well-lighted, and the works by the pariahs of the Salon can be examined under the best possible conditions. The administration has indeed here and there with malice aforethought hung on the line certain ridiculous canvases which attract the eager attention of the greater part of the public."

The exhibition was considered unworthy of attention by those publications committed to support the government. Not a word appeared in the *Moniteur,* where Théophile Gautier devoted twelve lengthy reviews to the accepted paintings. Maxime Du Camp, the critic for the *Revue des deux mondes,* after an unusually severe account of the official Salon, expressed in an addendum his opinion of the whole performance without referring to any artist by name.[5] Between his lines there can still be read something of the brutality of the public's behavior toward the unfortunate exhibitors.

> This exhibition, at once sad and grotesque, is one of the oddest you could see. It offers abundant proof of what we knew already, that the jury always displays an unbelievable leniency. Save for one or two questionable exceptions there is not a painting which deserves the honor of the official galler-

5. Maxime Du Camp (1822–94), author and critic, friend of Flaubert with whom he traveled in Europe and the Near East. One of the founders, with Gautier and Laurent Pichat, of the *Revue de Paris* (1851–58); frequent contributor to the *Revue des deux mondes;* author of an encyclopedic study of contemporary Paris and of a history of the Commune.

ies . . . There is even something cruel about this exhibition; people laugh as they do at a farce. As a matter of fact, it is a continual parody, a parody of drawing, of color, of composition. These, then, are the unrecognized geniuses and their productions! These are the impatient painters, those who complain, who rail at men's injustice, at their hard lot, who appeal to posterity! No more brilliant sanction could have been given the decisions of the jury, and it can be thanked for having tried to spare us the sight of such lamentable things.

A few voices spoke out in defense of the artists. Fernand Desnoyers, in his *La Peinture en 1863,* a hastily compiled brochure containing the opinions of his friends, expressed his disgust with the whole performance. His description of the popular reaction to Manet's work concluded with one of the soundest observations of the day:

> Manet's three pictures must have profoundly upset the dogmatic ideas of the jury. The public also has not failed to be astonished by this kind of painting which at the same time aggravates art lovers and makes art critics facetious. You can consider it evil but not mediocre. Manet certainly has not the least bias. He will keep on because he is sure of himself in the long run, whatever the art lovers claim they find in his manner imitative of Goya or of Couture—small difference that makes. I believe that Manet is indeed his own master. That is the finest praise one can give him.

Manet was represented in the Salon des Refusés by three etchings and three large paintings. In two of the latter he continued the Spanish themes of recent years, but *Mlle. V. as an Espada* (Fig. 5) and the *Young Man as a Majo* (Fig. 4) attracted little attention compared with the storm of abuse provoked by the painting now known as the *Déjeuner sur l'herbe* but then exhibited as *Le Bain* (Fig. 6). The title did nothing to divert attention from the fact that the canvas displayed two women, one entirely nude, on a holiday in the country in the company of two fully clothed young men. Manet's desire to interpret modern life in terms of the great pic-

torial tradition of European art, all the while reinforcing it by a
respect for visual truth as complete and coherent as any possessed
by the masters of the past, was paradoxically too naïve and too subtle
for the public. Antonin Proust later recalled that at Argenteuil
one day in 1862 Manet, while watching two women bathing in the
Seine, had said that in his student days he had copied Giorgione's
Fête champêtre in the Louvre. But he now found it too dark and
wished to do it again in "transparent atmosphere" with contempo-
rary figures. Some effort is required today to re-create the sense
of outrage which the Parisian middle classes experienced at the
depiction of such an event, perhaps common enough in certain
circles but one to which they preferred to close their eyes. Any
sanction which Manet might have sought by the implicit reference
to the subject of Giorgione's painting where an almost identical
situation had been treated in terms of early sixteenth-century Ven-
ice, or by his adaptation, for the composition, of the group of river
deities in Marcantonio Raimondi's engraving after Raphael's *Judg-
ment of Paris,* a reference unnoticed at the time and unmentioned
by the artist, was dissipated when the public realized that three of
the figures in *Le Bain* were portraits of living people who might
even, were the spectators fortunate, be seen strolling through the
galleries of the Salon.[6] Mlle. Victorine Meurend, Manet's favorite
model of these years, had posed for the seated nude. The male
figures were portraits of his brother Eugène and of Ferdinand
Leenhoff, the brother of Suzanne Leenhoff, the Dutch lady whom
Manet was to marry in October of that year.

There is a story to the effect that Napoleon III confirmed the
government's attitude for an obsequious press and bewildered
public when, upon visiting the Salon, he paused before *Le Bain*
for several minutes and then, without a word, turned away with a
gesture indicating that he considered the painting an offense against
public morality. Such an opinion at the least helps to account for
the astonishing language which soon appeared in the popular hand-

6. The reference to Raphael was noted by Chesneau when his review of the Salon
appeared in book form as *L'Art et les artistes modernes en France et en Angleterre*
(1864), p. 190. For later studies of the sources see Gustav Pauli, "Raffael und Manet,"
Monatshefte für Kunstwissenschaft 1 (1908), 53; G. Mesnil, "*Le Déjeuner sur l'herbe
di Manet ed Il Concerto campestre* di Giorgione," *L'Arte,* N.S., 5 (1934), 250–7.

books. Louis Etienne in his brochure, *Le Jury et les exposants,* stated the case almost as a public prosecutor, and his remarks can stand as the typical popular reaction:

A commonplace woman of the demimonde, as naked as can be, shamelessly lolls between two dandies dressed to the teeth. These latter look like schoolboys on a holiday, perpetrating an outrage to play the man, and I search in vain for the meaning of this unbecoming rebus . . . This is a young man's practical joke, a shameful open sore not worth exhibiting this way . . . The landscape is well handled . . . , but the figures are slipshod.

By others the problem was studied as an artistic as well as a moral issue. Louis Martinet, as the first dealer ever to exhibit Manet's work, had a particular interest in the fate of his protégé. In the May 15 issue of his own journal, the *Courrier artistique,* he printed a review of the Salon des Refusés by one of his collaborators, Edouard Lockroy: [7]

The exhibition of the rejected works, which we saw only for a moment, will certainly be a triumph for the jury. More than 1,500 artists have withdrawn, and of course some of the best. Nevertheless among the remaining canvases are some which would have held an honorable place with the work which was accepted . . . Manet has a gift for displeasing the jury. If he had only that, we should most certainly not be grateful to him, but he has others. Manet has not yet had the last word. His paintings, whose qualities the public cannot appreciate, are full of good intentions. Manet will triumph some day, we have no doubt, over all the obstacles he encounters, and we shall be the first to applaud his success.

Meanwhile another friend had come to his defense. Zacharie Astruc, an amateur sculptor, musician, poet, and critic for whom Manet had made a lithograph after *Lola de Valence* to illustrate

7. Edouard Lockroy (1840–1913), liberal politician and man of letters, secretary to Renan with whom he traveled to Palestine, 1860–64. Frequent contributor to *Figaro.* After 1871 sat on the extreme left in the assembly.

Astruc's serenade of the same title, published a weekly paper, *Le Salon,* during the run of the exhibition.[8] Here he defended the abused artist more energetically than anyone else. In describing the effect of Manet's work upon the spectator his language had none of the precision later critics achieved after lengthier study, but his remarks were unusually perceptive for the time. At the least he succeeded in relegating to a subordinate role the departures from conventional technique which so exasperated his contemporaries.

> One must have the strength of two to stand up under the storm of fools who pour in here by the thousands to jeer to the limit, with stupid smiles on their lips . . . Manet, one of the greatest personalities of our time, is its luster, inspiration, pungent savor, and surprise. The injustice committed in his case is so flagrant it confounds . . . In contrast to the great natural-born talents who compel us to study first the technical aspects of their art, he imposes and, so to speak, manifests his personal vitality . . . He pleases or displeases at once; he quickly charms, attracts, or repels. His individuality is so powerful that it eludes technical considerations. Technique is effaced in favor of the full metaphysical and tangible value of the work. Only long afterwards are we aware of the method by which it was accomplished, the elements of color, relief, and modeling.

And of the painting of Victorine Meurend as an espada, "a strange picture," he declared that there was "nothing more engaging than this young woman holding a naked sword, nothing freer, stronger than this portrait."

Although, with the exception of Zacharie Astruc, Manet's friends seem to have had little opportunity or inclination to defend him publicly, two professional critics who were accustomed to make the rounds of the Salon in search of new talent and who could not be accused of partiality or enmity toward the young painter were preparing their accounts of this year's event. In 1863 Jules Antoine Castagnary, an attorney obliged to suppress his liberal political

8. Zacharie Astruc (1835–1907), author of *Les Quatorze Stations du Salon* (1859), and *Le Salon intime* (1860). After 1865 he often exhibited water colors and academic sculpture at the Salon.

opinions during the Empire, was already well known as an experienced art critic and as one of the serious apologists for the realist movement.[9] In his first important criticism, published as *Philosophie du Salon de 1857*, he had developed the theory that classicism and romanticism had run their course and were being supplanted by the painting of modern life in all its phases which he described as "naturalism." For him the academic hierarchy of historical and religious art would have to yield to three types of naturalist painting: landscape, portraiture, and scenes of modern life. Courbet most fully exemplified his ideal of naturalism, although he also admired Millet and the Barbizon masters. As will appear in the course of this account Castagnary, although not always sympathetic to Manet's technical procedure, usually followed his work with interest. Indeed, such a critic could scarcely fail to be perplexed by Manet's first paintings, wherein the extent of his commitment to modern manners was not always apparent in the predominantly Spanish repertory. For Castagnary, who believed that the "modern" quality of contemporary painting was to be found in the choice and treatment of subject matter, Manet's subjects were incomprehensible as interpretations of contemporary life and his technique a further impediment to logical understanding. What is remarkable, though, is the precision with which he described just those aspects of Manet's technique which set him apart from academic artists:

> There has been a lot of excitement about this young man. Let us be serious. The *Bath,* the *Majo,* the *Espada* are good sketches, I will grant you. There is a certain verve in the colors, a certain freedom of touch which are in no way commonplace. But then what? Is this drawing? Is this painting? Manet thinks himself resolute and powerful. He is only hard. And the amazing thing is that he is as soft as he is hard. That's because he is uncertain about some things and leaves them to chance.

9. Jules Antoine Castagnary (1830–88), critic and administrator, later a member and finally president of the Municipal Council of Paris. His reviews are most conveniently consulted in his *Salons, 1857–1870* (1892). For the most recent study of Castagnary's criticism see J. C. Sloane, *French Painting between the Past and the Present,* ch. 5.

Not one detail has attained its exact and final form. I see garments without feeling the anatomical structure which supports them and explains their movements. I see boneless fingers and heads without skulls. I see side whiskers made of two strips of black cloth that could have been glued to the cheeks. What else do I see? The artist's lack of conviction and sincerity.

Théophile Thoré, probably the most gifted as well as the most liberal critic who commanded wide attention during these later years of the Empire, published the most thoughtful review of the Salon that year.[10] Like Castagnary, he had started life as an attorney but soon turned to politics. His liberal attitude led him into strenuous opposition to the governments of Charles X and Louis-Philippe, and he took an active part in the revolutions of 1830 and 1848. For his part in the uprising of May 1848 he was exiled until 1859. During nine years spent largely in Belgium he made a particular study of Dutch and Flemish painting, which may account for his partiality toward the realist movement of the 1850's and 1860's. But in spite of his profound belief that modern painting must deal with modern times, and his concern with discovering and estimating the value of progressive art, he was unprepared to accept Manet's indifference toward the subjects of his paintings. His review of the Salon, published in Brussels in *L'Indépendance belge,* was the only one which took into account its general character, and it contained the significant suggestion that the exhibition as a whole represented a new tendency in French painting, a realism almost primitive in its rude strength.

After due thought one sees that most of the rejected paintings share a certain similarity in primary conception and technique; in their eccentricities they resemble each other. An

10. Théophile Thoré (1807–69) had written art criticism since the early 1830's. His reviews of the 1860's were collected and published posthumously under his pseudonym as *Salons de W. Bürger, 1861 à 1868, avec une préface par T. Thoré* (2 vols. Paris, 1870). His study of the art of Vermeer has been republished by André Blum in his *Vermeer and Thoré-Bürger* (Geneva, 1946). See also H. Marguéry, "Un pionnier de l'histoire de l'art, Thoré-Bürger," *Gazette des beaux-arts,* Series 5, *11* (1925), 229–45, 295–331, 367–80.

innocent stranger who might visit this Salon thinking he was in the official exhibition would undoubtedly suppose that the French school tends with apparent unity toward the reproduction of men and nature just as we see them, without preconceived ideals or stylistic dogmas, without tradition but also without individual inspiration. It looks as if these artists were taking art back to its origins without bothering about what civilization has been able to do before them. . . . People who begin anything have, even in their barbarism, something sincere and deeply felt, and at the same time ludicrous and incomplete, something both novel and unique. French art, as it is seen in the rejected work, seems to begin or to begin all over again. It is odd and crude yet sometimes exactly right, even profound. The subjects are no longer the same as those in the official galleries: very little mythology or history; contemporary life, especially among the common people; very little refinement and no taste. Things are as they are, beautiful or ugly, distinguished or ordinary, and in a technique entirely different from those sanctioned by the long domination of Italian art. Instead of looking for outlines which the Academy calls *drawing,* instead of slaving over details which those who admire classic art call *finish,* these painters try to create an effect in its striking unity, without bothering about correct lines or minute details. . . .

If the artistic unrest as it appears in the work of a great many young painters signifies, as it seems to, a return to nature and humanity, we must not take exception to it. The misfortune is that they have scarcely any imagination and that they despise charm. These pioneers of the possible transfiguration of an old exhausted art are for the most part until now only impotent or even absurd. Therefore they excite the uncontrolled laughter of gentlemen well educated on sane principles. But let there appear some painters of genius, loving beauty and distinction in the same subjects and techniques, and the revolution will be quick. The public would even be astonished at having admired the nonsense now triumphant in the official Salon.

In the light of such searching analysis of the position reached in 1863 not only by Manet but also by Whistler, Fantin-Latour, Legros, and Pissarro, each in his own way having attempted "a return to nature and humanity," it might be thought that the works would fare well. But not even Thoré was prepared for quite such audacious technique or unconventional subject matter.

> After Whistler, the artist who arouses the most discussion is Manet. He, too, is a true painter; several of his etchings, particularly the reproduction of the *Petits cavaliers* by Velasquez in the Louvre, exhibited among the rejected works, are lively, witty, and colorful. His three paintings look a bit like a provocation to the public which is dazzled by the too vivid color. In the center, a bathing scene; to the left a Spanish *Majo;* to the right a Parisian girl in the costume of an *Espada,* waving her purple cape in the bull ring. Manet loves Spain, and his favorite master seems to be Goya, whose vivid and contrasting hues, whose free and fiery touch, he imitates. There are some amazing materials in these two Spanish figures, the *Majo's* black costume and the heavy scarlet burnous which he carries over his arm, the pink silk stockings of the young Parisian disguised as an espada. But underneath these brilliant costumes personality itself is somewhat lacking; the heads ought to have been painted differently from the drapery, with more accent and contrast.
>
> The *Bath* is very daring. . . . The nude hasn't a good figure, unfortunately, and one can't think of anything uglier than the man stretched out next to her, who hasn't even thought of taking off, out of doors, his horrid padded cap. It is the contrast of a creature so inappropriate in a pastoral scene with this undraped bather that is shocking. I can't imagine what made an artist of intelligence and refinement select such an absurd composition, which elegant and charming characters might perhaps have justified. But there are qualities of color and light in the landscape, and even very convincing bits of modeling in the woman's body.

In spite of the scandal and disturbance the Salon des Refusés led to important reforms in the organization of the official exhibitions.

On June 24 and 29 the *Moniteur* announced that henceforward the Salon would be held annually instead of biennially, and that it would be placed under the direction of the director-general of the Imperial Museums who would take the title of secretary-general of fine arts. On August 2 another decree declared that, in the future, three-fourths of the jury would be selected by the artists who had previously received awards. The stranglehold of the Institute could be broken and a way opened for the election of a jury more nearly representative of contemporary artistic trends.

For Manet his participation in the Salon des Refusés worked both for and against his advantage. Long afterward it might be thought that he had gained an important step, for himself and for modern art, by his deliberate decision to stand with the rejected. But this is perhaps to overestimate the significance of the Salon des Refusés as a rallying place for the avant-garde. As a matter of fact, although Whistler, Cézanne, and Pissarro eventually came to prominence, in 1863 they had not yet achieved that mastery of individual style which would be theirs within the next decades. And of the names with which Manet's would be associated so shortly, neither Renoir, Monet, nor Sisley had as yet emerged from his apprenticeship with Gleyre. On the contrary, for the rest of his life Manet was considered by the general public a painter who belonged to the lunatic fringe. As will appear from the examination of the caricaturists' treatment of his subsequent Salon contributions, neither his work nor his appearance was ever regarded as other than shabby, willfully untidy, and arrogantly contemptuous of public opinion. In terms such as these the artist paid dearly for his participation in the Salon des Refusés. On the credit side he could cast up only whatever advantage accrued in the nineteenth century from sensational publicity.

1 8 6 4

THE FOLLOWING year the jury accepted Manet's two contributions without demur. Perhaps the members hesitated to risk a repetition of the scandal of 1863, or perhaps they were impressed by Manet's attempt to court official favor by offering a religious subject as well as a genre scene. More probably they yielded to the suggestion of the Marquis de Chennevières, the chief curator of the

Louvre in charge of the Salon, to whom Baudelaire had written urging that the works submitted by Manet and Fantin-Latour be hung advantageously.[11] But their complaisance was not matched by popular or critical approval. Both Manet's canvases were severely abused.

The *Incident in the Bull Ring* was, up to this time, Manet's closest approach to a painting of action and drama, but it was also one of his most derivative works. Even his contemporaries were aware that the figure of the dead toreador in the foreground of the arena owed all but its costume to a seventeenth-century painting of a dead warrior, then in the Pourtalès Collection and attributed to Velasquez.[12] In the center stood the furious bull while the matadors crowded against the wooden palisade in the background. To most critics the perspective was so distorted that it was hard to understand. Most probably it resembled the abrupt and flattened space of *Mlle. V. as an Espada,* where the bull and the toreadors are also illogically small in relation to the principal figure. In each work Manet may have looked to the Japanese print for his composition, attempting in a similar way to arrange realistic figures in a decorative pattern freed from the limitations of conventional perspective space. Théophile Gautier, fils, in the *Monde illustré* on June 18, described the painting as it must have seemed to many and accused the painter of having capitalized on his previous notoriety: [13]

> It would appear that he has profited too late by the jury's indulgence, and that he has taken advantage of being included among painters recommended to the public's attention to push to an extreme a paradox which, had it been handled more delicately, would certainly have fascinated many people. His *Incident in the Bull Ring* is, we must admit, completely unin-

11. This information is contained in Baudelaire's letter of March 22, 1864 to Fantin-Latour.

12. The Pourtalès painting, now in the National Gallery, London, is attributed to an unknown seventeenth-century Spanish master, although Italian and Bohemian origins have been suggested. It depicts a dead warrior in armor lying diagonally across the interior of a cave.

13. Théophile Gautier, fils (born 1836), was the eldest of Gautier's three illegitimate children. After a brief career as a critic and translator he entered politics, becoming *sous-préfet* of Ambert.

telligible. A microscopic bull stands on its hind legs, aston-
ished, in the center of an arena spread with yellow sand. In the
foreground a toreador is stretched out on the diagonal; in the
background other toreadors stand out, much too large, against
the barrier surrounding the enclosure.

In *L'Artiste* on June 1 Hector de Callias had been even more
specific in his charges:

> Manet . . . has a good deal of imagination, but this is how
> he abuses it. He transports himself to Spain . . . and brings
> us back a *Bullfight* divided into three planes, a three-part
> treatise. In the first plane there is a toreador, perhaps an espada,
> who didn't know how to stick his little sword neatly into the
> scruff of the bull's neck, and who has been disembowelled by
> the two little swords which the bull uses for horns. Finally
> there is a microscopic bull. But that's due to the perspective,
> you'll say. Not at all. In the background, against the tiers of
> the arena, the *toreros* are quite in proportion and appear to be
> laughing at this little bull which they could crush under the
> heels of their pumps.

Even the predominantly black-and-white tonality, relieved by
touches of yellow, was offensive. A. J. Du Pays, writing in *L'Illus-
tration* on July 1, could see "only the audacity of putting black
beside yellow." [14] Edmond About in the *Petit-Journal* on June 3
was more deliberate: [15]

> We shall not discuss the two duds which Manet couldn't
> bring off. This young man who paints with ink and constantly
> drops the inkwell will eventually not even irritate the public.
> He may caricature angels or paint a wooden toreador killed by
> a horned rat, but the public will go its own way saying 'Manet
> is still having a good time. Let's see the real paintings!'

14. Joseph-Augustin Du Pays (1804–79), contributor to *L'Illustration* from 1845,
and author of guidebooks of several countries.

15. Edmond About (1828–85), novelist and journalist, succeeded in offending both
the Right and the Left during the Empire and Republic. His principal criticism was
Nos Artistes au Salon de 1857; his best-known novel, *L'Homme à l'oreille cassée* (1862).

Since two serious critics had called the bull "microscopic," and Louis Leroy, as we have seen, had ridiculed it in *Charivari*, Manet apparently thought there was some justice in the complaints about his perspective. He destroyed the composition by cutting it in pieces, preserving only the small section of the bullfighters in the background (Fig. 8a) and the dead toreador (Fig. 8b). Even in the *Déjeuner sur l'herbe* Manet's inability to convey an adequate sense of atmospheric distance placed the bathing figure ambiguously in space. Although Cham in his caricature in *Charivari* on May 22 (Fig. 9a) undoubtedly further exaggerated the awkward perspective, he preserved enough of the original scheme for us to conjecture the general composition. The accompanying legend referred to the prevailing opinion of Manet's color scheme: "Since he had to complain to his paint seller, Manet has decided to use only his ink-well." [16]

Two days after Cham's cartoon appeared, the art critic of *Charivari* devoted his first lengthy satire to Manet. Since this was the Louis Leroy who ten years later would coin the word "Impressionist" to describe an exhibition organized by a group of Manet's young friends, it is interesting to see how he approached the subject of the new realism. Leroy's task was to compose, during the two months the Salon was open, a series of bi-weekly satires on the work exhibited. His essays are not so much detailed criticisms as the ironical reflections of an amused spectator of the battles which ensued at each Salon. In a sense Leroy had malice toward all, for his barbs were directed impartially against academic pomposities and radical innovations. He must frequently have visited the Salon, lending his dramatist's sharp ear to the muttered remarks of the public and the artists. Even now, wherever the passage of time has not completely worn away the memory of painters and paintings, one catches the sprightly echo of the Salon discussions. It is so with his account of a conversation between two solid citizens in front of Manet's painting:

16. Cham, pseudonym of Amédée de Noé (1819–79), painter and caricaturist. Pupil of Delaroche and Charlet, he contributed innumerable cartoons to *Charivari*. Several collections of his work were published in his lifetime.

"Calm down! Here is Manet's *Incident in the Bull Ring."*

"Upon my word! Is it possible that the transparency of shadows could be treated in this fashion? It's hardly worth the trouble to do a Spanish sky if it is of so little use. The bull is like a carelessly cut silhouette."

"There's no use talking about the atmosphere. The fellows in the background are needlessly diminished; they haven't fled far enough for that."

"The dead man in the foreground has a certain solemnity. He is less jolly than the others, although he is cut out of the canvas with a sledge hammer."

"Manet must suffer from an acute affliction of the retina. Nature couldn't appear this way without an aberration of the optic nerve."

"I hope the artist will have his eyes examined by a good oculist. More than that, I earnestly urge his family to take pains to prevent him, when he is cured, from seeing the paintings he produced during his illness. He would suffer too much if he saw them."

Manet's second contribution this year presented a more intricate problem for the critics. The *Dead Christ with Angels* (Fig. 12) was the first of his two large religious paintings.[17] Here he challenged not only the established academic standards for such subjects but set out to test, as it were, the values of his own aesthetic against that of the realist group led by Courbet, for that master had indicated his impatience with all religious painting by declaring that he could not paint an angel because he had never seen one.[18]

17. Aside from the copies after Titian's *Virgin with the Rabbit* (J.W.B., 3), an unfinished *Discovery of Moses* (J.W.B., 55), and fragments of a *Noli Me Tangere* (J.W.B., 69, 70), Manet's *oeuvre* contains no other religious paintings. Antonin Proust wrote that later in life he wanted to paint a Crucifixion which he considered "the foundation, . . . the poem, of humanity."

18. Victor Fournel, *Les Artistes français contemporains* (Tours, 1884), p. 366. See also Courbet's famous letter of December 25, 1861 to his pupils protesting that "art exists only in the representation of objects visible and tangible to the artist," and that "imagination in art consists in knowing how to find the most complete expression of an existing thing but never in inventing or creating the thing itself." See Charles Léger, *Courbet* (Paris, 1929), pp. 86-8.

Manet's solution of this metaphysical difficulty was simplicity itself. One may never have seen an angel, but one may paint persons dressed as angels.

As an arrangement of figures posed in the studio the painting is entirely clear and even conventional, since it was based upon a similar composition in the Louvre at that time attributed to Tintoretto.[19] The nude male figure seated facing the spectator is supported on either side by two draped female models to whose shoulders large wings are attached. Manet himself must have been aware that little idealization had entered into this conception of a religious theme, for the appropriate reference to St. John xx.12 is inscribed on a rock in the foreground beneath which lies crushed the serpent of old Adam. But his indifference to biblical accuracy appears elsewhere. In spite of Baudelaire's advice he placed the wound on the left rather than on the right side of the body. Possibly in this way he wished to emphasize the fact that this was intended as a contemporary rendering of the theme and should not, or could not, be judged solely on the basis of its resemblance to conventional religious iconography.[20]

There was more to the picture than this. In color it was a startling contrast to the sharp opposition of black and white in the *Bullfight*. Here dark tones were almost abolished; in the nude figure the modeling retreated in a blaze of brightness to the very edge of the forms, illustrating the first public dismissal of intermediate values (already achieved in the *Olympia* painted the year before but not exhibited until 1865). In the angels Manet introduced an amount and intensity of blue very different from the restricted hues of his earlier work.

In the conservative press the longest criticism of the two paintings was published by Théophile Gautier, the first time he had had an opportunity to consider Manet's work since the Salon of 1861.

19. For Manet's use of compositions of the dead Christ supported by angels by Tintoretto and Veronese, see Michel Florisoone, "Manet inspiré par Venise," *L'Amour de l'art, 18* (January 1937), 26–7.

20. Tabarant, p. 81. Manet subsequently executed a water-color version in reverse (in which the wound appears on the right side), probably in preparation for his etching of 1864. This position of the wound is not exceptional in post-Renaissance religious painting. See Guérin, No. 34.

There had been no Salon in 1862 and as the semiofficial government critic he had refrained from discussing the Salon des Refusés in the *Moniteur*. Now he was disgusted by the *Dead Christ,* and his strictures reveal his fundamental tendency to consider such historical painting in the light of the established formulae of idealistic painting. But his remarks about the *Incident in the Bull Ring* were more perceptive as well as more generous. The subject appealed to his taste for things Spanish and allowed him to display his acquaintance with Spanish art and his familiarity with the colloquial language of the bull ring. But for all that, his estimate of Manet's talent, accomplishments, and position as leader of the younger painters was surprisingly just. Perhaps Gautier was still aware of the regard held for Manet by Baudelaire. This seems not improbable; his criticism became less perspicacious after Baudelaire's decline and death within the next three years. In his remarks on June 25 in the *Moniteur* Gautier introduced Manet by comparing the *Dead Christ* with a similar religious subject by another painter, J. R. H. Lazerges, who is otherwise unknown to criticism:

> The *Angels at the Tomb of Christ,* by Manet, the frightful realist, have been conceived according to quite a different method. If Lazerges's *Christ* is too pale, too clean, too scrubbed, Manet's, on the other hand, seems never to have known soap and water. The livid aspect of death is mixed with soiled half tones, with dirty, black shadows which the Resurrection will never wash clean, if a cadaver so far gone can ever be resurrected. The angels, one of whom has brilliant azure wings, have nothing celestial about them, and the artist hasn't tried to raise them above a vulgar level. But one shouldn't, for all that, assume that Manet is devoid of talent; he has it and a great deal of it. Like Courbet, but in another way, he has true pictorial qualities, the qualities of a true painter. He attacks each part boldly and knows how to preserve the larger unity of local colors. From one end of the painting to another his figures are related to the range of color selected, and are like the preliminary sketches of a master. Unhappily, Manet intentionally abandons them at this stage and doesn't carry his work very far.

One can find fault with him and regret the use he makes of gifts rare enough not to be misused, but one must, however, recognize that he has a certain power, a certain effect on contemporary painting, of which he represents the most exaggerated tendencies. Manet has his admirers, quite fanatic ones whom he drags down his path. Already some satellites are circling round this new star and describe orbits of which he is the center. That is unfortunate from several points of view, for in art any imitation other than that of nature is detrimental, and Manet cannot serve as a model since he has broken loose from rules accepted by centuries of logic.

The other painting was more to his taste. Perhaps the Spanish subject, as much as the technique, recalled the enthusiasm he had felt for the *Guitarist* of 1861.

The *Incident in the Bull Ring* is better suited to the talent of a realist painter than the *Angels at the Tomb of Christ,* a subject which calls for some stylistic dignity and a certain idealizing convention. The pose of the torero, flung across the canvas on the sand of the arena, most convincingly suggests collapse and death. Just so a man who has been struck down and who will never recover from his wound lies flat on the earth. One would say that the warm muffled black tones of his garments were borrowed from Velasquez' palette, and the broad pink sash which binds the body of the dying man does not interfere with the rhythm of the figure, fortunately continuous from head to foot.

A similar motif was treated by Goya in the *Death of Pepe Illo,* the celebrated swordsman. There the bull, distracted by the capes of the *chulos,* had been led toward another corner of the arena. But Manet has not calculated correctly the diminution of perspective. His men are a great deal too large in relation to his bull. A much longer distance would be necessary to reduce to that size such a formidable animal as a fighting bull. A *novillo* two years old would be larger. The area defined by the palisade (*los tablas*) is no more accurately arranged, and the ground, which should be flat, seems to slope

like the floor of a stage. Manet was wrong not to consult for the arrangement of his picture those humble and useful guides whose advice the proudest artists listen to, that is to say, the handbooks on perspective. One's eye, no longer disturbed by these fleeing lines, would quickly enjoy the strong color and the vigorous brushwork, qualities one should not deny Manet. Furthermore such subjects [as the *Bullfight*] are well suited to the nature of this artist who paints with such feeling for the Spanish school and is related to Goya, as Goya was related to Velasquez: *longo proximus intervalle.*

Surprisingly enough Hector de Callias, who had little to say for the *Bullfight,* found something to his taste in the other painting. In *L'Artiste* on June 1 he wrote:

In the *Dead Christ* Manet has not, as in the *Bullfight,* an imaginary perspective. Now it is color trying to be too fantastic. In the midst of the darkness of the sepulchre shines a strangely azure wing; over Christ's knees is spread an inexplicable pink drapery. Must we say that with all his faults Manet is still a painter whose temperament is revealed in every brush stroke? How much imagination he would have if he didn't try to have too much!

At least Gautier and de Callias were now aware that they had to deal with a remarkably gifted painter whose works might displease but who perhaps could be directed toward better things by the little encouragement they mixed with their condemnation. In the popular press public horror at this direct and unsentimental treatment of a religious theme was not constrained by hope of future improvement. (Mme.) C. de Sault, in *Le Temps* on May 12, wrote that "Manet is young, and ignorance is a youthful sickness from which one recovers; it's not the same with blindness and infatuation," and concluded, self-righteously, "Father, forgive them for they know not what they do!" [21] The outraged religious sensi-

21. C. de Sault, pseudonym of Claire Christine d'Agoult (born 1830), Mme. Guy de Charnacé, author of many critical reviews, and of *Essais de critique d'art* (1864). She was the daughter of Daniel Stern (Marie de Flavigny d'Agoult, 1805–76, novelist and literary critic).

bility of the devout was even more deliberately stated by (Mme.)
Raoul de Navery on June 7 in the *Gazette des Etrangers:* [22]

> We have never seen such audaciously bad taste, the negation
> of scientific anatomy, spoiled color, lampblack abused and ap-
> plied to the face of the most beautiful of men, carried so far as
> by Manet in the *Dead Christ.*

But an anonymous reviewer in *La Vie parisienne* on May 1 (the
date suggests that he had attended a private viewing and probably
a discussion of the painting) placed the picture more accurately in
relation to contemporary religious thought when he remarked, al-
most offhandedly, "and do not neglect Manet's *Christ,* or the *Poor
Miner Rescued from a Coal Mine,* executed for Renan." Just as
Ernest Renan, whose *Vie de Jésus* had been published the year be-
fore, had reduced the stature of the Messiah to the proportions of
a historical figure, so Manet had stripped from this nude model all
vestiges of centuries-old idealization.

It was time for someone to intervene in hopes of settling the
issue. Against the almost blasphemous mouthings of the popular
press the timid concessions of Gautier and de Callias were of little
avail. Unfortunately this year Castagnary failed to mention Manet's
contributions. But Thoré-Bürger, after due reflection, published
in *L'Indépendance belge* on June 15 the lengthiest, the most con-
sidered, and the most generous criticism Manet had received to
date:

> Here is another victim of the viciousness of public morals, a
> voluntary victim stretched out in the center of a bull ring at
> one end of a vast arena. This toreador, disemboweled for the
> amusement of several thousand frantic spectators, is a life-sized
> figure audaciously copied from a masterpiece in the Pourtalès
> Collection, assuredly painted by Velasquez. Manet thinks no
> more of "taking what he wants where he finds it" than of
> hurling on the canvas his bizarre and splendid colors which
> drive the middle classes wild. His painting is a kind of chal-

22. Raoul de Navery, pseudonym of Eugénie-Caroline Saffray (1834–85), prolific
novelist.

lenge, and he apparently wants to exasperate the public like the picadors in his Spanish bullfight jabbing arrows with multicolored ribbons into the neck of a savage adversary. He hasn't yet seized the bull by the horns.

Manet has the qualities of a magician, luminous effects, flamboyant hues, copied from Velasquez and Goya, his favorite masters. He thought of them while composing and executing his *Bullfight*.

Thoré was not the first to notice Manet's dependence on Velasquez and Goya for certain elements of design and expression, but in his reference to another Spanish master, then comparatively obscure, he gave further proof of his understanding of the relation of Manet's art to the European tradition.

In his second painting, the *Dead Christ*, he has imitated another Spanish master, El Greco, with equal intensity, no doubt as a sort of gibe at the bashful admirers of discreet and tidy painting. This dead Christ seated naturally, full-face, his two arms held against his body, is terrifying to behold. Perhaps he is about to come to life under the wings of the two attendant angels. Extraordinary wings from another world, colored a blue more intense than the very depths of the sky! Nothing like it is to be seen in the plumage of earthly birds but maybe angels, those birds of heaven, wear such colors. And the public has no right to laugh at them since it has never seen any angels, any more than it has seen a sphinx. . . . One needn't argue about angels and colors . . .

I maintain, however, that this formidable Christ and these angels with Prussian-blue wings seem to be making fun of a world which says, "Who would have thought of such a thing! It's an aberration!" A very distinguished lady thus upbraided Manet's poor Christ, exposed to the derision of the Parisian pharisees. That doesn't prevent the whites of the shroud and the flesh tones from being very true. The modeling of the right arm particularly and the foreshortening of the legs resemble masters who are fairly well esteemed, Rubens in his *Dead Christ* and *Christ in the Hay*, in the Antwerp Mu-

seum, and even certain Christs by Annibale Carracci in moments of large and grandiose execution. The comparison is singular. However, it's El Greco, the pupil of Titian and the master of Luis Tristan, who became in turn the master of Velasquez, that Manet's Christ resembles.

Enough now about these eccentricities which conceal a real painter whose works, some day, perhaps will be admired. Let us remember Eugène Delacroix's beginnings, his triumph at the Universal Exposition of 1855, and the sale, after his death.

Thoré-Bürger's statement that Manet depended upon no less than three Spanish painters for his technique, composition, and interpretation came to the attention of Baudelaire, who was then in Brussels on his ill-fated lecture tour. In a letter to the critic, the longest and most interesting letter Baudelaire wrote on the subject of his friend's art, he denied the possibility of Manet's having been influenced by Spanish painting. Although his position was scarcely tenable, since it is impossible to overlook the extraordinary similarity between Manet's *Toreador* and the Pourtalès *Dead Warrior,* Baudelaire's letter is significant as an explanation of the aesthetic attraction which Manet felt for Spanish painting; it thus absolves him of the charge of merely plagiarizing the earlier masters.[23]

I do not know if you remember me and our discussions of old. So many years pass so quickly! . . . I read your work most assiduously and I want to thank you for the pleasure you have given me in coming to the defense of my friend Edouard Manet, and in dealing him a little bit of justice. However, there are a few small points to straighten out in the opinions which you have published.

Manet, whom people think wild and insane, is simply a very straightforward, unaffected person, as reasonable as he can be but unfortunately touched by romanticism from birth.

The word "imitation" is unfair. Manet has never seen a

23. Baudelaire's position is the more paradoxical since he could very well have directed Manet's attention to Spanish painting in the first years of their acquaintance. On May 14, 1859 he wrote the photographer Nadar urging him to purchase prints after Goya's *Duchess of Alba.*

Goya; Manet has never seen a Greco; Manet has never seen the Pourtalès Collection. This seems unbelievable to you, but it's true.

I have myself admired, in amazement, these mysterious coincidences.

At the time when we used to enjoy that wonderful Spanish Museum which the stupid French Republic in its excessive respect for private property gave back to the House of Orléans, Manet was a youngster serving in the navy.[24] People have told him so much about his imitations of Goya that now he is trying to see some Goyas.

It is true that he has seen Velasquez, I know not where. You don't believe what I tell you? You doubt that such surprising mathematical parallels can be found in nature? Very well! People have accused me, yes me, of imitating Edgar Poe!

Do you know why I have translated Poe so patiently? *Because he resembled me.* The first time I opened one of his books I saw, with terror and ecstasy, not only subjects I had dreamed of, but *phrases* I had thought of and he had written twenty years earlier.

Et nunc erudimini, vos qui judicatis! . . . Do not be annoyed, but keep in some corner of your mind a kind thought for me. Every time you try to do a good deed for Manet, I shall thank you . . .

I have the courage, perhaps the complete effrontery, of my convictions. You may quote my letter, or a few lines of it. I have told you the absolute truth.

Thoré-Bürger immediately replied. In *L'Indépendance belge* on June 26 he acknowledged the letter under the heading "Charles Baudelaire and Mysterious Coincidences," but with regard to the *Dead Toreador* he maintained that if Manet had not visited the Pourtalès Collection, he must have had second sight, "through some intermediary or other." And he generously concluded: "It is

24. Baudelaire refers to Louis-Philippe's extensive collection of Spanish paintings which was on exhibition in the Louvre during his reign. A list of these and of the Spanish paintings bequeathed to the King by Frank Hall Standish will be found in G. Guillaume-Reicher, *Théophile Gautier et L'Espagne* (Ligugé, 1936), pp. 495–502.

a pleasure to repeat that this young artist is a true painter. By himself he is more a painter than the whole regiment of Rome prize winners."

So the Salon of 1864 closed with the lines as bitterly drawn as before. Despite Thoré-Bürger and Baudelaire, Manet stood accused in the popular press of faults of technique, errors of design, and indecent interpretation. Some slight encouragement came on July 18 when Philippe Burty mentioned in the *Presse* the painting of the *Combat between the Kearsarge and the Alabama* (Fig. 21) which was on display in a shop window.[25] For Burty it was "painted with an unusual power of realization, or at the very least, of verisimilitude." The few lines drew from the artist a letter in which he thanked the critic for the favorable notice and hoped that he would not apply the proverb "once is enough." Burty's remark, with Gautier's and de Callias' grudging concessions, suggests that Manet was gaining adherents among the more progressive artists and writers of his own generation. The respect and friendship felt for him by his contemporaries were manifested by Fantin-Latour in his group portrait, *Homage to Delacroix,* painted this year in memory of the master who had died the previous August. Manet stands in the forefront of a group which includes Champfleury, Duranty, Baudelaire, Legros, and the painter himself. He faces Whistler, whose work, had he continued to exhibit in Paris, might have helped to sustain Manet in his public struggles. Fantin's intention in grouping these men together is clear: for him they were not only united in their admiration for Delacroix but as the outcasts of 1863 they were committed to a new artistic program. Each in his way had seized some aspect of contemporary life and interpreted it with his own accent, whether in painting, poetry, or criticism. The following year Fantin included Manet in another group portrait (now destroyed), which elicited the following unsympathetic remarks from Paul Mantz, writing in the *Gazette des Beaux-arts* for July 1, 1865:

> Fantin, having had the idea of uniting in an *Homage to Truth* the most recent converts to nature, has had the greatest

25. There is some question as to whether or not Manet was present at the battle. See J. C. Sloane, "Manet and History," *Art Quarterly* (Summer, 1951), pp. 93–106. French writers inevitably spell "Kearsarge" as "Kearsage."

difficulty in procuring some realists, and since his painting couldn't remain empty he was obliged to grant places among the worshipers of the nude goddess to Whistler, who lives in such close communion with the fantastic, and to Manet, the prince of visionaries. You will agree that from the moment when the painter of *Olympia* can pass as a realist—and this title has been bestowed upon him by Fantin and the critic of *Le Siècle* (Castagnary)—the confusion of Babel will begin again, nonsense will be spoken, or rather there will be no more realists.

1 8 6 5

EARLY in 1865 Martinet arranged another one-man exhibition which opened in February. From a letter of this period it is apparent that in addition to the fragment of the *Bullfight,* entitled the *Dead Toreador,* and the painting of the *Kearsarge and Alabama,* the artist had ready several seascapes and still lifes of fish, fruit, and flowers. Had he considered sending seascapes and still lifes to the Salon, it is possible that the acceptance of his technical procedures might have been hastened. As Gonzague Privat, a minor painter and journalist, wrote a few months later in his *Places aux jeunes, causeries critiques sur le Salon de 1865,* "the proof that Manet lacks knowledge is that when he paints a still life he executes a very beautiful painting, seeing that it's less difficult to do a casserole or a lobster than a nude woman." [26] Neither kind of painting posed for the uninitiated spectator the fundamental problem raised by the figure compositions which involved interpretation of the contemporary subject in terms of new technical methods. But for one who wished above all to be received as a leading painter by public and critics alike there could be no question of compromise with the academic process. Landscape and still life were still at the bottom of the hierarchy, far below historical painting and portraiture. Even yet the work of the Barbizon painters, especially Millet and Rousseau, with Corot, was accepted as independent art of the first

26. Gonzague Privat (born 1843), painter and journalist, is best known for this one review which has been carefully examined by J. C. Sloane in *French Painting between the Past and the Present,* pp. 188–91.

order only by critics as liberal, and as thoughtful, as Castagnary and Thoré-Bürger. Consequently for the Salon of 1865 Manet again challenged the established order with his versions of two eminently respectable themes: a religious painting, his second and last, depicting *Christ Scourged* (Fig. 13), and a large study of the female nude, *Olympia* (Fig. 7), which he had painted in 1863.

In one sense the two paintings this year were complementary studies of the male and female nude, somewhat in the manner of Courbet's companion groups of the *Wrestlers* and *Bathers* at the Salon of 1853. Courbet, however, had presented his paintings quite candidly as studies of contemporary figures. Manet hesitated to go so far. His male nudes, these two years, were posed as Christ. Again the two paintings of 1865 represent his divided interests. According to Baudelaire he had been "touched by romanticism from birth." *Christ Scourged* is in one sense the most romantic work he ever sent to the Salon because it is the most eclectic of all his paintings. The Italianate composition, the somber Spanish coloring, the theatrical properties, and the contemporary personages are parts which fail to coalesce into a whole convincing either as design or expression.[27] A popular model, Janvier, posed for the central figure; the three attendant soldiers were commonplace contemporary types, dressed in a curious mixture of modern clothing and theatrical costume. The soldier to the right of Christ wears trousers, an antique sword, and a fur jacket. The unamalgamated mixture is not unlike that found in Courbet's early works, in such a painting as his *Guitarero* of 1845 where the aspect of the work as a self-portrait is contradicted by the medieval costume. The attempt to create a "modern" version of a traditional subject resembles in intention the *Déjeuner sur l'herbe,* although this time the character of the shock effect differed.

Much in the picture offended, although the possibility of plagiarism seems to have been considered the least of its faults. But if the insipid figure of Christ was unconvincing, there was about the whole painting that same refusal to idealize or to sentimentalize

27. M. Florisoone, in *Manet* (Monaco, 1947), p. xvi, has suggested that Manet was endeavoring, in the soldiers, to suggest "second-century Gauls." The composition as a whole is a variation of Titian's *Christ Crowned with Thorns* in the Louvre.

which had earned for the *Dead Christ* the apt rebuke that it was a religious painting for Renan. The clumsy design, the abbreviated drawing of the hands and feet, and the deliberate crudity in the scale of values (still visible in the high light on the old soldier's nose) were unpardonable offenses against contemporary taste and technique. Manet had run so far ahead of convention that even Gautier was left behind. He who alone had admired the *Guitarist* in 1861 now declared on June 24 in the *Moniteur* that in the *Christ Scourged* "the artist seems to have taken pleasure in bringing together ignoble, low, and horrible types . . . The technique recalls, without the verve, the most foolish sketches of Goya when he amused himself as a painter by throwing buckets of paint at his canvases."

In *Olympia* tradition and modern life collided with even greater violence, for here Manet was reworking one of the most familiar as well as one of the most conventionally idealized themes of European painting. In her nudity and recumbent pose Olympia proclaimed for those who knew anything at all of the past that her ancestresses were the Venetian Venuses of the High Renaissance, in particular Titian's *Venus of Urbino*. Not only the pose, the interior scene, the motif of the servant, the animal on the bed (Titian's little dog changed into a black cat) but specifically the bangle on the woman's right wrist obliged the spectator to acknowledge Olympia's heritage. That the reference to Titian was intentional on Manet's part can be seen by comparing his preliminary drawing with a later water-color study for the composition. In the drawing the model strikes a pose quite unlike the Titianesque arrangement which first appears in the water color.[28] But what continues to astonish after so many years is that Manet, bitterly resenting the notoriety which the *Déjeuner sur l'herbe* had brought him (chiefly because of the portrait of Victorine Meurend in that painting), should again have offered the public the same affront; this was the same model, still nude. More than anything else it was this portrait

28. Manet copied the *Venus of Urbino* in Florence in 1853 or 1856 (J.W.B., 4). The several preliminary studies for the painting and the various states of Manet's etching after it, with a history and criticism of *Olympia,* have been presented by François Mathey in *Olympia* (Paris, 1948).

character which shocked the public, for Olympia was obviously naked rather than conventionally nude. Her attributes were the proof. The narrow black ribbon around her throat, and the silk slippers, one dangling from her right foot, the other lying on the bed, showed that she belonged to the demimonde far more than to the *demi-dieux*. Her wide eyes, imperturbable expression, and impertinent attitude seemed, indeed they still seem, to force the spectator to assume that he is in the same room with her. No conventional generalizations of face or figure mitigated the disconcerting surprise of seeing a modern young woman in a situation few ladies and gentlemen could publicly acknowledge. In such plain terms as these one touches the heart of the controversy which set the public against Manet. The motif of the reclining nude and attendant servant had been seen before, and even at the Salon. Olympia's predecessors included most notably Ingres' *Odalisque with Slave* (1839–40). At the Salon of 1842 Jalabert had shown an *Odalisque* reclining in the same position as Ingres' but with an attendant Negro servant rather than a Turkish slave. But in each example, and more might be brought to witness, some slight allusion to a place and time other than the present, or some conspicuous reticence had lain like a slight veil of idealization between the unclad form and the spectator. An averted glance, a fold of drapery, or a Turkish pillow was sufficient to establish the propriety of the subject. *Olympia* ignored such advantages. She was, in 1863, incontrovertibly there.[29]

The bewilderment was not lessened by the classic overtones of the title. "Olympia? What Olympia?" Jules Claretie exclaimed. On the label Manet had inscribed the first five lines of a lengthy poem by Zacharie Astruc celebrating, in pseudo-Baudelairean verse, the ambiguous charms of this "auguste jeune fille":

29. The difference between *Olympia* and such conventional nudes can best be seen by examining Courbet's *Woman with Parrot* (New York, Metropolitan Museum), which enjoyed considerable popular success at the Salon of 1866. She is as nude, and perhaps as provocative, as *Olympia,* but her pose is extravagantly artificial and her face turned away from the spectator. By 1868 even a contemporary nude was permissible, providing there were some degree of generalization. That year About described Lefebvre's nude *Odalisque* as "the principal painting in the Salon . . . a *parisienne* of eighteen or twenty."

> Quand, lasse de rêver, Olympia s'éveille,
> Le printemps entre au bras du doux messager noir;
> C'est l'esclave, à la nuit amoureuse pareille,
> Qui vient fleurir le jour délicieux à voir:
> L'auguste jeune fille en qui la flamme veille.[30]

The most important distinction, however, which a severe critic might make between Manet's two paintings in this Salon would concern not so much the subject as the technique. In the *Olympia* the technical and conceptual experiments of the earlier years finally found a coherent and complete expression. The restricted color range of the *Bullfight,* the full frontal lighting of the *Dead Christ,* the contemporary subject devoid of any moralizing or romantic idealization which he had sought but never achieved in the Spanish themes and which had been compromised in the *Déjeuner sur l'herbe* by the ambiguous treatment of the theme, all this was now realized in terms of simplified color and design and with a new assurance in technique. Manet's technical innovation lay in the suppression of almost all the intermediate values between the highest light and the deepest shade. Only along the edges of the forms, along the contours, was there a pronounced and then very abrupt change in value. Today we read these outlined shapes as three-dimensional form without difficulty; in 1865, to eyes so long accustomed to more complex and gradual transitions from light to dark, *Olympia* looked like an arrangement of flat patterns lacking the depth and three-dimensionality needed in such elaborate compositions. This aspect called forth the remark attributed to Courbet that *Olympia* resembled the Queen of Spades just out of the tub.[31] It is easy to understand how pale and two-dimensional she must have seemed to the creator of the *Bathers.*

The popular and official reaction was equally prompt but less discerning. This time the humorous journals were quick to detect what would be the sensation of this year's Salon. Louis Leroy men-

30. The entire poem of fifty verses, *La Fille des îles,* may be found in J. Meier-Graefe, *Manet* (Munich, 1912). See also Tabarant, p. 105.

31. "C'est plat, ce n'est pas modelé, on disait une dame de pique d'un jeu de cartes, sortant du bain." The remark was first reported by Albert Wolff in *Figaro,* May 1, 1883.

tioned *Olympia* on May 5 in *Charivari,* and Bertall's cartoon appeared in the *Journal amusant* on the 10th.[32] On the 13th A. J. Du Pays, in a preliminary survey of the more prominent paintings published in *L'Illustration,* compared *Olympia* with Théodule Ribot's *Saint Sebastian,* a painting so dark and somber that it seemed at the time similar to Manet's own Spanish manner:

> Separate mention must be made of the black painting of the *Saint Sebastian* by Ribot who, finding his inspiration in the crude manner of Ribera, wantonly cultivates ugliness but displays energetically pictorial qualities. A much more pronounced ugliness is still apparent in Manet's paintings, *Olympia* and *Christ Scourged,* whose pictorial value we confess we do not appreciate. They are offensive eccentricities and lively sensations of the Salon.

Since Du Pays admitted he couldn't understand Manet's work it is no surprise to discover that in his later articles he avoided all reference to *Olympia* and only once mentioned its companion: "Beyond all eccentricities, beyond painting, beyond art itself, there is Manet's *Christ Scourged.*" On the 21st the official opinion was delivered by the prominent critic Charles Clément in the *Journal des débats:* [33]

> As to the two canvases contributed by Manet, they are beyond words. It would have been very unfortunate to reject them. An example was required. The jury accepted them. It was well done.

This curious refusal, or at least hesitation, to criticize Manet's work (it can scarcely be called inability since the critics found a

32. Bertall, pseudonym of Charles Albert d'Arnoux (1820–82), pupil of Drolling and protégé of Balzac, whose *Oeuvres complètes* (1842–55) he illustrated. He contributed illustrations to many other books, principally for children, and caricatures to most of the illustrated journals of the day.

33. Charles Clément (1821–87), art historian and administrator, editor of the *Revue des deux mondes,* 1850–63, and art critic of the *Journal des débats* from 1864. Author of several works on Renaissance art and monographs on Léopold Robert, Gleyre, and Decamps.

plentiful vocabulary when they wished to praise work which struck their fancy) is characteristic of the popular press. As yet there were no words in the dictionaries of criticism to describe this kind of painting. Rather than coin them the journalists fell back upon satirical abuse or the bald statement of public opinion. Herein, of course, they failed in their primary function as critics, for their remarks are worthless either as explanation or evaluation. This pharisaical attitude was most clearly expressed by Paul de Saint-Victor on May 28 in the *Presse:*

> The mob, as at the Morgue, crowds around the spicy *Olympia* and the frightful *Ecce Homo* by Manet. Art sunk so low doesn't even deserve reproach. "Do not speak of them; observe and pass on," Vergil says to Dante while crossing one of the abysses of hell. But Manet's characters belong rather to Scarron's hell than to Dante's.

Félix Jahyer, who published a hastily compiled handbook of the Salon, was inclined to fit the action to the words: [34]

> Such indecency! It seems to me that *Olympia* could have been hung at a height out of range of the eye where certain unassuming studies by conscientious workers have been lost . . . I cannot take this painter's intentions seriously. Up to now he has made himself the apostle of the ugly and repulsive. I should hope that the derision of serious people would disgust him with this manner so contrary to art.

Even in a supposedly serious journal Manet fared no better. Ernest Fillonneau, in the *Moniteur des arts* (which had failed to mention Manet in 1863 or 1864), offered the typical humorous description of *Olympia:*

> An epidemic of crazy laughter prevails . . . in front of the canvases by Manet . . . [It is] a subject of general surprise that the jury accepted these works . . . Olympia is a nude, recumbent woman to whom some sort of Negress offers a

34. Félix Jahyer is known only for his reviews of the Salons of 1865 and 1866, and for a book of verse, *Pauvretés du coeur* (1866).

bouquet voluminously wrapped in paper. At the foot of the
bed crouches a black cat, its hair on end, who probably doesn't
like flowers since it cuts such a pathetic figure. Moreover, the
heroine herself seems indifferent to the homage of the Negress.
Is Olympia waiting for her bath or for the laundress?

Elsewhere Manet was spurned if not completely ignored. The
only mention of him in the *Gazette des beaux-arts* this year oc-
curred when Paul Mantz referred to him as "the prince of vision-
aries" in his criticism of Fantin-Latour's *Homage to Truth.* Maxime
Du Camp had nothing to say in his long article in the *Revue des
deux mondes,* but Léon Lagrange, who had passed from the
Gazette to the *Correspondant,* a monthly of general interest, con-
tinued his vein of sarcasm:

> After Ribot, must we speak of Manet? No, if it is only to as-
> certain that this is a group of invalids trying to pass themselves
> off as incurable. A hospital flirtation! Do they think they can
> impose themselves on us? They will be cured, one after the
> other, and Manet himself in spite of his excesses will not die
> impenitent.

Worse than that, even a critic who had detected a measure of talent
in 1863 now turned against him. Ernest Chesneau's confused posi-
tion, typical of his inability to accept the consequences of his own
interest in modern art, can be judged by the fact that only the past
March he had (much to the artist's surprise) purchased a small paint-
ing by Manet. But now in the May 16 *Constitutionnel* he brought
out the following reproach:

> I must say that the grotesque aspect of his contributions has
> two causes: first, an almost childish ignorance of the funda-
> mentals of drawing, and then, a prejudice in favor of incon-
> ceivable vulgarity. . . . He succeeds in provoking almost scan-
> dalous laughter, which causes the Salon visitors to crowd
> around this ludicrous creature called *Olympia* . . . In this
> case, the comedy is caused by the loudly advertised intention
> of producing a noble work, a pretension thwarted by the ab-
> solute impotence of the execution.

The most specific summary of the charges against *Olympia* and its author was presented by Jules Claretie in the May 15 issue of *L'Artiste:* [35]

> I like audacity and I believe, like Danton, that a good deal is necessary, but yet not too much. Once upon a time there was a young man called Manet who, one fine day, bravely exhibited among the rejected paintings a nude woman lunching with some young men dressed in sack suits and capped with Spanish sombreros. Many cried shame, some smiled, others applauded, all noted the name of the audacious fellow who already had something and who promised much more. We find him again this year with two dreadful canvases, challenges hurled at the public, mockeries or parodies, how can one tell? Yes, mockeries. What is this Odalisque with a yellow stomach, a base model picked up I know not where, who represents Olympia? Olympia? What Olympia? A courtesan no doubt. Manet cannot be accused of idealizing the foolish virgins, he who makes them vulgar virgins. I had promised myself not to speak of it any more.

Three days after the Salon closed on June 20, having been prolonged for five days, Claretie resumed the attack in *Figaro:*

> During the last few days of the Salon several alterations took place in the arrangement of the paintings. You had seen Manet's *Venus with the Cat* flaunting her wan nudity on the stairs. Public censure chased her from that place of honor. One found the wretched woman again, when one did find her, at a height where even the worst daubs had never been hung, above the huge door of the last room, where you scarcely knew whether you were looking at a parcel of nude flesh or a bundle of laundry.

35. Jules Arsène-Arnaud, called Claretie (1840–1913), prolific novelist, historian, dramatist, critic, and liberal politician. During Manet's lifetime he contributed critical reviews to *Figaro, L'Indépendance belge, L'Illustration,* and the *Presse.* His principal studies of art were collected as *Peintres et sculpteurs contemporains* (1873), and *L'Art et les artistes contemporains* (1876).

What seems, even a century later, so exasperating about this criticism is not so much the brutality—even the cruelty—of much of it, or the cynical mockery which accompanied every mention of the public's bewilderment and laughter, as the general disinclination on the part of the critics themselves to make any attempt to understand the intention of Manet's work and so to estimate it in terms of the painter's purpose. Such an attitude, especially coming as it did from so many of the younger generation, must have been deeply discouraging. Typical of this point of view was the paragraph by Théophile Gautier, fils, in the *Monde illustré* on May 6:

> In certain circles Manet's paintings have already been extensively discussed. This artist counted a bit on the jury refusing his works; this would have been a fine occasion to exclaim about injustice and prejudice. But nothing like that happened. The jury accepted his paintings and was kind enough to have them hung in one of the best places in the Salon, so that everyone could judge the case with full knowledge. The jury ought indeed to have been good enough to ask Manet for a statement of his tendencies which should have been printed as a brochure. Perhaps that would have enlightened public opinion. As it is, the appearance alone of Manet's pictures doesn't sufficiently satisfy the eye and the mind; it doesn't explain the hue and cry that people have tried to stir up about this new school. Perhaps his aesthetic is excellent, but it is really impossible to have any idea of it in actual practice. The *Christ Mocked* beggars description. In *Olympia* Manet seems to have made some concession to public taste. In spite of his prejudices one sees pieces which demand no more than to be thought good.

Gautier, père, whose remarks about the *Christ Scourged* from his account in the *Moniteur* on June 24 have already been quoted, continued in the same vein:

> With some repugnance I come to the peculiar paintings by Manet. It is awkward to discuss them, but one cannot pass by

them in silence . . . In many persons' opinion it would be enough to pass by and laugh; that is a mistake. Manet is not of no account; he has a school, he has admirers and even enthusiasts; his influence extends further than you think. Manet has the distinction of being a danger. But the danger is now passed. *Olympia* can be understood from no point of view, even if you take it for what it is, a puny model stretched out on a sheet. The color of the flesh is dirty, the modeling nonexistent. The shadows are indicated by more or less large smears of blacking. What's to be said for the Negress who brings a bunch of flowers wrapped in a paper, or for the black cat which leaves its dirty footprints on the bed? We would still forgive the ugliness, were it only truthful, carefully studied, heightened by some splendid effect of color..The least beautiful woman has bones, muscles, skin, and some sort of color. Here there is nothing, we are sorry to say, but the desire to attract attention at any price.

Gautier's criticism is still interesting for his near success in resolving the issue. Certainly *Olympia* was incomprehensible from any point of view except that of modern realism. Neither romantic nor idealistic criticism could ever have solved the problem raised by this painting, but if it is "taken for what it is," as Gautier suggests, the answer appears in the barest enumeration of the elements which compose the design. *Olympia* is a puny model, stretched out on a sheet, and the Negro woman and cat are there. That is all. There is no need to explain them; it is impossible to explain them, except as elements which occur in the work primarily for pictorial necessity, a necessity which is inextricably part of the painter's vision.

In these terms the few remarks sympathetic to the painter's intention are indicative of the trend which criticism was ultimately to take, although it would not achieve this without another considerable scandal. The story of the almost imperceptible conversion of such reactionaries as Paul Mantz and Gautier himself belongs to a later chapter. Here two isolated reflections will suffice to show that not all the more conservative observers were offended

or obtuse. On June 15 in *L'Artiste* (Mme.) Marc de Montifaud submitted a minority report after Claretie's outburst: [36]

> We can recognize Manet's touch in the midst of the eccentricities he has been pleased to offer us . . . and this touch denotes a vigor which, used by a healthier imagination, could produce real work.

On July 8 after the exhibition closed, *L'Autographe au Salon,* a weekly folio of drawings by artists whose works had been exhibited, published a page of pen-and-ink sketches by Manet after three of his Spanish subjects, *Lola de Valence,* the boy drinking from *Los Gitanos,* and a group from the *Spanish Ballet.* This unsigned paragraph accompanied the reproductions:

> He who laughs last laughs best. Manet has fired his shots today, and the wide-open ears of the public have heard his name. Let him just take time, from now on, to clean out and tidy up his pictures, and you will see the public marveling over this same painting which has so thoroughly frightened it. For Manet has unusual qualities of originality and character as a draftsman, of subtlety and pungency as a colorist. You can see this even in these little sketches which seem to have been done with the end of a pen, with the flawless casualness and picturesque spirit of Goya.

The most perceptive criticism was published by one who remains the least familiar of all Manet's critics. Gonzague Privat appeared only once as a reviewer of the Salon, but his comments on Manet were so penetrating that one can regret his voice was not henceforward annually opposed to the routine chorus of disparagement. Privat, unlike most of the professional reviewers for the newspapers and journals, was himself a painter. Through his own experience he saw more deeply than others into the actual construction of Manet's work, and he was, perhaps for the same reason, less concerned with the implications of subject matter. Even the title of his booklet, *Place aux jeunes,* signified that he was anxious to secure

36. Marc de Montifaud, pseudonym of Marie-Amélie Chartroule de Montifaud, Mme. J. F. L. de Quivogne, a frequent contributor to critical reviews.

recognition for the artists who, in his opinion, stood for progressive tendencies in contemporary art. To his credit he selected, among the mass of mediocrity, such "newcomers" as Puvis de Chavannes, Whistler, Manet, and Berthe Morisot, a young lady who was exhibiting at the Salon for the first time. Of Manet he wrote:

> Do not be displeased; Manet's *Olympia* is more than something good; solid and painterly qualities predominate in it. The young girl is done in a flat tone, her flesh is of an exquisite delicacy, a nicety, in a perfect relationship with the white draperies. The background is charming, the green curtains which enclose the bed are of a light and airy color. But the public, the crude public that finds it easier to laugh than to look, understands nothing at all of this art which is too abstract for its intelligence.

In that last phrase Privat had edged very close to the truth of the difficulty in which Manet found himself with the public. It was true that in a sense his art was "too abstract." The appeal too thoroughly depended on an appreciation, as Privat understood, of relationships between colors and forms, subtleties of brushwork which had little if anything to do with the "intelligence," that is to say with the public's desire to understand the picture as a story, an anecdote, a dramatic presentment of some attitude toward history. But even Privat failed to sense the degree to which Manet had won his own position as a painter, for he added that Manet lacked technique, that if the *Olympia* were "well drawn . . . more skillfully modeled, you would have a charming picture, because it has in it the great seed: life, because it has been conceived and painted by a sincere man."

All in all this was the most understanding criticism Manet received in 1865. For some reason or other Castagnary again failed to notice his work. Even Thoré-Bürger was not entirely satisfied with his offerings. In his *Salon* he too accused Théodule Ribot of having fallen victim to the darkness of Ribera through his enthusiasm for painting the same sort of subject used by the Spanish master. Such imitation he declared was "fatal and irresistible" and he warned Manet of the same danger.

Manet should not want to be taken for an old hack at copy-
work. Nevertheless, having had the unfortunate idea of paint-
ing a Christ scourged, well enough. But this new work is al-
most a copy of the famous composition by Van Dyck! A year
ago, painting a Spanish subject which he had never seen, he
copied the Velasquez in the Pourtalès Collection . . . Manet's
Olympia has caused all Paris to run to see this curious woman
with her magnificent bouquet, her Negress, and her black
cat. Manet's friends defy the author of the Siamese Scarabs
[Gérôme] to paint a bouquet so luminous or a cat so weird.

With *Olympia* Manet exhibited for the last time at the Salon a
painting wherein the influence of Baudelaire could be considered
paramount. If the poet's query from Brussels, "Is it really a cat?"
means that he had never seen the painting, already two years old,
in the artist's studio, he thus could not have played a decisive part
in its design. But the cat is too intimately a Baudelairean symbol
not to have wakened in the minds of the spectators of 1865, just as
it cannot fail to now, memories of those cats who stalk through the
pages of the *Fleurs du mal*. Manet's, surely, is blood brother to
Baudelaire's:

> . . . le long des maisons, sous les portes cochères,
> Des chats passaient furtivement,
> L'oreille au guet, ou bien, commes des ombres chères,
> Nous accompagnaient lentement.

If the cat is Baudelairean, the human figures are no less so,
though less obviously. In the Paris of 1865 a Negro woman was still
an exotic figure, reminiscent of strange lands and climates warmer
than the Ile de France. In her we touch upon perhaps one of the
rare instances where a pictorial image bears some reference to
Manet's earlier experience in Rio de Janeiro; in his letters home he
wrote of the plight of the Negro slaves and of their physical beauty.
Baudelaire as a young man had also made the tropical voyage, as
far as Martinique. Images of warmth and dark flesh gleam from his
earlier poems, and Manet had painted Baudelaire's notorious mis-

tress, the mulatto Jeanne Duval, probably two years earlier.[37]

Finally, Olympia herself can be thought of as symbolizing more than one aspect of the woman, alternately beloved and loathed, who passes through the poems of the *Fleurs du mal*. Her imperturbable expression, which more than one critic might have confessed was what disturbed him as much as her nakedness, recalls that of the woman whom Baudelaire described as "Le Serpent qui danse":

> Tes yeux, où rien ne se révèle
> De doux ni d'amer,
> Sont deux bijoux froids où se mêle
> L'or avec le fer.

There is an even closer resemblance to one of the most dangerous, judging by standards of official propriety, of all Baudelaire's women, she whose beauty was celebrated with such candor in "Les Bijoux," one of the six poems suppressed by the police censorship after the publication of the *Fleurs du mal* in 1857. Reading it now one cannot but wonder how much of the expressive quality of *Olympia* may have been due to Manet's having heard from Baudelaire's own lips, in the early days of their acquaintance, the magical words which parallel the cold, haughty beauty of his painted image:

> Les yeux fixés sur moi, comme un tigre dompté,
> D'un air vague et rêveur elle essayait des poses,
> Et la candeur unie à la lubricité
> Donnait un charme neuf à ses métamorphoses;
>
> Et son bras et sa jambe, et sa cuisse et ses reins,
> Polis comme de l'huile, onduleux comme un cygne,
> Passaient devant mes yeux clairvoyants et sereins;
> Et son ventre et ses seins, ces grappes de ma vigne . . .
>
> Je croyais voir unis par un nouveau dessin
> Les hanches de l'Antiope au buste d'un imberbe,

37. This *Portrait de la maîtresse de Baudelaire*, now in the Budapest Museum (J.W.B., 110), was so described in the inventory of Manet's studio prepared in December 1883. A preliminary water color is in the Bremen Museum. Tabarant, p. 57, has pointed out that the accepted date of 1864 is probably two years too late.

Tant sa taille faisait ressortir son bassin.
Sur ce teint fauve et brun le fard était superbe!

—Et la lampe s'étant résignée à mourir,
Comme le foyer seul illuminait la chambre,
Chaque fois qu'il poussait un flamboyant soupir,
Il inondait de sang cette peau couleur d'ambre!

Even the colors of the picture, as we have seen earlier in relation to Manet's first paintings, have a Baudelairean character. If *Olympia* no longer blazes like a jewel "rose et noir," her colors—white, black, pale yellow, and green—convey a sensation for which the verbal expression might well be this metaphor from the sonnet "Avec ses vêtements ondoyants et nacrés," from the *Fleurs du mal:*

Où tout n'est qu'or, acier, lumière et diamants,
Resplendit à jamais, comme un astre inutile,
La froide majesté de la femme stérile.

The Baudelairean suggestions need not be read in terms of influences restricting the personal expression of either man. Far more was it an instance of "correspondances" as Baudelaire might have said. Poet and painter were committed to reveal what they took to be the significant character, poetically or pictorially stated, of motifs discovered in contemporary life. That life supplied them only with the objects they needed. The subjects of their work, of *Olympia* as of "Les Femmes damnées," were the transpositions of those objects into artistic realities saturated with the accent and flavor of their own personalities, desperate or indifferent as each chose. *Olympia* scandalized a generation which mistook the object for the subject, which saw her only as a transcription of life. On such terms, to be sure, a spirit of vulgar realism seemed to mock tradition. Yet Manet's realism has little to do with the realism of a Courbet or a Daumier, concerned with explaining or correcting human conduct. *Olympia* explains and corrects nothing. With her Manet had for the first time reached a position where his personality and his sense of artistic fitness conferred on the painting his own sense of style.

1 8 6 6

ALTHOUGH 1865 had seen Manet's cause apparently no further advanced with the public or the critics, and the expressed hostility to his work appeared stronger than before, the new year was to bring both his greatest humiliation up to this time and, from an unexpected quarter, his most energetic champion. During the winter Manet had completed two large figure studies, a portrait of the actor Philibert Rouvière as Hamlet [1] and the *Fifer,* a boy in military uniform.[2] Once more two paintings represented two aspects of Manet's aesthetic. The gloomily romantic portrait of Rouvière, later known as the *Tragic Actor* (Fig. 11), in pose, costume, and somber color still suggested the influence of Velasquez. In the *Fifer* (Fig. 14), on the contrary, Manet carried further the scheme of *Olympia* in the emphatic flat pattern, the elimination of values, and the oppositions of large areas of bright, clear color, in this case red, black, white, and yellow.

In no respect could either of these paintings be reproached on the moral grounds which had been invoked against the *Déjeuner sur l'herbe* and *Olympia,* yet both were rejected by the jury. The

1. Philibert Rouvière (1809–65) had studied painting with Gros before turning to the stage. Through the 1840's he played with considerable success the role of Hamlet in the translation by Dumas, père, and Meurice. He based his costume and make-up on Delacroix's interpretations of *Hamlet.* According to Tabarant, p. 103, Paul Roudier and Antonin Proust posed for the legs and hands in the portrait after Rouvière's death October 19, 1865.

2. Paul Jamot proposed Victorine Meurend as the model for the *Fifer* in his "*Le Fifre* et Victorine Meurend," *Revue de l'art ancien et moderne, 51* (1927), 31–41. Tabarant, p. 119, suggests Léon Koëlla-Leenhoff who had posed for the *Boy with a Sword.*

rebuff was all the more abrupt since it was evident to the artist, to his friends, and even to the public who could expect to see his work now that it had been exhibited three years running, that the jury and by extension the government considered Manet inadequate as an artist. And the refusal was the more embarrassing since this year three-fourths of the jury had been elected by the participating artists themselves.[3]

Since subject matter was no longer an immediate concern, and certainly portraits of actors in costume and regimental mascots were not rarities as Salon subjects, the judgment must have been rendered on the fundamental issues of technique and pictorial conception. The rejection not only wounded the artist's pride; it could have calamitous financial consequences. Up to now Manet had failed to sell any of his larger works. His private means were sufficient for him to continue painting for some time to come, but his resources were not inexhaustible, and only through recognition at the Salon could he hope to find prospective purchasers. They would certainly be scarcer than ever now that he had been refused once more by the jury.

With his paintings rejected Manet was effectively cut off from any publicity in the Salon criticisms. There was no occasion for the regular reviewers to mention him, unless in the tone of spite used by Félix Jahyer when he remarked in his *Salon de 1866:* "Since Manet has been politely shown to the door, Monet has been chosen as leader of this brilliant school of braggadocio." Although Jahyer excoriated Claude Monet for his *Forest of Fontainebleau* and *Camille,* the appearance of a rival with a name so curiously similar to his did nothing to lessen Manet's irritation.[4] Later in the season

3. How consistently Manet was opposed by his colleagues can be seen from the presence on this jury of Gérôme, Cabanel, Meissonier, Gleyre, and Baudry. Only Corot, Daubigny, and Théodore Rousseau, who served as an alternate, could be considered sympathetic to the new movement. Gautier, Paul de Saint-Victor, and Charles Blanc were official appointees. When the rejections became known a disappointed painter, Jules Holtzapffel, committed suicide in his studio, thereby provoking a minor scandal. See Tabarant, pp. 122–3.

4. Although each came in time to know and to admire the other, Manet seems to have been exasperated when Monet's work first attracted favorable attention at the Salon, and the inevitable confusion of names resulted. There is some question as to whether this happened in 1865 or 1866. See John Rewald, *The History of Impression-*

Thoré included in his review his opinion of the rejection, which was perhaps the soundest criticism the painter received that year, and which will be examined in relation to Thoré's criticism of Manet as a whole.

Thus in the late winter of 1866 Manet's fortunes were far from bright. His paintings had been rejected, the Salon was about to open, and none of his friends had spoken on his behalf. In February, however, Antoine Guillemet brought to the studio a young man who was writing art criticism for the weekly *L'Evénement* under the pseudonym of "Claude." He was Emile Zola.[5] He had already come to dislike the whole Salon system and the hierarchy of academic values against which Manet had stumbled. Since Zola would, for the remainder of the artist's life and even after his death, stand as the chief witness to Manet's art in the eyes of the public, it is well to observe that his first visit to the studio occurred at a time when he had only recently turned to art criticism as a means of earning his livelihood. Zola was twenty-six, and for a youth of his liberal tendencies the opportunity to defend a painter despised for his attack on the Academy must have seemed one not to be missed. Whether or not he deeply or sensitively understood the meaning of Manet's pictorial innovations for the moment was a small matter. Undoubtedly he had been assured by his close friend, Paul Cézanne, that Manet commanded respect among the younger progressive painters. This was enough for Zola. In language both vivid and enthusiastic, even if lacking a sophisticated artistic vocabulary and burdened with literary mannerisms, he welcomed Manet as the artistic outcast come to revive the splendor of French art. His article on Manet appeared in *L'Evénement* on May 7, following two attacks on the jury on April 27 and 30 and a statement on May 4 about "the artistic moment," in which he called for an art realistic in the sense that it would be based upon what is "real," namely

ism (New York, 1946), pp. 106, 118, n. 35. In 1866 André Gill entitled his cartoon of Monet's *Camille:* "Monet ou Manet?–Monet. Mais, c'est à Manet que nous devons ce Monet; bravo, Monet; merci, Manet."

5. The relations between Manet and Zola have been recounted by Ima N. Ebin in "Manet and Zola," *Gazette des beaux-arts,* Series 6, 27 (1945), 356–78. See also John Rewald, *Cézanne . . . son amitié pour Zola* (Paris, 1939), chs. 7, 8, and 16.

nature, but combined with the individual or personal temperament of the artist. Such art would above all look forward rather than backward to the past. And he feared that there would be little of it at the Salon.

To these first four articles were added three on other phases of the Salon and a final "Farewell of an Art Critic." The articles, more especially the one on Manet, had prompted such a flood of protest from outraged subscribers that Zola had been obliged to abstain from art criticism when he refused to alter his opinions. Later Zola republished his articles, with other critical essays, under the provocative title *Mes haines,* with a dedication to his friend Paul Cézanne. So were linked perhaps the three most controversial personalities of later nineteenth-century French art: he who was to become the leading naturalistic prose writer, the painter whose work continued the realist tradition of Courbet while modifying it so that it became a point of departure for the Impressionists, and the painter who would reconstruct Impressionism in new terms for the twentieth century. Although Zola subsequently became disenchanted with modern painting, and especially with Impressionism, there is no reason to suspect that his first art criticism was insincere. From the first he defined the issues with greater clarity than they had yet received, perhaps because he was aware that the expressive demands of Manet's art required a technique for which academic recipes were useless. For these reasons Zola's criticism, almost forgotten today and still untranslated into English, deserves quotations lengthier than the selections from other critics examined in this study. In the article on May 7 Zola declared:

> I shall make myself as clear as possible about Manet. I do not want any misunderstanding between the public and myself. I do not admit, and I shall never admit, that a jury should have the right to prohibit the public from seeing one of the most vigorous individuals of our times . . .
>
> It appears that I am the first to praise Manet without reservations. This is because I care little for all those boudoir paintings, those colored images, those miserable canvases wherein I find nothing alive. I have already stated that I am only interested in temperament . . .

The artists themselves, his colleagues, those who should see clearly in this matter, do not dare to come to a decision. Some, and I am speaking of the fools, laugh without looking, gloating over these strong compelling canvases. Others talk about an inadequate talent, willful brutality, and systematic violence. In short, they let the public have its joke without dreaming of just saying to it: "Don't laugh so loud if you don't want to be taken for imbeciles. There isn't the least thing laughable in all this. There is only a sincere artist following his own bent, who feverishly seeks the truth and who has none of our laziness."

I am so sure that Manet will be one of the masters of tomorrow that I should believe I had made a good bargain, had I the money, in buying all his canvases today. In fifty years they will sell for fifteen or twenty times more, and then certain forty-thousand-franc paintings won't be worth forty francs. It is not even necessary to have very much intelligence to prophesy such things.

Zola could speak with such conviction about Manet as a man and as an artist on the basis of his own experience. Unlike earlier critics who knew only one or two paintings exhibited among a thousand others at the Salon, Zola had visited the studio. More than that, he must have discussed at some length with the artist the problems of modern painting as Manet saw them and the solutions which the painter proposed.

In his studio I understood Manet completely. I had liked him instinctively; thenceforward I came to know his talent, that talent which I am going to try to analyze. In the Salon his canvases cry out under the cruel light, in the midst of ten-cent images stuck on the wall around them. At last I saw them separately as every picture should be seen, in the very place where it was painted.

Manet's talent is compounded of simplicity and accuracy. Doubtless, in the face of the disbelief of certain of my colleagues, he would appear to have decided to examine reality bit by bit, he would have rejected all acquired knowledge, all traditional experience, he would have wished to start from the

beginning, that is to say from the exact observation of objects.

He has then courageously set himself in front of a subject, he has seen this subject in broad areas of color, by strong contrasts, and he has painted each thing as he has seen it. Who dares here to speak of paltry calculation, who dares to accuse a conscientious artist of mocking art and himself? The scoffers should be punished, for they insult a man who will be one of our national glories and they insult him miserably, laughing at one who doesn't even deign to laugh at them. I assure you that your derision and sneers disturb him very little.

Like the skillful showman he was, Zola played upon the feelings of his readers by reminding them of Manet's past audacities, and then appealed to their curiosity with a brief but remarkably deft description of the painting none of them would be allowed to see, this year's rejected *Fifer*.

I saw again the *Déjeuner sur l'herbe,* that masterpiece exhibited at the Salon des Refusés, and I defy our fashionable painters to give us a horizon wider or more filled with light and air . . . I also saw *Olympia* again, she who has the serious fault of closely resembling young ladies of your acquaintance. There, isn't that so? What a strange madness not to paint like the others! If, at the least, Manet had borrowed Cabanel's powder puff and powdered Olympia's face and hands a bit, the young lady would have been presentable.

But the work which I really prefer is the *Fifer,* the canvas rejected this year. Against a luminous grey background stands the young musician, in uniform, full face, with red breeches and garrison cap. I said earlier that Manet's talent was compounded of accuracy and simplicity, recalling especially the impression which this canvas left with me. I do not believe it possible to obtain a more powerful effect with less complicated means . . .

You know what effect Manet's canvases produce at the Salon. Quite simply they burst open the wall. All around them stretch the sweets of the fashionable artistic confectioners, sugar-candy trees and pastry houses, gingerbread gentlemen and ladies

made of vanilla cream. The candy shop becomes pinker and sweeter, and the artist's living canvases take on a certain bitterness in the midst of this river of milk. Also, one must see the faces made by the grown-up children passing through the gallery. For two cents you will not make them swallow true flesh having the reality of life, but they stuff themselves like famished people with all the sickening sweetness served them . . .

I have tried to grant Manet the position which belongs to him, as one of the first. You will perhaps laugh at the panegyrist as you laughed at the painter. Some day we shall both be avenged. There is an eternal truth which sustains me in my criticism: that temperaments alone live and dominate the ages. It is impossible, impossible, do you understand? that Manet should not have his day of triumph and that he will not crush the timid mediocrities which surround him.

While in almost all respects Zola's estimate of Manet's talent was correct, and even his financial calculations as to the future value of the canvases were extraordinarily accurate, it is easy to see how radical his article appeared at the time. Not only his support of a painter considered a dangerous revolutionary but his attack on the cream-puff-and-pastry school of Salon nudity and sentimentality struck at the heart of the artistic prejudices of the middle class. Here Zola's article could be of little immediate assistance. Manet's battle would be won only when the public understood, not how false were their previous admirations, but how soundly his art was related to the traditions they professed to admire. At the moment the artist was properly grateful, and that very day, May 7, Manet wrote Zola a letter which was to lead to further relations between them: "I do not know where to find you in order to greet you and to tell you how happy I am to be defended by a man of your talent. What a fine article! A thousand thanks."

1 8 6 7

THE FIRST product of this friendship was a revised and enlarged version of the earlier article which appeared on January 1, 1867, in

the *Revue du XIXe siècle,*[6] with the subtitle: "A new style in paint-
ing: M. Edouard Manet." On the whole the new version, described
as a "biographical and critical study" when it was republished in
June, preserved the tone of warm friendship and generous defense
of the despised artist, even if in the opening pages the careful reader
might detect hints of the serious reservations which Zola would later
come to feel about Manet's art. It included several new biographical
details and extended explanations of certain paintings which had
not appeared until then. The more sophisticated vocabulary and
subtler elucidation of Manet's technique were undoubtedly the
result of further conversations with the painter. In the introduction
Zola set forth his intentions more soberly and clearly than he had
before.[7]

It is a delicate matter to analyze an artist's personality bit by
bit. Such an undertaking is always difficult, and can only be
truly and thoroughly accomplished for a man whose work is
completed and who has already achieved what was expected
of him. His whole career can then be studied; all aspects of his
genius can be examined, an accurate and definitive likeness
can be drawn without fear of overlooking any details. And for
the critic there is the absorbing pleasure in pretending that he
can afterwards reconstruct the living man complete with limbs
and nerves and heart, with body and soul intact.

In studying the painter Edouard Manet today I cannot ex-
perience this pleasure. His remarkable work first appeared only
six or seven years ago. I should not dare to pronounce a final
judgment on the thirty or forty canvases which I have been
permitted to examine and enjoy. These constitute no finished
whole; their author is at that restless age when talent expands

6. This was the title, later the subtitle, for *L'Artiste* from 1867 to 1891. Although
the editor prefaced Zola's remarks with a statement to the effect that the *Revue* wel-
comed various opinions on art, the publication of the article in a periodical which
had not been unduly generous toward Manet in the recent past represents an impor-
tant stage in the general recognition of his position.

7. For the complete text of Zola's *Edouard Manet,* from which this and the fol-
lowing quotations have been taken, see *Mes haines* in the *Oeuvres complètes,* edited
by Maurice Le Blond, *41* (Paris, F. Bernouard, 1938), 243–79. *Manet* was first reprinted
with *Mes haines* in 1879.

and develops. Doubtless until now he has revealed only a fraction of his gifts and before him lie too many years, too far a future, and too many varied adventures for me to try in these pages to paint the definitive portrait . . .

Briefly, this curious situation has developed: a young painter quite simply followed his own visual and intellectual inclinations; he started to paint without regard for the sacred academic rules; in this way he produced such distinctive works, so vigorous and acrid in character, that people accustomed to other kinds were dazed. Now these very people, without trying to understand why they were dazed, have abused the young painter; they have questioned both his sincerity and his talent, and have made him out to be a grotesque sort of jumping jack sticking out his tongue to amuse the passers-by . . .

I have only one object, to appease the agitators' blind irritation, to make them come around to a more intelligent point of view, to urge them to open their eyes and at all events not to carry on so in the street. I am asking them for intelligent criticism, not alone for Edouard Manet but for all individual talents who are yet to appear. As my appeal continues my object is no longer the acceptance of one man, it becomes the acceptance of all art. In studying in Edouard Manet the reception accorded unusual personalities I protest against this reception. I have turned a particular question into one which interests all true artists.

For several reasons this work, I repeat, cannot be a definitive portrait; it is a simple enquiry into the present state of affairs, a brief based on the regrettable facts which seem to me a sad revelation of the condition to which two centuries of tradition have led the public in artistic matters.

In his first chapter, "The Man and the Artist," Zola described Manet's handsome personal appearance in order to dispel the notion that the artist was "a kind of bohemian, a scamp, a ridiculous bogeyman," and added: "I am convinced that the true portrait of the real Edouard Manet will actually surprise some people. Henceforth they will study his work with less unseemly laughter and more

respect. The problem amounts to this: undoubtedly Manet paints in an unaffected and completely serious manner, and it is only a question whether his works show real talent or whether he is grossly deceiving himself." [8]

Zola's discussion of Manet's artistic education is interesting as the first published record of his relations with Couture, preceding by thirty years Antonin Proust's recollections of that time. After mentioning Manet's experience as a sailor Zola continued:

> For three years he struggled in the shadow of the master, he worked without knowing any too well what he was looking at or what he wanted. It was only in 1860 [sic] that he painted the *Absinthe Drinker,* a canvas still faintly suggestive of the work of Couture but which already contains the seeds of the artist's personal manner . . .
>
> I should not want to make a principle out of the fact that a pupil's failure when he obeys his master's instructions is the sign of original talent, and from that to argue that Manet wasted his time with Couture. There is necessarily for each artist a period, varying in length, of fumbling and hesitation. It is assumed that each artist should spend this period in the studio of a master, and I see no harm in that. Advice, even if it sometimes retards the flowering of original talent, doesn't prevent it from appearing some time, and sooner or later it is completely forgotten if only the artist has some degree of individuality.
>
> But in this case I prefer to consider Manet's long and painful apprenticeship as a symptom of originality . . . Thus it was that on setting aside the influence of a personality so different from his own, Manet tried to seek and to see for himself. I repeat, for three years he smarted from the beating he had been given. As the saying goes, he had appeared with a new word on the tip of his tongue but he couldn't pronounce

8. Despite Manet's well-groomed, dignified appearance, substantiated by all contemporary accounts, and by Fantin-Latour's *Portrait of Manet* of 1870 (Chicago, Art Institute), the public continued to regard him as a raffish, half-lunatic tramp, if contemporary cartoons can be trusted. The most familiar description of Manet is probably George Moore's, in his *Modern Painting* (London, 1893).

it. Then when his eyes were opened he saw things clearly, his tongue was no longer stopped, and he spoke.

He spoke a stern but elegant language which shocked the public to a degree. I do not contend that this language was entirely new, and that it did not contain some Spanish expressions which I should have had to translate for myself. But from certain bold and veracious metaphors it was easy to see that an artist had been born unto us. He spoke a language which he had made his own, and which henceforth belonged only to him.

This seems to mean that Manet had now, in 1866, realized both the extent of his dependence on the older masters and the importance of achieving a more individual expression. Perhaps today one can suspect that it was not so much the intuitive development suggested by Zola as the persistent references, from Gautier in 1861 and Thoré in 1861 and 1865, to his dependence on the Spanish masters that determined him to strike out on his own. Zola's account of such a synthesis of prolonged experiments and much trial and error is important for the suggestion it contains of Manet's own conception of the pictorial aspects of the naturalistic method which Zola himself would soon attempt to develop in his fiction:

Since he felt that he was getting nowhere by copying the old masters, by painting nature seen through other eyes than his own, quite simply one fine morning he understood that it was up to him to try to see nature as it is without looking for it in the works and opinions of others. As soon as this idea occurred to him he took anything whatsoever, a person or an object, put it in his studio and began to reproduce it on canvas according to his own ability to see it and to understand it. He made an effort to forget everything he had studied in the museums; he tried not to recall the advice he had received or the paintings he had studied. He became no more than an individual intellect served by specially gifted organs, set down in front of nature and interpreting it in his own manner.

For Zola, the primary obstacle was the public which refused to accept the evidence of such direct vision and insisted on relating

each work of art to an ideal standard of beauty arbitrarily based upon the classic art of Greece and Rome. Zola sarcastically dismissed any such theory of an ideal standard and proposed his own:

> I accept without distinction all human beings who have ever lived and who at any time, in any place, under any circumstances, have felt the imperative obligation to create as human beings, to represent in art objects and persons. So I behold a vast spectacle, each part of which interests and moves me profoundly. Every great artist came into the world to give us a new and personal interpretation of nature. Reality is the constant factor and the various temperaments are the creative elements which give the works of art different characteristics. For me the powerfully human interest of works of art resides in these different characteristics, in these aspects always new . . . Beauty is no longer an absolute, a preposterous universal standard. Beauty is identical with life itself, the human element mingling with the constant element of reality to bring to light works of art which belong to mankind. Beauty lives within us, not outside us. What do I care for philosophical abstraction, for an ideal perfection conjured up by a small group of men! What interests me as a man is mankind, the source of my life. What touches me, what delights me in human creation, in works of art, is to find deep within each of them an artist, a brother, who shows me nature under a new aspect, with all the power or all the gentleness of his own personality. Seen this way a work of art tells me the story of a body and soul, it speaks to me of a culture and a people.

He then discussed Manet's work on the basis of the law of values. Since there is nothing here which would have been unfamiliar to an experienced art critic, it appears that Zola was eagerly learning his lesson from the artist himself. But his discussion is important as the first extended and accurate published description of Manet's technique. Zola here discussed what all earlier critics had avoided. Had they bothered about it themselves, they would not have had to complain that the works were unintelligible, even impossible to criticize.

Edouard Manet ordinarily starts with a hue lighter than the actual color in nature. His paintings are bright, luminous, and generally pale. A full white light softly illuminates the objects. Nothing whatever is forced. Figures and landscape are bathed in a sort of gay clarity which fills the whole canvas.

Then I am impressed by an inevitable consequence of this exact observation of the law of values. The artist, in front of any subject at all, lets himself be guided by his eyes which perceive this subject in broad areas of related tones. A head placed against a wall is nothing more than a whitish spot against a greyish background, and the clothing next to the face becomes, for example, a bluish spot beside a whitish spot. In this way the extremely simple arrangement of precise and delicate brush strokes with almost no detail gives the painting a striking relief at a distance of a few feet. I stress this aspect of Manet's works for it dominates them and makes them what they are. His whole artistic temperament consists in the way his vision is organized. He sees in terms of light and mass.

Toward the close of this first chapter Zola tried to define the impression made upon him by this art, to put into words the precise quality of personality, of temperament, which to him was an artist's most important contribution. Since his vocabulary was preponderantly literary rather than pictorial, this was no easy task, yet the words which he uses were perhaps as precise as any then available to describe this new kind of painting. Zola's description of the quality of Manet's art comes very close to that combination of truth and imagination, of modern life interpreted with taste, which Baudelaire had considered a primary requirement of contemporary art.

In the third place I am impressed by a dry but winning charm. Don't misunderstand me. I am not talking about the pink-and-white charm of a china doll. I am talking about a poignant and truly human charm. Manet is a man of the world, and in his painting there are certain exquisite lines, certain slender and lovely attitudes, which betray his fondness for high society.

Therein lies the instinctive element, the very nature of the painter . . .

The first impression produced by a canvas by Manet is a little austere. We are not accustomed to seeing such simple and direct translations of reality. Then, as I said, there is such a surprisingly elegant awkwardness. The eye at first perceives only colors applied in large areas. Soon the objects take shape and fall into place. After a few seconds the whole vigorous effect appears, and it is a truly charming experience to contemplate this luminous and serious painting which interprets nature with a gentle brutality, if I may so express myself.

Several times Zola had referred to Manet's method of selecting a subject and interpreting it pictorially. His definition of the method, one of the earliest statements of the significance of form considered apart from content, gave the lie to the academic critics forever searching for extrapictorial values of content and form.

I take this opportunity to denounce the relationship some people have wished to establish between Manet's paintings and Baudelaire's poetry.[9] I know that a warm friendship exists between the poet and the painter, but I believe I can say that the latter has never been guilty of the stupidity committed by many others of wishing to put ideas into his paintings. The brief analysis of his talent which I have just given proves how simply he confronts nature. If he assembles several objects or figures he is guided in his choice only by his desire to create fine brush strokes, beautiful oppositions of tone. It is ridiculous to try to make a mystical dreamer out of an artist obedient to such a temperament.

Manet was the supreme example of the artist interpreting nature "just as it is." "In Manet's work [the spectator] must look finally for nothing more than reality translated by a particular personality and beautiful for its human interest."

9. Had Zola been more sensitive to poetic values he might have realized that his own reaction to Manet's painting might be considered a critical parallel to Baudelaire's taste which had found "un goût suave au vin le plus amer." See the poem "La Voix" in the *Fleurs du mal*.

As he came to realize that perhaps in this principle lay not only the reasons for Manet's technique but the whole secret of his vision, Zola stressed his discoveries in order that there might be no further misunderstanding between artist and public. Zola, by a process of subtraction, had finally laid bare the source of the curiously dispassionate withdrawal, that deliberate refusal of the artist as creator to intervene between his creatures and the spectator, which is still such a dominant aspect of Manet's art and which, as much as anything else, baffled the public of the 1860's. Zola's analysis also enabled him to minimize the Spanish element in the artist's development.

> I cannot repeat too often that we must forget a thousand things in order to understand and enjoy this work. It is no longer a question of the search for absolute beauty; this artist paints neither story nor sentiment. So-called composition does not exist for him. His self-imposed task is not to represent such and such a historical idea or event. For this reason we must judge him neither as a moralist nor as a man of letters. We must judge him as a painter. His attitude toward figure painting is like the academic attitude toward still life. That is to say, he arranges the figures in front of him somewhat at random, and then his only concern is to establish them on the canvas just as he sees them with the sharp contrasts which they produce in opposition to each other. Ask nothing more from him than an accurately literal translation. He knows neither how to sing nor to philosophize. He knows how to paint, and that is all.

Upon the premise that Manet was exclusively a painter, dedicated solely to communicating the results of optical experience, Zola could construct his familiar hypothesis of the mutual interdependence of art and science. In the following paragraph the reader will detect overtones of Zola's theory of "scientific method" in artistic expression. He had found it in Claude Bernard's *Introduction à l' étude de la médecine expérimentale* (1865) and he was to argue it energetically in the preface to his novel *Thérèse Raquin* (1867), upon which he may already have been at work.

> He is a child of our times. To me he is an analytical painter.

Since science required a solid foundation and returned to the exact observation of facts, everything has been called in question. This movement has occurred not only in the scientific world. All fields of knowledge, all human undertakings look for constant and definite principles in reality. Our modern landscape painters have far surpassed our painters of history and genre because they have studied our countryside, content to set down the first edge of a wood they come to. Manet applied the same method in each of his works. While others rack their brains to invent a new *Death of Caesar* or a new *Socrates Drinking the Hemlock,* he calmly poses figures and objects in his studio and starts to paint, all the while carefully analyzing the whole . . .

He has been reproached for imitating the Spanish painters. I agree that there is some resemblance in his early work to those masters. One is always someone's son. But ever since his *Déjeuner sur l'herbe* he seems to me to assert clearly this personality which I have tried briefly to explain and criticize. Perhaps the truth is that the public, seeing him paint Spanish scenes and costumes, made up its mind that he took his models from beyond the Pyrenees. It is not far from that to the accusation of plagiarism. But it is good to know that if Manet has painted an espada or a maja, it is because he has in his studio some Spanish costumes which he considers beautiful in color. He visited Spain only in 1865 and his canvases have an accent too individual for anyone to want to think him only a bastard of Velasquez or Goya.

Zola now had a method with which he could analyze and evaluate Manet's major paintings. His second chapter, "The Work," is an account of his impressions upon visiting the studio. His remarks on the earlier paintings are conventional and probably reflect the artist's own deprecatory opinions. The *Absinthe Drinker* is "almost intentionally melodramatic." "The painter was still self-conscious . . . Besides, I fail to find here the direct and precise temperament, powerful and large, which the artist will later affirm." The *Guitarist* and *Boy with a Sword* are "good, solid paintings, and moreover very sensitive, which should in no way have

offended the public's weak eyesight." But he preferred the more recent works, and it was in contemplation of these that his criticism became more complex and acute.

The *Déjeuner sur l'herbe* is Manet's greatest painting, the one in which he has realized the dream of every painter: to paint life-sized figures in a landscape. The ability with which he has overcome this difficulty is well known . . . The public was scandalized by this nude, which was all it saw in the painting. "Good heavens! How indecent! A woman without a stitch on alongside two clothed men." Such a thing had never been seen before! But that was a gross mistake, for in the Louvre there are more than fifty canvases in which both clothed and nude figures occur. But no one goes to the Louvre to be shocked, and besides, the public took good care not to judge the *Déjeuner sur l'herbe* as a real work of art should be judged. It saw there only some people who were lunching out of doors after a swim, and it believed that the artist had been intentionally obscene and vulgar in composing such a subject, when he had simply tried to obtain vivid contrasts and free disposition of masses. Painters, especially Manet who is an analytical painter, do not share this preoccupation with subject matter which frets the public above everything else; for them the subject is only a pretext for painting, but for the public it is all there is. So, undoubtedly, the nude woman in the *Déjeuner sur l'herbe* is only there to provide the artist with an opportunity to paint a bit of flesh. What should be noticed in this painting is not the picnic but the landscape as a whole, its strength and delicacy, the broad solid foreground and the light delicate distance, the firm flesh modeled in large areas of light, the supple and strong materials, and especially the delightful silhouette in the background of the woman in her chemise, a charming white spot in the midst of the green leaves. Finally the whole effect, full of atmosphere, this fragment of nature treated with a simplicity so exactly right, is all an admirable page upon which an artist has put the elements unique and peculiar to him.

In 1864 Manet exhibited the *Dead Christ* and a *Bullfight*.

Of the latter painting he has preserved only the toreador in the foreground—the *Dead Man* which is very close in style to the *Boy with a Sword*. The technique is minute and tight, very fine and solid. Even now I know that it will be a success at the artist's exhibition, for the public loves to examine every inch without being scandalized by the too brutal harshness of real originality. I confess that I much prefer the *Dead Christ*. There I recognize Manet completely, his obstinate eye and audacious hand. It has been said that this Christ was not really *the* Christ, and I admit that this could be so. For me it is a cadaver freely and vigorously painted in a strong light, and I even like the angels in the background, those children with great blue wings who are so strangely elegant and gentle.

Zola supported his unqualified opinion that *Olympia* was a masterpiece with an extensive and scrupulous analysis of the painting itself. Never again would he write such direct and accurate criticism; perhaps never again would he know so well a great contemporary artist.

In 1865 Manet was again accepted at the Salon; he exhibited a *Christ Mocked by the Soldiers* and his masterpiece, his *Olympia*. I said masterpiece, and I will not retract the word. I maintain that this canvas is truly the painter's flesh and blood. It is all his and his alone. It will endure as the characteristic expression of his talent, as the highest mark of his power. In it I read the personality of Manet and when I analyzed the artist's temperament I had before me only this canvas which sums up all the others. Here we have, as the popular jokers say, an Epinal print. Olympia, reclining on the white sheets, is a large pale spot on the black background. In this black background are the head of a Negress carrying a bouquet and the famous cat which has entertained the public so much. Thus at the first glance you distinguish only two tones in the painting, two strong tones played off against each other. Moreover, details have disappeared. Look at the head of the young girl. The lips are two narrow pink lines, the eyes are reduced to a few black strokes. Now look closely at the bouquet. Some patches of pink,

blue, and green. Everything is simplified and if you wish to reconstruct reality you must step back a bit. Then a curious thing happens. Each object falls into its proper plane. Olympia's head projects from the background in astonishing relief, the bouquet becomes marvelously fresh and brilliant. An accurate eye and a direct hand performed this miracle. The painter worked as nature works, in simple masses and large areas of light, and his work has the somewhat rude and austere appearance of nature itself. In addition there is a personal quality; art lives only by prejudice. And this bias is found in just that elegant austerity, that violence of transitions which I have pointed out. This is the personal accent, the particular savor of his work. Nothing is more exquisitely refined than the pale tones of the white linen on which Olympia reclines. In the juxtaposition of these various whites an immense difficulty has been overcome. The child's body itself is charmingly pallid. She is a girl of sixteen, doubtless some model whom Edouard Manet has quietly copied just as she was. And everyone exclaimed that this nude body was indecent. That's as it should be since here in the flesh is a girl whom the artist has put on canvas in her youthful, slightly tarnished nakedness. When other artists correct nature by painting Venus they lie. Manet asked himself why he should lie. Why not tell the truth? He has introduced us to Olympia, a girl of our own times, whom we have met in the streets pulling a thin shawl of faded wool over her narrow shoulders. As usual the public took good care not to understand what the painter wanted. There are even people who have looked for a philosophical meaning in the painting. Others, less restrained, would not have been displeased to find an indecent intention.

In the paintings discussed up to this point Zola was dealing with work which had been seen either at the Salons or at Martinet's. His criticism was thus offered as a corrective to the views expressed publicly elsewhere. From here, however, Zola ventured to analyze work which had not yet been exhibited, and his purpose now was clearly one of advertisement. In the spring of this very year the

government would open a great international exposition on the Champ de Mars, the first held in Paris since 1855. At that time Courbet, annoyed by the rejection of two paintings he had submitted to the retrospective exhibition, had arranged an exhibition of his own work, at his own expense, outside the exposition grounds. Zola and Manet hoped that this would not be necessary, and the former, in preparing his article, thought to arouse public interest to such a pitch that the jury would not dare reject Manet's work. His hints were certainly broad enough:

> Recently I saw in his studio about thirty canvases of which the earliest dates from 1860. He has brought them together to judge the effect they will produce at the Universal Exposition, I certainly hope to see them again on the Champ de Mars next May, and I expect they will establish the artist's reputation definitively and firmly. He who was once defeated by the public cannot be refused his splendid revenge as a victor. The jury will understand that it would be unintelligent arbitrarily to slight, on the forthcoming official occasion, one of the most genuine and original personalities in contemporary art. In this case rejection would be virtually murder, an official assassination.

Finally he tried to arouse the public's curiosity by describing the paintings it had been forbidden to see by the jury's rejection in 1866, and by an account of the seascapes and still lifes, which were scarcely known at all:

> I have now reached the last works, those the public has not yet seen. Observe the instability of human affairs. Admitted at the Salon on two consecutive occasions, Manet was rejected point-blank in 1866. The jury accepts the oddly original *Olympia,* but wants neither the *Fifer* nor the *Tragic Actor,* canvases which, while they contain the artist's whole personality, do not express it so completely. In the *Tragic Actor,* Rouvière as Hamlet wears a black costume which is a marvel of technique. I have rarely seen anything like the finesse of tone or a similar facility in painting juxtaposed materials of the same color. I

also have a preference for the *Fifer,* a little fellow, the mascot of a military band, who plays his instrument with heart and soul. One of our great modern landscape painters said that this painting was a "tailor's signboard" and I agree with him, if by that he means that the young musician's uniform was treated with the simplicity of a sign. The yellow braid, the blue-black tunic, the red breeches are here just large spots. And the simplification effected by the artist's clear and accurate vision produces a canvas quite light, charming in its grace and naïveté and acutely real.

Lastly there are four canvases scarcely dry: the *Smoker,* the *Guitar Player,* a *Portrait of Madame M.,* and a *Young Woman of 1866* . . . In conclusion I find, clearly stated in the *Young Woman of 1866,* Manet's innate elegance as a man of the world. A young woman dressed in a long pink dressing gown stands with her head graciously tilted, inhaling the perfume of a bunch of violets she holds in her right hand. At her left a parrot hangs on its perch. The dressing gown is infinitely graceful, very soft, ample, and rich. The movement of the young woman has an indescribable charm. She might be even too pretty if the temperament of the painter had not endowed the whole with his austere imprint.

I almost forgot four remarkable marines . . . in which the wonderful waves show that the artist has known and loved the sea, and seven paintings of still life and flowers which happily are becoming accepted as masterpieces by everyone. The most outspoken enemies of Manet's talent agree that he paints inanimate objects very well . . .

Such is the work of Edouard Manet, such is the general effect which the public will, I hope, be invited to see in one of the halls of the Universal Exposition. I cannot think that the public will remain blind and ironical in front of this complete and harmonious whole, the parts of which I have only briefly examined. There the manifestation will be so original and so human that truth should finally be victorious. And the public should especially keep in mind that these paintings represent only six years of work and that the artist is barely

thirty-three years old. The future is his. Even I do not dare restrict him to the present.

In the third and concluding chapter Zola turned to the problem of the popular reaction to Manet's painting. Public ridicule, he felt, was based upon ignorance and the familiar tendency of the many to join in the laughter of the few.

> The public has a bone to gnaw, and a whole regiment appears whose business it is to keep up the spirits of the mob and they do it with a will. The caricaturists get hold of the man and his work. The critics laugh louder than the disinterested. On the whole it's only laughter, only hot air. Not the slightest conviction, not the least concern for the truth. Art is a solemn affair, it is profoundly boring. So it is necessary to enliven it a bit, to find a canvas at the Salon that can be made ridiculous. And recourse can always be had to an unfamiliar work which is the mature product of a new personality . . . The public has not even tried to understand the work. It has stayed, so to say, on the surface. What shocks and irritates it is not the essential structure of the work but the general and superficial aspects. If possible it would willingly accept the same subject presented in another manner.
>
> The worst horror is originality. Unknown to ourselves we are all more or less creatures of habit who stick stubbornly to the trodden path. Every new road frightens us; we suspect unknown precipices and refuse to go forward. We always have to have the same view; we laugh at or are irritated by things we do not know. That is why we completely accept adulterated daring and violently reject whatever upsets our habits. As soon as an important figure appears, distrust and fright overcome us. We are like skittish horses who rear in front of a tree fallen across the road, because they understand neither the nature nor the cause of the obstacle, and they don't try to explain it for themselves.

The remedy, and the only one at that, was simple. Education alone could overcome public apathy and cynicism, but unfortu-

nately at this very juncture they who should above all perform the duties of instruction had failed in their obligations.

> Then along come the art critics who pour more oil on the fire. Art critics are musicians all playing different tunes at once, each hearing only his own instrument in the frightful uproar they produce. One wants color, another drawing, a third a moral . . . Thus there is no basis for analysis. Truth is not single and complete. There are only more or less reasonable variations. Several persons may examine the same work from different points of view and each one will pass judgment according to the circumstances and his own inclinations . . . It is a simple matter of education. When a Delacroix appears, everybody hisses: "Why does he not look like the others!" The French flair, which I would willingly exchange today for something a bit weightier, the French flair interferes and there are tidbits enough for the discontented.

The result was the present state of distrust among public, painters, and critics. Zola's diagnosis was clear and direct; his analysis went to the heart of the problem which had vexed French criticism since the first years of the century.

> The public will never be just toward the truly creative artists if it cannot be content with seeking in a work only a free translation of nature in an individual and novel language. Is it not profoundly sad today to think that Delacroix was hissed, that this genius who has triumphed only in death was driven to despair? What do his former detractors now think, and why do they not loudly confess that they were blind and unintelligent? There would be a lesson in that. Perhaps then they would decide to understand that there is no universal standard, no rules, no obligations of any kind but rather living beings, offering one a liberal interpretation of life at the expense of flesh and blood, ascending all the more in human glory as they are most personal and absolute.

But Zola was not discouraged. The day would come when Manet would win out:

He has, however, only to bide his time. The crowd, as I said, is a big baby which hasn't the least conviction of its own and which always ends by agreeing with the people who insist. The old, old story of talent first flouted and then admired this side idolatry will be repeated for Edouard Manet. The fate of the masters, of Delacroix and Courbet for example, will be his . . . Tomorrow, if not today, he will be understood and accepted, and if I have insisted on the public attitude before each personality as it appears, it is because the study of this point is precisely the general concern of these few pages.

Manet's response to Zola's enthusiastic article was as quick and warm as it had been the year before. On January 2 he wrote the author his thanks and communicated a most important decision:

You have given me a first-rate New Year's present, and your remarkable article pleases me very much. It comes at an opportune time, for I have been considered unworthy to benefit, as so many others, by the advantage of the invitation list, and as I augur nothing good from my judges I shall take good care not to send them any paintings. They would only make a fool of me by accepting one or two, and that would be that. To the public, the others would be good enough to throw to the dogs.

I have decided to have my own exhibition. I have at least some forty paintings to show. I have already been offered a plot of land, very well situated near the Champ de Mars. I am going to take the chance and, backed by men like you, I count on succeeding.[10]

Manet's decision, to refuse to submit his work to the jury since he had been omitted from the official list of artists invited to exhibit, was a serious one, which it seems likely he would never have reached had not Zola's article, appearing in one of the leading journals, given him hope that even outside the official exposition his art might at last receive the kind of attention which it deserved.

10. The letter was first published by P. Jamot, G. Wildenstein, and M.-L. Bataille, *Manet* (Paris, 1932), p. 82.

His funds were low, but by borrowing money from his mother he managed to erect a temporary structure on the Place de l'Alma, where on May 24 he opened an exhibition of fifty works, including three copies after the old masters, three etchings after his own paintings, and all the works accepted or rejected by the juries from 1859 to 1866 with the exception of the portrait of his parents. There were also the paintings which had been seen at Martinet's, including *Music in the Tuileries Gardens,* the *Old Musician,* and *Lola de Valence.* Among the new works were the *Combat between the Kearsarge and the Alabama,* (Fig. 22) and the *Woman with a Parrot,* (Fig. 18). The public could also see for the first time the seascapes and still lifes mentioned by Zola.

Earlier in the year Zola had suggested that his article be reprinted and distributed at the exhibition. Manet had at first approved of the idea, but later wrote Zola that he believed, after due reflection, "it would be bad taste and a waste of our resources to republish and for me to sell such a perfect tribute to myself." Zola then reissued his article as a brochure, with a new introduction, an etched portrait of Manet by Bracquemond, and Manet's own etching after *Olympia.*

For his exhibition Manet published a catalogue containing an unsigned preface. This has been attributed to Zacharie Astruc, but there is much about it which suggests a collaborative undertaking between Zola and Manet. These are the painter's opinions expressed in direct and simple language:

Reasons for a Private Exhibition

Since 1861 Manet has been exhibiting, or trying to exhibit.

This year he has decided to show the sum total of his works directly to the public.

Manet received an honorable mention when he first exhibited at the Salon. But since then he has seen himself rejected by the jury too often not to think that, if an artist's beginning is a struggle, at least one must fight with equal weapons. That is to say one must be able also to exhibit what one has done.

Without that the artist would be all too easily shut up in a circle from which there is no exit. He would be forced either to stack his canvases or roll them up in a hayloft.

It is said that official recognition, encouragement, and rewards are actually a guarantee of talent in the eyes of a certain part of the public; they are thereby forewarned in behalf of or against the accepted or rejected works. But, on the other hand, the painter is assured that it is the spontaneous impression of this same public which motivates the chilly welcome the various juries give his canvas.

In these circumstances the artist has been advised to wait.

To wait for what? Until there is no longer a jury?

He has preferred to settle the question with the public.

The artist does not say today, "Come and see faultless work," but, "Come and see sincere work."

This sincerity gives the work a character of protest, albeit the painter merely thought of rendering his impression.

Manet has never wished to protest. It is rather against him who did not expect it that people have protested, because there is a traditional system of teaching form, technique, and appearances in painting, and because those who have been brought up according to such principles do not acknowledge any other. From that they derive their naïve intolerance. Outside of their formulas nothing is valid, and they become not only critics but adversaries, and active adversaries.

To exhibit is for the artist the vital concern, the sine qua non; for it happens that after looking at something you become used to what was surprising or, if you wish, shocking. Little by little you understand and accept it.

Time itself imperceptibly works on paintings and softens the original harshness.

To exhibit is to find friends and allies for the struggle.

Manet has always recognized talent wherever he found it and has presumed neither to overthrow earlier painting nor to make it new. He has merely tried to be himself and not someone else. Besides, Manet has found important encouragement and has been able to see how much the judgment of men

of real talent is daily becoming more favorable toward him.

Therefore it is now only a question for the painter of gaining the good will of the public which has been turned into a would-be enemy.

The exhibition, unfortunately, was neither a critical nor a popular success. Although here was an unexampled opportunity to study practically all Manet's work, the critics for the most part failed to take advantage of it. Surprisingly, Jules Claretie, who had objected to Manet's work in 1855, showed some signs of a better understanding. In a dispatch to *L'Indépendance belge,* published on June 15, he acknowledged that Manet had talent, "and a deal of it," and added:

> Among the young painters I don't find many colorists equal to the author of the *Fifer* and the *Tragic Actor.* He's a Velasquez of the boulevards, let us say, or a Spaniard of Paris, but if he hasn't the startling originality that Emile Zola very sincerely finds in him, at least he deserves to attract the attention of the public, and of the critics who create the public.

This was an intelligent statement, but it appeared in another country. In Paris not a word of Manet's exhibition appeared in either the *Gazette des beaux-arts* or *L'Artiste.* Neither *L'Illustration* nor the *Monde illustré* provided its readers with a view of the building, its contents, or an account of the exhibition. Only in the *Journal amusant,* at the hands of a caricaturist of the sort Zola had just denounced, did Manet receive what would seem to be, if not criticism, at least publicity. No less than three pages were devoted to views of the building and caricatures of the principal works in it (Fig. 9). The affair seems to have met somewhat the response accorded any warmed-over scandal. The public was convinced that the paintings were worthless, convinced by the very critics who might have helped them to a clearer view of the matter. Visitors were few and those who came were only amused.

After the close of the Salon in 1865 Manet had gone abroad for the first time since his visits to Italy, Germany, and the Low Countries in 1853 and 1856. This time he went to Spain, to see the master-

pieces of Spanish painting which he had admired for so long at second hand. They did not disappoint him. In a letter to Fantin-Latour he wrote of his pleasure in seeing Velasquez and Goya in the Prado. He also visted Burgos, Valladolid, and Toledo. But traveling by himself proved tedious and he cut his visit short. More important for his future than the sight of the Spanish paintings, which tended to confirm his earlier opinions quite as much as they affected his mature ones, was a chance encounter with a fellow traveler in a Spanish restaurant. Manet disliked Spanish cooking, and this young man irritated him by promptly ordering the waiter to bring him all the dishes Manet disdainfully refused. He finally accused the man of mocking him, whereupon it appeared that the nondescript food which offended Manet's Parisian palate tasted like ambrosia to the traveler, who had just come from a walking trip in Portugal where the cooking was far worse than in Spain. Apologies having been exchanged, Manet soon became a fast friend of the stranger, Théodore Duret. Like Castagnary and Thoré before him, Duret had abandoned a professional career for art criticism. He loved to travel for travel's sake, but in this way was acquiring a wider experience of art in other countries than most critics of the period possessed. He was to be one of the first European travelers to visit Japan.

Two years later Duret was ready to publish his first book, a small volume entitled *Les Peintres français en 1867*, in which he presented his observations on the current predicament in criticism. More discriminating in artistic matters than Zola, and more industrious in his search for new talent, Duret shared the novelist's enthusiasm for Manet. He did not, however, base his defense solely on an antipathy toward official art and popular ignorance or on his personal admiration for one painter. Duret recognized the basic difficulty: that governmental control fostered the maintenance of mediocrity, for only in this way could official art secure the broad public support upon which it must depend for its continued existence. Duret described two categories of contemporary art in addition to the progressive painting which he admired. Far below that in artistic excellence were official art and bourgeois or, as we might say, popular art. The official artists were usually men of

some technical skill, but their imagination was compromised by their subservient acceptance of governmental commissions for portraits, military and historical scenes, and the like. The popular artists, on the other hand, catered to the public demand for sentiment and illustration. Duret's distinctions are important. He did not, like Zola, place the major portion of the blame on the public for its ignorance. There were artists who encumbered the scene and confused the public by offering, under the guise of fine painting, articles of no inherent imaginative power or artistic value. Duret apologized for using the adjective "bourgeois" as a neologism, but pleaded that it was already in use among the artists themselves to describe the second-rate articles. His diagnosis cleared the way for all future distinctions between painting which seeks only to please the widest possible public and that which attempts to interpret nature and the world with intelligence and sensibility. In these terms Duret could make even more subtle distinctions, as in his article on the genre painters where he isolated the truly pictorial qualities present in Meissonier but lacking in Gérôme. So it was that in the section on Manet, which followed his discussion of Ingres and the naturalists (or the men of Barbizon), he had a flexible set of criteria with which to reassess Manet's work. His article must, for these reasons, be extensively quoted:

> We are so much the more disposed to watch out for Manet, since he has been very unjustly treated by the official juries and by his fellow artists, who have on several occasions closed the door of official expositions to him. When one is obliged, at the annual expositions of the Champs-Elysées, to endure the sight of the hundreds of canvases which the jury accepts, and which are so completely inferior that they haven't even the value of any striking defects, one asks in the name of what principles and by virtue of what right the members of the jury believe they can refuse admission to works as imperfect as they would have us suppose, but which at least indicate that the artist has enough power and originality to do something on his own and, from that fact alone, make him a hundred times superior to the copyists and imitators forever prevented

from showing life as it is. All true artists are vigorous persons, profoundly original, most often obeying in their methods of production a kind of instinct and inherent natural strength. Let all these individuals develop instead of trying to restrict them, let them freely express the outstanding aspects of their nature. Everything which will contribute toward assuring the individual his freedom of action will contribute to the development of the artist. Look favorably then upon the newcomers, however inadequate or eccentric they may appear to you, often just because they aren't like you. . . .

When one has heard the excitement stirred up over Manet, the anathemas of which he has been the object, the wrath he has incurred, and then comes for the first time into the presence of his work, one must be very much astonished on seeing nothing in it truly extravagant. One might at least have expected to find a man trying to paint as no one ever has on earth, or at the very most as a man might paint on the moon or in the kingdom of Laputa. One discovers quite simply the work of an artist whose principal faults are due to the fact that he began to paint before knowing enough about handling a brush. . . . Even as a beginner, when he understood his craft very imperfectly, he began to paint spontaneously, relying on his own inspiration without preoccupying himself with principles and procedures familiar to the studios, and he has drawn one after another on canvas large compositions and life-sized figures. Manet is apparently of the lineage of those audacious artists who take the offensive at once, and who aspire to conquer everything by force. . . . Manet has been painting too short a time, and he has not yet given enough of the real measure which he will be able to produce later for me to try definitely to characterize his manner now and to define his work. I shall just limit myself to establishing what outstanding virtues and defects I seem to find in him.

I have already said that the principal faults of Manet come from the fact that he began to paint before knowing how, working all alone and learning as he painted. Now, as then, this is the reason for most of his faults and failures. The great-

est reproach that can perhaps be brought against Manet is that he works too quickly and treats his paintings too much like sketches. His technique is not developed far enough, his modeling lacks firmness, and these faults are apparent above all in his handling of figures. An artist must, to prove his ability, develop the value and strength of form as far as possible, and Manet condemns himself to remain far below what he could do by painting in too hasty and thoughtless a manner.

As to his natural abilities, the first is a true feeling for color which gives his paintings a most original range of tones. His canvases always have air and depth; there is in them a great boldness of touch and a great truth to appearance in the figures, which betray neither posing nor strain. Finally, when the artist doesn't try to scale with one bound the most difficult summits of art in doing over again large studies of the nude, he gives us works like his *Guitarist,* his *Boy with a Sword,* his still lifes, where he effortlessly achieves accurate tones and knows how to render completely, by a broad and bold technique, the exact effect he seeks.

Although Duret's taste at this time was at least relatively so conservative that he preferred the earlier to the more recent work, his sober reflections, together with the revised and enlarged edition of Zola's enthusiastic articles, placed Manet in 1867 toward the forefront of the artists whose works were a matter of concern to those interested in contemporary painting.

1868

FROM THE Salon des Refusés until the end of the Empire in 1870 Manet's claim to be considered a serious and competent painter was a constant issue in the annual criticism of the Salon. Even when he was excluded in 1866 Zola's challenge kept his name before the public, and his own exhibition of 1867, if it failed to elicit any extended criticism in the press, at least presented him as an artist who refused to accept official ostracism. Degrees of difference, in kind as well as in quality, may be observed in the criticism of these years. The differences in quality correspond in general to differences in kind, since those who were disposed to admire Manet had to study the paintings more carefully and state their opinions with more attention to shades of meaning than did those whose instinctive or even premeditated dislike required no more than a brusque rejection of his talent. The latter type of criticism has already been presented in the quotations from the popular press and the weekly humorists who merely reiterated the first shock of public antipathy. Is it possible to think that the more erudite reviews in the *Gazette des beaux-arts* and the *Moniteur* required little more effort? Again and again writers such as Lagrange and Paul de Saint-Victor, who were unable or unwilling to consider seriously any deviation from academic tradition, could easily dismiss Manet as incompetent since he failed to conform to the technical standards of the Academy and the expressive demands of history painting. If, a century later, we have perhaps too indiscriminately relegated academic painting to the attic and have so hidden from ourselves certain surprises of delicate execution and sensitive expression, the fact remains that

the academic painters of the nineteenth century, elsewhere as well as in France, were very quickly forgotten, and that almost to a man they failed to contribute much toward establishing the modern tradition. Such painting and the criticism of it has done little or nothing to illuminate for a later age the meaning of the creative process. Yet even if the conservative point of view survives the collapse of dynasties it does not endure intact. For the student of criticism not the least interesting aspect of the reviews published in the government papers and in the respectable *Gazette des beaux-arts* was the gradual if grudging acknowledgment that the newer painting could not be blithely dismissed with a reference to lurid subject and technical incompetence. From this point of view neither Théophile Gautier nor Paul Mantz can be unqualifiedly invoked as blind leaders of the opposition. To use them for such a purpose is not to see how their convictions, although foreign to our taste, were at least based upon an honest and innate preference for one kind of painting, a preference, moreover, that could admit the evidence of accomplishment in other directions. But even those critics who were more charitably disposed toward Manet and interested in the direction his art was taking were at times bewildered and depressed by his apparently meaningless compositions and careless execution.

It is in terms of the problems raised by Manet's maturer technique that the conservative as well as the liberal criticism of the later 1860's can most profitably be re-examined. Manet sent six paintings to the last three Salons of this decade. These in one way or another were among his most complete and mature accomplishments. In each he dealt directly with some situation in modern life, and in each he solved his pictorial problems in a manner far more personal than before. In only one, the *Balcony,* was there a reference to tradition, and even then the resemblances between Manet's design and Goya's *Las Majas* are less marked than the differences. Indeed, one might insist that these six works are peculiarly Manet's, to an even greater degree than the more spectacularly "modern" works of the 1870's in which he was often, and possibly often to his detriment, persuaded by the younger Impressionists to adopt a technical method with which he was not always in complete sympathy.

In retrospect it is now possibly easier to sympathize with those whose moral principles had been outraged by the paintings of 1863, 1864, and 1865, and whose critical judgments were upset by innovations of color, drawing, and design, than to understand the reservations some critics still felt obliged to make before the simplicity and coherent expression of the *Young Woman of 1866* or the *Balcony*. The critics, however, must be allowed to judge for themselves before we judge them.

Manet repaid his debt to Zola during the winter of 1867–68 when he painted the writer's portrait. In the course of the sittings the friendship, now two years old, must have grown more intimate, for in April Zola, temporarily in financial embarrassment, paid Manet the compliment of turning to him for help. On April 7 he wrote asking for the loan of 600 francs until he should receive his royalties from the reprinting of *Thérèse Raquin*. In return for his help, Zola dedicated to Manet his next novel, *Madeleine Ferat*, with the inscription: "When I indignantly defended your talent, I did not know you. Fools have dared to say that we were both comrades in search of scandal. The public made possible our friendship. In dedicating this book to you I should like to give you a token of friendship now complete and lasting."

At the Salon of 1868 Zola's portrait (Fig. 16) and the *Woman with a Parrot* (Fig. 18), which Zola had admired in the studio in 1866 and which had been seen in the exhibition of 1867, were accepted. Although according to him they were "badly hung in corners, or very high beside the doors," they attracted sufficient attention to justify his assertion that Manet would have to be reckoned with as a leading artist. The *Woman with a Parrot*, which Zola in his pamphlet had described and had christened *A Young Woman of 1866*, was another study of Victorine Meurend, this time as a full-length standing figure clad in a pink dressing gown. In the right foreground a grey parrot sat on his perch. Here was a study of contemporary life without the mannerism of ambiguous references to past masters which had prevailed in his Salon contributions from the *Spanish Guitarist* to *Olympia*. Yet there was an entirely accidental relationship to another artist which told

against any public favor for the painting. In 1866 Courbet had shown at the Salon a large canvas of a reclining nude woman holding a parrot in one hand (New York, Metropolitan Museum). The elaborate pose and artificial gesture were Courbet's answer to the criticism directed against himself and, in a roundabout way, a reply to Manet's challenge in *Olympia*. Courbet's complicated design, sober color scheme, and dense modeling were the antitheses of Manet's clear scale of values and flat pattern. To the public of 1868 it appeared that Manet was offering another rebuttal to Courbet; Courbet's lady had donned her wrapper! That the problem was rather one of discovering subjects in modern life, and a treatment appropriate to them, went unobserved.

Zola's portrait was a more intimate testimony not only to the friendship between the two men but to their mutual artistic interests. Indeed, it is in the accessories rather than in the face and figure that the interest of the painting lies, for neither here nor elsewhere did Manet display any particular gift for revealing the psychological personality of his male sitters.[1] Whatever novelty there is, whatever accent of contemporary life, is found in the unconventional pose of the writer, seated in profile before a desk cluttered with papers and books, among them his pamphlet on Manet. To the left is a Japanese screen; in a rack on the right a print by Utamaro and Goya's etching after Velasquez's *Los Borrachos*, partially concealed by a photograph of *Olympia*. Here are the compositional elements mentioned so frequently by Zola; the Japanese prints which "resemble Manet's work in their strange elegance and magnificent spots of color," and the Spanish masters who gave to him "the Spanish accent with which he spoke for the first time." In both paintings Manet's characteristic color scheme at this time is developed with conscious subtlety: in the *Young Woman*, pink against black relieved by yellow and grey; in *Zola*,

1. S. L. Faison, Jr. has suggested that Manet unconsciously transferred to Zola a large measure of his own physical distinction and sartorial elegance, and that the portrait is "more highly charged with Manet's personality than with Zola's." See his "Manet's Portrait of Zola," *Magazine of Art, 42* (1949), 162–8. The bust of Zola by Philippe Solari (c. 1866, repr. by Faison, Fig. 3) is, however, not unlike Manet's image of the writer.

the black and grey costume against a variegated background of which the spots of color on wall and desk perform the same service rendered by the bouquet in *Olympia.*

Popular reaction was discouragingly similar to that of previous years. Neither the artist's rejection by the jury in 1866 nor his own exhibition the following year had caused any reconsideration of his position or accomplishments by the press. For Gustave Vattier, on June 5 in the *Nain jaune,* the painting was just another of the artist's "coarse and ugly eccentricities, the fruit of vanity and impotence." In the *Presse,* which on previous occasions had published Paul Mantz's slighting remarks, Marius Chaumelin half humorously attacked him: [2]

> Parrots and black cats have never pleased the classicists. Allowance can be made for black cats, fantastic as they may be, but what about parrots? Manet, who ought not to have forgotten the panic caused by his black cat in *Olympia,* has borrowed a parrot from his friend Courbet and placed it on a perch beside a young lady in a pink dressing gown. These realists are capable of anything! The misfortune is that this cursed parrot is not stuffed like the portraits of Cabanel, and that the pink dressing gown is too strong in color. The accessories even prevent one looking at the face, but nothing is lost by that.

In the art journals he fared no better, although strangely enough, where once he had been charged with willful novelty he was now attacked for opposite reasons. The *Gazette des beaux-arts* continued to dismiss his work as an aberration. On June 1, J. Grangedor remarked: [3]

> Although we are reluctant to join our voice to the hue and cry which follow Manet, and which he has stirred up quite voluntarily and uselessly, we fear that for ourselves we cannot pass over his work in silence. This artist seems to us more willful than ingenuous. In the practice of art it is especially

2. Jean-Marie-Marius Chaumelin (born 1833), journalist and man of letters, contributed to many periodicals and collaborative publications.

3. J. Grangedor, pseudonym of Jules Joly (d. 1870), chemist and journalist.

necessary to know how to guard against the strength of one's own character. How many false vocations pursued in this field toward or against everything, and sometimes with real heroism, have ended only in lamentable or ridiculous results! Manet poses as a systematic painter. But of what does his system consist? It is impossible for us to understand it. The portrait he exhibits corresponds only imperfectly to any artistic pretension. Reproduced in a black-and-white engraving it would evidently lose something of its outlandish appearance. What would it then retain of real originality? Nothing, absolutely nothing.

In the May issue of *L'Artiste*, Marc de Montifaud published a more extended criticism:

Is the painter of *Olympia* motivated by real conviction? If so, he is to be respected and pitied. But as with all false convictions one could prove that the results are also false. If he wants to try to revive the style of Goya, it is not to be done by using these layers of heavy impasto which don't even have the beauty of violence. If Goya for a moment returned to examine the opaque planes and earthen tints of one of his most persistent imitators he would smile sympathetically but sadly.

What must be granted Manet is his attitude toward the figure, the way his models are posed. What he lacks is control, the precise tint in the intense coloring of which he dreams and which he only crudely portrays. His portrait of Emile Zola, less black than those of other years, was done with a few strokes rather than really painted. The artist may try as hard as he likes to draw the imagination beyond the actual frame; he will not succeed in making acceptable these manipulations of the brush which here and there really have the accent of certain works from the school of Ribera, where one can verify inspiration in impetuosity.

In studying Zola's countenance one feels one has the right to intervene even in the name of false realism. What artistic temperament will seriously accept these bituminous reflections, these muffled hues, these planes which seem modeled in

chalk? This is not said out of spite, but in sorrow before an obstinacy which is the master of brilliant qualities but which buries them beneath leaden and chalky appearances. Zola . . . seems better realized than the *Young Woman*. One could perhaps point out in this composition livelier color and a clearer general harmony. But that is all; nothing emerges from this canvas to prove that realism—a word whose meaning is destroyed every day—has achieved in Manet the rigorous standards of merit and dignity which the painter ceaselessly spurns.

Théophile Gautier had soon recovered from his initial enthusiasm over the *Guitarist* of 1861. In 1863 he had ignored the Salon des Refusés and in 1865 in the *Moniteur* had condemned *Olympia* as another error in ugliness. Yet in 1864, although distressed by the livid atmosphere of the *Dead Christ* and by the faulty perspective in the *Bullfight,* he had carefully distinguished what he considered to be Manet's true qualities as a painter from those elements which were still felt to be the protests of a young man determined to flout authority. It is then all the more remarkable that in 1868 two of the longest considerations Manet received were written by Gautier and Mantz. Although both writers felt obliged to justify their position with respect to their readers, there may be noticed in their objections not so much a change in tone as the more precise language with which they state those objections. Can it be that Zola's articles, although far from persuading them, had at least led them to look at Manet's works as serious painting rather than as radical attacks against conventional art? The length alone of their criticisms suggests that his work was attracting more attention and perhaps timid approval from a public which had by now grown accustomed to audacities of color and simplifications of design.

Théophile Gautier's remarks occupied a large part of his third article on the Salon which appeared in the *Moniteur* on May 11. After observing that all the great masters of the early part of the century had been received at first with antipathy or worse, yet had possessed then as much talent as they showed later when they were famous, Gautier wondered whether it were ever possible to under-

stand anything other than the work of one's own generation. He insisted that he had tried to be fair toward modern painting even when it disgusted him, and he believed this feeling was shared by many people whose studies, beliefs, and tastes made such work unendurable to them.

Does this mean that there is absolutely nothing in Manet's painting? He has a quality which gives to the least of his canvases a recognizable stamp: the complete unity of local color, a quality it is true, obtained by sacrificing modeling, chiaroscuro, transitional tones, and details. This prepossession lends, from a distance, a certain air of authority to the figures painted or rather sketched by the artist. This method is not his own; it comes from Velasquez and especially from Goya from whom Manet borrows his chalky lights and waxen shadows. But what he hasn't borrowed from the fiery Spanish painter, so dangerous a model anyway, is the verve, the spirit, the inexhaustible invention and fantastic power displayed in the *Caprices,* the *Misfortunes of War,* and the *Bullfights.* . . .

In the *Young Woman* the indefinite and neutral-colored background must have been borrowed from the wall of the studio, smeared with an olive color. If there were nothing more, it would be enough to make a beautiful picture. In art the simplest motif suffices, and great men have produced masterpieces with no more complicated a subject than this. But when in a painting there is neither composition, nor drama, nor poetry, the technique must be perfect. And here this is not the case. This young woman, it is said, was painted from a model whose head is delicate, graceful, and spiritual, and crowned with the richest Venetian tresses a colorist could desire. Without painting a portrait the artist could have profited from the object he had before him. It was even his duty as a realist who doesn't bother about the ideal and does not try to paint, like Raphael, according to a certain type of beauty which he has within him. The head he shows us is certainly not flattering. Over commonplace and poorly drawn features he spreads an earthy color which does not represent the flesh

tint of a young woman's fair complexion. The light which should flicker like golden sparks in her hair dies sadly. The false and ambiguous pink dress does not suggest the body it covers. The folds can scarcely be discerned and are negligently drawn with one stroke of the brush. The sticks of the perch are out of perspective, and the parrot sits there with difficulty. We do not know whether a certain truth unknown to us is present in this picture which has its admirers, but certainly there is no charm in it. And yet a young woman in pink holding a bunch of violets is a graceful subject and one on which you should look with pleasure. . . .

Before Zola's portrait Gautier was just as bewildered, although a bit more temperate, but he confessed that it was "probable" that the paintings of Courbet, Manet, and Monet contained qualities which eluded the men of his romantic generation, and he concluded, more generously than one would have expected:

> Whatever else it may be, the portrait of Emile Zola, in spite of too abrupt oppositions of black and white, is painted broadly enough and returns to the world of art from which the artist's other works violently departed.

Paul Mantz, writing in *L'Illustration* on June 6, stated his position in much the same terms:

> Manet, whose name for peaceable people has become a sort of bugbear, is himself in the throes of plenty of worries. A searching honesty, a conviction which seemed strongly entrenched, inspired his first works. The broad colors and bravura brushwork of the *Spanish Guitarist* and the *Boy with a Sword* made one think of the seventeenth-century Spanish masters. Since then Manet has gotten far away from these healthy practices. As a colorist he has less courage; as a craftsman he is less original. He has taken a singular liking for black tones and his ideal consists of opposing them to chalky whites in such a way as to present on the canvas a series of more or less contrasting spots. This technique, new in France, has been practiced before in Spain. El Greco and Goya himself some-

times played that game, but the former had seen Venice and
he kept his shadows light. The latter was full of resources and
he knew, like the skillful engraver that he was, how the blacks
and whites should complement each other. The two masters
understood, besides, that color is a language, and it was in
order to translate an emotion that they sought effects alter-
nately vaporous, harsh, and dramatic. This need of expression
hardly bothers Manet. He succeeds well enough in still-life
subjects; as a portraitist he is less successful. In the portrait
of Emile Zola the chief interest belongs not to the person but
to certain Japanese sketches with which the walls are covered;
the head is indifferent and vague and as for these blacks which
Manet professes to love, they are ambiguous and weak. In his
other painting the artist shows us a young woman in a pink
dressing gown, standing beside a grey parrot's stand; on the
floor lies a peeled orange. Here, the scale of colors is delicately
inscribed. It is annoying that this woman has a head that is
scarcely attractive. Manet's intention, one must suppose, was
to set up a symphonic dialogue, a sort of duet between the
young woman's pink dress and the rosy hue of her face. He
hasn't attained his goal at all because he does not know how
to paint flesh. Nature is of little interest to him; life's spectacles
don't move him. This indifference will be his downfall. Manet
seems to us to have less enthusiasm than dilettantism. If he had
ever so little passion he would arouse someone because there
are still about twenty of us in France who have a taste for
novelty and hardihood. But Manet doesn't even make use of
the modest resources of his palette. With the little that he pos-
sesses, he might say something—and he says nothing.

In contrast to the conservative critics, there were a few men of
some reputation in their own time who were less easily beguiled
by the fashionable Salon successes and who were not inclined to
dismiss an artist so obviously in earnest as Manet without at least
giving his work some close attention. It is not irrelevant to observe
that it is to their writing rather than to those of the academic per-
suasion that one goes today for an understanding of the critical

currents in nineteenth-century France. And it is to their credit that they were more actively on the watch for the appearance of younger talents who might renew the living tradition of French painting. Their attempts to understand the new painters and to explain them to the public still command our respect even if we no longer accept their major premises or their detailed strictures. The just criticism of contemporary art was no easier then than it is today when we are inclined to accept more than is necessary for fear of neglecting the little which will turn out to be essential. For these reasons the opinions of Castagnary and Thoré, whose reservations about Manet since the Salon des Refusés have already been quoted, still appear important in the context of their times. Their writings reveal the most significant shift in critical attitudes toward Manet, for it is probable that their position, as much as any, as much even as the gradual familiarity which his work had been gaining with the public, may be held responsible for the conversion of such critics as Mantz and Wolff, at that time more widely read or easily accessible. If the public lacked any wide acquaintance with Thoré's writings, it is nevertheless possible that the Parisian critics were aware in 1866, when Manet was excluded from the Salon, that Thoré like Zola had taken the trouble to examine for himself the paintings rejected by the jury. In his *Salon* for that year Thoré included his opinion of that rejection:

I prefer Manet's mad sketches to the academic Hercules. And so I again visited his studio where I found a large portrait of a man in black, in the same vein as Velasquez' portraits, which the jury refused. There was also, besides a "Landscape of the Sea," as Courbet calls it, and some exquisite flowers, a study of a young girl in a pink dress that will perhaps be rejected at the next Salon. These pink tones on a grey background would challenge the deftest colorists. A sketch, it is true, like Watteau's *Ile de Cythère* in the Louvre. Watteau could have pushed his sketch to perfection. Manet is still struggling against that extreme difficulty in painting, which is to finish certain parts of the canvas in order to give to the whole its proper effect.

But we can predict that he will have his measure of success, like all those persecuted by the Salon.

Apparently neither Castagnary nor Thoré took account of Manet's exhibition in 1867, but that they had not forgotten him appears in their reviews of the Salon of 1868. They had always taken Manet seriously even when they contended that his talent was unregulated and his promise only partially fulfilled. It is of some moment, then, that this year saw their most favorable criticism and their most sympathetic understanding.

In his *Salon* Castagnary remarked that forceful painters always persevered in spite of all the odds against them, and by way of illustration asked:

Didn't Courbet persevere? Didn't Manet persevere? Manet! I almost forgot to speak of him. This year brought him real success. His *Portrait of Zola* is one of the best portraits in the Salon. The accessories, table, books, engravings, the whole still life is treated in a masterly fashion. The principal figure is not so happy, with the exception of the hand which is very beautiful and the velvet coat which is astonishing. Unfortunately the face lacks modeling; it seems like a profile affixed to a background. This is because the artist has no talent for gradations of tone; he paints in black and white and with difficulty succeeds in making his objects three-dimensional. How many insults he has already received because of his technical inexperience or the errors which have escaped him. However, without bothering about such storms he smiles and passes by. He follows the law of his own temperament.

Thoré went into more detail in his discussion, but like Castagnary he felt that Manet might all too easily allow himself to be led into exaggerations and eccentricities, away from the true painting of contemporary life:

I venture to say that Manet sees very well indeed. That is a painter's first qualification. But as a matter of fact he still must have other qualities in addition to that. Manet sees color and

light, after that he doesn't bother about the rest. When he has put on his canvas the "spot of color" by which a person or object appears in its natural surroundings, he thinks he's done. Don't ask more of him, at that moment. But he will disentangle himself later on, when he considers giving relative values to the essential parts of his figures. His present fault is a sort of pantheism which thinks no more of a head than of a slipper, which sometimes bestows even more importance on a bouquet of flowers than on a woman's face, as in his famous painting of the *Black Cat*. He paints everything almost uniformly, furniture, carpets, books, clothing, chairs, the high lights of a face, as in his portrait of Zola.

This portrait of our colleague Zola, who writes about art and letters with lively independence, has nonetheless triumphed over the animosity of "the timid souls." They have not found it too unseemly nor too eccentric. They have allowed that the books, especially an open illustrated volume, and other objects encumbering the table or attached to the paneled wall, were astonishingly realistic. Certainly the technique is broad and generous. But the principal merit of the portrait as in other works by Manet, is the light which circulates in this interior and which everywhere determines the modeling and the relief.

The intangible air, as we said earlier, is also present in the portrait of a young woman in a pink dress, standing beside a handsome grey parrot, roosting on its perch. The soft pink dress harmonizes with a delicate pearl-colored background. Some pink and grey, and a small touch of lemon yellow at the base of the parrot's stand, that is all. The head, although seen from in front and in the same light as the pink material, attracts scarcely any attention; it is lost in the modulations of the color scheme.

Thoré's remark that Manet "sees very well indeed," although mitigated by his objections to the painter's attitude toward subject matter, established a point of departure for later criticism. When Manet's appearance at the Salon was no longer a novelty, when his

importance could no longer be ignored, even a conservative critic had to say something not entirely foolish about his work. And that something could very well be an offhand compliment to the painter's visual sincerity. So it is that in a routine *Salon* published in 1869 by an otherwise obscure author, Ernest Hache, Thoré's statement was developed a bit further.[4] Manet was described as "one who represents" (the neologism, *représentateur*, was italicized by the author):

> You may deny him all the qualities you wish [yet] he possesses, to an almost unique and unattainable degree [a quality] which animates his paintings; we mean the highly seasoned, naïve personality. Manet derives neither from Velasquez nor from Goya, to whom he has been compared. He is himself. He paints what he sees, as he sees it, and he sees truly.

One would think that from such a start a critic would have been led to examine Manet's canvases from the point of view of their truth to visual experience, but Ernest Hache was not equal to the task and his conclusions trickle away in the conventional complaint that the paintings display neither drawing, knowledge of modeling, technical finish, "interest," nor "idea."

Meanwhile the portrait's subject had again turned art critic. Zola had been hired by the publisher of *L'Evénement illustré*, successor to the earlier *L'Evénement*. In his new series of *Salons* he was more interested in such newcomers as Pissarro, Monet, and Renoir, although he stated his belief that Manet had gained in the esteem of his colleagues by his one-man exhibition of 1867. Since one of the paintings was a portrait of himself, Zola felt that he did "not have the right to mention the names of the painters who freely express their admiration for the portrait exhibited by the young master," but he added that such painters were "numerous and ranked among the best." And he added: "In my opinion Edouard Manet's success is complete. I didn't dare to dream that it would be so swift and

4. The name Hache may be a still unrecorded pseudonym, since it is otherwise unknown. The review, which was unknown to Tourneux, appeared in Hache's *Les Merveilles de l'art et de l'industrie* (Paris, 1869), pp. 231–330.

so respectable." Yet his distrust of the general public persisted in his description of a typical crowd at the Salon:

> As for the public, it does not yet understand, but it no longer laughs. It amused me, last Sunday, to study the faces of people who stopped in front of Manet's canvases. Sunday is really the people's day, the day of the ignorant, of those whose artistic education is still entirely unformed.
>
> I saw people arrive who had come with the firm intention of having a bit of fun. They remained with open eyes, parted lips, completely out of countenance, without smiling at all. Without being aware of it they became used to what they saw. Originality, which had seemed to them so prodigiously comic, affects them no more than the uneasy surprise a child experiences when put in front of an unknown object.
>
> Others entered the gallery, glanced along the walls, and were attracted by the strange elegance of the painter's work. They came closer, they looked in their catalogues. When they saw Manet's name they tried to laugh. But the paintings were there, clear, luminous, seeming to look at them with solemn and proud disdain. And they went away ill at ease, no longer knowing what they should think, moved in spite of themselves by the sincere voice of talent, prepared for admiration next year.

Zola's account of the gradual conversion of the public might seem overly optimistic if read in the light of the remarks in the popular press which indicated no considerable change in popular opinion. Indeed, the general dislike of his portrait may be considered an important reason for his change of heart during the ensuing years. After 1868 his name is missing from the criticism of Manet until, in 1879, in a review published in Russian in St. Petersburg, he obliquely attacked the painter for having failed to consummate his talent as a realist. Certainly Zola, who was not unaware of the persuasive power of favorable notices, must have read and pondered Louis Leroy's satirical dialogues in *Charivari,* where the paintings themselves were represented as participating in a prolonged and witless discussion of artistic problems. On June 4 the *Portrait of Zola* constantly interrupted the proceedings with indignant repudi-

ations of most established values. At one point it remarked: "At the end of yesterday's session I forgot to mention a half-dozen points upon which my lack of belief is complete: I deny form, color, line, composition, I deny common sense . . . virtue, distinction, everybody, poetry, truth, civilization, etc." Even though such a wholesale cultural agnosticism was attributed to Manet, the association with his own portrait could prove awkward. At the least it indicated how closely now, to the public at large, were joined the names of the two men. Yet this was scarcely the position Zola had taken in his own criticism of Manet nor one, presumably, he would wish connected with his own work.

The portrait is certainly curious. However handsome it may appear as a design and as a study in relations of color unusually sophisticated for the time, it has always failed to persuade as an interpretation of the man it presumes to represent. But the reasons for its failure to communicate the psychological reality of Emile Zola were not to be sought in a general condemnation of superficial technical crudities of drawing and modeling. Zola himself, with his consuming interest in character portrayal, might have been dismayed had he read the most astute criticism of the painting which appeared that year, not in any of the more prominent journals but in the newspaper *La Gironde*. The critic was Odilon Redon, twenty-eight years old and still far from the position he would later claim as a painter of delicately imagined subjects pervasively symbolic in expression. The second installment of his review, published on June 9, was devoted to a lengthy consideration of Courbet, followed by a criticism of Manet and a few words on Jongkind, Pissarro, and Monet, whom he recognized as landscape painters of unusual promise. In his analysis of the philosophical premises of Courbet's art, Redon revealed not only his acute comprehension of the limitations of realism but also the reasons why he would himself later reject both realism and Impressionism. For him the purpose of Courbet, and, by extension, of Manet, was "none other than the direct reproduction of reality: to see nature and to render it attractive by the fidelity alone with which it is reproduced." Courbet's virtues consisted in his "almost distinguished" sense of color, and his ability to create, in his landscapes, a total effect of space and

atmosphere; his faults Redon attributed to his obsession with ugly subjects and his deficient draftsmanship. These virtues and these defects he found in those painters who acknowledged Courbet as their leader, judging by the great influence he exercised over their work. Such, for example, was Manet, "so extravagant and so eccentric." But Redon did not confuse Manet's particular brand of realism with Courbet's, and, in his analysis of the *Portrait of Zola,* he was able to weigh virtues against defects and to reach a point from which he could state the reasons for the disturbing lack of psychological intimacy which marks so many of Manet's portraits. It is unfortunate that Redon's criticism has been so neglected. His statements are perhaps the most penetrating which any contemporary critic published on this aspect of Manet's art:

> Complete approval of the work of this painter is impossible, perhaps because he has erred in not holding to a type of painting which would be better suited to his temperament. The *Portrait of Zola* is not treated with the severity, the knowledge, which this noble type of art demands. There are qualities in it which one would not want to deny: it attracts attention, one studies it in spite of oneself; in comparing it with the canvases beside it one actually feels something out of the ordinary; it is marked by originality, it awakens interest by the harmony, the novelty, the elegance of tone. The varied nuances of the books and pamphlets on the table attract the eye and are rendered with a true painter's talent, as well as all the accessories; but that is precisely where it is wrong, since it is a question of a portrait.
>
> Manet's fault, and the fault of all those who, like him, wish to limit themselves to the textual reproduction of reality, is to sacrifice man and his ideas for fine technique, for the successful accessory. Since man has for them no more interest, no more importance, than the beauty of flesh or the picturesque look of his dress, it follows that their characters lack moral vitality, that intimate internal life which the painter translates in those happy moments when he expresses with the most intensity, perhaps, because he has seen and felt in a manner

more profound and more vital. On this point true artists are clearly opposed to petty and restricted research. While they are aware of the necessity for a foundation in "seen" reality, true art for them resides in "felt" reality. This is what this apparently too exclusive little group does not admit . . . The *Portrait of Zola* does not seem to us worth imitating; it is rather a still life, so to speak, than the expression of a human being . . . Manet, who appears to us especially well equipped for still-life painting, should limit himself to that, which is not of an inferior order when it is treated with such talent.

1 8 6 9

THE PAINTINGS Manet sent to the Salon of 1869, the *Balcony* (Fig. 19) and the *Luncheon* (Fig. 15), were the most unequivocal transcriptions of modern life he had yet offered the public. Indeed, so complete were the appearance and flavor of the present that most critics failed to notice the relation of the *Balcony* to its Spanish prototype, Goya's *Majas on a Balcony*.[5] Such had not been the case a few years earlier when the artist had barely concealed his sources or had draped his models in fancy dress, creating, as Jahyer had written, a kind of painting between realism and romanticism. Now he impressed his borrowed theme with his own manner. In the contemporary costume and sober mien of the figures in the *Balcony* there was little beyond a vague similarity of posture to recall the coquetry of Goya. Manet's painting was quite directly a portrait study of his friends, Berthe Morisot, the violinist Jenny Claus, and the painter Antoine Guillemet, seated or standing on a narrow balcony opening from an interior room. Behind the figures in the dark interior a boy can be seen carrying a coffee service. The figures are separated from the spectator by a light iron grille, painted green as are the shutters which frame the open door. For so large a composition the color scheme is remarkably compact, Manet's favorite contrast of black and white countered by the strong greens

5. Manet probably knew the version of the *Majas* then in the Montpensier Collection in Paris. It had been reproduced in the first French monograph on the artist, Charles Yriarte's *Goya* (1867), opp. p. 90.

and given the subtlest accent by the lavender hydrangea in the lower left corner.

The *Luncheon* depicts a young man (probably Léon Koëlla-Leenhoff) standing before a table littered with the remains of a recent meal.[6] Behind the table to the right appears an older man, Auguste Rousselin, a friend of Manet's from the days of Couture's studio. In the left background a servant stands holding a silver coffeepot. Here again were the accents and attributes of modern life, the casual attitudes, the table littered with oyster shells, and a half-peeled lemon, the rubber plant, and the cat indecorously washing itself. Even the curious heap of armor in the left corner, so reminiscent of the discarded costumes to be seen in any academic artist's studio, can be explained as objects which the artist found in the actual room where he set his figures, lodgings rented from an old sea captain at Boulogne in the summer of 1868.[7]

Both the *Balcony* and the *Luncheon* were symptomatic of a major development in Manet's art of this period. More than the *Déjeuner sur l'herbe* or *Olympia* with their sardonic hints of the old masters and of life among the *déclassés,* these were his most searching and consistent attempts to create direct transcriptions of modern life in compositions of several figures, without narrative subject or complications of costume or setting. But, compared with the figure paintings of the younger Impressionists of these years, Manet's were not yet devoid of romanticism. There was and is still, in these paintings of 1869 and in the *Zola* and the *Young Woman of 1866,* a curious feeling of figures arbitrarily arranged in modern settings rather than seen suddenly and as suddenly set down on the canvas. That fresh visual perception which communicates the rustle of movement and the play of shifting light had already been caught by Monet in his *Camille* (Bremen, Kunsthalle) at the Salon

6. Léon-Edouard Koëlla-Leenhoff (1852–1927) was raised in the Manet household ostensibly as the younger brother of Mme. Manet (neé Leenhoff). At the time of his birth and again in 1872 Mme. Manet legally acknowledged him as her son, but nothing is known of the putative father, Koëlla. The suspicion recurs that he was Manet's natural son. See A. Tabarant, p. 17. He was Manet's model for several paintings including the *Boy with a Sword* (New York, Metropolitan Museum) and *Boy Blowing Soap Bubbles* (Oeiras, Portugal, Calouste Gulbenkian Foundation).

7. Tabarant, p. 153, had this information from Léon Koëlla-Leenhoff.

of 1866, and by Renoir in his *Lise* (Essen, Folkwang Museum), exhibited in 1868 and executed entirely in the open air. Compared with these Manet's men and women are more dignified but more remote. As they seem posed, so they seem more traditional, the contemporary critics notwithstanding. They were modern in dress, but their modernity was compromised by their attitudes and by their facial expressions. And the light in these paintings is just as ambiguous. Manet's flat, frontal illumination destroyed the traditional studio chiaroscuro, but since it was intentionally contrived to reinforce his design, it communicates little feeling of actual light, whether indoors or out. Neither painting enjoyed even the moderate approval granted the *Portrait of Zola* the year before. The insistence that the artist should idealize nature inevitably made Manet's work seem intentionally ugly. What is noticeable in all the adverse criticism, however, is the pained surprise that anyone who possessed such genuine pictorial talent should have been led astray, either through ignorance or obstinacy. This note of regret, long present in the criticism of Thoré and Castagnary, at last reached the popular press. Marius Chaumelin in *L'Art contemporain* was as scornful as ever:

> Manet must be taken to task, for although he possesses the true painter's temperament he has persisted in reproducing repulsively vulgar subjects, scenes devoid of interest. All his efforts should be directed toward expressing living nature in its most beautiful forms.

Later on, in *l'Indépendance belge,* where he had succeeded Thoré as Parisian correspondent, Chaumelin tempered his remarks to some extent. Writing on June 21 for a public, few of whose members would have had an opportunity to see these particular paintings, he declared:

> The important thing for [Manet] is that the public should notice his paintings, and he shrinks from no audacity—I was going to say, from no eccentricity—to attract such attention. His two paintings this year have greatly scandalized the admirers of neat, tidy, sentimental, bourgeois painting. . . . At

first glance these two paintings are not very pleasing, we must admit it. . . . No expression, no feeling, no composition. Then what is left in these pictures which is worth the trouble of looking at them? There are two or three heads modeled in light with unusual freedom, some still lifes of extraordinary truth, and—especially in the *Luncheon*—a harmony of very effective grey tones. But Manet must be no less blamed, when he has a true painter's temperament, for so obstinately reproducing subjects of offensive vulgarity, types without character, and scenes devoid of all interest.

This year the cartoonists were busier than ever. The *Journal amusant* on May 22 and 29 published Bertall's drawings, which are a curious indication of what seemed to the public the disorderly, commonplace character of the paintings. Under his drawing of the *Balcony* Bertall wrote: "The Ten Cent Store. Everything is ten cents. Just look! The dolls, the toy dogs, the balloons, the flower-pots, and everything else. This is truly remarkable. The original idea was to have lighted this scene with the help of the subdued green light of the pharmacist's bottle-lamp across the street. Manet is making real progress." And beneath the *Luncheon:* "In this painting there is something to eat and drink. Some pretty whites, handsome blacks, a good yellow, a splendid jar, some oysters, and the celebrated black cat for dessert. Only the gentlemen who are respectively a painter and sketcher turn their backs and don't seem to get along together."

An indication of a possible change in the prevailing opinion that Manet's work was totally unintelligible occurred in Pierre Veron's [8] remark in the *Journal amusant* on May 27 when he referred to Manet as "Such a clever painter of still life [*nature morte*] that all his characters look as if they had risen from their graves. The luncheon table with its accessories is excellent. But his friends are likely to be furious. This is almost reasonable painting."

Curiously enough, in another humorous publication there was additional evidence that the critics had made some progress in

8. Pierre Veron (1831–1900), poet, journalist, editor in chief of *Charivari*, 1865–99, for which he wrote a daily satirical article.

developing at least a rudimentary set of criteria. Louis Leroy's satirical article in *Charivari* on May 6, while possibly no more charitable than his accounts of previous years, was at least couched as an essay in criticism, and the phraseology may be considered a reflection of contemporary usage:

> You must be eager, dear reader, to know what I, in my capacity as singer-in-ordinary to the painter of the *Beautiful Olympia*, think of his contributions this year. In the *Luncheon* the "spot" is everything. Background and details are charming in tone. The figures themselves would cause me no pain if I could see them at a distance of a gunshot or two. Unfortunately they lose when examined at close range. They are terribly feeble so far as form goes. But, I repeat, the coloring is splendid. Oh dear, I ate my cake first. The *Balcony* is infinitely less powerful than the *Luncheon*. The woman leaning on her elbow has some distinction, but the dandy behind her is ludicrous. He is hardly sketched in, yet he makes you want to laugh. What would happen if the technique were more developed. And the ironwork of the balcony, dear Manet? Confess that you thought of me when you painted it? You said to yourself, "I am not so gay as usual this year; let's do something for my Zoilus. Let's thin out some Veronese green in a big pot and go at it like a house painter. Let's put the colors on flat without bothering at all about breaking them up; so I shall get a pleasant uniformity for which the hack writers will be much obliged to me." And in fact, each time I pass by this *Balcony with Green Bars* my brow clears and I become hilarious.

This almost imperceptible tendency to consider Manet as a painter to be criticized on pictorial grounds rather than as an offender against public propriety eventually occurs in criticism of a slightly higher quality. Although he took away with the left hand what he gave with the right, Théophile Gautier was at last obliged to concede that Manet was a painter who had to be reckoned with. As had happened before, Gustave Moreau and Manet, just because their paintings hung in the same gallery containing work by all painters whose names began with "M," were considered in se-

quence. After expressing his admiration for Moreau, whose work understandably appealed to his romantic tastes, Gautier, in his review in *L'Illustration* on May 15, turned to Manet:

> One must not look for any transition between Gustave Moreau and Manet. They are at the opposite poles of art and no comparison, not even an antithetical one, can be established between them. One cannot deny, however, that despite his tremendous faults Manet has the knack of arousing one's lively curiosity. One worries about what he does. One asks oneself: "Will there be some Manets in the Salon?" He has his fanatical followers and his detractors. Very few remain indifferent to this strange painting, which seems the negation of art and yet which adheres to it. Manet's influence is greater than one thinks, and many feel it perhaps without realizing it. It is found in many talents which, by their nature, appear as if they ought to escape it. Without being the leader of a school—he has neither the knowledge, nor the experience, nor the principles necessary for such a role—Manet exerts a certain influence on contemporary painting. And this influence he owes to one thing only: the persistence of local color which he maintains from one end to the other of his figures. This gives them a powerful unity, despite the faulty drawing and perspective, the clumsy and barbarous execution, done to disgust even the least delicate. This local color is usually refined enough and shows a summary but true feeling for color in the artist. This is Manet's real merit, in having studied a good deal the Spanish school, Velasquez and especially Goya, whose loose technique he even outdoes. . . . For Manet, in his capacity as a realist, scorns imagination. In the *Luncheon,* the figure of the fop leaning against the table is very true to type, in attitude and costume. The servant and the bearded man leaning on his elbow who are seen in the background are rather delicate in tone. But why this armor on the table? Is it a luncheon which follows or which precedes a duel? We don't know. The *Balcony,* whose Venetian blinds, done in a green which Rousseau wanted for the shutters of his ideal house, are thrown back

against the wall, shows us, in a blue-green half-light, two girls dressed in white, one seated and the other standing, putting on her gloves. Behind them stands a gentleman, some dandy or other, bathed in a half tone which erases the modeling and makes him look like a paper cutout. In its arrangement this painting reminds one of a canvas by an eighteenth-century Spanish painter, an imitator of Goya, whose name escapes us and which could be seen in the Standish collection acquired by King Louis-Philippe. Manet's exhibition is comparatively prudent and won't create a scandal. If he wanted to take the trouble, he could become a good painter. He has the temperament for it.

This year even Paul Mantz, who had returned to the *Gazette des beaux-arts* after an absence of three years, took Manet seriously, and his criticism in the July issue is the longest Manet had yet received in that journal. More than that, it is the clearest statement this year that Manet's works would have to be examined primarily as painting, that is to say as arrangements of colors and values regardless of the expressed subject or the implied interpretation. Although from the context it is obvious that Mantz's remarks about the decorative aspects of the *Balcony* were made partly in jest, partly in contempt, he had all the same established the point of departure for the criticism of later Post-Impressionist and Symbolist painting.

Those who love spontaneous effects once put their hopes in Manet. The idea that unto us a Velasquez had been born was somewhat consoling and, while frightening the philistines, certain pictures exhibited at one time on the Boulevard des Italiens aroused a very legitimate curiosity. Manet seems to want to keep us waiting; it is apparent that if he has something to say, he won't say it yet. We reproach him for this reticence. The time has come to speak out, even though the profane may be somewhat shocked. But Manet betrays his secret neither in the *Luncheon* nor in the *Balcony*. Even though he offers some details in delicate grey the first of these paintings has little significance; the second [the *Balcony*] is more important. . . . One doesn't quite know what these good people are doing on

the balcony, and the German critics, curious about the philo-
sophical meaning of things, would here be very hard put to
understand or explain the content. The accentuation of a
type, the characterization of a feeling or an idea, would be
sought in vain in this painting devoid of thought. Let us admit
that it is a question of a combination of colors and let us look
at them as we would look at the extravagant arabesques of
Persian pottery, the harmony of a bouquet, the decorative glit-
ter of wallpaper. In this respect Manet has some talent and
sometimes he seems to rise to the point of planning his paint-
ings. With the vivacious and clear green of the Venetian blinds
heightening the rosy carnations of the young girl, with the
blacks and whites of the clothing, a colorist would have made
a gay and lively picture. Manet hasn't quite succeeded. How-
ever, he has discovered some extremely delicate fleshtones and,
if he has not solved the problem, one must be grateful to him
for at least posing it. His painting has almost as much interest
as a still life.

Mantz's position, at this date, was equivocal. He was willing to
grant that Manet understood color and he was no longer disturbed
by the contemporary subject but, like Gautier, he was not yet pre-
pared to accept it without interpretation. There was no need to cast
aspersions on German criticism; he and his colleagues quite as much
required a meaning in the sense of some justification for placing
figures in particular positions. In attempting the large Salon picture
Manet still felt obliged to arrange his figures in a complex composi-
tion, but such an intricate order necessarily implied some reason
for the arrangement. In renouncing all cause of action Manet left
his figures suspended midway between motion and repose. Seen in
the company of elaborately motivated companions in the Salon,
they appeared meaningless by default. How difficult it was for the
critics to resolve this dilemma is apparent in the most serious criti-
cism devoted to Manet this year. Although Castagnary, like Mantz,
gave Manet more thought and space than he had hitherto devoted
to him, he still insisted on a literal reading of the subject matter of
the large paintings. These compositions are essentially portraits

in which the figures are presented full-face toward the spectator as in the conventional portrait where such a man-to-man relationship between spectator and sitter is natural and logical. Yet the situations in which these figures appear are of such a narrative character as to confuse, not to say embarrass, the spectator who seeks to identify himself with the figures as portraits or with the composition as an observed scene. Castagnary's criticism of the position of the figures in the *Luncheon* cannot be dismissed. If the figures in the *Balcony* are to be taken as actually seated on a balcony above ground level, then where is the spectator to think himself? This disregard of a certain order of dramatic and optical logic perhaps explains the angry outburst over *Olympia*. Where is the spectator if not actually in the room with the young woman? A similar confusion of position within and without the picture space prevails in the much later *Bar at the Folies-Bergère*. Castagnary's criticism which appeared in his sixth and last article on the *Salon,* on June 11 in the *Siècle,* is thus not so senseless a rebuke as it might appear at first reading:

> Manet is a true painter. If he would not prejudice himself too much beforehand, if he would consent to study some more, that is to say to broaden his mind and perfect his technique, I have no doubt that he would leave on contemporary art the mark of genuine originality. Up to now he has been more whimsical than observant, more fantastic than effective. His work is meager, if one discounts the still lifes and flowers which he paints masterfully. To what is this sterility due? To the fact that while basing his art on nature he neglects to have as his goal the interpretation of life. He borrows his subjects from the poets or finds them in his imagination; he doesn't bother about discovering them in contemporary life. It follows that much in his compositions is arbitrary. In looking at this *Luncheon,* for example, I see, on a table where coffee has been served, a half-peeled lemon and some fresh oysters; these objects hardly go together. Why were they put there? I know well the reason why. It is because Manet possesses, in the highest degree, a feeling for the colored spot; because he excels in re-

producing what is inanimate, and that, feeling himself superior in still lifes, he finds himself naturally brought to do as many as possible. This is an explanation but not an excuse. Our minds are more logical, and for this very reason more severe. We need nothing more than what is suitable. I would not have insisted upon this detail if it were not characteristic. Just as Manet assembles, for the mere pleasure of astonishing, objects which should be mutually incompatible, in the same fashion he arranges his people at random without any reason or meaning for the composition. The result is uncertainty and often obscurity in the thought. What is this young man of the *Luncheon* doing, the one who is seated in the foreground and who seems to be looking at the public? He is well painted, it is true, and vigorously brushed, but where is he? In the dining room? If so, having his back to the table, he has the wall between himself and us, and his position is inexplicable. On the *Balcony* I see two women, one of whom is very young. Are they sisters? Is this a mother and daughter? I don't know. And then one has seated herself apparently just to enjoy the view of the street; the other is putting on her gloves as if she were about to leave. This contradictory attitude bewilders me. Certainly, I like the color, and I freely confess that Manet finds the correct value, often even an agreeable one. I shall add that when he has learned the art of nuances, of half tones, of all those subtle secrets by which objects are modeled and space as well as light developed on canvas, he will rival the most talented of the great colorists. But a feeling for form, for fitness are indispensable. Neither the writer nor the painter can neglect them. Like characters in a comedy, so in a painting each figure must be in its place, play its part and so contribute to the expression of the general idea. Nothing arbitrary and nothing superfluous, such is the law of every artistic composition.

This year a new writer appeared whose relations with Manet would become somewhat difficult in the following decade. Albert Wolff, who had worked in Paris for ten years as a journalist, was a

German by birth.[9] He had just now been entrusted with the art criticism for *Figaro*. His arrogant and informal language (he boasted that his opinions were so independent that each visit to the Salon gained him two or three new enemies) strikes a strangely contemporary note among the more ponderous, and more carefully pondered, articles of his contemporaries. For all that, as with Mantz and Castagnary, Wolff betrays even in his impatience an awareness of Manet's gifts, and thereby stumbles, so to speak, over the threshold of more modern criticism. On May 20, in a lengthy notice on Manet, he stated:

> Among the artists of the younger generation there is none who irritates me so much as Manet. If this painter had no talent, you could shrug your shoulders before his pictures and disregard them, but the wretch has very real qualities which call for discussion. He has to a very high degree a feeling for pictorial values, and he renders admirably his first impression of nature . . . Manet paints and often paints well everything which passes before his eyes: a lemon, a woman, a knife, a blue cravat, or a man about town. . . . Manet believes he is making paintings, but in reality he only brushes in sketches . . . He lacks imagination; he will never do anything else, you may be sure of it . . . I haven't the pleasure of knowing Manet; it seems that he is a charming man, and what is more, a man of spirit. Add to this natural gift a true and incontestable temperament of a painter, and ask yourselves how, with all that, an artist can end in this crude kind of art where, as in the green blinds of the *Balcony*, he stoops to compete with house painters. Truly it's exasperating!

Although the critics might very slowly be coming around to Manet's point of view, the rate of progress combined with continued public hostility was discouraging, for the artist had placed high hopes on these particular paintings. In March Berthe Morisot's mother had written another daughter that "Manet seems mad. He

9. Albert Wolff (1835–91) contributed for many years to *Figaro*, wrote many plays, and published *Cent chefs-d'oeuvres des collections parisiennes* (1884) and *Mémoires d'un parisien*, 6 vols., (1884–88).

expects success, and then suddenly he is overcome by doubts which make him moody." Berthe Morisot herself, who was more than usually interested in the *Balcony* since she had posed for the principal figure and had been studying with Manet for a year, described his predicament in a letter to her sister dated May 2: [10]

> You will understand that my first concern was to make my way to Gallery "M." I found Manet, his hat over his eyes, looking bewildered; he begged me to look at his painting since he did not dare himself. I have never seen such an expressive face. He laughed uneasily, declaring at one and the same time that his painting was very bad and that it would be very successful.
>
> To me he is a decidedly charming person who pleases me immensely. His paintings, as usual, give the impression of strange, or even unripe, fruit. To me they are far from unpleasant. In the *Balcony* I am more odd than ugly. It seems that the epithet of "femme fatale" has gone the rounds of the sight-seers.

In another letter of the same period she added:

> Poor Manet is unhappy. As usual his exhibition is not appreciated by the public, but for him it is always a new source of surprise. He told me, however, that I brought him good luck, and that he had an offer to sell the *Balcony*. I wish it could be, but I am very much afraid that his hopes will once more be checked.

1 8 7 0

EARLY IN 1870 Manet took part in a movement directed toward changing the principles governing the selection of the jury for the Salon. He joined a committee, organized by the animal painter Jules de la Rochenoire, which prepared a list of names of progressive painters from which it was hoped that the official jury might be selected. Manet urged Zola to insert a note in one of his papers

10. See Denis Rouart, ed., *Correspondence de Berthe Morisot avec sa famille et ses amis* (Paris, 1950), pp. 25, 31.

advising the public that the list was a liberal one supported by a large number of artists. But in spite of their exertions the list was of little effect. Only Corot, Daubigny, and Millet, who were also on the official slate, with Félix Ziem, were elected instead of such men as Courbet, Daumier, Frère, Amand Gautier, Ribot, and Vollon. Manet found his work judged by the officially approved Bonnat, Gérôme, Gleyre, Cabanel, Pils, and Meissonier. Fortunately even a jury so composed accepted his two contributions, the *Music Lesson* (Fig. 20), depicting Zacharie Astruc playing the guitar for a young lady, and the *Portrait of Mlle. E.G.* (Fig. 17), the initials standing for Eva Gonzalès, a gifted young woman who had persuaded Manet to give her painting lessons and who had aroused his interest to a degree which irritated Berthe Morisot.

Both pictures have considerable iconographic importance, not only for Manet's work but for later painting as well. In a sense they are both subjects from the studio, although in no sense the usual artificial "studio subject." Rather they are transcriptions, slightly formalized for official exhibitions, of actions occurring in the midst of a painter's life. Comparison of the *Music Lesson,* so easily and informally arranged, with the half romantic and exotically costumed *Guitarist* of 1861 shows how far Manet had come in his search for the truly contemporary subject. The poignantly lovely portrait of Eva Gonzalès is proof of Manet's sensitivity to the charm of the young woman as she sat working in his studio.

In both paintings there prevails a dominantly dark tonality, reminiscent of his earlier Spanish manner. The color schemes again are based on the contrast between dark and light relieved by accents of rose and yellow. In the portrait of Eva Gonzalès there are possibly recollections of a painting by Whistler with which Manet was familiar. The arrangement of a long white dress descending to the patterned carpet, where a peony lies as if casually flung down, is very close to the white dress, figured Chinese rug, and scattered flowers in Whistler's *White Girl* (Washington, National Gallery of Art, Whittemore Collection) which had been exhibited at the Salon des Refusés.

Neither painting escaped the jeers of the professional humorists. For Cham, in his cartoon in *Charivari* on May 15, the *Music Lesson*

was "not to be confused with a drawing lesson." For Bertall in the *Journal amusant* on May 21 the coloring was objectionable: "Manet's guitar is always the same; variations on a single string, black and white—yes or no, a plebiscitary nocturne in two voices—white paper on black paper, a melancholy idea suggesting an obituary notice."

In *Charivari* on June 16 Louis Leroy ridiculed the supposed rivalry between Courbet and Manet and the younger man's pretensions to Courbet's position as leader of the realists. Under the heading, "Distribution of Awards," he invented the following scene:

The Master of Ceremonies (in a shrill voice): Mr. Manet. (Exclamations of joy in the assembly. The king comes down from his throne, takes three steps toward the famous artist, and clasps him to his breast effusively.)

Gustave I: My glorious subject, what can I offer you? A doll from Giroux which says, "Courbet is Courbet, and Manet is his prophet"? Or else a rich coat of black velvet spotted with the most beautiful colors of the palette?

Manet (simply): Half your throne will suffice, sire.

Gustave I: Confound it! How you do go on! But you must undergo a test before that. Give us a sample of your method. (Manet takes a little stick which he rests against a white canvas, then an enormous brush laden with multicolored hues, and he immediately covers the canvas like a house painter.)

Gustave I (following the work): That's it, that's it exactly. . . . rose-and-white spots for the woman, yellow and black for the man. It's perfect. But, really, I have no idea what those colors which have run are supposed to represent.

Manet: Hands, sire, and very successfully too. There is one which has six fingers, but it's better to err too much than too little. (Gustave I, enchanted, embraces the laureate again, and takes off on a dazzling cloud, after putting Manet beside him on a smaller one.)

In the *Reveil* on May 13 Laurent Pichat directed this charge of brutality against even Eva Gonzalès herself:

> Saints in the desert or delivered into the hands of their executioners are no more courageous than the young lady who has allowed Manet to represent her life-sized in a rather dirty white dress. And far from expressing her horror she laughs at the torture, she smiles in the midst of her filthiness as if in an apotheosis and, by an excess of heroism which no Saint Theresa ever thought of in her ecstasies, not content to laugh, this unfortunate woman who ought to be frightened by palettes and colors is painting! She laughs and she paints!

Marius Chaumelin in the *Presse* was disagreeable, as usual. On June 23 he titled his article "Manet's Horrors" and remarked:

> Manet, who in the minds of some blind admirers is credited with having supplanted Courbet, is a fake realist. He only appears sincere, simple, and genuine. Unable to draw carefully, he paints dislocated figures awkwardly and painfully. His two paintings this year, the *Music Lesson* especially, exceed the most ridiculous things you could imagine.

This sense of excess, of brutality carried beyond endurance, seems almost inexplicable in the face of these paintings. What might have been justified by the *Déjeuner* or *Olympia* seems hardly called for now, especially since the two paintings go no further in their depiction of modern life than the works shown the year before. In *L'Illustration* on May 21 Olivier Merson, who would have much to say about Manet during the following decade, summarized what seems to have been the general popular opinion: [11]

> If he wished, Manet could distinguish himself otherwise than by the ridiculous system in which he entrenches himself more each day. If I had the time, I would examine his work in detail. I would evaluate his qualities, and the proof that he has the means to build a reputation with something better than the eccentricities with which he has entertained the habitués

11. Charles-Olivier Merson (1822–1902), painter, critic, and conservative politician. Art critic for the *Monde illustré*, author of monographs on Ingres and Le Brun.

of the Salon every year would shine forth like the sun. If he sinned through simple ignorance, he could be forgiven. But not at all. He chooses, he knows what he is doing, and what he does in the end provokes only laughter or pity. Consider the *Music Lesson* and the *Portrait of Mlle. E.G.*, and whoever finds my words exaggerated can throw the first stone.

Even Castagnary was at last impatient. That he who had so earnestly and for so many years spoken in defense of naturalism should fail to admire Manet is perhaps as clear evidence as any that this artist's work was truly new and therefore not to be criticized in terms of any other aesthetic than his own. This year the appearance of Manet's influence on another artist, Eva Gonzalès, and her obviously close relation to him as the subject of one of his own contributions, afforded Castagnary the opportunity to chastize them both. Of Eva Gonzalès he wrote:

> What is most urgent for Mlle. Gonzalès is that she should leave Manet's faults to himself. She works a bit with black and tends, like that artist, to suppress the half tones. That is a dangerous propensity, which leads to no sincere artistic technique but to mannerism. Briefly, the first thing to do would be to suppress the backgrounds and to paint in the open air, under the beautiful true light of heaven.

With regard to Manet his censure was even more specific:

> Chance has brought Manet's name into this, and I must reprimand him. I have nothing to say about this painter who for six years seems to have made it his duty to show us at each Salon that he possesses some of the qualities necessary for picture making. These qualities I do not deny, but I am waiting for the pictures. His duty is to furnish according to his ability and temperament a reflection of the society in which we live, but to see in this vast spectacle only himself and his associates, the model close at hand, Zacharie Astruc who consents to appear as a mandolin player on a green sofa, is proof neither of extensive intellectual preoccupations nor of powerful faculties of observation.

It is clear that Castagnary had hoped that Manet would continue the social tendencies of Courbet and Millet. Himself a man of profound liberal convictions, he distrusted an art which seemed increasingly inclined to deal only on its own terms with matters of purely private interest. In spite of his startling suggestion that Eva Gonzalès should work out of doors, such criticism, taking no account of technical progress or of the true significance of an iconography which disdained comment, could not fail to discount Manet's real accomplishment.

This year Théodore Duret again published a significant analysis of Manet, but unfortunately his review of the Salon of 1870 appeared during May and June in an opposition paper, *L'Electeur libre*, and so probably did the artist more harm than good, since to the conservatives favor from such a quarter was tinged with radicalism. Nevertheless Duret, like Zola before him but with surer artistic insight, was trying to establish a system of criticism for the evaluation of Manet.

> We traverse the Salon, we pass in front of hundreds of well-painted canvases, carefully executed, of agreeable subjects, but it is all dull, without accent, with nothing to grip us. Suddenly we come before the works of Manet, and here is something standing out from the uniform background of the rest which strikes us and stops us. At last we are in the presence of someone who has his own view of things, who puts down the reflection of a vision innate with him and not borrowed from his predecessors or his rivals. Here is someone who will procure for us, as art lovers, the rare pleasure of seeing the visible world under a new and original aspect.
>
> Consequently we stopped before the errors of Manet, but we were not alone in standing there. On the contrary, there was a crowd around us, and soon we noticed that the good public which earlier was in ecstasies before any old imitation was now laughing at your original artist just because of the originality and invention which attracted and beguiled us . . .
>
> Let us then look at Manet in order to see what is new and original about him. Let us relish him for that, and let us do

away with this erroneous system of criticism which pretends to class works of art according to a single standard and by conventional established rules. In doing this we shall no longer preoccupy ourselves in his presence with draftsmanship as it is understood in the school of Ingres, which disturbed us before with Delacroix. But observing that the personages are quite three-dimensional, that their movements are accurate, that their attitudes betray neither strain nor a conscious pose, we shall find that this drawing is what it should be for an artist to be himself and not someone else.

We can now relish Manet at leisure, for what in his work is excellent and novel, for the gamut of color and the original character of his palette. He produces, from the vision which he casts over things, a truly individual impression. No one has the feeling for values and for accent in coloring objects more than he. Everything is resolved in his eyes into variations of color. Every shade or distinct tint becomes a well-marked tone, a special note of the palette. He does not work from light to dark, from shadow to high light, but with one color which stands for light, with another for shadow, and so is explained the inherent peculiarity of his technique . . .

This year Manet exhibits two canvases which show him progressing beyond anything he had shown us up to now. . . . Of his two canvases, the *Music Lesson* and the *Portrait of Mlle. E.G.,* we prefer the second as the more harmonious. We assert, in front of this portrait, that it is absolutely impossible for us to understand what arouses the public's prejudice to disparage it. The prevailing tone of the whole work is in no way crude or shrill. Quite on the contrary, the white dress of the young lady harmonizes with the sky-blue carpet and the grey background of the painting, the pose is natural, the body full of movement, and as for the features, if they are thought a bit too individual, in Manet's manner, this facial type is at the least full of life and does not lack elegance.

For us, watching the continuous development of so marked a personality, arriving by one success after another at such a work as the *Portrait of Mlle. E.G.,* we sum up the opinion

which we formed a long time ago about Manet by saying that he is an innovator, one of the rare beings who has his own view of nature and who, for that reason, is very much alive.

Just before this Manet had painted a small portrait of Duret, standing with hat and stick beside a tabouret on which rested a tray containing the materials for a *citron pressé,* the whole composing the freshest of miniature still lifes (Paris, Petit Palais). Duret, so the story goes, wishing to convince the public of Manet's talent even against its will, persuaded the artist to sign the picture upside down, so that when it was exhibited its authorship would not be immediately apparent and it could be judged on its own merits. So far as is known the joke was never carried out in Manet's lifetime; there is no indication that the portrait was exhibited before 1884.[12]

In 1870 one important critical voice was silent. Théophile Thoré had died April 30, 1869. After Baudelaire he had been the first to recognize Manet's significance as a modern artist. However much he regretted Manet's dependence on traditional models he never underestimated the painter's position. Throughout the later 1860's Thoré's stringent but thoughtful censure had been a valuable corrective to Zola's robust but unselective enthusiasm. His position in this respect was soon taken by a new critic. The novelist Edmond Duranty had already distinguished himself as a champion of the painting of modern life. An early supporter of Courbet, he had published in 1856 six issues of a review entitled *Le Réalisme.* Later in his novels, notably in *Le Malheur d'Henriette Gérard* (1861), he continued the dispassionate scrutiny of contemporary life inaugurated by Flaubert and the de Goncourts.[13] He and Manet had known each other for some time as fellow habitués of the Café Guerbois, but their relations were not consistently amicable; only as recently as February of this year they had engaged in a duel, the

12. The portrait of Duret is reproduced in color in M. Florisoone, *Manet* (Monaco, 1947), opp. plate 89.

13. Louis-Emile-Edmond Duranty (1833–80), novelist and critic. His important contribution to art history, "La Caricature etrangère pendant la guerre de 1870–71" was published in the *Gazette des beaux-arts,* but his critical reviews have not been collected. A new edition of *La Nouvelle Peinture,* edited by M. Guérin, appeared in 1946.

result of some still inexplicable difference of opinion. In the light of this episode the article in *Paris-Journal* on May 5, entitled "Manet and His Subject Matter," was proof that Duranty still held the painter's work in profound respect. The remarks commenced with an anecdote illustrating how the popular attitude toward Manet's name prohibited serious criticism of his work:

> While I was looking at Manet's *Music Lesson* a solemn gentleman was also contemplating it. After his perusal he opened his catalogue, saw the name Manet, shuddered and went away uttering the terrible words, "What a debauch!"

Duranty took pains to correct this opinion:

> Now there is precisely nothing less debauched than the works of Manet. It has been said that they might have been done by a child. In contrast to polite and trifling painting, Manet works with intentional simplicity and disdains all guile. . . . In every exhibition, at a distance of two hundred paces, through one gallery after another, there is only one painting which stands out from all the others: it is always Manet's. You may laugh because it is ludicrous that some one thing doesn't resemble others. But the painters, even those who don't like it, have always recognized the beautiful and impressive qualities of Manet's work. And so, today, I want to do him, even while warning him, the greatest service one can render a man. Formerly we had counted on him, because of these fine qualities, to found the important modern school. A few young painters have followed him and continue to do so. But they must be led further by more than subject matter. . . . It is necessary to transcend subject matter. . . . With the exception of Courbet, our contemporary painters lack power. Manet, too, has that powerful coloring which makes a painting shine forth from others. But if it is not sustained by a powerful technique, all these vivid spots of color float away and evaporate. The public gasps and jeers and we no longer know how to defend ourselves, to justify ourselves when accused of "liking the incom-

prehensible excellences" of a man for whom we have wanted
and prophesied triumph as one of the first painters of the age.

Manet and his art attracted additional attention this year through
the presence at the Salon of Fantin-Latour's *Atelier aux Batignolles*
(Paris, Musée du Louvre), a group portrait of Manet and his friends
which showed the artist at work before his easel. Once again Fantin
portrayed Manet as the elegant Parisian he was, well dressed, scru-
pulously neat, the studio in impeccable order. But such visual evi-
dence could not persuade the public that Manet was not a radical,
in life as in art, and the painting was generally considered a mani-
festo of the new movement. Such were the sentiments behind
Bertall's cartoon in the *Journal amusant* on May 21, entitled "Jesus
Painting in the Midst of His Disciples, or the Divine School of
Manet." The legend read, in sacrilegious parody: "At that time
J[esus] Manet said to His Disciples, 'Verily, verily, I say unto you,
he who has a knack for painting is a great painter. Go and paint,
and you will light the world, and your tubes of paint will be your
lanterns.' " [14]

14. The phrase, "Vos vessies seront des lanternes," is a pun on the idiom, "prendre
des vessies pour des lanternes," meaning to believe that the moon is made of green
cheese. The joke is intended to stress the gullibility of the public as well as Manet's
indifference to tradition.

THE TURNING POINT: 1870-73

1 8 7 0 – 7 1

WITH THE outbreak of the war in July 1870, followed by the collapse of the Empire and the siege of Paris through the winter, Manet's activity was necessarily diverted from painting. He had spent part of the summer of 1870 in the country visiting the painter Joseph de Nittis. In September, when Paris was threatened, he sent his wife and mother south and then enlisted in the National Guard for the defense of the capital. Ironically the colonel of his regiment was Ernest Meissonier, but their relations as comrades in arms prompted no mutual artistic sympathies. Manet remained in Paris during the siege, and his letters are eloquent testimony to the suffering of the Parisians during that dreadful winter.[1] After the capitulation he was able to leave the city on February 12, 1871, and join his family in the Pyrenees. Later they removed to Arcachon near Bordeaux until Manet returned to Paris shortly before the insurrection and Commune in May. During its brief existence the Commune proposed the organization of a federation of artists to which he was elected.

The collapse of the Empire could have caused him little concern: he had never been an enthusiastic supporter of the Emperor. In one of his letters written aboard ship on his way to Brazil in 1848 he asked his father for political news and confessed his apprehension over the election of the Prince-President. In 1863 he had suffered as a result of Napoleon's attitude toward the *Déjeuner sur l'herbe* and in 1867 he had been forbidden to exhibit his large

1. Manet's letters have been published by Tabarant as *Une correspondance inédite d'Edouard Manet. Lettres du siège de Paris* (Paris, 1935).

canvas of the *Execution of the Emperor Maximilian,* which was considered an oblique comment on the incompetence of the imperial administration in foreign affairs.[2] During the Commune he expressed his admiration for Gambetta and hoped to paint his portrait, only to be disappointed by Gambetta's refusal, which Manet attributed to "bourgeois" timidity. But apart from his political convictions Manet had certainly had enough of the imperial administration of the fine arts. He might expect something more to his taste under another dispensation. Meanwhile the interruption of the war and the change of government present us with an opportunity to review his progress to date.

For eleven years Manet had actively participated in the organized artistic life of Paris, and for a young painter it had been an unusually turbulent career. Out of the nine occasions when he had offered his work to the public at the Salon he had gained one minor award, but this had been without consequence since any favor which might have accrued had been brusquely obliterated two years later. In 1863 and 1865 his work had been consistently derided by the public and the popular press. For another man such contumely might not have been a cause for so much dismay. A Courbet or a Delacroix, expecting nothing from public favor, would have conceded nothing to popular taste. With Manet it was another matter. As a member of a conservative family whose social standards he never repudiated, he could justify his artistic career only by a popular success at the Salon. If he were to be considered a revolutionary in artistic matters, and he assuredly disclaimed such a role by word and deed all his life, he would have preferred to exert his liberalizing influence from within the academic stronghold rather than by assault from without. Strange as this situation must appear to our eyes, which have learned never to look upon academic distinctions as signs of originality and progress, it must be remembered that Manet's attitude was as much a reflection of the still prevailing strength of the academic tradition as it was of his own conventional ambitions.

2. The documentary and critical history of the *Execution* has been compiled by Kurt Martin in *Die Erschiessung Kaiser Maximilians von Mexico von Edouard Manet* (Berlin, 1948).

One might wonder why, when he was unable to secure the desired favor by painting in his own way, he had not at least once tried to curry favor by an essay in the academic manner, as Courbet had in 1866 with his *Woman with a Parrot*. Those who suspect his talent might answer that it was because he couldn't, that his studies with Couture had been too desultory, his education too inadequate, his imagination too limited for him to carry off the elaborately contrived and intricately executed historical subject in the manner of Robert-Fleury or Cabanel. Yet in a sense this was exactly what he had done with the *Déjeuner sur l'herbe* and *Olympia*. Certainly his power of conceiving an imaginatively novel design was not notable. A good case can be made for his continued dependence on the suggestions of others in matters of composition.[3] And in technique it is just possible that he not only disliked but even could not master the artificialities of academic brushwork. But, paradoxically, the peculiar relation he assumed toward the great tradition proved to be that aspect of his art which incurred almost universal public hostility and only infrequent private admiration, namely his conviction that the traditional compositions of the past could be used for the depiction of the life of his own times. In refusing to deviate from this position he became, even against his will, the acknowledged champion of modern painting.

This point of view was based on a fallacy all too apparent a few years later. What made his paintings seem so strange and peculiar to his contemporaries was the grotesque character of contemporary scenes arranged in imitation of the grand manner. The compositions of Velasquez and Goya, of Titian, Tintoretto, and Raphael, had been contemporary in their day and had arisen logically out of situations within their own experience. An air of masquerade or worse was the inevitable result when men and women of the 1860's posed in attitudes originally determined by other customs and costumes. Here are to be found the reasons for the hesitation, felt even by those who were inclined to admire Manet, such as Thoré-Bürger and Castagnary, men puzzled and disappointed but yet unable to state exactly what bothered them. It accounts for Baude-

3. Notably by Germain Bazin in "Manet et la tradition," *L'Amour de l'art*, 18, No. 5 (1932), pp. 153–63.

laire's remark that Manet had been "touched by romanticism from birth." They were bewildered by his failure to create an art wholly of his own time. Here also, in spite of his earlier enthusiasm, is one of the reasons for Zola's later rejection of Manet as the leading naturalist painter of modern times.

Although the eleven years had ended in failure in terms of material rewards, and it must be remembered that his studio was full of unsold canvases, they had brought him a number of friends and critics of whom any artist might be proud. It was only unfortunate, from his point of view, that often his warmest admirers were also in public disfavor. To a later generation the support and encouragement of Charles Baudelaire would seem invaluable, but in the early 1860's praise from the author of the *Fleurs du mal* was suspect in the extreme. It can now be seen how his association with the poet invested Olympia's black cat with a diabolical significance quite out of proportion to its part in the artistic scheme of the painting. Thoré-Bürger and Castagnary were known to be politically liberal. Young Zola was an untrustworthy radical in matters of criticism and Théodore Duret's most important review appeared in a republican journal. At this remove it is easy to set the opinions of these disinterested critics above the vilifications of the subservient official press; at the time the attacks of Paul Mantz or the reservations of Théophile Gautier in the eminently respectable *Moniteur* or *Gazette des beaux-arts* outweighed them a hundred to one.

Yet out of this mass of conflicting claims and controversy an orderly pattern of criticism can be traced. On the score of form and content the academic position was obviously irreconcilable with the requirements of modern art. The "ideal standard" denounced by Zola could never take account of Manet's contemporary subjects and technical procedures. So long as modern art was to be judged by reference to the past, Manet's themes and handling would always appear vulgar and slovenly. Even those who admired him were unable at first to find the words which would best characterize the individual qualities of his art. It is interesting to observe that friend and foe alike described his work as "strange" and "elegant." They spoke of the "savor" and "pungency" of his painting. For Baudelaire it had "charm." To Zola it was "stern, harsh, and acrid."

These words may not properly belong to the vocabulary of pictorial criticism, but they are still useful for describing certain aspects of his painting. There was, and indeed still is, something strange and elegant about these personages, so enviously aloof from all worldly concerns, so refined in their appearance. Of his favorite models both Victorine Meurend and the aristocratic Berthe Morisot possessed an unusual beauty which was not to the common taste. And when such persons were represented according to a greatly simplified system of values within a restricted range of color skillfully articulated in relation to a dominant pattern of black and white, the result was so thoroughly a reversal of familiar modulations that it could not fail to distress the routine vision of the public. Only toward the end of the 1860's did a few critics begin to understand that his method of representation was based on artistic principles rather than on arbitrary willfulness.

Such a system was the result of a vision that saw and translated nature almost entirely in terms of value rather than of line or color. For this reason Manet's drawings are comparatively rare and in contrast to his paintings relatively uninteresting. Also it follows that his graphic work is the least important aspect of his career; while it is quantitatively considerable there are few truly original prints. Of his seventy-nine etchings and lithographs, forty are reproductions of his own paintings, treated in terms of broad oppositions of light and dark with little linear definition. Such a continuous concern with the translation of his own color designs into black and white reveals his lifelong preoccupation with problems of value contrasts. It explains his reluctance to accept the brilliant Impressionist palette, and it emphasizes his masterly use of black as a positive element, indeed as a color, equal in importance to the usual hues. It is not surprising that the influence of Goya occurs so frequently in his prints, for the Spaniard had worked with black and white in terms of value relations rather than of linear constructions. A clear and forceful statement of Manet's technique would perhaps have led to an earlier appreciation of his achievement. Then Castagnary would not have had to complain, the caricaturists echoing the charge, that Manet could not draw and that the faces and hands of his figures were execrably misshapen. Whatever may be Zola's

weaknesses as a critic, his assistance in resolving the dilemma made possible Théodore de Banville's ironical remark in his journal on June 21, 1872:

> Manet has made an irreparable mistake by being, in the true sense of the word, a *painter*. For him color is language, music, and he speaks this language rather than translates it into sentimental or literary terms.

In material as in critical affairs, the tide was about to turn. Late in 1872 an unexpected windfall occurred. An adventurous young dealer, Paul Durand-Ruel, finding that his stock needed replenishing, began to take an interest in contemporary painting. The slow but gradual popularity of the Barbizon masters in whom he specialized had lifted them out of his range and he needed a new list of artists whose works he could acquire cheaply. In December he visited Manet's studio and agreed to purchase twenty-two paintings, among them the *Absinthe Drinker*, the *Spanish Guitarist, Mlle. V. as an Espada*, the *Young Man as a Majo*, the *Dead Christ*, the *Dead Toreador*, the *Fifer, Rouvière as Hamlet*, and the *Young Woman with a Parrot*. This was an excellent start and other purchasers followed. Soon after, a dealer named Fèvre bought the *Boy with a Sword*, and Théodore Duret acquired the *Toreador Saluting*. With the establishment of the Third Republic and the revival of the annual Salon, Manet could again hope to win the critics and public to his program.

<div align="center">1 8 7 2</div>

THE FIRST postwar Salon was held in the spring of 1872, but Manet had no new work to offer. He had painted only a few landscapes during the summer of 1870 and since then the war and the Commune had intervened. His decision to send the *Combat between the Kearsarge and the Alabama* (Fig. 22), painted in 1864 and admired by Burty when it was exhibited in a dealer's window that year, was perhaps based on the fact that the pictures he had recently sold had all been early work. If he had hoped that a new spirit under the new Republic would immediately prevail in criti-

cism, he must have found the first reviews anything but encouraging. The more superficial critics had not changed their attitude. Especially in the popular journals exception was taken to the high horizon and the oblique perspective, Manet's double tribute to the truth of vision and to his admiration for Japanese prints. In the *Journal amusant* on May 25 Pierre Veron referred to him as:

> A little less eccentric than usual. Evidently Manet falls into step behind Courbet in everything. Because Courbet painted seascapes, Manet wanted to paint seascapes. It seems that this picture represents a naval battle. Ah, if Manet didn't want to be so startling, he could perhaps be something else.

Stop's cartoon [4] in the same issue bore the legend:

> Without caring for the everyday bourgeois laws of perspective, Manet has had the ingenious idea of giving us a vertical section of the ocean so that we can read on the fishes' faces their impressions of the battle taking place above them.

In *Charivari* on May 16 Louis Leroy compared the ships to toy boats and remarked that this would be proper if the painting were comical: "But no, it is so serious it borders on tediousness. There is nothing to hold on to in it, and it is regrettable that Manet has not just exhibited one of his still lifes which, by exception, he does very well."

Cham's cartoon on June 2 also took exception to the perspective: "The Kearsarge and the Alabama, thinking Manet's sea improbable, have gone off to fight on the edge of the frame."

For one reason or another the professional journals on the whole neglected Manet this year. In *L'Artiste* Jules Fleurichamp lamented the disappearance of what he was pleased to call "thoughtful painting," for which he held Manet, "the painter of signboards, the con-

4. Stop, pseudonym of L. P. G. B. Morel-Retz (1825–99), painter and dramatist. A pupil of Gleyre, he exhibited at the Salon 1857–65, but was most active as a caricaturist for *L'Illustration*, the *Journal amusant*, and *Charivari*. He designed sets and costumes for Offenbach's *Orphée en Enfers*.

tractor's painter," chiefly responsible.[5] The *Gazette des beaux-arts* and the *Moniteur* failed to mention him, the latter apparently because the painting of the naval combat could not be fitted into Charles Clément's rigid categories of religious subjects, historical paintings, portraits, and still life. For the rest of Manet's life Clément remained the chief critic of the *Moniteur* and consistently ignored him. The typical attitude which such conservative critics might be expected to take was expressed by Jules Claretie. In his *Salon* he examined Manet's entire career but could find little to say for it. He remembered the *Spanish Guitarist* as a fine piece of painting and he recalled, at Durand-Ruel's recent exhibition of his purchases, the *Toreador* and the *Espada,* but to him these were only fragments of painting, not complete pictures:

> Nor is the *Kearsarge and Alabama* . . . any more of a painting. Manet has been a sailor, a cabin-boy [sic] and ordinary seaman in his youth. You would not say so after seeing his seascape where the perspective is treated a bit too much in the Japanese style. I was actually at Cherbourg at the time of the battle and Manet's picture doesn't show me the dramatic side of it. Some spectators on a bark watch from afar the two steamships bombarding each other. A brownish-green ship's hull, a bit of sky, flakes of smoke, and that's the battle! However, the water is black, thick, and admirably painted. Manet's material qualities are always present, the qualities of brushwork, but really one can't consider that as painting and we were right to expect more from a vigorous young man who had exhibited nothing for two years.

So even under the new regime Manet could not please the conservative critics. Until the end of his life their attitude remained substantially the same and henceforth in this account they may be assumed to be continuing their rear-guard action. But this year the new voices, in number if not in volume, almost equaled the old. Even from a source which might well have been hostile came a surprisingly accurate estimate of his painting. Edmond Duranty, the

5. Jules Fleurichamp, pseudonym of Jules Paton (dates unknown), journalist.

novelist and critic, with whom Manet had fought a duel only two
years before, was apparently willing to forget his ill will and in
his *Salon,* published in *Paris-Journal* on May 30, mentioned the
painting:

> This fragment is interesting precisely because of the vigorous
> splendor of the paint itself, the design, and an alluring, unusual
> quality which does not astonish people before they have time
> to take into account Manet's so strongly personal and pictorial
> characteristics which are always an energetic departure from
> consecrated types and traditional techniques.

An unexpected convert was the novelist and critic Barbey d'Aure-
villey.[6] Although more at home in letters than in art he published
this year a review of the Salon in the *Gaulois.* With the irrepres-
sible enthusiasm which made him such a provocative if somewhat
partial literary critic he praised the pictures he most admired. Even
though he was more interested in the content of a painting than
in its formal expression or technical invention, his discussion of
Manet was important at the time, for most of the previous ad-
verse criticism had been directed against Manet's subjects. In his
final article, on July 3, Barbey devoted more space to explaining
why he liked Manet than most critics had spent telling why they
didn't. His extended and generous consideration of the artist's
personality and his attempt, for all the mingled metaphors, to re-
late Manet's pictorial ideas to literature, suggest again the curious
circumstance that the most penetrating studies of this painting had
come, and would continue to come, from men of letters rather than
from professional art critics. In the following quotation the italics
are Barbey's own:

> Edouard Manet, according to some, has no talent. He is a
> systematic and willful dauber, who has lately been pitilessly
> *ridiculed,* which doesn't mean that he is ridiculous. Oh, no,
> not at all! According to others, he is a man of genius, no less,

6. Jules Amédée Barbey d'Aurevilley (1808–89), prominent novelist and critic. His
novels, which combine realistic description with romantic explorations of witchcraft,
include a number dealing with life in his native Normandy. His Salon was repub-
lished in *Sensations d'art* (1887).

who like all geniuses, those *gentlemen* of art and thought, know everything without having learned anything. I base my opinion on a single one of Manet's works, his *Spanish Dancer* (Lola de Valence), too Chinese for me, and I am not Chinese enough to like it a great deal, but I can see in it some *new* talents. But what I like more than any painting, what suits me right off, is the man, artist or thinker, who *can* ride rough-shod over ordinary ideas with sword in hand in the name of Initiative. On another score, safe reputations, which all my life have played the same tune, have prejudiced me in favor of bad ones, and I willingly discount the insult, the ridicule, the derision in which they are tumbled like pickled peaches in sugar syrup, in order to determine what there is to these bad reputations, sometimes as misleading as the good ones. Finally, a last point in Manet's favor, among the men who hoped for a great deal from this young painter, even from the beginning, there was Baudelaire. And in art Baudelaire was somebody. He had an assured deeply penetrating eye, almost somnam-bulistic. He *saw!* His works in aesthetics, which are full of thoughts suggested by painting, give a splendid idea of the kind of art critic he would have been and which death has cut down. He loved audacity, and Manet's didn't frighten him. What would he have said, if he had lived and if he had seen the *Combat of the Kearsarge and Alabama?* I don't know, but still, even though I don't see as clearly as Baudelaire into the future of a man and the power of his talents, I have been affected, before this painting, by a sensation I didn't think Manet capable of dealing me.

It is a feeling of nature and landscape, very simple and very powerful. Can I believe that I owe this to Manet? If ever there were a man of culture, of a high, ripe culture as they say of game, if there were ever a refined fastidious person . . . if there were ever a sly and artful rascal, it is Manet. Here in making this picture—a picture of war and assault which he has conceived and executed with the tension of a man who wants by all means to escape from the frightful conventionality in which we are submerged—whatever is most natural, most

original, what has been in reach of every brush since the world began, that Manet has best expressed in his painting of the *Kearsarge and the Alabama.*

A less clever man than Manet would have placed his contending vessels in the foreground in order to concentrate the spectator's attention more on the combat itself; but Manet has done as Stendhal did in his Battle of Waterloo seen from the rear, by a single small group apart from the battlefield . . . Manet has pushed his ships to the horizon. He has *coyly* diminished them by distance. But the sea which surges all around, the sea which he spreads out even to the frame of his picture, alone tells enough about the battle. And it is more terrible. You can judge the battle by its movement, by its broad swells, by its great waves wrenched from the deeps.

I am a man of the sea. I was brought up in sea spray. I have corsairs and fishermen in my veins because I am a Norman and of Scandinavian blood, and the waves of Manet's sea have captivated me, and I said to myself that I recognized it. It is a wonderful example of accurate observation. Manet's picture is, before anything else, a magnificent marine . . . He could have suppressed the ships and his picture would only have been greater. The sea alone, with its turgid green swells, means more than the men who move about and shoot at each other on the surface, whose cannon balls sink in its depths without ever filling them! A very fine thing this is, in conception and execution! Manet, in spite of the vaunted and execrable culture which corrupts us all, can become a great painter of nature. Today with his seascape of the *Alabama* he has married Nature herself! He has done it like the Doge of Venice; he has thrown a ring, which I swear is a golden one, into the sea.

From the reserved friendship of Baudelaire and the enthusiasm of the rebellious young Zola to the admiration of such reputable writers as Barbey d'Aurevilley and Théodore de Banville was a long and significant step. Men of sensitivity and understanding were at last not afraid to state their belief that Manet's greatest gift lay in his ability to realize through paint a vision of nature for

which any form of interpretation or idealization would only be superfluous and would detract from the finest effects.

Later this year another important event occurred in the development of modern criticism. At Durand-Ruel's request Armand Silvestre prepared an article on contemporary painting for a three-volume catalogue of the dealer's collection.[7] The catalogue was to contain 300 engravings after works by Corot, Millet, Delacroix, and Courbet, among the earlier generation, and, as well, work by Manet, Monet, Pissarro, Sisley, and Degas. This was not only the first time that the latter group had been placed so prominently in relation to earlier painting, but it was also the first attempt to characterize the new landscape painting and Manet's relation to the younger men. The introduction was published as a separate article in the important but short-lived *La Renaissance littéraire et artistique* on September 28, 1872. The date is of some interest historically since it precedes by more than a year and a half the sensational first exhibition of the Impressionists in April 1874. Even so early Silvestre recognized the innovations Monet, Sisley, and Pissarro had introduced into landscape painting and he succeeded in defining the differences among them, a remarkable feat at a time when to almost everyone else their paintings were meaningless daubs. He recognized too their relation, although a "very indirect" one, to Manet. If the other men's art was "both gracious and sincere," Silvestre felt that Manet had not always sought the first of these qualities. Yet the four works reproduced in the catalogue were beyond cavil:

> His *Dead Toreador* is a masterpiece of draftsmanship and the most complete symphony in the key of black that has ever been attempted. The *Boy with a Sword* is a superb piece of painting. The *Guitarist* is one of the most vivid figures in contemporary art. As for the *Alabama* it is a marine the vigorous accuracy of which is equaled only by Delacroix . . . The time has come for the public to be convinced, enthusiastic,

7. Paul-Armand Silvestre (1837–1901), man of letters and administrator of fine arts and archives. His published works include several volumes of poetry, criticism, plays, and many Rabelaisian short stories. The Durand-Ruel catalogue was never placed on public sale.

or disgusted, but not dumfounded. It may cease to look at his canvases or buy them at a high price. But it cannot be content any longer with noisy curiosity. At heart everyone knows that the painter has emerged from the struggle victorious. He can still be discussed but not in bewilderment.

Five weeks later, on November 2, the same periodical carried an appreciative notice by Philippe Burty who had had little to say of Manet since his favorable remark on the *Kearsarge* eight years earlier. From his careful description of the artist's recent work it is clear that Manet too was participating in the new tendency in landscape painting. Like Monet, Pissarro, Sisley, and Renoir he was working toward a more immediate effect of out-of-door light and atmosphere. Impressionism as a means and end, as a technique and type of painting, was already in existence. Only a historical accident was required to change Burty's "impression of nature" into Louis Leroy's satirical "Impressionist."

> Edouard Manet, a first-rate painter little appreciated by the Institute and its sycophants, works with ever increasing sureness. His friends have been able to see only the sketch for a *Racecourse,* unbelievably true to appearances. The day the canvas was finished it entered a famous collection. But he has in the studio a still unfinished double portrait sketched in broad daylight. A young woman dressed in that blue twill which has been all the rage this autumn is sitting beside her little daughter. The latter, dressed in white, stands and looks through the railings of the Place des Batignolles at the fleecy white smoke of a passing train and at the houses on the other side of the tracks. The motion, the sun, fresh air, and rays of light all give the impression of nature, but of nature seen with sensitivity and translated with refinement.

1873

OF THE two paintings Manet sent to the Salon of 1873 one was greeted with renewed cries of protest, while the other, to everyone's surprise, immediately proved to be the most popular of all Manet's

work. The first, a portrait of Berthe Morisot reclining on a sofa, painted in the winter of 1869–70 and entitled *Le Repos* (*Resting*, Fig. 21), was greeted with a storm of abuse. Edouard Drumont, in the *Petit-Journal* on June 2, declared it a "horror." The second painting, finished only a few weeks before the Salon opened, was a portrait of the engraver Emile Bellot, an habitué of the Café Guerbois, sitting by a restaurant table enjoying a pipe and a glass of beer (Fig. 23). *Le Bon Bock* (translatable as *A Good Glass of Beer*) reminded many of tavern scenes by the Dutch masters of the seventeenth century, and because of its traditional elements won for Manet unusually enthusiastic reviews even from those conservative critics who had been most opposed to his work heretofore.[8] Jules Claretie, in the *Soir* on May 6, pronounced it "a marvel of life and color." Ernest Chesneau, in the *Petit-Journal* on May 11, declared that "Manet has never painted better than this year, he has never found more finesse in his greys, so ably varied, he has never seen or rendered better the outward appearance of forms."

The caricaturists were quick to attack both paintings. *Le Repos,* wherein Manet's favorite black-and-white scheme predominated in the figure of a woman in a white dress against a dark background, was all too easily ridiculed. Cham's cartoon in *Charivari* on May 23 bore the legend: "A lady resting after having swept the chimney herself." In another cartoon Cham referred to her as "the goddess of slovenliness." Bertall, whose cartoons appeared this year in *L'Illustration,* called her simply "Seasickness." Poor Berthe Morisot! She had not been far wrong when she wrote in 1869 that the public thought her portrait in the *Balcony* more odd than ugly.

But more curious than the cartoonists' attacks was the haste of one journalist to condemn the painting without taking time to study it. In *L'Illustration* Francion treated his readers to a preview of the important works. That he had only glanced at *Le Repos* is evident in his reference to it as "a woman standing." When the

8. Manet had a lifelong interest in Dutch painting. In his student days he had copied the *Absinthe Drinker* by Adriaen Brouwer in the Louvre (J.W.B., No. 22). He visited the Netherlands in 1856, in 1863 on the occasion of his marriage, and again in the summer of 1872.

error was called to his attention he corrected it with little grace in a later article:

> Let us look at the paintings by Manet who pretends to be a personality and to have pupils; let us be indulgent and pass by this woman who is neither painted nor drawn, neither standing nor seated.

The *Bon Bock* attracted unexpected attention. The public as well as the critics felt that Manet had at last arrived at a definite point in his career, and the caricaturists made the most of this opinion. More than any other of his pictures, not excluding *Olympia,* this was the subject of cartoons which did not cease to appear even after the Salon closed. By now an ingrained tendency was at work to treat every painting of Manet's with contempt. So Cham in *Charivari* on May 23 called it "a good glass of beer but a rotten picture," and in another cartoon he referred to the subject's costume as "the official dress for the next Commune." But later in the week, aware that public favor had turned toward the painting, he published a third cartoon in the *Monde illustré* with a jocular play upon the title, "A bon zig, bon bock" ("to the decent chap, a small beer"). But he hadn't finished. So powerful was the attraction of the painting that early in June he issued a fourth cartoon showing the good fellow drinking a second glass in an establishment eloquently named the "Salon des Refusés."

On the whole the *Bon Bock* delighted almost everyone. Only a few still complained, like Francion on June 14 in *L'Illustration,* about the apparently hasty technique.

> Let us go at once to the *Bon Bock* . . . It is undeniable that there emerges from this canvas a certain accent of truth. Could it be that Manet has taken care with his drawing, that he has marked out the planes of the face, that he has taken the trouble to model the flesh tones and to paint in the hands? Nothing of the sort. Manet has limited himself to a most summary sketch, wherein there are a thousand things to be done over, but which at some distance creates a certain illusion, like any work which has remained in the form of a sketch. Whenever there was a

difficulty, the author prudently stopped. But the artist who slips out as soon as technical difficulties appear is unworthy of the name. He may be a clever man who tries to deceive the ignorant public, but surely he is not a painter. It is not to Manet, then, that we shall look if we wish to discover sincere realism at the Salon. We shall leave him in his rightful isolation.

One of the longest and most serious criticisms this year appeared where Manet had formerly been ignored. Although the *Revue des deux mondes* annually published a review of the Salon, no mention had yet been made of Manet, even in the turbulent years of 1863 and 1865. Now in the issue of June 1, 1873 the reviewer, Ernest Duvergier de Hauranne, taking time from his duties as deputy to the National Assembly, faced the issue squarely.[9] He was satisfied in general with the administration of the Salon but regretted the absence of really significant painting, "la grande peinture" as he called it, and inquired:

Are we then reduced to asking Manet for the secret of great art? Manet has some pretensions to originality. It is said that he has founded a school; it should be said that he has perverted the ideas of some inexperienced beginners and surrounded himself with a certain number of embittered daubers, impotent and egotistical. It's always said that Manet is a master, a reformer, and that he should only be spoken of with respect . . . For this painter, misunderstood by the public and disdaining all the little artistic skills, the banner of realism is evidently only a mask which hides a system of aesthetics of his own. Has reality ever resembled these soft, shapeless manikins, pallid, purplish, or black, crudely portrayed by means of sloppy and vague planes, without harmony or unity, which he tries to offer us as the last word in modern art? There are surely some tavern signs which are more real than this alleged realism of Manet's. His canvas called *Le Repos,* which represents a woman dressed in white thrown on a sofa, is a con-

9. Louis-Prosper-Ernest Duvergier de Hauranne (1843–77), politician and journalist. He was a member of the liberal opposition under the Empire and a prominent republican from 1870 until his premature death.

fusion defying all description; one must have faith to try to disentangle the good intentions which could be hiding under this indecent and barbarous smear. As for the *Bon Bock*, the head of the beer drinker betrays a certain effort, a beginning of effort and modeling. But what a hard, flat, confused, uncertain touch! What a shrill and crude mixture of charcoal and broken bricks! The hand which holds the pipe must have been painted with palette scrapings and modeled with a sponge. It is too much to speak of Manet seriously. If he were more conscientious he would be only a poor painter, but in defying common sense he has at least succeeded in creating a scandal, and he forces us to mention his name.

That all these complaints accurately reflected the general confusion over this painting is clear from the humorous account of his visit to the Salon published by Ernest d'Hervilly in *La Renaissance littéraire et artistique* on May 31: [10]

> The flood carries me on and I give way to it. But soon it recoils in terror. It has just brought me in front of Manet's *Bon Bock*. There the best-dressed people clutch their catalogues in their hot hands. Through tight lips they foam a little at the mouth. They contemplate the beer drinker in astonishment mingled with wrath. They no longer find the artist's method of painting odious. Not at all! They are overcome and almost convinced. They find "certain qualities in this handsome canvas, but they don't understand the choice of a subject like that."
>
> "Oh, dear!" they mutter in a low and unintelligible voice, "if only Manet were willing to paint grandmothers and grandchildren weeping in each others' arms for no particular reason, how we should like it! This is one of those subjects that a wellborn artist ought never even to touch. A beer drinker! Dear, dear!"

But in spite of such quibbles the *Bon Bock* must be accounted Manet's first popular success. Albert Wolff, who never liked Manet

10. Marie-Ernest d'Hervilly (1839–1911), railroad engineer, poet, dramatist, and journalist. His liberal writings were once prosecuted under the Empire and defended by Gambetta (1864).

as man or artist, might complain in *Figaro* on May 12 that the painter had put water in his beer, to which Alfred Stevens could retort that it wasn't water but Haarlem beer, referring to the obvious influence of Frans Hals, but the engaging humor of the rotund little man withstood all attacks from those who still failed to appreciate the technique in which it was painted.

On the whole the favorable critics were more outspoken than those who still complained of Manet's ineptitude and ugliness. Even Castagnary was almost won over although his comment on the lack of definition in the hands shows that he was unaware of the Impressionists' interest in establishing the actual focal distance for the most important objects in the picture. Since in this they had been preceded by Velasquez and Hals, the *Bon Bock* asserted once again Manet's interest in the great seventeenth-century realists. On June 14 in the *Siècle* Castagnary wrote:

> Manet has painted a portrait which is well composed as a painting, and which also expresses through prominent characteristics the habits of the person depicted. This portrait, the *Bon Bock,* has had a great deal of success and it deserved it. Manet has never painted better. His color keeps its harmony and his modeling takes on real strength. Why must he neglect the extremities to such a degree? The hands, being in front of the face, should logically be drawn in more detail. Why has he let them go so deplorably? With the progress which contemporary taste is making I think this is the only cause for dispute between Manet and the serious members of the public. Even if it be costly to him, he should quickly force himself to get rid of it.

A surprising opinion appeared in the *Gazette des beaux-arts* where Georges Lafenestre,[11] who had ignored Manet the year before in *L'Illustration,* now favorably compared his work with academic painting:

11. Georges Lafenestre (1837–1919), poet and critic, published reviews of the Salon in the *Moniteur universel* from 1868. From 1870 he was a member of the Ministry of Fine Arts; he was assistant curator of paintings in the Louvre from 1886 and curator from 1888. His reviews were collected as *La Peinture et la sculpture aux Salons de 1868 à 1874* (Paris, 1881).

Cabanel's refined and delicate technique is marvelously suited to the society he studies, but we would not ask him to paint for us with the same perfection situations which are simpler, more robust, or more vulgar, as we would be sure not to demand of Manet an intense and profound intellectual study of delicate and refined models. The honest, broad, and vivid portrait, a beer drinker, which Manet exhibits this year under the title of the *Bon Bock,* is, without a doubt, in his lively, quick, and brutal style, an object of value, which in an instructive way contrasts with the petty mannerism and the sickening mawkishness of all the clumsy imitators of Cabanel, Dubufe, Bouguereau, and Chaplin. But it is obvious that these summary processes, which moreover would be more suitable in mural than in easel painting, are not applicable in all cases. It is not with a series of spots more or less well juxtaposed, in refined hues and harmonious accord, that the human form can be rendered in its interesting aspects, in what is profound and peculiar to it. And Manet himself shows, in his *Repos,* that what is adequate for the interpretation of the good-humored appearance of a ruddy smoker stuffed with dinner, becomes remarkably inadequate when it is a question of rendering the grace, delicacy, and spontaneity in the figure of a young woman.

A more unexpected conversion was that of Paul Mantz. He had passed from the *Gazette des beaux-arts* to *Le Temps* where on May 24, in attitude and language astonishingly close to Zola's position in 1866, he devoted a long section to Manet in his third article on the Salon.

The ignorant and the detractors were perhaps wrong to greet the first manifestations of Manet's talent with such foolish uproar and such bitter banter. In this country we aren't very liberal. We dispute with the artist his right to choose the methods which appear to him preferable for the expression of his vision. That is despotism . . . We don't insist now that Manet be elected a member of the Institute, but we do say that he is not as black as he has been painted, and that this sup-

posed demon come forth from the pit to frighten women and children is an interesting painter, a peaceful and distinguished man . . . Manet is an artist, and we are delighted to observe that the public has returned to more friendly feelings and has this year given him an unusual reception . . . The *Bon Bock* is not an heroic or solemn composition. It is a kind of portrait, enriched with the accessories which define the character of the model and place him against his social background, the café . . . The painting is executed in a very sober color scheme, the dominant note being the restrained black of the clothing, enlivened by the broken whites of the shirt and the lively flesh tones.

And he concluded his discussion of the *Bon Bock* with an unexpectedly apt description of Manet's point of view:

With his resources voluntarily restricted the painter has known how to obtain a sufficiently rich and complex harmony. What he has also discovered is the perfect truth of an attitude, the representation of a typical personality. He has expressed a moment which resumes a whole lifetime.

But Mantz still thought it well to make reservations about *Le Repos:*

Manet is less happy in another portrait, that of a young woman dressed in white muslin and seated, in a position which is not the most comfortable, on the edge of a divan . . . The tone of this study is not without distinction [but] this painting seems to be two or three years old. It is, in any case, from the period when Manet was satisfied with little. More than once he has shown this kind of laziness. He seeks an impression, he thinks he has set down a passage, and he stops. Everything else is lacking.

A general summary of this persistent feeling that Manet always stopped short of completing his work was expressed in more detail by Marc de Montifaud. In her statement in *L'Artiste* on June 1 that Manet should be judged "by those standards by which his

work becomes comprehensible and distinct" she reached a critical position which, had it only been held by others in the succeeding decades, would have made the subsequent quarrels over Impressionism less bitter if not unnecessary.

For several years now Manet has been earnestly searching for local color, that stumbling block on which so many palettes are broken, and which entails great deviations from reality in some artists, Karl Daubigny for example. Manet's *Bon Bock*, if one consents to stand at a distance to look at it—which is really necessary—achieves a sort of lively brutality in the execution, if I may so express myself. Don't demand of the picture preordained rules of composition; the author doesn't understand them or doesn't want to understand them, but only the free and dominant note which each object has in nature. Manet doesn't look for the expression of a face but rather for its general appearance. One perceives at first glance in his *Drinker* colored areas laid on one next to the other with a somewhat crude simplicity and without any shading. But stand off a bit. Relations between masses of color begin to be established; each part falls into place, each detail becomes exact. The forehead is outlined with energetic clarity; the cheeks become rounded. The lips, which had seemed to be only two red lines, stand out solidly; the head is vigorously modeled. In the half-filled glass appears the transparent clear liquid; the smoke from the pipe evaporates, and the whole figure emerges, powerful and serene.

I know that the strongest objection that can be brought against it is that a painting is made to be seen close to as well as from a distance. But one must, I believe, cease to judge Manet except by those standards by which his work becomes comprehensible and distinct. Then, since it acquires from a certain point of view serious qualities, it would be unfair not to use them in judging him.

The generally informed and frequently sympathetic discussion of the two paintings indicated that the public was at last prepared to study without prejudice such scenes of modern life. Philippe

Burty expressed this view in his anonymous article in *La République française* on May 18:

> Manet achieves a legitimate success with the *Bon Bock*. It has been said that he has taken a step toward the public. Oh, no! The public is going to him and understands him better. Nothing has been changed in his system which consists of seizing the movement of life, the flash of sunlight, the natural attitude.

The suggestion that Manet was the painter of modern life could not help but recall the great poet who had demanded just such an art. But the association of Manet's name with Baudelaire's could be construed for or against his advantage. For Théophile Silvestre, who had been an intransigent champion of modern art when he published his history of contemporary artists in 1856 but who was now irascibly conservative, Baudelaire was still tainted with ugliness.[12] On July 13, long after the Salon had closed, he finally mentioned Manet in his review in the *Pays:*

> The lamented Charles Baudelaire, something of a *poseur* and the best of fellows, had an extreme and extravagant taste for the painting of Edouard Manet. He thought it excellent from every point of view and on this subject permitted not the least objection. The color alone of the most insignificant and formless paintings by his dear Manet was intoxicating to him. This infatuation, one of the strangest mannerisms, whether genuine or affected, of the author of the *Fleurs du mal* and of the *Curiosités esthétiques,* has astonished us several times . . . Manet has a taste for modern life and the cult of realism; perhaps his intuitions are good, but he seldom realizes them. Some find in him a sense of elegance, but he has it neither fundamentally, nor in form, composition, nor detail. To be convinced of this truth it is sufficient to look at the lady seated on a couch with outstretched arms, which he exhibits this year . . . Manet is

12. Théophile Silvestre (1823–76), journalist and man of letters. A republican in 1848, he later became a supporter of the Empire. His *Histoire des artistes vivants, français et étrangers* (1856), was his most significant study of contemporary art.

a born painter. He has a true painter's temperament, but his intellectual powers are weak . . . Manet in some respects is a very interesting artist, but an embryonic artist.

Silvestre's apathetic and confused attitude is perhaps best understood as a last reactionary attempt to discount the more subtle suggestion of Manet's relation to Baudelaire which had been set forth by Théodore de Banville in the *National* on May 15:

The *Bon Bock*. This is fine, sensitive, and charming in color: it is truth itself, seized, so one would believe, in a moment of luminous improvisation, if one did not know how much knowledge and study are needed to make works which seem to blossom so spontaneously and effortlessly . . . Manet's other canvas, *Le Repos,* is an engaging portrait which holds our attention and which imposes itself on our imagination by an intense character of *modernity,* if we may use this now indispensable barbarism. Baudelaire was indeed right to esteem Manet's painting, for this patient and sensitive artist is perhaps the only one in whose work one discovers that subtle feeling for modern life which was the exquisite originality of the *Fleurs du mal.*

Manet was enjoying his first critical success. He seemed at last on the threshold, not of fame precisely since he had already been infamous, but of that kind of substantial reputation which might ultimately ensure a succession of clients and rewards. If the portrait of Berthe Morisot was little liked, the beer drinker brought him some measure of material satisfaction. In September Albert Hecht purchased a landscape entitled *Swallows,* and in November Henri Rouart bought a *Beach Scene.* There appeared a new and even more gratifying patron in the opera singer Jean-Baptiste Faure.[13] On November 18 Manet recorded that he had just sold him, at very respectable prices, the *Bon Bock,* the *Luncheon, Lola de*

13. Jean-Baptiste Faure (1830–1914), famous French baritone, member of the Paris Opéra from 1861. He created many important roles, including Nelusko in Meyerbeer's *L'Africaine* (1865), the title role in Ambroise Thomas' *Hamlet* (1868), and Mephistopheles in the first performance of *Faust* at the Opéra (1869). He also composed many songs including "Les Rameaux."

Valence, and two smaller paintings, *Toilers of the Sea* and *Masquer-
ade at the Opera.* And in December Manet was accorded an honor
granted only to a recognized artist. The popular novelist Fervac-
ques published in *Figaro* on Christmas day a description of
a visit to Manet's studio which was set up in a large hall, formerly
a fencing school, at 4 rue de St. Pétersbourg.[14] Fervaques' account
suggests the curious atmosphere of a room richly furnished in the
Renaissance taste overlooking the Place de l'Europe, where an
iron bridge crossed the railroad tracks leading to the Gare St. La-
zare. As in his painting, the *Luncheon,* remnants of the past were
jostled by the crowding, commonplace present.

> At the entrance the artist came toward us, smiling affably and
> offering his hand in friendly fashion. We went into the hall,
> a large room paneled in dark antique oak with a ceiling of
> beams alternating with dark-colored coffers. A clear, soft, un-
> varying light enters through the windows overlooking the
> Place de l'Europe. The railroad passes close by, giving off
> plumes of white smoke which swirl in the air. The ground,
> continually shaken, trembles underfoot and shudders like the
> deck of a ship at sea. In the distance, the view extends down
> the Rue de Rome, with its attractive ground-floor gardens and
> imposing houses. Then, on the heights of the Boulevard des
> Batignolles a somber dark hollow: it is the tunnel, an obscure
> and mysterious orifice devouring the trains which plunge
> under its vault with a sharp whistle.
>
> On the walls were some of the painter's works. First of all
> the famous *Déjeuner sur l'herbe,* rejected by the jury which
> stupidly did not understand that this was not a naked woman
> but a woman undressed, which is quite different. Then the
> paintings exhibited on other occasions: the *Music Lesson,* the
> *Balcony, Olympia* with her Negress and her strange black
> cat which is certainly a close relative of Hoffmann's famous
> Murr . . .

14. Fervacques, pseudonym of Léon Duchemin (1840–76), journalist, popular
novelist, and art critic for *Echos de Paris* and *Figaro.* See J. Barbey d'Aurevilly, *Les
Oeuvres et les hommes* (1895), pp. 219–45.

While we were admiring this painting, so much abused and yet so full of talent, Manet made a water color of a punchinello who posed in the center of the studio dressed in his charming conventional costume. This was boldly drawn with a delicate touch, fine and colorful, entirely unlike the painter's usual manner.

1 8 7 4

Two of the four paintings which Manet submitted to the Salon of 1874 were rejected, the first time in seven years that his work had been refused. Disturbing as this must have been, there was an additional cause for embarrassment in the fact that these two had been lent by their owners. The *Swallows* (Zürich, Collection Bührle), painted in 1873, was a small but fresh and open landscape with figures, Manet's wife and mother, sitting in a field which stretched away to a distant horizon (Fig. 24). It had been purchased that same year by Albert Hecht: he and his brother Henri, Parisian bankers both, were to become two of Manet's most loyal supporters. *The Opera Ball* (New York, Metropolitan Museum of Art), depicting the foyer of the opera house crowded with women in fancy dress and men in evening clothes, had been bought by Faure in November 1873 soon after it was finished [1] (Fig. 30). According to Théodore Duret, one of the models for the men in the painting, Manet took extravagant care to reproduce all the variety, the small accidents of pose and dress, to be seen in a crowd in movement: "He carried so far his desire to capture the lifelike quality, to lose nothing of its chic, that he varied the models, even for the actors in the background, of whom one would see only a detail of a head or shoulder."

The jury which rejected these glimpses of modern life included,

1. The scene was laid in the "old" opera house, on the Rue Le Peletier, also the setting for Degas' early studies of opera and ballet. It was destroyed by fire on October 28, 1873. Charles Garnier's "new" opera house, the present Paris Opéra, was opened in 1875.

under the chairmanship of Bonnat, such perennial Salon special-
ists as Henner, Cabanel, Hébert, Cabat, Vollon, Meissonier, and
Bouguereau. The wonder is that they could and did accept the
Railway (Fig. 25) and the water color, *Punchinello* (Fig. 10). The
latter, a subject derived from one of the costumed figures in the
Opera Ball, attracted little attention compared with the new storm
of protest which arose over the *Railroad.* This painting, which
Burty had seen in progress in the studio in 1872, represents a young
woman seated and a little girl standing, her back to the spectator,
in front of an iron grating which separates them from a railway
cut. The background is filled with smoke and steam from a train
passing unseen along the tracks below. The painting had been
carried out mostly in the garden of Alphonse Hirsch, a friend of
Manet's who lived nearby. Victorine Meurend, grown mature in
the ten years since she had first posed for Manet, sat for the young
woman; Hirsch's young daughter was the model for the little girl.
This was the largest painting Manet had executed up to this time
either wholly or in great part out of doors, and to that extent it
was evidence of his acceptance of the working methods of the
younger Impressionists, especially Monet and Renoir, who for
some time had been painting figure subjects of considerable size
in the open air.[2] The story of Manet's relations with Monet and
Renoir up to this time is still obscure, but that they must have been
reasonably intimate would appear from the fact that in the sum-
mer of this year, 1874, Manet and Renoir joined Monet for a short
time at Argenteuil where they worked on common themes in
Monet's garden.[3]

Such associations, however, could only confirm certain tendencies
which had appeared in Manet's work as early as 1864, and which

2. Monet's *Women in the Garden* (1866, Paris, Louvre) and Renoir's *Lise* (1868,
Essen Folkwang Museum) seem to have been the first large figure compositions painted
entirely in the open air.

3. Monet's *Manet Painting in Monet's Garden,* with Manet's and Renoir's paintings
of *Mme. Monet and Her Son in Their Garden,* painted during this visit, are re-
produced together in John Rewald, *The History of Impressionism,* pp. 276–7. It was
on this occasion that Manet, according to Vollard, told Monet that Renoir had no
talent. The story has been frequently repeated, but was vigorously contradicted by
Tabarant, pp. 252–7. See also Léon Rosenthal, *Manet, acquafortiste et lithographe*
(Paris, 1925), ch. 6.

had preoccupied him increasingly through the following decade. In 1864 his first seascape, the *Kearsarge and Alabama,* had revealed his command of water and humid atmosphere, even though recorded in the somber tonality of those years. His visit to Spain and his studies of Velasquez and Goya undoubtedly enlarged his interest in atmospheric effects, even as they reinforced his understanding of the use to be made of themes from modern life. On later occasions, at Boulogne in 1868 and 1869, at Arcachon and Bordeaux in the spring of 1871, and at Berck-sur-Mer in 1873, he pursued his research in the transcription of light and movement in a manner, if not entirely in a technique, analogous to the experiments of Monet and Renoir at Bougival and Argenteuil during the same period. With them he helped to make explicit the primary Impressionist concern with the moment in time and the position in space, seen instantly and revealed through light. His paintings of 1869, the *Harbor of Boulogne in Moonlight* (Paris, Musée du Louvre) and the *Departure of the Folkestone Boat* (Philadelphia Museum, Tyson Collection), state the motifs of place and time in a thoroughly Impressionist mood. But unlike Monet and Renoir, Manet was unready, one might even think physiologically unable, to sacrifice his own way of seeing, his own sense of color harmonies based upon the opposition of values. To the end of his life he retained that feeling for a pictorial arrangement which is equivalent to, rather than identical with, the accidental dispositions of nature so ardently examined by the Impressionists. When he died in 1883, still in possession of his personal pictorial order, Monet and Renoir were on the point of abandoning the impersonal Impressionist technique to create, in the next ten years, more individual manners.

While Manet had been preparing his contributions for the Salon, Monet, with Sisley and Renoir, was at work on an exhibition of another kind. Discouraged by the prospect of continual rejections at the Salon, Monet and his friends decided to organize an independent exhibition of their own. Manet was invited to contribute, but, probably because of the resounding success of the *Bon Bock* the year before, preferred to send again to the Salon. Monet's exhibition, wherein he was joined by Cézanne, Degas, Bracquemond,

Guillaumin, Pissarro, Sisley, Berthe Morisot, and a somewhat heterogeneous group of painters discontented in one way or another with the Salon, opened on April 15 in the studio of the photographer Nadar on the Boulevard des Capucines. Although it was presented as a group exhibition without a specific title, it received a more notorious name a few days later when Louis Leroy, referring to a painting by Monet entitled *Impression—Sunrise,* headed his review on April 19 in *Charivari:* "Exhibition of the Impressionists." So was created, almost by accident, the name which was to annoy the group until they grudgingly accepted it, and which was to embroil Manet in further critical confusion.[4]

Manet's abstention from the exhibition, even though it had been arranged by a group of artists who looked to him as a leader in their attack on academic tradition, should have been sufficient indication that he did not consider himself one of their number. But it was as ineffectual a gesture as Delacroix's insistence that he was not a romantic but a classic artist. Nor was Manet's position made any clearer by his *Railway* at the Salon. Under Monet's influence he was working with a much brighter palette, although the range of color and the intensity of particular hues did not approach that of the Impressionists themselves. In details he continued to eliminate contour modeling as his vision more accurately recorded natural appearances at a given distance.

For those who had been able to accept the subdued color and relatively precise definition of the *Bon Bock,* the *Railway* was a new outrage. The cartoonists seized every opportunity to point out the folly of such a course. Stop, in the *Journal amusant* on June 13, described it as: "Two madwomen, attacked by incurable Manet-mania (*Monomanétie*), watch the passing train through the bars of their padded cell." In *L'Illustration* on May 23 Bertall alluded, not very kindly, to Manet's new-found patron: "The *Railway,* or the departure of Faure for England, which explains the woebegone expression of the figures. This is no happier for Manet." On May 15 in *Charivari* Cham, whose infantile drawing suggested the opin-

4. According to A. Proust, "impression" in the modern sense was used in Manet's circle as early as 1868. See L. Dimier, "Sur l'époque véritable du mot d'impressionisme," *Bulletin de la Société de l'Histoire de l'Art Français* (1927), pp. 40–1.

ion generally held of the painter's technique, had called it: "The lady with the trained seal. These unfortunate creatures, finding themselves painted in this fashion, wanted to flee! But the artist, foreseeing this, put up a grating which cut off all retreat."

In the *Revue des deux mondes* Duvergier de Hauranne returned to the attack with an account which was typical of the conservative reaction:

> Is Manet's *Railway* a double portrait or a subject picture? . . . We lack information to solve this problem; we hesitate all the more concerning the young girl which at least might be a portrait seen from the rear. Manet has introduced so many innovations that nothing he does should astonish us. It is apparent that in spite of his revolutionary intentions Manet is an essentially bourgeois painter. We might even say that he is the most profoundly bourgeois of all the contemporary painters who have succeeded in stirring up a little excitement on their own account. Doubtless he belongs to a school which, failing to recognize beauty and unable to feel it, has made a new ideal of triviality and platitude. But his is the painting of shop-fronts and at the most his art attains to the heights of painters of tavern signs.

On the credit side Manet could look to Castagnary who came to him in the *Siècle* on June 19, after a detailed discussion of the usual Salon contributions of the academic painters, with the words:

> Finally, since I am listing the paintings and so that nothing should be forgotten, there is Manet's *Railway,* so powerful in its light, so distinguished in color, and a lost profile so gracefully indicated, a dress of blue cloth so broadly modeled that I ignore the unfinished state of the face and hands.

The water color of *Punchinello* (Paris, Collection Brodin), for which the painter Edmond André posed, was consistently ignored in the midst of the uproar over the *Railway*. It was an unobjectionable study of the comic character who had appeared at the extreme left of the *Masquerade at the Opera,* now reworked in a pose very close to that of Watteau's little posturing figure, *L'Indifférent*

(Paris, Musée du Louvre). Manet must have had an unusual affection for this unassuming little work. He developed it again on a larger scale in oil, and two years later in a colored lithograph.[5] Before publishing the print Manet proposed a competition among the poets who were his friends for a suitable verse to accompany the painting. When the competition produced nothing which satisfied him, he approached Théodore de Banville who sent him this graceful couplet:

> Féroce et rose, avec du feu dans la prunelle,
> Effronté, saoul, divin, c'est lui, Polichinelle.

By now it was easier to call the turn on those who blamed Manet for his choice of subject. Armand Silvestre, who earlier had so skillfully distinguished the varying personalities of the Impressionists, exposed the misunderstanding very neatly. On June 19, in *L'Opinion nationale,* he pointed out in his discussion of the *Railway* that

> It is not Manet's ability as a painter which is disputed, but the selection [of subject matter] of his paintings, which continues to be severely censured. On that score, certainly, there has been a misunderstanding between artists and public too long drawn out. If Manet had entitled his painting *Clytemnestra and the Young Iphigenia,* as Bonnat has designated as *Christ* his commonplace figure of a tortured criminal, I should understand how one might disapprove of the style of the work and even that one could grow indignant. But what is the problem? What has the painter wanted to do? To give us a truthful impression of a familiar scene . . . A work so conceived must have only two qualities: truth, and beauty of color. Well then, it is hard to imagine anything more truthful than this painting, and one would have to have a sensitivity very little developed not to admire certain passages of truly marvelous color, such as the

5. See also Guérin, No. 79, for the history of the print. The police mistook it for a caricature of Marshal MacMahon and seized the first set of proofs. De Banville's verse was a handsome return for the portrait etching which Manet had intended to offer the poet in 1874 as an illustration for the latter's *Ballades*. It remained unpublished after two states had been executed (Guérin, Nos. 60–1).

child's neck and shoulders, which are of a milky, amber-like color unusually enjoyable.

On the whole, the critical harvest this year would have been lean, had not a new voice spoken in behalf of Manet and of a more liberal attitude toward modern painting in general. On April 12, even before the Salon opened, a little known schoolteacher and poet, Stéphane Mallarmé, published a lengthy article in *La Renaissance littéraire et artistique,* a journal which energetically supported modern artistic tendencies during the four years it existed. Mallarmé, who had arrived in Paris from the provinces only two years before, could not further the painter's cause to any appreciable extent. As a poet he was still unknown to the general public; not for ten years would his reputation be increased, and then still within a very restricted limit, by the praise of Joris Huysmans and Paul Verlaine. His importance at this point in Manet's career lies rather in the fact that through their relationship Huysmans probably came to admire Manet's work and later to publish his own opinions.

The primary object of Mallarmé's article, "The Painting Jury for 1874 and Manet," was to accuse the members of the jury of having broken faith with the public by prohibiting it from seeing the artist's work and so from making up its own mind about Manet's achievement. In addition, by accepting only part of his work, the jury presumed to pass judgment on the absolute value of Manet's performance, but the public still had no way of estimating the validity of the jury's decision. Logically, therefore, the jury should have accepted all or none. Mallarmé thus revived the issue which had precipitated the Salon des Refusés eleven years before.

Since this argument is now familiar, Mallarmé's article is perhaps more interesting today for his description of the rejected works, in itself proof of his familiarity with the painter's studio, and for his discussion of the possibility of the public's coming to terms with the apparent crudities of Manet's technique. Herein he was both less contemptuous of the public and more optimistic for the future than Zola had been in 1867. After suggesting that Manet's extraordinary ability to simplify the visual process was the principal cause for the jury's distrust, Mallarmé turned to the rejected works:

Three paintings were presented by the undaunted intruder: *Masquerade at the Opera, Swallows,* and *The Railway.* Of the three, *Masquerade,* which is paramount in the painter's work, marking the culmination of many an earlier attempt, was certainly the work which stood the least chance of receiving unanimous approval; the second, *Swallows,* although in the eyes of an amateur it is very remarkable and possesses a serene charm, could have been considered less significant. The idea was to reject both as a pair: so it would seem that all the harsh indictments were not reserved for the outstanding work alone, but that the quieter product was handled with equal severity! . . . As the most profound wisdom does not foresee everything and as its plans are always deficient in some respect, so the third picture remained, itself deceptively important and rich in suggestions for those who like to look at painting.

I think that this canvas, which escaped the wiles and schemes of the Salon organizers, has still another surprise for them, when what may be said about it will have been said by those who are interested in certain problems, particularly of pure craftsmanship.

This report will be settled right here at the Salon: as for the two rejected works, which tomorrow will return to those galleries where their place awaits them, they must be discussed, not with the jury who, if need be, would tell me what I must appreciate, but with the public who lack any foundation for their convictions.

To indicate what the basis for such convictions might be, Mallarmé then examined *Masquerade* and *Swallows* in some detail. Once again it was a poet, rather than a professional critic, who understood the essential character of this art as well as the intentions of the artist. Mallarmé concluded his analysis of the *Masquerade* in terms which virtually paraphrase Baudelaire's demand in 1845 for painting which should express the heroism of modern life. And he added his own opinions on the vexed subject of Manet's lack of "finish":

To represent part of a ball at the opera: what were the dangers to avoid in such an audacious undertaking? The jarring din

of costumes which aren't real clothes, and the bewildered gestures which are of no time or place and which offer no authentically human poses to plastic art. Thus, in this painting, the masks merely serve to break the potential monotony of a background of black garments by a few fresh flowery tones; and they recede sufficiently to give the impression, in this solemn group of foyer-strollers, of a rendezvous apt for showing the appeal of a modern crowd, which could not be painted without the few gay notes to brighten it. The aesthetic is beyond reproach, and as for the execution of this piece which the demands of the uniform contemporary costume made so very difficult, I believe one can only marvel at the exquisite nuances in the blacks: in the dress coats and dominoes, in the hats and masks, in the velvet, the broadcloth, the satin and silks. The eye is hardly aware of the need for the bright notes injected by the fancy dress: it only distinguishes them after having been first attracted and held by the outstanding charm of the solemn and harmonious color of a group composed almost exclusively of men. There is therefore nothing disorderly or scandalous about the painting, which seems to want to step out of its frame: it is, on the contrary, the heroic attempt to capture, through the means peculiar to this art, a complete vision of contemporary life.

As for the *Swallows,* I will grant the most superficial critics a single objection in order to refute it later on.

Two women are seated on the grass of a dune in northern France, which stretches back to a village on the horizon behind which one can feel the sea, so vast is the atmosphere surrounding the two figures. From afar off come the swallows which give the painting its title. One is first aware of the feeling of open air; and these women, lost in daydreams or contemplation, are really only accessories to the composition, as it is fitting that the painter's eye, arrested only by the harmony of their grey dresses and a September afternoon, should see them in so vast a space.

I have pointed out one reservation, made from the academic point of view for those who would not pay any attention to the few preceding remarks: it is that, if you wish, his paintings in

the colloquial phrase are not "finished" enough. It seems to
me that for some time the existence of this joke has been called
in question by those who first uttered it. What is an "unfin-
ished" work, if all its elements are in accord, and if it possesses
a charm which could easily be broken by an additional touch?
Besides I could, if I wished to be explicit, point out that this
criterion, applied to the merit of a painting without previous
study of the quantity of the impression given, should logically
be used to judge the too finished as well as the slovenly work
of art; whereas, through a peculiar inconsistency, one never
sees the judges deal severely with a canvas which is both in-
significant and frighteningly detailed.

In conclusion Mallarmé reiterated his contention that the jury
had no right to prevent the public from seeing Manet's work, and
he hinted that the time would come when a more artistically sensi-
tive public would insist on seeing for itself works of really "modern"
art.

The public, deprived of its right of admiration or ridicule,
now knows everything: all that remains is to formulate, in
its name, a question of general interest which this incident
raises.

The question which must be settled once more, and with
the usual futility, is contained entirely in these words: in the
judgment passed both by the jury and the public on this year's
painting, what is the task which falls on the jury and what is
that reserved for the people?

From the mere fact of grouping together the outstanding
talents of an era, wherein each of necessity possesses a unique
originality, comes the result that the comparisons between
them must be made not on the grounds of originality, but of
the exact and even abstract talent contained in the work to be
judged. All artists have a quite unbiased feeling, vague at times
in the solitude of work, but accentuated when in contact with
others, about the value which is universally discernible in any
art: it is a precious element, and the only contribution de-
manded of them in the present situation. It is up to the public,

which pays in glory and in cash, to decide whether the spirit in which a work of art, be it ancient or modern, has been conceived, and its rich or rarified character, in brief, everything which affects the feelings of the people or of the individual, is worth its criticism. It is the master up to this point, and can demand to see *all there is*. Entrusted by the nebulous vote of the painters with the responsibility of choosing, from among the framed pictures offered, those that are really paintings in order to show them to us, the jury can only say: this is a painting, or that is not a painting. None must be hidden; as soon as certain tendencies, which have until then lain dormant in the public, find their artistic expression or their beauty through the work of a painter, they must make each other's acquaintance; and not to introduce one to the other is to turn a blunder into a lie and an injustice. . . .

When the time comes when the public's patience, already tried, will be utterly exhausted, what will be done without the attraction—wisely provided for—of art designed to please those who seek the new? The public, from whom, as universal source, nothing is hidden, will find itself again in this hoard of living work: and this time its break with the past will be complete. It is sorry politics indeed to cheat Manet of a few years' success!

This new master, who annually shows his developing talent in a spirit of lofty thought and misunderstood wisdom and who therefore becomes more and more blamed and disliked by the exponents of traditional painting, this master had the right to wait until the implications of his conduct were finally understood by a sensitive jury preoccupied with nothing other than talent.

This analysis, so discriminating and just, so informed with the artist's intention, so aware of the public's right to judge original art on its own merits, must mean that Mallarmé and Manet were by this time more than mere acquaintances. The poet must have become the familiar of the studio to have penetrated so quickly and so surely Manet's apparent indifference to public opinion. If the

language of the review was Mallarmé's, the point of view was Manet's. One senses the condition approaching despair of the painter, certain of his talents but still prohibited by malice and stupidity from reaching the public which might, if uninstructed by opposing counsel, render a different verdict. What is certain is that their relationship soon developed into an enduring friendship; upon Manet's death Mallarmé declared that he had seen the painter "almost every day for ten years." And it led to an interesting artistic collaboration. The next year Manet supplied five wash drawings, which were reproduced lithographically, for Mallarmé's translation of Poe's "Raven," and in 1876 four drawings for wood engravings illustrating Mallarmé's "L'Après-midi d'un faune." [6] From the latter year the *Portrait of Mallarmé* (Paris, Musée du Louvre) shows the poet casually lounging in the studio, his right hand, holding a cigar, resting on the pages of an open book. Much smaller, brighter, and less formal than the *Portrait of Zola*, it is still another witness to the discernment of a distinguished man of letters, aware of the truly pictorial quality of Manet's most unliterary art.

Mallarmé paid two further tributes to Manet. An article entitled "The Impressionists and Edouard Manet" was published in translation in the English *Art Monthly Review and Photographic Folio* on September 30, 1876.[7] Therein the poet summarized in general terms the development of the Impressionist aesthetic and remarked on the critical acumen of Baudelaire and Zola in distinguishing so early Manet from his academic contemporaries. The original French manuscript has never been discovered, and the article itself had no influence on the criticism of Manet's work in France. In the last book published during his lifetime, *Divagations* (1897), Mallarmé included among his "Médaillons et Portraits" the two paragraphs on Manet quoted here on page 8 in the original French. For the concise yet allusive imagery with which Mallarmé

6. For these illustrations see Guérin, Nos. 84–6, 93. For a brief consideration of Manet's drawings in relation to the poetic and musical contents of Mallarmé's poem and its interpretation see Thomas Munro, "The *Afternoon of a Faun* and the Interrelation of the Arts," *Journal of Aesthetics and Art Criticism, 10* (1951), 95–111.

7. See S. Mallarmé, *Oeuvres complètes* (Paris, Bibliothèque de la Pléiade, 1945), pp. 1616-7.

evoked Manet's personality and the interaction of his eye and hand upon his art no English translation is possible.

1 8 7 5

MANET forced the jury's hand by sending only one canvas, *Argenteuil* (Fig. 26), to the Salon of 1875. It is tempting to think that his action might have been prompted by a suggestion from Mallarmé, since the latter in his article had criticized the jury for discriminating among a number of paintings. In any case, the members of the jury were obliged either to accept or to reject Manet's single offering, and in accepting it they were possibly influenced by a desire to avoid further public complaints since there was little in the new work which could have pleased them. Castagnary even hinted that they had at first rejected the painting and had only accepted it after a second consideration.

In subject and technique this depiction of a man and woman seated in a boat by the banks of the Seine at Argenteuil was more radical than the *Railway* of 1874. Although Manet had declined to join his friends in their independent group exhibition, his sympathy and support for their point of view were explicit in *Argenteuil*. It was transparently "Impressionist." The choice of subject requiring an analytical study of light, the vibrant palette, and the casual composition were all elements bearing a close relation to Monet's and Renoir's pictures of summer pastimes along the Seine.

Popular reaction to the new painting could have been no surprise to anyone who had observed the excitement over the Impressionist exhibition the year before. Manet's adherence to the new cause transferred to him the ridicule and misapprehension which had greeted the Impressionists. To critics and public the painting, like any truly Impressionist work at this time, appeared completely incomprehensible. Their condemnation of Manet's technique is perhaps understandable; we are already familiar with popular distaste for radical innovations in color and brushwork. But the violent antipathy expressed toward the subject seems less reasonable, until we recall that Manet's scrupulously objective treatment left the

average spectator at loose ends in front of even so simple a subject. Had the boating theme been treated as an excuse for an amusing reflection on summer pleasures and the lights of love it would have been closer to their hearts as well as to their previous experience.

The difficulty of accepting the commonplace character of the subject was soon taken up by the caricaturists. On May 22 in the *Journal amusant* Stop added to his ragged drawing the following dialogue:

> "Good Lord! What's that?"
> "That's Manet and Manette."
> "What are they doing?"
> "I think they're in a boat."
> "But that blue wall?"
> "That's the Seine."
> "Are you sure?"
> "Well, someone told me so."

In the same publication Pierre Veron on May 8 expressed his opinion:

> Will Manet then never settle down? When a baby climbs on the table and breaks the plates it seems very amusing. But to play the same game at the age of forty-five! If he wished, Manet would have enough talent to make a name for himself, without always having to stick his feet in the food.

This year Cham was indefatigable, devoting no less than three cartoons to Manet in *Charivari,* and an additional one published later in book form. The persistence of his cartoons is proof enough that for all its unpopularity the painting compelled attention. On May 9 the first appeared, a fairly accurate representation of the composition, but with the faces and background drawn in childish fashion (Fig. 9b). The legend was a bit less than delicate: "N.B. Since Manet seems subject to a painterly indisposition in the spring, he ought to take a good purgative about this time of year." On June 6 a second cartoon appeared showing the now famous couple standing on their heads on top of the water: "Manet's lady and gentleman canoers are cracking their skulls on their wooden river

after learning that the painting will not win the medal of honor."
The third of the series, on June 20, showed the couple stepping out
of their frame on the day of the closing of the Salon with the ex-
planation: "Manet's two canoers aren't sorry to leave, since people
have been laughing in their faces for almost two months." The
fourth bore the more subtle title: "Canoers just after running
aground in the Salon. (Painting has its Wagner also?)"

Bertall's cartoon in *L'Illustration* on May 29 carried a caption
explicitly referring to the outrageous colors and simplified draw-
ing:

> From the bottom of our heart we thank Manet for having
> injected a note of gaiety into this somewhat solemn Salon.
> There is nothing more amusing than these canoers, both in
> grey, suddenly set off against the pale blue which, traditionally,
> flows at Argenteuil. The background is to be admired, exe-
> cuted by the son of the house, aged four, who has a taste for
> landscape.

On the testimony of the caricatures, Manet was condemned in
the popular mind for offenses against color and draftsmanship. The
more literate criticisms were merely more specific. Jean Rousseau,
a young Belgian satirist who had joined the staff of *Figaro* as art
critic, complained on May 2 that [8]

> The heads and costumes have a certain liveliness. That is all.
> Behind the figures there is an indigo river, hard as iron and
> straight as a wall. In the background a view, or rather a stew,
> of Argenteuil; not a line, not a plane, not a shape carried out.
> The master has reached the stage of a twenty-year-old student.

For Mario Proth, who included an account of Manet this year
in a review of the Salon published as *Voyage au pays des peintres,*
the painting merely raised once more a tiresome issue:

8. Jean Rousseau (1829–91), Belgian painter and critic. He lived for ten years in
Paris, 1854–64, where he contributed to *Figaro*. Upon his return to Belgium he be-
came a prominent art historian and administrator of fine arts. See René Janssens,
Les Maîtres de la critique d'art (Brussels, 1935), pp. 92–3.

The problem of Manet persists. For it cannot be kept secret that each year there is a Manet question, just as there is an eastern question or an Alsace-Lorraine question. It undeniably testifies to the partiality of the French people in general and of the Parisians in particular for that dubious kind of entertainment called "nuisance value." Each year, during the deliberations of the jury, one could find in Paris at least three groups and one and one-half coteries anxious to learn whether Manet will be accepted or rejected. Each year he would be rejected if he were not accepted. He begins one way and invariably finishes another . . . Each year, with the permission of the authorities and without endangering the public safety or the European balance of power, still so unstable, he creates his same little disturbance, firing his same little revolver in the same corner of the same gallery of the same exhibition.

But one year, forever memorable in the Salon, there was a variation. The *Bon Bock* was accepted straight off. The public, kind enough on the whole and always ready to discover serious qualities, thought it saw the beginning of wisdom or of sincerity in a clever painter. It waited and hoped. Was that a premeditated step on Manet's part to "turn the trick?" . . . If the wishes we expressed last week were granted, that is to say if free exhibitions with a jury elected by universal suffrage were permitted, either the Manet problem would quickly disappear or I am much mistaken. If Manet were always accepted, he would never be refused. His canoers would peaceably float down their indigo river catching, I fear, only very small fry, and Manet's annual little revolver shots would from now on make no more noise than an ordinary Salon explosion.

A more deliberate analysis of the artist's shortcomings was reached in *L'Illustration* on May 29 by Francion:

We would rather not have mentioned Manet. But the attacks of those who refuse to grant him any kind of merit, no less than the exaggerated praise of others who wish to make him the leader of the movement, force us to put in his rightful place an artist who, moreover, amuses even more than he excites the

public. It is undeniable that his canoers, seated beside each other, are realistic in tone and attitude, if one stands off to look at them. But a painting of this kind should also be seen from a distance of one or two feet, else it is merely a sketch, a shapeless rough draft, and has no business being in a public exhibition. Therein lies Manet's whole secret. He begins and does not finish; as soon as his paintings have reached a certain point, he leaves them incomplete. Neither drawing nor modeling count for him. It is obvious that in such imperfect works there could not be many serious mistakes; they avoid them through their imperfectness. It becomes easy for enthusiastic friends and ignorant admirers to praise in Manet a certain accuracy of tone which, even so, one must not exaggerate. In reality it is only a very clever resolution not to venture into the realm of painting. Truly Manet makes fun of the public and of the jury by sending them barely outlined sketches, and one must wait until he exhibits a painting in order to discuss him as an artist.

But this was not to be a wholly unfavorable year for Manet. Castagnary on May 29 in the *Siècle* offered a truly judicious account of the painting, the more surprising since he had usually been inclined to dismiss the painter with some remark to the effect that his drawing was still disappointing. Although he could not banish his regret that Manet's work still appeared unfinished, his lengthy review is important since it represents his allegiance at last to Manet's cause. In this respect Castagnary, so long before this the supporter of Courbet and the realists, now came forward to carry on the work begun by Thoré-Bürger, and at the same time published one of the earliest coherent definitions of the relation between Impressionist vision and technique. His opening sentences left no doubt of his sincere and generous acceptance of Manet as an important painter:

> And Manet, because finally I have come to him, has he not deserved medals all the time he has been exhibiting? He is the head of a school and exerts an indisputable influence on a certain group of artists. For this reason alone his place is

marked in the history of contemporary art. When the time comes to write about the evolutions or deviations of nineteenth-century French painting, one can forget Cabanel but one must reckon with Manet. Such a situation should have impressed the jury. If one adds that Manet is an absolutely conscientious artist, that he bases his canvases on nature, that he spares neither time nor effort to make them good, that he only puts them aside when he thinks he has reached the goal that he set for himself, the jury's attitude toward Manet is even more unseemly. "The public laughs in front of Manet's canvases," replies the jury to those who reproach it for having first refused the painting of *Argenteuil,* and for having taken it back only after the revision. I do not know how competent they are who laugh, but I am convinced that, when the public will have understood the goal toward which Manet is striving and the efforts he is making to reach it, it will take his side. The sight of an intelligent man who wants to advance painting a step and who devotes to this cause all the strength which nature has granted him, is not laughable. The public well knows it, and it has never begrudged its interests to one who works with sincerity.

What Manet paints is contemporary life. I suppose there is nothing to be said against that; the canoers of Argenteuil are well worth *Thamar and Absalom* (by Cabanel); in any case, they interest us more. What Manet wanted more particularly, in choosing the *Canoers of Argenteuil* as a subject, was to portray the open air, as it is called in the profession. Open air is difficult. Only he who has renounced sauces and artificial coloring, whose healthy and accurate eye does not distort light rays, can appreciate its allure, can relish its subtleties and delicacies and hope to transfer it to canvas. In every case, each attempt at this is a step away from convention toward greater truth, naturalism, and life. The open air has only one danger and I am coming to that. But, in the meantime, look at the *Canoers of Argenteuil.* Is it the color of our atmosphere, yes or no? Is it the light of the suburbs of Paris, yes or no? Are

the figures enveloped by the surrounding air, yes or no? And how supple are the materials, soft and smooth to the sight! The woman's dress is remarkable! The bouquet of grass and flowers which she holds in her lap is astounding.

Even his hesitant suggestion that Manet pay more attention to the drawing and modeling of his figures was not irrelevant. It anticipated the stricter draftsmanship which Renoir adopted after 1883 and which Degas never renounced.

If we stopped there all would be well except, of course, for the water which is too intensely blue and which I leave to whoever wants to defend it. But I said that there was a danger in the search for the open air. This is it. The open air obliterates details, abbreviates and simplifies form. That is why, in Manet's painting, the hands and face are insufficiently modeled. Manet paints as he sees, he reproduces the sensation his eye communicates to him; from the point of view of sincerity he is above reproach. But it is nevertheless true that, since our imagination is accustomed to complete the information our eye gives us when we know it is insufficient or to correct it when we know it is wrong, we cannot be satisfied with Manet's summary sensations. Our mind goes further than his eye; it imperiously demands that life-sized figures, which are placed in the foreground and which we must see first, have the most detailed faces, the most modeled hands.

I think therefore—and here I very humbly offer this point of view to the practitioners—I think it would be an advantage to take the best qualities of the open air and to put aside the imperfect ones. Let us keep for the landscape, for inanimate objects, clear light with its charming transitions; as for the figures, let us have the courage to draw them more carefully, to model them to the degree which the laws of our reason and the satisfaction of our own eyes demand.

Let Manet think this over. This is the cause of the disagreement which exists between one section of the public and himself. And indeed, one can dissipate this cause without doing

any harm to the open air, without compromising the progress made in pure light. Why not try it, if the public's assent can be had at this price?

Two weeks earlier Ernest Chesneau had made amends for his earlier attacks on Manet by issuing a more direct appeal to the public to overcome its habit of ridiculing Manet and to consider his work on its merits. On May 14 in *Paris-Journal* he wrote:

> This is the real truth about Manet. You were disgusted with Corot for forty years, weren't you? And now you praise him to the skies. Well, well! Corot is the father of Manet. If you ridicule Manet, then ridicule Corot. If you like the one you should understand the other. The reason why you laugh or are astonished in front of Manet's work is only an old habit acquired a dozen years ago. You look at nature, but you don't see it. If you saw it, if you knew how to look at it, you would indeed be obliged to acknowledge the victory or at least the foretaste of victory which the art of Manet has achieved.

1 8 7 6

THE COMMOTION over *Argenteuil* with the attendant references to the Impressionists told heavily against Manet the following year. As if aware that the opposition was in no way mollified he returned to his practice of submitting to the Salon two canvases in contrasting manners. The *Artist* (Fig. 28), a full-length portrait of the etcher Marcellin Desboutin who was exhibiting this year with the Impressionists, was a studio painting, dark in tone and in style close to such earlier full-length figures as the mendicants he had painted upon his return from Spain, his eyes still filled with Velasquez. Behind the figure the white dog drinking from a glass conferred that note of commonplace reality which was so suspect at the Salon. The modeling of the dog's body in broad patches of light and shade, although expressive of the movement of a form in space, lacked the prerequisite academic "finish."

In the *Laundress* (Fig. 27), on the other hand, there was no compromise with the new manner. Castagnary's suggestion had

been ignored. A familiar subject from everyday life was treated with full regard for the brighter palette, the suppression of detail, the casual composition, and the shortened focal distance which had previously appeared in *Argenteuil*. Of all Manet's paintings of this decade the *Laundress* had the most complete unity, in Impressionist terms, of subject, expression, and technique. The somewhat static postures of the *Railway* and *Argenteuil* had disappeared in favor of the informal but subtly integrated action of the two figures, of the woman easily wringing out the wash and the child steadying itself by clinging to the tub. And even of Manet's work to come, this more than any other was informed with a deeply winning sense of human charm, of the fragrance created when a lovely woman and a plump baby are discovered together on a fine day. But the jury was not convinced, and both paintings were rejected. The refusal quickly became known to the public. On April 5 two newspapers, the *Gaulois* and *La France,* reported that the jury's decision had been unanimous. The following day a more circumstantial account was published in the *Bien public:*

> It is true, entirely true, that Manet has almost unanimously been rejected. His two paintings, the *Laundress* and a portrait, have been blackballed without a word of protest. Here is what we learned this morning: when the jury came to examine Manet's paintings, one of the members exclaimed, "Enough of this. We have allowed Manet ten years to turn over a new leaf. He hasn't done so; on the contrary he grows worse. Reject him!" "Let's reject him. Let him stay by himself with his two paintings," cried the other jurors. Only two painters tried to defend the author of the *Bon Bock.* When they opened their mouths, they were interrupted. Manet was unanimously rejected, except for two votes.

But this time Manet refused to accept such a verdict without protest. As in 1867 he decided to offer his work to the public on his own terms in order that it might judge for itself, as Mallarmé had suggested, the wisdom of the jury's decision. He issued printed invitations to his friends and acquaintances to come "to see his paintings rejected by the jury of 1876," which would be on view

in his studio from April 15 to May 1, that is to say, for the two weeks before the opening of the official Salon.

Exhibited this way, with a brace of police standing guard at the door, the paintings probably attracted more attention than would have been the case had they been accepted and hung in the Salon. The studio was crowded each day and the visitors' book was soon filled with signatures and comments, sometimes friendly, but often abusive, and more extraordinary in that they must have been written in the painter's presence. Such remarks as this reference to the *Laundress* were frequent: "Manet is right: dirty linen should always be washed at home." While there were the usual objections and disparaging criticisms in the newspapers, the press on the whole was inclined to deal favorably with a painter who so clearly had the courage of his convictions and whose work, for all that might be said against it, would at least be a bright spot missing from the increasingly dreary Salons. Some expressed their respect for the man and their disappointment in his work, with the perennial objection that he failed to carry his work to completion. In the *Petite Presse* on April 17 Albert Wolff, who had just described the Impressionists, concurrently holding their second exhibition, as "five or six lunatics afflicted with insane ambition," offered Manet the benefit of his opinion:

> In his work rejected this year there are the same qualities as in the paintings which were accepted at other times. But the faults are more notable. Manet is a curious personality. As a painter he has an eye but no soul. The fairy godmother who presided at his birth gave him the primary qualities an artist must have . . . But soon the bad fairy came on the scene and said: "Child, you will never go further. Through my power I steal from you the qualities which in the end make an artist." For us who like Manet very much the sight of the *Laundress* has been a sad occasion.

In the *Soleil* on April 20 Emile Porcheron wrote:

> Through sheer incompetence Manet doesn't finish what he begins, and he must credit the spectator with a generous dose

of good will to add mentally what is lacking in his painting. Let us begin by saying that, bad as the two pictures rejected by the vote of the jury may be, the judges who have already accepted so many of Manet's contributions ought to have admitted him even this year for the sake of consistency. We see hanging on the studio wall that famous *Olympia* which made a whole generation burst out laughing. Well indeed! Between that picture and the present works, it must be admitted that the painter has made some progress which the jury should recognize to a certain extent. It would have been more reasonable, all the same, to refuse Manet's productions from the beginning; in this way he would have been spared the annoyance of taking the wrong tack, and he would have been able to devote himself to an entirely different activity from painting, for which he was perhaps not born. When, after fifteen years of work, a man arrives at the present wretched result, it must be admitted that it hardly seems to have been worth his while.

But all the criticism was not so contemptuous. The anonymous critic of the *Courrier de France* wrote on April 16:

In our opinion these pictures are neither better nor worse than Manet's previous work. They leave in the minds of those who see them the same doubts, the same hesitations as the *Bon Bock* and the *Canoers on the Seine (Argenteuil)*. Is Manet an excellent painter, who is at the same time a spirited fellow and a joker amusing himself at the public's expense, or is he indeed an ignorant painter, of false vision who, at times, produces a fine piece of brushwork? . . . This problem is always present in criticism, and the two pictures which he offers the public are not of a sort to permit its solution. There are parts here worthy of a great painter, and others which would embarrass a beginner.

Bertall mocked the academic attitude in *Paris-Journal* on April 30. He described an imaginary visit to Manet's studio by one of the members of the jury "whose real talent you and I and every-

body else recognize." The gentleman explained Manet's rejection in this fashion:

> In our opinion, the point has been proved. Until he is ninety, Manet will continue to offer the same expectations. What he doesn't know by now, he will never know . . . Can you conceive our French school, one of the unassailable glories of our country, as they say, represented in ten years by a series of paintings like the *Laundress,* the *Canoers,* the *Luncheon,* the portrait of Desboutin, etc., etc.? First of all look at the portrait of Desboutin, since Desboutin is here. This portrait is black from top to bottom, it is the portrait of a miner. Let us go on to the *Laundress.* Nothing is described, nothing is finished. The child is a baby doll without form or drawing. The mother is dressed in an absurd fashion. Her gestures don't lack accuracy, but everything is painted with a messy broken touch, without precision and without effect . . . The whole, however, does not lack a certain impression of freshness, and if Baudry, for example, spent a good day's work on the canvas, something satisfactory would emerge. In short, Manet strikes me as a wealthy amateur who has always had considerable inclinations for painting, and who has never had enough time to take advantage of them.

In addition to these somewhat repetitious and inconsequential jibes, there were other and weightier opinions. Armand Silvestre, who had expressed his admiration for Manet in 1872 and 1874, published his remarks on April 23 in *L'Opinion:*

> Have these canvases been rejected out of respect for tradition? Tradition would amount to very little if it could be threatened by an individual attempt, and it is apparent that an artist always has the right to substitute his personal vision for the lessons even of the masters. Is it because his technique has appeared inadequate? Manet has, in everyone's opinion, painted pieces of incontestable mastery, and one of his two paintings this year, the *Portrait,* contains one of them, the large greyhound drinking, which Velasquez would not have

disowned. Or, finally, has it been decided that the public is not interested in these experiments? The crowd at Manet's private exhibition certainly proves the contrary. It is then incontestably a matter of taste, and Manet pays the penalty for all the excitement stirred up by the little group of intransigents of which he is considered the leader.

Even in the Salon his absence made him all the more conspicuous. Castagnary felt obliged to comment upon it in his review:

Indeed, no! It is not a good thing to refuse Manet. You will not change him. He knows what he wants, he knows that he is an original and powerful artist. His manner doesn't suit you? That may be, but it's his and he sticks to it. Furthermore, Manet is one of those painters one doesn't refuse. For twenty years he has been working sincerely and courageously under the eyes of Paris. He occupies in contemporary art a position quite different from Bouguereau, for example, whom I see among the members of the jury. He has painted pictures which will certainly last longer than Gérôme's *Mohammedan Priest at the Door of a Mosque,* who is not on the jury and deserves to be. His portrait this year, this portrait of Desboutin which you refused, would have been one of the strongest canvases of the Salon. But the success of the *Bon Bock* frightened you; you didn't want it repeated on a larger scale. What folly! The public, who only trusts you halfway, has run to the painter's studio, and these eager visitors have amply compensated for your brutal rejection.

The most accurate estimate of Manet's position appeared, as had happened earlier in 1867 with Duret's criticism, in an obscure quarter and from a direction little calculated to allay academic hostility. This was the year of the second Impressionist exhibition held in the galleries of Durand-Ruel, which coincided with Manet's open house. In general the critics and public were as hostile as ever to the group, with a single exception. Edmond Duranty, the friend of the Impressionists who had participated in their discussions for a number of years, issued a small pamphlet entitled *La Nouvelle*

Peinture. Although Manet had not exhibited with the group, his relations with the Impressionists were well known to Duranty, and the inclusion of Manet in this discussion was all the more appropriate since it was known that Durand-Ruel had only four years before purchased a considerable number of his paintings. Without mentioning the artist by name Duranty thus described his position in the Impressionist movement:

> Finally one other has repeated the most daring statements, has endured the most desperate struggle, has opened not only a light but great windows to the open air and true sunlight, has assumed the leadership of the movement, and has many times given to the public with the candor and courage which are proper to a man of genius, the most original works, tainted with faults but endowed with the best qualities, works full of amplitude and accent, standing out against all others, and wherein the strongest expression necessarily collides with the hesitations of a sentiment which, almost entirely new, has not yet discovered all the means of assuming form and realization.

1 8 7 7

ONE MIGHT have supposed that after the humiliating rejection of his work in 1876 Manet would have abandoned all hope of a Salon success. But as before, he declined to associate himself with the Impressionists, who held their third exhibition in April, and again offered two paintings to the jury. The critics thought he had broken with the Impressionists, but it is clear from a letter written this spring to Albert Wolff that Manet had no such intention. He recommended to Wolff's attention the work of "my friends Monet, Sisley, Renoir, and Berthe Morisot," and sagely added: "Perhaps you won't yet like this kind of painting, but you will come to like it. While waiting for that, it would be very kind of you to mention it in *Figaro*." He concluded the letter by inviting Wolff to visit his studio to see the still unfinished portrait of Faure which was intended for the Salon (Fig. 29).

The celebrated baritone, for several years one of Manet's principal patrons, had proposed the commission at the time of the

private exhibition, as a generous proof of his confidence in Manet's talent as a portrait painter. And he had also suggested the pose, as Hamlet in Ambroise Thomas' opera, the part in which he had enjoyed his greatest success from 1868 when he created the role until his retirement this same year. After trying out the theme of *Hamlet and the Ghost* Manet established his final version in which the singer, sword in hand, his left arm outflung, advances toward the footlights at the climax of an aria. A preliminary study (Hamburg, Kunsthalle) shows Manet's intention of placing the figure on the stage in the midst of a performance. Bits of scenery, omitted in the final painting, appear to the left and behind the singer. Before the portrait was finished Faure and Manet had a difference of opinion. The singer, returning from an out-of-town engagement, was disturbed to find the legs no longer his own, and his feelings were not soothed when Manet explained that in his absence they had been painted from a model who had better-looking ones. Faure refused to accept the portrait, but allowed Manet to submit it to the Salon. And he did not let the disagreement disturb their friendship.

With the portrait Manet sent a painting, soon after known as *Nana* (Fig. 32), depicting the corner of a boudoir where a young woman is seen completing her toilet in the presence of a man in evening clothes, half of whose figure appears in the right background.[9] The woman has momentarily paused to look directly out of the painting at the spectator, who may be considered a third, invisible participant in the scene. The subject proved too much for the jury. The painting, after having been tentatively accepted and perhaps hung, was removed from exhibition just before the Salon opened. For the history of Manet's iconography *Nana* is of more than passing interest. Here essentially were the characters and a situation not entirely unlike those of the *Déjeuner sur l'herbe*. The young woman may even be taken for Olympia risen from her couch

9. Tabarant, p. 299, identifies the woman as a professional model, Henriette Hauser, famous at the end of the Empire as "Citron," a *demoiselle de galanterie* and mistress of the Prince of Orange. The relation of the subject and title of the painting to Zola's novel is obscure, but the identification of Manet's figure with the Nana of *L'Assommoir*, serialized from July 1876 to January 1877, was first mentioned by Huysmans on May 13, 1877 in an article in *L'Artiste* of Brussels.

to dress for the evening's amusements. But a theme of the contemporary *vie galante* was now treated as a transient episode of modern life without the hesitations or references to the past which had compromised the more majestic predecessors. Manet's exploration of a particular way of life, even more explicit than anything Degas had painted up to this time, announced the subject matter which Toulouse-Lautrec would make his own some fifteen years later.

At the Salon, therefore, Manet was represented only by the portrait of Faure. A comparison of this painting with the portrait of Rouvière as Hamlet which had been rejected in 1866 shows how thoroughly Manet had accepted certain consequences of the Impressionist point of view. The tight modeling and restrained scale of values of the earlier work were replaced by abbreviated brushwork and stronger contrasts of light and dark. More important than these technical considerations was the use to which they had been put, the reason indeed for which they had been developed. Rouvière stood solidly and quietly, isolated in a shadowed and undefined space. Faure, on the contrary, was portrayed in the very act of singing, close to the footlights whose brilliant reflection placed the whole figure specifically in space and time.

Yet this demonstration of the most significant element in the entire Impressionist aesthetic, namely the necessity for portraying a subject as it is seen in a certain place at a given time, was generally misunderstood or unappreciated by Manet's contemporaries. Perhaps Castagnary might have clarified the terms on which the painting was to be judged, but he only remarked that "Manet's portrait of Faure has been placed too high; it would have been interesting to study closely the delicate hues and general harmony of the color."

In the *Gazette des beaux-arts* this year Edmond Duranty published his "Reflections of a Bourgeois on the Salon of Painting," but curiously, though so sensitive to the portrayal of sunlight, he misunderstood the most important aspect of the work, the quality of the artificial light within it.

> Manet's portrait of Faure as Hamlet naturally belongs to the theater, and he is very much the actor in pose, costume, and

attitude. Rather than lighting it from the footlights, the painter has chosen a somewhat artificial light and atmosphere which become a figure borrowed from the theater. A certain elegance and refinement, new to his brush, are added without weakening the pungent liveliness of execution which transcends detail to achieve the effect of the general appearance. Manet has been a bold originator, and more than one among his better-known contemporaries has profited without admitting it to himself from the unusual discoveries made by this artist in terms of the unexpected, the candid clarity, the reality of natural impressions. Thereupon, we shall leave him to the lions and tigers.

The "lions and tigers" had not hesitated to have their say. Emile Cardon wrote on May 19 in the *Soleil:*

How many nameless monstrosities must have passed before the jury for it to decide to accept the *Portrait of Faure as Hamlet* by Manet? In my opinion the number must have been appalling, for Manet has never fallen so low. He has, in recent years, exhibited some very ludicrous and very ridiculous things, the *Lady in a Park at Argenteuil* [sic] for example, but he has never presented a work so divested of any kind of quality as that which figures today at the Salon.

If I had not been assured that Faure had posed twenty-six or thirty-eight times for this portrait, I should have wagered that Manet had taken for a model one of those crudely carved puppets from a marionette theater, whose limbs are dislocated, twisted, and badly attached. Let us pass on. When criticism encounters works of this sort, it should be imperative to preserve absolute silence.

The charge that Faure looked like a marionette was repeated on June 6 by Baron Schop in the *National:* [10]

The whole painting is in a bright, very harmonious color scheme. Aside from that there is neither drawing, nor anatomy, nor truth in the posture. A lifeless and unbalanced marionette.

10. Baron Schop, pseudonym of Edmond Texier (1816–87), journalist, liberal politician, and editor in chief of *L'Illustration.*

Perhaps Faure produces this impression on the "gallery gods" at the opera through the luminous mist in the hall, but this is not the effect from the orchestra seats.

Henry Houssaye, the son of Arsène Houssaye, had little more to say in his article in the *Revue des deux mondes*, which is scarcely surprising since he thought Jules Breton's *Gleaners* the best painting in the Salon.[11]

The portrait of Faure as Hamlet, a figure flat, without proportions, without relief, without air, without life, and which is not straight on its legs, definitely demonstrates the futility of Manet's would-be temperament and the deficiency of his early studies. This ridiculous portrait concludes the long series of sensational portraits in the Salon of 1877.

A more thoughtful but no less disconcerting account was rendered in *L'Illustration* on May 26 by Jules Comte, a newcomer to the ranks of Manet's detractors but one who was to say much in the next few years.[12]

Separate mention must be made of Manet's portrait of Faure which the jury has had the weakness to accept and which the administration has placed as high as possible, not high enough however for it to be seen without standing on tiptoe. Manet believes he has finished a painting when he has discovered an almost accurate gesture. He must really be making fun of the public to dare to offer it this wooden head on which he has stuck a false beard, with an open mouth crying ridiculously and big eyes looking like two round unlit balls. Doubtless all attempts in art are worthy of respect, but on condition that they are sincere. Here sincerity itself is lacking; there is nothing, nothing, absolutely nothing more than a complete absence of talent and an unparalleled ignorance of the most

11. Henry Houssaye (1848–1911) studied painting before turning to letters. His reviews for the *Revue des deux mondes* were collected in 1882. He published several works on ancient history and art.

12. Jules-Abel Comte (1846–1912), critic and administrator, from 1876 head of instruction for the ministry of fine arts where he was instrumental in reforming the teaching of drawing.

elementary principles of technique. It is sad just to have to stop in front of such nonentities. But it is the duty of criticism to put the public on guard against them when they are loudmouthed and rowdy.

The widespread opinion that Manet was an incompetent and irreverent dabbler, whose portrait of Faure was an insulting display of his technical inefficiency, was cleverly and succinctly expressed by Cham in his cartoon this year in *Charivari*. The crude pen drawing of Faure was labeled: "Hamlet, gone mad, has had himself painted by Manet" (Fig. 9c).

It is in the caricatures that one finds the most explicit statement of the general public misunderstanding of the relations between Manet and his Impressionist friends. As early as April 29, before the Salon opened and during the third Impressionist exhibition, Cham concluded a long series of caricatures of paintings in that exhibition with a drawing of Manet recoiling from one of their works. It was entitled: "Manet insulted by an Impressionist," and bore the legend: "Eh! va donc, Raphaël."

Manet's letter to Wolff is sufficient evidence that the relations among the painters were at least cordial, but to the average person, spectator or critic, the disparity between Manet's art and the increasingly radical productions of the Impressionists seemed greater than it actually was. This feeling must have been strengthened by Manet's continued presence at the Salon where he was represented by a large portrait, a genre that did not readily admit of treatment in purely Impressionist terms. The difficulties attending Manet's efforts to reconcile two divergent modes were understood by at least one critic, Frédéric Chevalier, in his article "Impressionism at the Salon," published in the July 1 issue of *L'Artiste:*

It has already been observed that in the name of Impressionism we can claim certain talents which, neglecting to profit from the sort of petty scandal that attends the movement, quietly attain the goal toward which it strives. There are many of these among the landscapists. Undoubtedly because the traditions which they must uproot are of longer standing, it seems more difficult for the portraitists and usually for the painters

of large figures to transmit their first impressions in all their charm and accuracy. Some, however, are most successful.

When it is a question of painting a portrait, that is to say of depicting a specific individual and not just any person, the moment in which this individual appears, no matter how brief a period it may be, must always allow one to grasp the principal characteristic traits. The impression of a quick glance is then better portrayed in that the essential characteristics, accurately expressed, dominate the others which have been altogether sacrificed to this over-all effect.

Manet does not seem to have grasped these very elementary considerations when he painted his portrait of Faure in the role of Hamlet. We readily see a fair-haired man opening his mouth, brandishing a dagger, and clothed as the costume designers of the theater are wont to dress the Prince of Denmark; but it is a commonplace figure whose expressionless features reveal neither the individuality of a great singer nor the great character of which Shakespeare dreamed. Another reproach; as soon as we see an object our eyes focus on one particular point to which the rest is subordinated. Such is not the case in the figure which Manet exhibits. All the details are of equal importance. It therefore does not seem to have been grasped by just one glance, but examined by an infinite number which would have focused on all points at the same time. Therein lies the error which an Impressionist, more than anyone else, should succeed in avoiding.

During the late spring Manet made what now seems to have been an attempt to placate one of his more hostile critics. He invited Albert Wolff, with whom he was on speaking terms, to visit the studio and then to sit for his portrait. Had the portrait been acceptable to the sitter and received at the Salon, Manet would at the least have established himself in a more favorable position with regard to the readers of Wolff's paper, *Figaro*. But the project came to nothing. Although, as Théodore Duret wrote some years later, Wolff, who was astonishingly unprepossessing, should have admired the portrait even in its sketchy condition, for it "made of

his ugliness something artistic, of a superior order," the critic soon wearied of the sittings and the canvas was never finished. Inconclusive as the episode was artistically, it may have helped to moderate Wolff's sarcasm in the next few years.

1 8 7 8

MANET had now to endure his last, but not his least, humiliating rebuff from the administration. The jury for the retrospective art exhibition to be held in connection with the Universal Exposition of 1878 had been selected as early as November 1876. The forty-two jurors for this important occasion were divided into three groups of fourteen members each, those appointed by the government, those selected by the Academy, and those elected by artists eligible to vote for the jury of the annual Salon. Under such conditions it was inevitable that a conservative point of view would prevail. Among the more prominent painters elected by the artists were Bonnat, Breton, Henner, Jalabert, and Vollon. The second group included eleven of the fourteen members of the Academy, among them Baudry, Bouguereau, Cabanel, Gérôme, and Meissonier. The government appointed such critics as Charles Blanc, Charles Clément, and Paul de Saint-Victor, in addition to an assortment of notables high in the administration of the fine arts. The unusually conservative character of this jury may be understood not only as a symptom of hesitation induced by the long years of depression through which France was passing but also as a reaction against the manifestation of new tendencies in the Impressionist exhibitions of 1874 and 1876.

An official decree stated that artists wishing to participate would be required to present, between May 15 and June 1, 1877, a list of the works they wished to exhibit, all of which had to have been executed not earlier than May 1, 1867. Those painters whose works were acceptable to the jury and who would then be exempt from further examination would be notified of that fact before July 15. Artists who received no such notification would then present their works to the jury for its scrutiny in January 1878. Although he could hope for only summary consideration from a jury which

included so many painters, critics, and administrators who he knew disliked his work, Manet prepared a list of thirteen paintings. Nine of these had already been seen at the Salon; they were the portraits of Zola and Eva Gonzalès, the *Balcony*, the *Luncheon, Le Repos,* the *Music Lesson,* the *Bon Bock,* the *Railway,* and *Argenteuil.* July 15 passed, and he received no notice that his work was acceptable. According to the regulations he would be obliged like any beginner to present these canvases, including those which had been exhibited before and were known throughout Paris, for reconsideration by the jury. Rather than submit to such a procedure he refrained from taking any further action with regard to the official exposition. And although he thought for a time of arranging his own exhibition, as in 1867, he was dissuaded by the rising costs of building construction. Even to the annual Salon this year he sent nothing, undoubtedly because the members of this jury, to a man, were also serving on the jury for the Exposition.

With nothing new on public exhibition there was little occasion this year for any comment on his work. One important notice appeared in Emile Bergerat's introduction to the catalogue of the sale of certain works from Faure's collection at the Hotel Drouot on April 29.[13] Bergerat was naturally anxious to promote the sale of the paintings, yet his remarks, under these circumstances, were unusually courageous:

> Manet is another painter for whom Faure, who is in the forefront in aesthetic matters, professes a tenacious and aggressive admiration. His admiration is justified, certainly, by the celebrated *Bon Bock,* which has rallied around Manet so many of the disaffected and has reconciled the public to him. Though the gods of Olympus may kill me, I declare that I find this *Bon Bock* admirable in color, and also technically very deft and the whole very solidly painted. As for the *Opera Ball,* it would be perhaps imprudent to slander it in front of the professionals. Such blacks! . . . Finally, the piece is by a colorist

13. Auguste-Emile Bergerat (1845-1923), journalist and dramatist, art critic for the *Journal officiel* and later editor in chief of *La Vie moderne.* He published two studies of his father-in-law, Théophile Gautier.

and a gifted painter whose only fault (not one in my eyes) is to offer his contemporaries their own images, in top hats and masquerade costumes. Manet would have been the first who had dared to paint our modern dress if Ingres had not painted the portrait of Bertin. *Quod erat demonstrandum.*

But this same catalogue which contained such an intelligent and generous mention of his work was also the cause of an unfortunate encounter which must have wounded him quite as deeply as Bergerat's remarks may have pleased. Manet was dissatisfied with the frontispiece, a mediocre reproduction of the *Bon Bock* attributed to Léopold Flameng, and communicated his opinion to the engraver's son François who had actually worked the plate. Manet received in reply the curt note: "The engraving of the *Bon Bock* is very poor because it accurately represents the painting."

The *Bon Bock* was one of three works by Manet which Faure had included in a group of paintings by older masters, among them a series of fine Corots, in order to see what the reaction would be. It could scarcely have been more disappointing. Faure was obliged to withdraw the *Bon Bock* and the *Opera Ball* when the bidding failed to reach 10,000 and 6,000 francs respectively. Only the oil version of *Punchinello* was sold, for 2,000 francs.

An even more distressing incident occurred in June when Ernest Hoschedé, a once wealthy department-store owner who had been among the first to patronize the Impressionists, went bankrupt and was obliged to dispose of the remainder of his collection at public auction. Twice before, in 1874 and 1875, he had sold Impressionist paintings from his collection, and the prices had not been unencouraging. But this forced sale was a disaster. Of five works by Manet, the highest price paid, for the *Ragman* (Norton Simon Foundation), was only 800 francs; Hoschedé had bought it from Durand-Ruel six years before for twice that amount. The other paintings, important examples of Manet's earlier work, were bought for much less by his loyal supporters. The *Street Singer* went to Faure, the *Young Man as a Majo* returned to Durand-Ruel, the *Woman with a Parrot* and the *Departure of the Folkestone Boat* were bought by Albert Hecht.

When the Universal Exposition opened that summer Manet could have looked back to the last one, in 1867, with some misgivings. In the eleven years which had elapsed he had not come very far, at least in the estimation of the public. He had sold a considerable number of his largest and most serious paintings, but he had sold them to no more than three or four private collectors who were not well known. He had had an unexpected popular success in 1873 with the *Bon Bock,* but now no one wished to buy it. Rejected in 1876, abused in 1877, ignored by the administration in 1878, he could scarcely have been even slightly consoled to learn that this year, in the retrospective exhibition celebrating the triumphs of French art, there were no paintings at all by Delacroix, Millet, Théodore Rousseau, Barye, Decamps, or Troyon, painters whom France could have honored among her illustrious dead of the past twenty years.

Fortunately the year did not pass without some friendly encouragement. Faure, their quarrel now forgotten, purchased in June for 3,000 francs no less a painting than the *Déjeuner sur l'herbe.* In May Théodore Duret published his brochure, *Les Peintres impressionistes,* in which he described Manet's present position with justice and vigor:

> All that we have seen in our time proves the perfect justice of this classification. Have not our greatest painters been treated with scorn when they first appeared? Who still hasn't his ears full of the nonsense which formed the basis for the judgments of both critics and the public toward them? Have we not pretended long enough that Delacroix did not know how to draw and that his paintings were only a riot of color? Has not Millet been sufficiently accused of making ignoble and vulgar landscapes and drawings that were impossible to hang in a salon? And what hasn't been said about Corot's painting? It isn't finished enough, it's only sketchy, it's a dirty grey, it's done with palette scrapings. It has been proved that for a long while, when a visitor ventured by some amazing chance into Corot's workshop and the latter timidly offered him a canvas the fellow refused it, little caring to take on what seemed

to him a daub and to spend the money for a frame. If Corot had not lived until eighty, he would have died in isolation and disdain. And Manet! One could say that criticism has gathered up all the insults which it has poured on his precursors for half a century, to throw them at his head all at one time. And yet criticism has since then made amends, the public is full of admiration; but what time and effort were necessary, since it came about slowly, painfully, through successive conquests.

1 8 7 9

THIS YEAR Manet's two paintings were accepted by the jury, surprisingly enough since each was an unmistakable demonstration of his adherence to Impressionism, although entirely in terms of his own conception of the formal compositions of two figures, such as he had already developed in the *Railway* and *Argenteuil* at the Salons of 1874 and 1875. *Boating* (Fig. 31), which had been painted five years before at Argenteuil, and the *Conservatory* (Fig. 38), finished the preceding winter in Paris, were scenes of modern life, of men and women in contemporary costume with no concessions whatever to the popular taste for anecdote and sentiment. Impressionist, too, were the comparatively bright colors, the free brushwork, and the unusual conditions of light and atmosphere. The two paintings also presented an interesting contrast between a holiday scene with figures informally dressed, and a more dignified depiction of a fashionable couple in an urban setting. In *Boating*, where Rodolphe Leenhoff, Manet's brother-in-law, is seen in the stern of a boat with a young, unidentified woman companion, the figures are irradiated by the strong light reflected from the brilliant blue surface of the river. The high, invisible horizon, the close-up focus on the figures, and the interruption of the shape and movement of the boat by the frame show how thoroughly Manet now accepted the aesthetic of the Japanese print. A decade before, he had been content simply to transfer the flat two-dimensional pattern and broad distribution of color to his *Fifer* without reconstructing the spatial design.

In the *Conservatory*, a portrait of Jules Guillemet and his young

American wife, the whole space is suffused with sunlight filtering through the glass roof and tinged with greens reflected from the many plants. In each painting the human figures dominate the atmospheric conditions. Not for a moment are they allowed to waver and disintegrate in the colored light as do so many of Monet's figures of the late 1870's. And each composition was worked out in a way peculiarly Manet's own; in each the woman is seated to the left of the canvas, the lower part of her body, turned to the right to avoid the otherwise awkward and difficult foreshortening, balanced by the man's figure beside her. The expressive quality of his subject matter was also unmistakably Manet's. In these paintings he had completed that process of treating, on the scale and with the dignity of conventional historical painting, the moment in modern life wherein, although nothing dramatic happens or indeed could happen, the sense of that life as immediate and modern is irresistibly communicated to the spectator. Compared with these two works, the *Balcony* and the *Luncheon* are seen as still darkly romantic, their structure too formally contrived wholly to express the quality of the passing moment.

Not only the acceptance of the two paintings, coming after the rejection of the *Laundress* in 1876, the abuse accorded the works exhibited in 1877, and Manet's abstention in 1878, but the marked change in contemporary criticism of the paintings this year indicate, as Duret had suggested, the gradual change in the public's attitude. For five years now Impressionism as a slogan and Impressionist paintings as artistic actualities had been familiar to the public. They no longer aroused such fierce antagonism, except in the most conservative circles. But a residue of bitterness still remained, not to be dissipated for some time to come. Perhaps the change in public interest frightened the academic party, for its attacks this year, though few, were as cruel as ever. In the June issue of *L'Artiste* Bertall, in a mention of the fourth Impressionist exhibition, remarked quite gratuitously, since as usual Manet was not exhibiting, that the painter, "the original instigator of this curious group, is nothing more than an opportunist. The formerly uncontested leader has shoved away the boat containing his disciples,

and it continues nonetheless to sail without him in its noble independence."

This curious opinion that Manet had deserted the Impressionists was the subject of Draner's cartoon in *Charivari* on April 23, representing Manet in the guise of the stout figure of the *Bon Bock*, sitting angrily alone at a café table.[14] The legend ran: "The former *refusé*, former realist, earlier an Impressionist, intentionist [sic], luminist, and at present nihilist." Four days later another cartoon showed "Manet himself, overcome by an attack of nerves at the sight of the independent painting [Impressionism] (Fig. 9d)." Clearly, when the Salon opened, this opinion would have had to be revised, but Draner did not return to the attack.

This year the anti-Manet party found only one really consistent voice. Henry Cochin, writing in the *Correspondant*, improved the occasion to abuse him in company with Renoir, who was exhibiting *Mme. Charpentier and Her Daughters* (New York, Metropolitan Museum).[15] He referred to the Impressionists as painters who

> have in common only their ignorance and incompetence. They are represented at the Salon only by Manet and Renoir, who are revolutionists among the revolutionaries, and appear to want to make amends to the public . . . Manet has certain talents and the manual dexterity for rendering physical details; as for Renoir, it is possible that he has something of what it takes to make a painter; but we are waiting, for the proof, for him to return to school to learn what he doesn't know.

In *L'Artiste* for July 1, Frédéric de Syène offered what was, considering the place, a considerable relaxation of that journal's usually unfavorable view of the artist:

> There is nothing to keep Manet from becoming, like a great many others, an excellent Impressionist. It would be sufficient

14. Draner, pseudonym of Jules Renard (1833–1926), caricaturist of Belgian origin. After 1861 he contributed to most of the Parisian illustrated journals and designed costumes for the leading theaters.

15. Henry Cochin (1854–1926), attorney, politician, and man of letters, student of early Italian literature and Flemish painting.

for his painting to express for us exactly what he feels at the first sight of things. While waiting for that, it is difficult to grant that the innumerable and harmonious shades of objects in the open air are translated through the eyes in the crudest and harshest tones, and that a face of flesh and blood gives the impression of a painted pasteboard mask. That's what takes place judging by his contributions this year. Manet has assumed the slogan *Manet et manebit,* but rather than seeing this as a tiresome omen, let us hope with all our hearts that he will not remain where he is.

To this can be added the review in the *Gazette des beaux-arts* on June 1 by Arthur Baignères, who also assumed that Manet was not an entirely hopeless case. In a discussion of the grand prix of the Salon, which had been won by a painting he thought hopelessly mediocre, Lehoux's *Saint John the Baptist,* he compared this prize with the prix de Rome, which at least had gone to a young man, and he wished that the Salon prize might be awarded to a young painter, gifted by nature and uncorrupted by the teaching of the Academy. His opinion of Manet proves how difficult it still was even for a clever man to accept Manet's visual perception as sufficiently pictorial:

Manet is unhappily overage; he would have been a perfect candidate for the Salon prize. He would have carried to Rome his palette, on which he knows how to mix such fine tones, and he would have learned that one can draw the forms in front of one instead of first coloring them; he would have known that we have behind our eyes a brain which thinks, and that it is better to use both rather than to rely only on the first. He would certainly have painted water as splendid and harmonious as that which carries his boat along; he would have brushed with the same ability the woman's face in the *Conservatory,* but he would perhaps have drawn an arm on the canoer, or he would have put shoulders under the head of the man who leans out of an empty coat collar, ending in two enormous sleeves from which emerge some formless spots that have to be taken for fingers and hands. It is too late; we

shall keep Manet as he is, or rather as he wishes to be, which is to say as a man whom nature intended to be a painter, and whom a certain turn of the imagination and a tendency for paradox have developed into a revolutionary. In politics these metamorphoses are sometimes seen, and power, by changing the point of view, makes a statesman out of a rebel. For Manet Rome would have been like power for Garibaldi.

Such regrets, of course, were foolish, but at least they suggested the possibility of revising the general opinion. It is interesting to observe that Castagnary, whose opinion in 1867 or 1869 had been at the stage reached by Baignères this year, especially in his dislike for the "unfinished" hands and faces, had by this time gone further. On June 28 he declared in the *Siècle:*

> Manet brings us back to the elegance of fashionable life and to the pastimes of the sporting world. Of his two pictures, *Boating* and the *Conservatory,* the latter is the better, and positively entrancing. On a garden bench, sheltered by palms and exotic plants, a young woman sits, a parasol in her hand. Leaning on his elbows on the back of the bench and bending over to speak to her is a middle-aged man who resembles the painter himself. Nothing could be simpler than the composition, nothing more natural than the attitudes. One thing, however, deserves even more praise: that is the freshness of the hues and the harmony of all the colors. But what is this! Faces and hands are more carefully drawn than usual: is Manet making concessions to the public?

For the past several years only Castagnary and Duret had maintained a consistent standard of critical appraisal in the midst of the journalists' slanders and caricaturists' defamations. Zola had been silent for almost a decade, although he was even now preparing to speak out in a curious manner, as will presently appear. Duranty's comments were infrequent, and Mallarmé's generous tribute in 1874 had passed unnoticed. Manet needed someone to plead for him as energetically and as wisely as they had, and this year such a person appeared. The young novelist and critic, Joris Huysmans,

began his series of Salon reviews which would continue during the remainder of Manet's life and would give to his last years the aura of literary relationships which Baudelaire's challenge had lent to his beginnings.[16]

In his first reviews of the Salon for the *Voltaire,* later collected under the title *L'Art moderne,* Huysmans took a positive stand against the prevailing mediocrity of former academic students. Except for Herkomer, Fantin-Latour, Raffaëlli, Manet, and a few others, there was little in the Salon which he thought actually contemporary in spirit. And of the few he mentioned, only Manet inspired him to write the lines which are among the most understanding the painter had received so far, and in which, in the discussion of color and composition, Huysmans revealed his understanding of the specifically Impressionist treatment of these elements.

> This year Manet has had his two canvases accepted. One, entitled the *Conservatory,* represents a woman seated on a green bench, listening to a gentleman who leans over the back of the bench; on all sides are tall plants, and on the left some red flowers. The woman, a bit awkward and thoughtful, is dressed in a gown which seems made with great strokes, rapidly—yes indeed, go to see it—and superbly executed; the man, bareheaded, the light playing over his forehead, sparkling here and there, touching the hands boldly drawn in a few strokes, holds a cigar. Posed this way, in a casual conversation, the woman is truly beautiful; she is a lively flirt. The air moves, the figures are marvelously projected in this green envelope which surrounds them. This is a most attractive modern work, a battle engaged and won against the academic conventions of sunlight, which is never studied from nature.
>
> His other canvas, *Boating,* is just as unusual. The bright blue water continues to exasperate a number of people. Water

16. Joris Karl (Charles-Marie-Georges) Huysmans (1848–1907), novelist and critic. His earlier realist novels on subjects not unlike those of Degas' studies of laundresses and milliners were succeeded by his famous "decadent" works, *A Rebours* (1884), and *Là-bas* (1891), which are related to the contemporary Symbolist movements in poetry and painting.

isn't that color? I beg your pardon, it is, at certain times, just as it has green and grey hues, just as it contains lavender, and slate-grey and light-buff reflections at other times. One must make up one's mind to look about. And there lies one of the great errors of contemporary landscape painters who, coming upon a river with a preconceived formula, do not establish between it, the sky reflected in it, the position of the banks which border it, the time and season as they are at the moment they are painting, the necessary accord which nature always establishes. Manet has never, thank heavens, known those prejudices stupidly maintained in the academies. He paints, by abbreviations, nature as it is and as he sees it. The woman, dressed in blue, seated in a boat cut off by the frame as in certain Japanese prints, is well placed, in broad daylight, and her figure energetically stands out against the oarsman dressed in white, against the vivid blue of the water. These are indeed pictures the like of which, alas, we shall rarely find in this tedious Salon.

Huysman's discriminating appreciation of the character of Manet's Impressionist vision recalls Zola's understanding of how his early manner, even in his most Spanish moments, was a necessary departure from the banalities of the contemporary anecdotal picture. But Zola had been silent, insofar as art criticism was concerned, for several years. During the 1870's he had devoted himself to his own literary problems, particularly novels of the Rougon-Macquart series, wherein his own naturalism reached a degree of detailed study far removed from Manet's elegant and concise glimpses of the upper middle classes. L'Assomoir, published in 1877, and Nana, which appeared in 1879, suggest the difference in the study of contemporary manners which separated the two men. But Zola had not finished with criticism. In 1879 he undertook to write a monthly review of artistic affairs in Paris for the Russian publication Viestnik Evropi (The Messenger of Europe), published in St. Petersburg. Perhaps the distance between the two capitals and the thought that few in Paris would read his articles in Russian translation gave him courage to write more stringently about

contemporary art than would have been tactful in France. And what he had to say is best read in the light of his understandable disappointment with the development of Impressionist painting. Founded as it was upon an essentially naturalistic program, in aesthetics as in technique, the flight of the Impressionist painters from the city to the pleasure resorts and sheltered villages along the Seine could only seem to the writer, if not a dereliction of duty, at least a thoughtless evasion of their responsibilities toward the moral problems which they might have helped him solve. Their stubborn persistence in maintaining their own standards in the face of popular disapproval and misunderstanding could well seem idiosyncratic to a man who depended upon evoking the widest public response with his portrayals of contemporary life. And from another point of view, the pictorial parallel to Zola's laborious accumulation of naturalistic detail was not the shorthand and austerely objective technique of the Impressionists, but the minutely realistic methods of many of the Salon painters. Zola seems sincerely to have admired such painters as Bastien-Lepage and Henri Gervex, who at this time were often considered followers of Manet, and he would probably have enjoyed such city scenes as Monet's railway stations had they only been executed in the manner of a Meissonier.

Zola's remarks on Manet and the Impressionists occur at the end of his brief review of the Salon published in the June issue of *Viestnik Evropi*. They might have gone unnoticed outside Russia had not a copy reached the *Revue politique et littéraire* which on June 26 published one paragraph in translation without further comment. The next day it was reprinted in *Figaro* with comments by Adolphe Racot:

> Zola has just broken with Manet. You will recall that a dozen years ago, in a series of articles entitled *My Salon,* the leader of the naturalist school rushed to break a lance in favor of the painter of *Olympia.* Today Zola, in his recent contribution to the *Messenger of Europe* in St. Petersburg, spoke in these terms of Manet in whose work, he says, the hand often betrays the thought. "Besides, all the Impressionists err on the side of technique. In art as in letters, form alone expresses new ideas and new methods. To be a man of talent, one must realize

what is living within oneself; otherwise, he is only a pioneer. The Impressionists are, in my opinion, just exactly pioneers. At one time they put great hopes in Manet; but Manet seems to have exhausted himself through production. He is satisfied with unfinished work; he does not study nature with the passion of the truly creative. All these artists are too easily satisfied. They erroneously disdain the solidity of work thoroughly thought out. That is why one can fear that they are only pointing out the way for the great artist of the future, for whom the world is waiting."

Racot concluded his notice by remarking: "These observations are very accurate, but they are raising a hue and cry in the Impressionist camp. At a time when it is necessary to work slowly and at length, it isn't worth the trouble. Can one become a classic all at once?"

Zola himself was disturbed by this publicity and hastened to write Manet the following day:

> My dear friend:
> I read with amazement the notice in *Figaro* announcing that I have broken off relations with you, and I am anxious to send you my best wishes.
> The translation of the quoted passage is inaccurate; furthermore the sense has been distorted. I have spoken of you in Russia, as I have in France for thirteen years, with profound appreciation for your talent and your personality.
> Cordially,
> Emile Zola.

To this Manet immediately replied:

> My dear friend:
> Your letter gives me the greatest pleasure and you will have no objections, I hope, if I insist on its publication in *Figaro*.
> I must confess that I was profoundly disillusioned upon reading this article, and I was deeply distressed by it.
> With best wishes,
> Edouard Manet.

Manet sent Zola's letter to Racot, who replied that since he had done no more than reprint the passage from the latest issue of the *Revue politique et littéraire,* it was to that publication that Zola should direct his complaint. Racot, however, published Zola's letter with the information he had given Manet, and the incident, so far as the public was concerned, was closed.

Zola's statement that the translation of the offending paragraph was inaccurate and that the sense had been distorted was only partially correct. He could have said, quite rightly, that the anonymous translator had confused Manet's name with Monet's—a mistake which had plagued both artists ever since Monet had first exhibited at the Salon — for the quoted text was actually a depreciatory reference to Monet's slapdash technique, as he now thought it.[17] What Zola could not do was to call for the publication, in French, of the whole text. To do so would be to reveal that in the immediately preceding paragraph he had indeed mentioned Manet in terms which could only be construed as an attack on Manet's art. Far away, and in a foreign language, he had publicly expressed his disappointment in Manet as a naturalist painter.

Zola's attitude, so contrary at first sight to what might have been expected of the foremost naturalist writer of the day, is partly to be understood as a consequence of his growing reputation. Whereas Manet seemed as far as ever from securing universal acclaim for his art, Zola was growing more famous each year, and, it may be added, more prosperous. For him now to jeopardize his position by again encouraging Manet might very well, so he may have argued, compromise his own ability to speak out on social problems to his huge audience. This was also the first time Zola had published any criticism of Manet since the exhibition of his own portrait in 1868. During a decade tastes and interests change; Zola's no less than Manet's. As the writer had come to believe that literary truth depended upon the accumulation of details, so the painter had learned that visual truth required the suppression of all but the most significant accents of light and atmosphere. It may be that Zola, sensing success at hand, no longer cared to have his name associated with that of a painter

17. For a French translation of the Russian text of Zola's review see F. W. J. Hemmings and R. J. Niess, *Emile Zola, Salons,* Geneva and Paris, 1959, pp. 226–30.

whom success eluded. But it is more generous to think that his con-
ception of realism had diverged too far from the pictorial ideas
developed by the Impressionists. How, one might ask, could Manet
ever have illustrated, in the most literal sense, the dramatic epi-
sodes in Zola's novels? The two systems were equivalent but not
interchangeable. The portrait of 1868, intended to crown the
friendship, may actually have been a principal cause of the gradual
estrangement between the two men. If Zola had had any earlier
misgivings about the character of Manet's realism, they would have
been confirmed by the critical reaction to that painting. One re-
view in particular suggests this interpretation. Marc de Montifaud,
writing in the issue of *L'Artiste* for May 1868, had raised the ques-
tion of the proper relation of technique to subject matter in a
realist aesthetic. The reader will recall, from the earlier discussion
of the critical reaction that year, these pertinent paragraphs:

> What must be granted Manet is his attitude toward the
> figure, the way his models are posed. What he lacks is control,
> the precise tint in the intense coloring of which he dreams and
> which he only crudely portrays. His portrait of Emile Zola,
> less black than those of other years, was done with a few strokes
> rather than really painted. The artist may try as hard as he
> likes to draw the imagination beyond the actual frame; he
> will not succeed in making acceptable these manipulations of
> the brush which here and there really have the accent of cer-
> tain works of the school of Ribera, where one can verify in-
> spiration in impetuosity.
>
> In studying Zola's countenance one feels one has the right
> to intervene even in the name of false realism. What artistic
> temperament will seriously accept these bituminous reflec-
> tions, these muffled hues, these planes which seem modeled in
> chalk? This is not said out of spite, but in sorrow before an
> obstinacy which is the master of brilliant qualities but which
> buries them beneath leaden and chalky appearances.

To understand the relations between Zola and Manet at this
point, it is well to consider just what Zola actually sent to St. Peters-
burg. Since the only source for this is the Russian translation of his

original French manuscript, the pertinent paragraphs of that translation are here retranslated into English in the hope that, even at this third remove, the sense of his statement will be clear.

Zola's "Paris Letter," dated June 14/26 and headed "Artistic and Literary News," began with a superficial discussion of the current Salon. This he found more mediocre than ever, a situation due, he thought, to the inexcusably slack standards of the jurors who felt obliged to accept not only the work of inferior students but the worthless painting of anyone who had a personal claim on their attention. In matters of taste the jury was weakly subservient to popular opinion, which as usual was a poor judge of such things. In contrast to the academic work exhibited in the Salon, the "predominant characteristic of contemporary French painting," so Zola felt, was "the search for truth in nature." The search for natural truth, begun by Courbet, was being continued by the Impressionists.

> I have already told you, I believe, about the small group of painters calling themselves Impressionists. To me the name seems unsuccessful. Nevertheless there is no doubt that these Impressionists, since they have taken the title themselves, are at the head of the contemporary movement. Each year, upon visiting the Salon, one is convinced that their influence finds a stronger and stronger expression. And, most curious of all, the jury inexorably rejects the work of these painters, who have finally stopped sending to the Salon at all. They formed a society and annually open independent exhibitions to which visitors come in crowds although, it is true, only out of curiosity and without any understanding. So we witness the amazing spectacle of a small group of painters who are ridiculed by the press which speaks of them only as if it were dying of laughter. Nevertheless they are the real inspiration for the official painting in the Salon from which they are forever banished.
>
> In explanation of this astonishing state of affairs, I will say something about the Impressionists. They have just had an exhibition this year on the Avenue de l'Opéra. There we saw the paintings of Monet who translates nature so faithfully,

Degas who portrays with such astonishing truth the charac-
ters he takes from contemporary life, Pissarro whose conscien-
tious investigations at times produce the illusion of reality, and
many others whom I shall not mention here. Besides, I intend
to restrict myself to a general survey.

The Impressionists introduced painting to the open air, to
the study of changing effects in nature according to the in-
numerable conditions of the weather and the time of day. In
this they considered that the fine technical methods of Courbet
could produce only splendid canvases painted in the studio.
This resulted in the disintegration of light, in the study of the
outdoors, of the play of iridescent color, of casual changes of
light and shade, of all optical phenomena which make the at-
mosphere so changeable and so hard to represent. It is difficult
to imagine what sort of revolution is entailed by the simple
fact of painting in the open air, when one is obliged to take
into consideration broad daylight instead of shutting oneself
up in the studio under the cold and unchanging light of a
large north window. This was the last stroke dealt classic and
romantic painting, nor is that all. This realistic movement,
begun by Courbet and freed from [conventional] technique,
extended by analysis, has discovered truth in innumerable light
effects.

I have not mentioned Edouard Manet, who was the leader
of the Impressionist painters. His paintings are exhibited in
the Salon. He was able to continue the movement of Courbet,
thanks to his honest eye which so well catches the right value.
That is the explanation for his long struggle with the public,
which is not easily won. He has been unable to work out his
own methods; he remains an excitable student, seeing very ac-
curately what takes place in nature, but not sure that he can
definitively and fully transmit his impressions. Therefore when
he starts out on his own path, you are not sure how he will
reach the end of it or whether he will reach it at all. He works
at random. When one of his paintings succeeds, then it is
indeed extraordinary, absolutely truthful, and unusually skill-
ful. But sometimes he makes mistakes, and then his paintings

are uneven and incomplete. In short, during the past fifteen years there has not appeared another more individual artist. If the technical side of the matter were equal to the accuracy of his impressions, he would be a great painter of the second half of the nineteenth century.

Then followed the paragraph quoted in Paris by the *Revue politique* and *Figaro*. Manet, however, did not allow this incident to affect his relations with his old friend. In the autumn following the exchange of letters Zola published a second edition of *Mes haines,* containing unchanged all his earlier articles on Manet. The latter showed by implication his admiration for Zola's naturalism in the following letter addressed to the Prefect of the Seine with a suggestion for a mural program which, had it been undertaken, would have been one of the greatest glories of nineteenth-century French art. It is possible that Manet was even acting upon a suggestion of Zola's, for the proposed title, *Le Ventre de Paris,* was that of one of Zola's novels.[18]

I have the honor to submit for your esteemed approval the following project for the decoration of the conference hall of the Municipal Council in the new Hôtel de Ville in Paris:

To paint a series of compositions representing, if I may use an expression now common and which well describes my idea, "Le Ventre de Paris," with the various public organizations depicted at work in the public and business activities of our times. I should show the Paris of the public markets, the railways, bridges, subterranean activities, race courses, and parks.

For the ceiling a gallery around which would be placed in appropriate positions all the men now living who in civil life have contributed or are contributing to the greatness and wealth of Paris.

It is tempting to think that, had his proposal been accepted, Paris would have gained a really modern, and perhaps the only truly Impressionist, mural of the period. It might have combined the

18. The letter was first published by Antonin Proust; see his *Edouard Manet, souvenirs* (Paris, 1913), p. 94.

specifically objective and materialist character of the urban land-scape, already exploited by Monet in his scenes of railway stations and of harbor activities along the Seine, with Manet's own figure style, so evocative in its urbanity of the social character of later nineteenth-century city life. Needless to say, nothing came of Manet's offer. His letter, so far as is known, was not even acknowledged.

THE LAST YEARS: 1880-83

1880

MORE OFTEN, year by year, the terms "modern art" and "modern life" occurred in the criticism of contemporary painting during the 1870's. Since no existing organ of artistic opinion was prepared to deal with contemporary painting in just these terms, it was perhaps inevitable that one should be created. This happened in 1879 when Emile Bergerat, who had so favorably described Manet's paintings at the Faure sale of 1878, founded his illustrated weekly, *La Vie moderne*. The contributors for the most part were drawn from among the more progressive group of younger Parisian writers. Armand Silvestre and Edmond Renoir, the painter's brother, were entrusted with the criticism of modern painting and soon persuaded Bergerat to enlist the aid of their artist friends for illustrations. To these activities were shortly added exhibitions of modern art held in the offices of the publisher on the Boulevard des Italiens. The first, organized in December 1879 for the benefit of the victims of a disastrous flood in Spain, consisted of small tambourines decorated by such fashionable artists as Rico, Boldini, Bonnat, Clairin, and Sarah Bernhardt. Manet contributed two such small circular paintings of Spanish dancers, close in spirit to the figures of his earlier Spanish ballet.

Bergerat seems to have had a taste for such artistic curiosities, for in March 1880 he arranged an exhibition of Easter eggs, actually ostrich eggs, decorated by Berne-Bellecour, Forain, Chaplin, Rops, and again by Manet who appropriately painted on his egg the puffed-out figure of Polichinelle.[1]

1. Four tambourines are catalogued in J.W.B., Nos. 344–7. The ostrich egg, broken in 1908 and pieced together, was in the collection of Bernheim-Jeune. Tabarant, p. 375, did not know its whereabouts in 1947.

April witnessed an increase in activity so far as the modern artists were concerned. On the first of the month the Impressionists opened their fifth exhibition, and ten days later *La Vie moderne* presented a one-man exhibition of Manet's work, the first which the painter had held on such a scale since his own exhibition in 1867. The character of the works included is the clearest indication of the degree to which Manet had accepted his position, implicit in the title of the gallery, as the painter of modern life. There were no longer circuitous references to historical painting or to the tradition of the old masters. Of the twenty-five works only ten were in oil, the remainder in pastel, a medium to which not only Manet but his friends among the Impressionists, Degas and Pissarro, were turning more frequently for the expression of contemporary life. No less than seven works were portraits, those of Manet's cousin, the lawyer Jules de Jouy, in oil, and the pastel portraits of Mme. Emile Zola, the actress Mlle. Valtesse de la Bigne, Constantin Guys, and George Moore, all representatives of the upper-middle-class society and of the literary and artistic circles of Manet's preference. To these were added café scenes in oil and pastel, subjects wherein Manet followed the precedent recently established by Degas in his *Absinthe Drinker* of 1876. These alone suggest how the monumental, even academic, character of the *Bon Bock* of 1873 had been abandoned for more casual scenes of daily life.

As might be expected the pages of *La Vie moderne* were open to a favorable review of the exhibition. To the issue of April 17 Gustave Goetschy contributed a lengthy article, three-fourths of which was taken up with a description of Manet's modesty and his personal appearance, so markedly at variance with the still prevailing popular conception of him as a disorderly, disheveled scamp.[2] So far Goetschy was only recapitulating Zola's account of 1866. In the remainder of the article Goetschy, in language reminiscent of Zola, characterized his art in terms of the strict Impressionist doctrine which Manet never completely accepted. But the

2. Gustave Goetschy published an album of Salon sketches, *Pressé pour le Salon*, illustrated by H. Pille (Paris, 1877), and a study of de Neuville and Detaille, *Les Jeunes Peintres militaires* (Paris, 1878).

accurate, matter-of-fact description, no less than the sincere and sympathetic appraisal, are proof that the new vision was comprehensible to the younger generation.

The novelty of Edouard Manet's contribution to art consists, first of all, in the way he places his figures and objects in atmosphere, in his scrupulous search to make the surroundings exactly accurate. One always knows, when looking at his paintings, just where, when, on what day, at what hour, they were painted. His characters live and move in an atmosphere all their own. Everything about them and around them is true. Moreover he has a peculiarly accurate feeling for gestures and attitudes. Since he wants to preserve in his works all the charm and sincerity of his first impression, he works quickly, indicating with broad and bright brush strokes the movement of the body, its anatomy and color, enveloping it in the appropriate general tone . . . He almost always poses his models in strong light, even in the cruel and brilliant clarity of actual sunlight.

His technique is simple. He works especially toward synthesis and simplification. In the symphony of a painting with each brush stroke, he makes each object sound its particular note. He is concerned above all else with rendering in the most exact and direct way the object just as it was at the moment when he set himself to reproduce it. He tries to preserve faithfully and vividly the impression which he has felt and he believes he has done enough when he sincerely expresses it. His scrupulous concern on this point extends to servility: that is why his portraits are such speaking likenesses.

As a painter Edouard Manet is a delicate and charming colorist. His palette is bright and sparkling. His pastels have a flowery freshness of color which evokes the memory of the exquisite work of artists of the eighteenth century . . . You will see some day that this Parisian, at whom you laughed, is a true painter and that he has depicted Paris with the imagination, the talent, and the originality of a great artist.

There were others who were still not convinced that Manet was indeed the painter of modern life. Their chief complaint was the

familiar charge that he had failed to master his craft, or at best was inclined, as Castagnary had for so long insisted, to leave his work unfinished. These opinions were reflected in a selection of current criticism published in *L'Artiste* on May 1. Bertall, who was turning from caricature to criticism, described the signs of amusement or distress which he detected on the faces of the visitors as they left the exhibition, and he asked:

> Actually what has an artist to gain, whatever be the talent he has or thinks he has, by exhibiting formless sketches, imperceptible outlines, representing without any reason or necessity such frightful and vulgar types, which haven't even observation and truth for an excuse . . . Why this series of women drinking beer, these clients of the cafés-concerts? If only there were the qualities of accurate impression, of color, or powerful modeling. But no, it's empty, without consistency, crude in color, where blue, green, and pink dominate, the most dangerous colors in painting.
>
> These are for the most part summary indications, which a little more work and even an idea would have been able to mature, but which have remained in an embryonic state, either through willfulness or impotence. Why stop at that point? For in most of the work exhibited, aside from the questionable taste, there is a strong hint of real talent.

A more subtle account of Manet's accomplishments was reached by Paul Sebillot, quoted in this same issue of *L'Artiste:* [3]

> Here we find Manet with his faulty taste, his sometimes slack and inadequate drawing, but also with his charming color. Manet is, everything considered, a painter from whom one cannot turn away in indifference, and he has been a real influence on our modern school; he was one of the first to abandon dark tones under the pretext of warmth, and he has shown what resources the gamut of bright colors offered. Although a very incomplete painter he has had more effect on contemporary art than even the undisputed masters . . .

3. Paul Sebillot (1846–1918), marine painter and man of letters, author of several collections of folk tales of his native Brittany.

Manet's pastels are less known than his oils; in them are the same delicate tones, but the same faults, because of the greater freedom of the medium, appear less shocking. They are among the most admired works in the present exhibition and they deserve to be.

Meanwhile Manet's two contributions to the Salon had been accepted by the jury without incident, although only one, the portrait of Antonin Proust (Fig. 34), was hung "on the line." This portrait, so full of masculine Parisian "flair," stirred up once more the tedious discussion as to whether it were a recognizable likeness. Although many critics were offended by the prevailingly blue color scheme, none remarked that this was not the first time Manet had shown his predilection for this particular color. The most antagonistic statement was published by Bertall. On May 10 in *Paris-Journal* he went so far as to insinuate that Manet had offered the portrait of Proust for reasons political as well as artistic:

> Manet has been entrusted with reproducing the frock coat and top hat of the future minister of fine arts, just as it is said that he will become the director of the Ecole des Beaux-arts and will lay out the new route assigned to French art. The real originality of Manet cannot be denied: it consists particularly in not caring to draw forms, in not modeling them, and in substituting for the lights and shades which routine painters, through prejudice, have continued to put in their canvases, certain flat and crude colors.

Albert Wolff was no more generous. Thinking, perhaps, of his own portrait of the year before which had been left unfinished, he wrote in *Figaro* on May 2:

> There are some fine qualities in the *Portrait of Antonin Proust* as well as in the *Luncheon* [sic], but why must Manet's work constantly remain below his talent, which is considerable? It is because the famous naturalist revolutionary is at bottom timid and hesitant; after the first sketch, which is always wonderful, the hesitations commence and the picture remains, despite colossal labor, in the state of a preliminary sketch.

But such dreary recapitulations of long-standing complaints were overborne by a series of statements elsewhere which, if no more profound, at least indicated that Manet's position was assured. Philippe Burty had now for some time been one of Manet's more perspicacious supporters. On May 4 in *La République française* he wrote: "Of all the official or governmental personages, Antonin Proust has had the happiest advantage: his portrait by Manet, his former companion in Couture's studio, is a striking resemblance and full of life." In the *National* a new critic, Charles Flor, signing himself "Flor O'Squarr," proved himself a new recruit to modern art.[4] On May 11 he wrote:

> Manet exhibits a very beautiful portrait of Antonin Proust, the deputy. More than anyone else, Manet understands the human countenance. All his portraits, so bold and decisive in brushwork, are profoundly studied. The likeness is perfect. A portrait by Manet is the physical and moral counterpart of an individual.

In *La Vie moderne* on May 22 Armand Silvestre, who had unaccountably failed to mention Manet in his salon review the previous year, was even more enthusiastic. After discussing Bonnat's portrait of the President of the Republic, Jules Grévy, he added:

> It is not by way of antithesis that I compare it with Manet's portrait of Antonin Proust, but simply because I consider the latter one of the most remarkable in the Salon. What spirited modernity in the countenance and in the costume! What brilliant execution in a bright and appropriate color scheme! I have never understood the public's hesitations in front of a painting, the first effect of which is to caress the eye with the freshness of color.

Even Paul Mantz was not disturbed. In *Le Temps* on June 6 he expressed his admiration:

> The painter has given to his model a great deal of swagger and a gallant air which is indeed that of Antonin Proust. The

4. Charles Flor (dates unknown), publicist, novelist, and dramatist, frequent contributor to *Figaro*.

whole face is alive and the color harmony dominated by a grey-blue, is sober, distinguished, and elegant. In studying this portrait, which will take an important place in Manet's work, one feels that one is going to be reconciled with his talent.

Mantz immediately added that "this illusion was of short duration." When he turned to the other painting, *Chez le père Lathuille* (Fig. 33), he detected that side of Manet he had so long distrusted:

Sheltered behind the portrait of Proust, Manet suddenly uncovers his batteries, letting us see a scene "in the open air" of the most disturbing character . . . For reasons which remain inexplicable, the young man has blue hair . . . The woman takes no account of her lack of distinction, which is extreme . . . To lunch with a woman so badly turned out is punishment beyond the horrors of the imagination . . . Let us forget this nightmare.

This "nightmare" was nothing more than Manet's latest contribution to the subject matter of the café scene, and another interpretation of what had become one of his favorite themes, the intimate relationship of a man and woman depicted in the circumstances of modern life. In this respect it represented a remarkable advance when compared with such subjects of the late 1860's as the *Balcony* and the *Luncheon* with their theatrical properties and contrived compositions. It was in the direct line of descent from the *Argenteuil* of 1875 and the *Boating* of 1879, a companion piece, so to speak, of Renoir's *Luncheon* scene of the same year (Frankfort, Staedelsches Kunstinstitut), just as, in its turn, Manet's painting can be considered the source for Toulouse-Lautrec's *A la mie* of 1891 (Boston, Museum of Fine Arts). While the ultimate origin of the subject can properly be traced to Degas' café scenes of the early 1870's, Manet's personal variations could already have been remarked in the several paintings of cafés and beer halls exhibited earlier this year at *La Vie moderne*. Here he had transferred the scene to the open-air terrace of a well-known Paris restaurant. The son of the proprietor, Louis Gauthier-Lathuille, and the actress Ellen Andrée, later replaced by another young woman, posed on

the actual terrace as luncheon was served to the other customers. Manet had at last followed the example of his friends the Impressionists and set up his canvas out of doors for a Salon painting.[5] In the course of this procedure, which was for him a radical departure for a Salon picture, he had adopted, for the background, the freest Impressionist technique he had used up to this time.

As with all his work each fresh departure encountered instant resistance from the public and from such conservative critics as stood for the popular attitude. Curiously enough, in 1880 there were many who were prepared to accept the consequences of the broader Impressionist rendering of light and atmosphere but who demurred at the subject matter so treated. To none did it occur that the subjects of such works were so inseparable from the technique developed by the Impressionists for just such casual, instantaneous occasions that modern life could not convincingly be depicted within the limitations of any academic method. A consideration of Manet's work up to this date would have proved the pertinence of this process. Whenever he had attempted to portray a more traditional theme in his broken brush stroke, such as the portrait of Faure as Hamlet, the contrast between conception and execution had been irreconcilable and had provoked a critical dispute which was not without justification. From another point of view it was equally impossible to adapt the older subject matter to the new technique. Not alone were the mythological and historical themes inconceivable in terms of the new methods, but even the timid, indoor elegances of Alfred Stevens or Chaplin would have inevitably been out of character within the Impressionist orbit. What is remarkable, therefore, in the criticism of *Chez le père Lathuille* this year was the general acceptance of the technical innovations quite as much as the accusations that the subject was vulgar.

There were, of course, a few who recognized the painting as a modern masterpiece. For Silvestre, "All is brightness and joy in this corner of a restaurant . . . There is truly extraordinary vitality in this little scene of everyday life, and Manet has never asserted with more intensity his limpid vision, so delicate and true, the

5. Gauthier-Lathuille's account of the sittings has been published by Tabarant, pp. 352–3.

clarity of his impressions, and the personal resources of his palette."
But such remarks were few and brief compared with the lengthier
and serious criticism elsewhere. Stéphane Loysel's remarks in
L'Illustration on May 15 are interesting as an indication that he
was prepared to accept the consequences of Impressionism as a
technique but still demanded of Manet the clarity of form and
precision of drawing which were attributes of conventional paint-
ing:

> However dazzling it may be, the surrounding atmosphere
> nonetheless encloses the thousand objects which form the
> world, and it will be one of our contemporary school's claims
> to glory that they have sought to free themselves from the
> bondage of studio lighting in order to show us nature, true
> nature, in the midst of the innumerable gradations of tone
> which encompass and permeate it. We make, however, no
> references to Manet, whose chief talent consists in not com-
> pleting anything, and offering to the public, as finished, works
> which have barely been sketched in. The painting he calls
> *Chez le père Lathuille,* which he follows with the subtitle "in
> the open air," tells us nothing of his talent. Under the pretext
> of remaining faithful to the feeling of values, it shows only
> the accuracy of a rough draft, and also the same ignorance of
> the art of his trade, the same unconsciousness of what consti-
> tutes painting.

A more formidable diagnosis of the situation was rendered in the
Gazette des beaux-arts on July 1 by Philippe de Chennevières, re-
cently the director of the Ecole des Beaux-arts. As a former mem-
ber of the government and from such a place as the *Gazette* he
spoke with the authority of a representative of the official point of
view, not only toward Manet as an individual but toward most
modern painting and even poetry:

> The portrait of Antonin Proust did Manet a lot of good this
> year. Everyone has agreed that this painting was an excellent
> preparation for a good work, and that with only a little more
> retouching the artist could complete the job. The easy stance

of the model, the refined and delicate tones of the clothing and face, well bathed in light, have been praised. If there weren't something incomplete, it would, I repeat, be a portrait to rehabilitate both the artist and his followers. But therein lies the tragedy and the weakness of the Impressionist school, of which Manet is the leader. They produce works often very interesting for the semiaccomplishment of a vague and certainly very delicate concept . . . a concept whose existence it would be foolhardy to dispute, since we see it very clearly and profitably put into practice by painters of the stature of Stevens, Bastien-Lepage, Madrazo, de Nittis, and Heilbuth, who have known how to use its good points without injuring their own talents. As for our professional Impressionists, one might think that they had pledged themselves to repelling the public by the extravagances of most of their productions. Aside from the disgusting commonplaceness of their subjects, they have made such a subtle and vulgar application of their system, which hardly holds any water, so disquietingly amorphous, that it almost seems as if it were an art against nature. By their slight, inadequate, and unhealthy affinities they remind me of certain of our Parnassians of whom, despite their impotence, one cannot say that they are not true poets. The Impressionists, too, are real painters, since they possess an element peculiar to art, and I merely take as an example Manet's *Chez le père Lathuille* in which the people in the front plane are truly in sickening taste, but in which the "open air" and sunshine are seen with the eyes of a master and translated with amazing certainty.

Manet's participation in the Salon this year can be concluded with the extended discussion of his work in a volume of Salon criticism by Roger-Ballu, published as *La Peinture au Salon de 1880* with the explanatory subtitle *Les Peintres émus, les peintres habiles.*[6] For Roger-Ballu "clever painters" were those endowed by Prometheus with manual dexterity. Of these the Salon was, as

6. Roger-Ballu (1852–1908), politician, critic, and administrator, author of *Les Artistes contemporains* (1877) and *L'Oeuvre de Barye* (1890).

always, full. The "painters of feeling," on the other hand, were more fortunate in being endowed by Minerva with the sovereign gifts of soul and temperament. Roger-Ballu surprisingly numbered Manet among them and went to some pains to justify his inclusion.

"What?" people will exclaim, "Do you place Manet among the painters of feeling? You aren't serious! You want to put people on the wrong track!" No! If one has the privilege of writing, one must be sincere; I do not retract my statement.

There can be no question here of his compositions which are entirely accidental, or of thought which is absent, of moral values to which he has never appealed. He has the knack of finding notes which render the color vibrations of nature, seen from a materialistic point of view. Sensitive he is, somewhat like Goya, a little like Velasquez (note particularly that I make no comparison). Let us now examine his painting this year: *Chez le père Lathuille.* Manet took care to add a subtitle for the public: "outdoors." What do we see in it? A man and woman seated at a restaurant table: two commonplace types; the faces are painted with large brush strokes, which seem to fight against each other, the blacks of the clothes seem blue, and the whites are dirty. The general effect is very discordant, and every one laughs. After this first glance, go back to the end of the hall and squint at it. The clashing hues blend together and while the blacks are still accented, the whites become transparent. Each object exists in the atmosphere and as if in relief, so much so that one has almost the illusion of reality; through the opened wall, one thinks one sees a corner of the restaurant. I call your attention to a detail which is peculiar to Manet's style. Behind the head of the seated man there is a post painted bright green, like those in newsstands. The way the head stands out against it is unbelievably true; the tonal relations are inimitably accurate.

It was one thing to protest that Manet had gone too far, that he had been chiefly responsible for introducing vulgar subjects,

crudely executed, into the tradition of French art. It was quite an-
other to believe that he had not gone far enough. There had earlier
been indications of this point of view, particularly in Cham's car-
toon of 1877 depicting Manet overcome with horror at the Impres-
sionist exhibition. To the followers of modern painting, there was
some truth in such an attitude. After the Impressionist exhibitions,
even Manet's later café scenes seemed a timid compromise between
the newer methods and Salon subject painting. Such an attitude
was expressed this year by Huysmans when, in reprinting his review
of the official Salon in his *L'Art moderne,* he added some com-
ments on the exhibition at *La Vie moderne.* Huysmans' criticism of
Manet as an incoherent and incomplete technician closely follows
Zola's statement the previous year in *Viestnik Evropi.* It is curious
that the leading naturalist and the forerunner of Symbolism should
each, starting from the standpoint of Champfleury's "Nature just
as it is," have arrived at a common opinion of Manet's failure to
achieve his goal.

For some unknown reason, Manet exhibits in the official waste-
land. He usually, and for reasons which I understand even less,
has one of his two paintings standing guard right on the line.
It's a strange decision which gives a good place to an artist
whose work extolled rebellion and aimed at nothing less than
sweeping out the pitiful remedies of the nursemaids of tradi-
tion. But this time the jury has managed to hang in the top
row a most exquisite painting, *Chez le père Lathuille,* while a
less exquisite painting by the same artist, the portrait of
Antonin Proust, oddly executed but empty and full of holes,
was put in the first row. I note with regret that the head seems
to be lit from within, like a night lamp, and the suede gloves
have been puffed out but do not contain any hands. On the
contrary, in the *Père Lathuille,* the young man and woman are
superb, and this canvas, so bright and lively, has a startling ef-
fect, for it sparkles amid all the official paintings which turn
rancid the minute one's eyes fall on them. Here is the modern-
ism I spoke of! . . . Here is life, depicted without exaggera-
tion, just as it is, in all its actuality, a daring work, unique

from the point of view of modern painting in this prolific Salon.

Other works, just as daring, were also presented by the painter in a one-man exhibition . . . [but] as always this artist, even with his good qualities, is incomplete. Among the Impressionists he has been a staunch supporter of the current movement, bringing a new concept, the test of "fresh air," to the realism which Courbet introduced, principally through his choice of subject. On the whole, while Courbet limited himself to treating, within a conventional technique enhanced by the abuse of the palette knife, subjects which were less conventional, less pleasant, and at times even less stupid than those of others, Manet overthrew all theories, all practices, and steered contemporary art into a new path.

Here ends the parallel. In spite of his old-fashioned way and ignorance of values, Courbet was a skillful practitioner. Manet had neither the strength nor the will to impose his ideas with a powerful work. Having rid himself after a fashion of imitations of Velasquez, Goya, Greco, and many others, he has hesitated and stumbled. He showed the way to others but he himself stayed in the same spot, in front of the Japanese prints, struggling with his faltering drawing, fighting against the spontaneity of his sketches which he spoiled as he reworked them. When all is said and done, Manet today is outdistanced by most of the painters who could once, and quite rightly, have considered him their leader.

At least Manet sensed that his work was as much a matter of discussion as ever. To this knowledge could be added the deeper satisfaction of Zola's criticism in *Voltaire* on June 19. However annoyed he might have been by Zola's previous equivocation, his irritation could have been dissipated by the generous challenge Zola once more flung to the critics who disputed Manet's position. But even if Zola were aware that this was an occasion to make amends, he still could not entirely suppress his disappointment that Manet had failed to fulfill his ideal of modern painting. This appears in his contention that Manet was the chief figure in a transitional

period, implying that he was not an artist of the first rank in his own right.[7]

> Edouard Manet has been one of the most indefatigable naturalistic craftsmen, and even today he has the soundest talent, he has displayed the most subtle and original individuality in the sincere study of nature. At the Salon this year he had a most remarkable portrait of Antonin Proust, and an open-air scene, *Chez le père Lathuille,* astonishingly gay and delicate in color. Fourteen years ago I was one of the first to defend Manet against the imbecile attacks of the public and press. Since that time he has worked hard, constantly fighting, impressing himself on men of intelligence with his rare artistic qualities and the sincerity of his efforts, and the originality, so apparent and distinctive, of his color. Some day we shall recognize what a place he holds in this period of transition through which our French school is passing at this time. He will endure as its most trenchant, most interesting, and most original personality.

1 8 8 1

THE SALON of 1881 occurred under unusual circumstances. The mounting dissatisfaction over the restrictive regulations which had prevailed for thirty years in the administration and organization of the annual exhibition was finally recognized by the government. On December 27, 1880 the Premier, Jules Ferry, who was also minister of education and fine arts, issued a decree whereby all artists who had ever been admitted to the Salon were invited to elect a committee of ninety members charged with arranging the next exhibition. In this way the connection between the Salon

7. Zola's four articles in *Voltaire,* June 18–22, under the general title "Le Naturalisme au Salon," contain hints of his ultimate disappointment in the Impressionists and his rejection of Impressionism as truly modern painting. For a fuller discussion of Zola's position at this time see John Rewald, *Cézanne . . . son amitié pour Zola* (Paris, 1939), chs. 16 and 22. Manet had at first expressed his annoyance at Zola's criticism in a letter to Duret, but in a second letter shortly afterward declared that "we need so much to be supported against all and sundry that a little radicalism would not be a bad thing."

and the government which had prevailed for so long was finally dissolved in theory if not in fact. Henceforward the conduct of the exhibition was to be in the hands of the artists themselves. This did not mean, however, that the Institute or the Ecole des Beaux-arts immediately lost their dominant influence over the Salon. Since most of the artists who had been admitted in the past had achieved their right of entry only through their acceptance of academic ideals, they were inclined to entrust affairs to established names and authoritative figures. At the elections to the committee in January Bonnat, Henner, Puvis de Chavannes, Jules Lefebvre, J. P. Laurens, and Henri Harpignies were elected by an overwhelming majority, sufficient indication that there would be no immediate change in the standards of the Salon. The following March this position was reaffirmed by the elections to the jury. In number of votes received the list of forty jurors was headed by Bonnat, Lefebvre, Laurens, Henner, Vollon, Jules Breton, Carolus-Duran, Harpignies, Bouguereau, and Detaille.

In spite of the conservative character of the jury Manet's two contributions were accepted. These were two portraits, each in its way a challenge to official sensibility. The first, of Henri Rochefort (Fig. 37), was by virtue of the subject susceptible to political interpretation. Rochefort, as much a political agitator as a politician, had consistently attacked and been prosecuted by successive French governments since the early days of the Second Empire. After the War of 1870 he had been condemned by the Versailles government to life imprisonment for his activity on behalf of the Commune, and was transported to New Caledonia. In 1874 he fled from the islands under dramatic circumstances in a small boat and eventually reached Europe by way of America. Only in 1880 was he permitted by a general amnesty to return to France. Soon after his arrival in Paris Manet persuaded him to sit for his portrait. Now to present in 1881 a likeness of such a man to the Salon was as clear an expression of Manet's unorthodox political sentiments as had been his attempt in 1867 to exhibit his painting of the execution of Maximilian. Rejection in this instance could have been justified on political rather than artistic grounds, but the portrait was accepted. The general opinion of the jury found some reflection in Alphonse

de Neuville's letter to Manet wherein he wrote: "I will not hide from you the fact that I would not have painted the portrait of Rochefort. At first it antagonized me toward you, but that has nothing to do with your qualities as a painter."

The other portrait, *Pertuiset, the Lion Hunter,* seems to have aroused laughter even among the jury, and indeed there is still something odd about the portly gentleman poised on one knee in the garden of his house in Paris with the pelt of a dead lion on the ground behind him (Fig. 35). Notwithstanding the somewhat ludicrous pose and accessories, the splendidly simple design and the elegantly restrained color scheme of green shot through with violet and relieved by black and white commanded the respect of the jury. It is said that Cabanel was instrumental in securing a majority vote with his remark: "Gentlemen, there are perhaps not four among us who could paint a head like that!"

Yet with two portraits in such questionable taste, at least from the academic point of view, a greater surprise than their acceptance was yet in store for the public. According to the new regulations for the conduct of the Salon this year, the members of the jury had the right to vote all the usual honors, except the grand medal of honor. Now Manet had received no official recognition at the Salon since his honorable mention in 1861, two decades before. This time certain of his friends, de Neuville, Henri Gervex, Carolus-Duran, and Guillemet among others, proposed his name for a second medal. Of the forty members of the jury, thirty-three were present at the meeting and the motion was carried by the scant majority of seventeen. Manet shared honors with a mixed company, the other painters receiving the same medal being Rixens, Comerre, Beauverie, Pointelin, Dameron, Théobald Chartran, Julien Dupré, and the American, John Singer Sargent.

The medal was worth more to Manet than a momentary sensation at the Salon. At last, at the age of forty-nine, he was hors concours; in the future he could send to the Salon what he pleased without having to submit his works to the jury. And in the hierarchy of French official dignities he was now eligible for honors superior even to a second medal.

For the public and the critics the award of the medal was a

signal to revive the whole question of Manet's significance for modern French art. Paul Mantz, who may have regretted his indulgence the year before, thought the *Rochefort* "purely and simply a portrait badly painted. But the portrait of Pertuiset, disguised as a lion hunter, is valuable as a manifesto . . . The hunter lying in wait for his prey, the surrounding landscape, the death agony of the lion skin, are enveloped in a truly indescribable purplish-red atmosphere."

For some the award could only be treated as a bad joke, as Olivier Merson declared in the *Monde illustré* on June 4:

> Good heavens, the best thing to do is to laugh it off. One could be angry. Certainly the circumstances invite such a reaction, for the public, which is not so stupid as is thought, look on in wide-eyed surprise, asking if it is being made fun of, while the connoisseurs shrug their shoulders in pity! Nonetheless, it is best to look at the matter from the comic and amusing side.

For others it was a more serious matter, one which called in question the relation of Manet to the French tradition. The most reasonable and considered statement of this point of view was presented by René Ménard in his Salon this year in *L'Art:* [8]

> The commotion which occurs at each Salon over the name of Manet has been increased this year by an official award which some consider a very tardy and entirely inadequate reparation, while others are tempted to see in it an incomprehensible bit of mystification. In any case this award satisfies no one and takes first place among the complaints which have arisen on all sides against the decisions of the jury in regard to the awards. Manet is not a newcomer, and those who are satisfied to laugh over the brutality of his technique only give proof of a very superficial acquaintance with artistic matters. This painter has a doctrine, he carries a banner, he is the leader of a school. And when I say that he is the leader of a school, I do not mean that

8. René-Joseph Ménard (1827–87), painter and critic. Exhibited landscapes and animal studies at the Salon until 1866. Author of several studies of decorative art and mythology.

he teaches art to young people who have come to put them-
selves under his direction; I know very well that he does noth-
ing of the sort. But I insist that his painting disturbs even the
artists who slander it most, and that after shrugging his shoul-
ders before a work which he has qualified as detestable, more
than one painter has said to himself, "This man knows neither
how to draw nor paint, but he has a manner of seeing nature
which is not without charm." I am absolutely sure that Manet
has exercised and still exercises a very real influence on con-
temporary painting.

Does this mean that Manet is a man whose talent is destined
to compel recognition and to triumph one day over all the
reservations of public opinion? I should not dare to maintain
that, for I have followed this artist since his beginnings and
I do not know a single work of his which can hold its place
beside those of the masters. To uphold for twenty years a
doctrine which still endures in spite of the very poor reception
which it has everywhere received is assuredly a sign of strength,
but never to formulate it in a decisive work is at the same time
a proof of weakness. This is Manet's position. As a revolution-
ary his banner proclaims his courage, but each of his works is
a new witness of impotence. I shall not mention his portrait
of Rochefort, destitute of any character as drawing, but his
Lion Hunter has indeed the right to arrest our attention, since
a jury of artists signals him out for impossible attention, and
the lion which he has killed never resembled any real beast
whatsoever. The absence of drawing is a fault which one must
concede to Manet since he is accustomed to it, but the color
of a painting lives only in the concord of hues which vibrate
in unison, and here all the colors are out of tune. The face itself
is accurate enough in color but it swears in this place, and the
violet color of the ground can, at worst, be found in nature
but never with such intensity. In the portrait of Antonin
Proust in the last Salon, in the *Bon Bock,* and in several other
works by Manet, the painter's audacity depended less on ac-
curate resemblance. Now that is precisely what is lacking here,
and Manet, whose talent has always been very uneven, has

certainly not raised himself this year to the height of his previous exhibitions. I don't complain at all about the medal which has been awarded him, but I deeply regret that he has not had it sooner, because it would perhaps have been applied to works infinitely more meritorious.

Another instance of the seriousness with which the critics usually favorably disposed toward Manet felt obliged to weigh the matter appeared in Roger-Ballu's article in the *Nouvelle revue:*

I have never treated this painter lightly, as has been done too often and deliberately. I have always endeavored to prize what was unusual and surprising in his disordered and confused work, where the good was mixed with the bad. But I confess that this time I must let the diatribes take their course. There is no more trace of the accurate perception of values, of those niceties in the relation of spots of color of which the preceding works offered us examples here and there. Those unique but precious qualities have departed, and I leave you to divine in what condition their absence leaves the painting of Manet . . . Never mind. Let us pass by quickly with regret for the real pictorial ability of a painter which will be extinguished without having produced anything, which will have been invisible since it has remained sterile, and which could have sustained and inspired a great talent if it had not been allowed to become perverted by such paradoxes of strangeness and ugliness.

Huysmans' review was decidedly unfavorable. For him the political character of the portrait of Rochefort was of small account, committed as he was to more strictly artistic concerns, but the undeniably theatrical properties of the *Pertuiset* disappointed the critic who had considered Manet the leading painter of modern life. In these terms his criticism is not unreasonable, although the harshness is unexpected after his previous admiration for Manet's scenes of contemporary life.

This year is decidedly bad, for now Manet in his turn is going to pieces. Like a new wine, a bit sharp but clean and of un-

usual taste, this artist's painting was strong and heady. Now it
is adulterated, laden with dregs, devoid of all bite and fra-
grance. His *Portrait of Rochefort,* executed in the semiofficial
technique, doesn't hold together. You might think that these
flesh tones were made of green cheese, all speckled and spotted,
and that the hair were grey smoke. There is no contrast, no life.
Manet has in no way understood this unusual physiognomy,
so delicate and nervous. As for Pertuiset on his knees about to
level his gun in a drawing room where doubtless he sees some
wild animals, with a stuffed yellow lion stretched out behind
him under the trees, truly I know not what to say. The pose of
this bewhiskered hunter, apparently slaying a rabbit in the
woods of Cucufa, is childish. In technique this canvas is not
superior to the wretched daubs which surround it. To distin-
guish himself from them Manet has seen fit to smear the earth
with violet; it is an uninteresting and too easy trick.

Such support as Manet found this year was rare compared to
these opinions. In *Voltaire* on May 12 Emile Bergerat wrote:

Here we are face to face with an energetic and influential per-
sonality . . . Do you really know why you laugh at the Salon
when you see the fluent blue harmonies of Pertuiset, the lion
killer? It's because the canvas is surrounded with shapeless
odds and ends which lack accent, color, and consistency. The
contrast is striking. Goya has made Picot's pupils laugh.

Bergerat's reference to Goya awakens echoes of Manet's first
criticism. Fifteen years earlier he had been reproached for imitat-
ing the Spanish masters. Paul Mantz accused him of acting like
a "Goya run mad in Mexico," Thoré-Bürger chided him for re-
sembling Greco and Ribera. For Zola he had "spoken with the
strongest Spanish accent." Now once again, in 1880 and 1881, the
critics were reminded of certain relations with Spanish painting.
Perhaps, as was not unusual, they were running together as a pack.
On May 5, in the *National,* Charles Flor discussed the portrait of
Rochefort with reference to a remark by one spectator that it re-
sembled Velasquez:

Compare this portrait with any other in the Salon and it will look false to you, but confront it with nature, with a man passing by, or, if possible, with Rochefort himself, and you will be struck by the great style, by the masterly bearing, by the powerful sincerity of this portrait, conceived and executed without regard for the banal conventions of the craft. . . . I repeated earlier the comparison which I heard expressed the other day: "It resembles Velasquez!" Are you indeed aware that this comparison is not so very exaggerated, and that Manet recalls the great Spanish master in more than one way?

Maurice Du Seigneur, in his reviews which he collected under the title *L'Art et les artistes au Salon de 1881,* was also reminded of Spanish painting: [9]

Manet is exhibiting two portraits. One, of *Henri Rochefort,* is painted in full light and with a broad brush, pallid but surprisingly truthful. The other, of *Pertuiset, the Lion Hunter,* disconcerts us quite a bit with its violet shadows and the stuffed animal. In spite of everything we are haunted by the memory of the Spanish painters, even in front of Manet's lesser canvases.

And Du Seigneur thereupon reprinted Baudelaire's letter to Thoré-Bürger absolving Manet from the accusation of having imitated Spanish painting.

With or without the approval of the public and the critics, Manet had won a medal of the second class. Armand Silvestre, on June 4 in *La Vie moderne,* assessed the award at its true value:

Frankly, Manet is above these qualified distinctions. Either you like his painting or you don't. For my part, I like it. Its audacious mastery should preserve it from such humiliating encouragement. They tell me that the jury thinks it has done well and even proved itself truly liberal by bestowing this award on Manet. So be it. I have nothing more to say. It seems

9. Maurice Du Seigneur (1845–92), architect and art critic, contributed to *La Vie littéraire* and *L'Artiste,* author of *L'Art et les artistes aux Salons* (1880–82), and *Les Principaux Monuments de Paris* (1892).

that even now there are still persons—how shall I put it, jury-men?—who think Manet's painting is only good for a laugh, and that this inquiring and audacious artist is one of the live-liest practical jokers of the day. The jury's decision with respect to these people has the character of a courageous protest. I am also told that the younger members of the jury wanted to thank Manet for the services he has rendered the school of modern colorists. A second-class medal for having had a great influence on our times! Don't you think that's a bit small?

Silvestre's opinion was not widely shared. At the distribution of the prizes, upon the closing of the Salon on June 26, the pro-nouncement of Manet's name was at first greeted with jeers, quickly drowned with applause. Manet, aware of his unpopularity on such occasions, had prudently remained at home.

As a well-known painter, recognized at the very Salon which from 1863 to 1878 had on five occasions been the scene of his greatest humiliations, he was now eligible for the Legion of Honor. That he should have prized a decoration scorned by such predecessors as Courbet and Daumier is merely another indication of his deter-mination that his manner of painting, already accepted as the most fertile influence in modern painting by some members of the younger generation, should be so acknowledged by the administra-tion. In November Gambetta became premier and appointed Antonin Proust minister of fine arts. The latter lost no time, and on December 30 Manet was made a chevalier of the Legion of Honor. It was none too soon, not only for Manet but for Proust, since the next month Gambetta was obliged to resign and Proust's short-lived tenure of power came to an end.

Manet appreciated the irony of the situation. To a congratu-latory letter from Ernest Chesneau which conveyed the good wishes of Nieuwerkerke, the very person who as minister of fine arts under the Empire had been so instrumental in maintaining the official attitude of disapproval toward him, Manet replied: "When you write to Nieuwerkerke tell him that I appreciate his good wishes, but that he himself should have been the one to decorate me. He would have made my fortune and now it is too late to make amends for twenty years of failure."

It was indeed too late. Not only had Manet managed to make his own way, unaided and opposed by all the forces of public and official opinion, but he was nearing the end of his career. An inflammation of the legs which had developed during the winter of 1880 was rapidly becoming more acute. From a letter to Mme. Emile Zola wherein he apologized for not coming himself to collect her portrait which was to be included in his exhibition at *La Vie moderne,* it is apparent that as early as April 1880 he had been forbidden to climb stairs. That summer he followed a course of hydrotherapy at Bellevue, where with his family he rented a villa belonging to Emilie Ambre, the opera singer whom he had painted in the role of Carmen.[10] The treatments had not produced the desired results and in 1881 Manet again retired to the country for the summer months, this time to Versailles. He was more and more frequently obliged to rest in order to prevent the recurrence of severe pains in his legs. The following summer when he rented a villa at Reuil, he was scarcely able to stir from his chair. The result of this enforced inactivity appeared in the character of the work executed during these summers. At each of the three places he painted several views of the gardens, but more and more he had to be satisfied with sketching, in water color and pastel, still lifes of the fruit and flowers which came as gifts from his many friends.

1 8 8 2

AFTER his return to Paris in the autumn of 1881 Manet occasionally appeared in public, leaning on a stick and concealing with difficulty the pain which tormented him. As a born Parisian he had resented his enforced absence from the capital. Heretofore he had scarcely ever been away from town for more than a few weeks at a time, even in the hottest months of the summer. When he returned it was therefore to revisit as many of his favorite pleasure haunts as possible and from one of them, the café of the Folies-

10. During the winter of 1879–80 Ambre had brought Manet's *Execution of Maximilian* to the United States with her on a concert tour. It was exhibited, with an admission charge, in Boston and New York, where it aroused considerable interest as the first large, so-called Impressionist painting to come to America. See Kurt Martin, *Die Erschiessung Kaiser Maximilians von . . . Manet* (Berlin, 1948).

Bergère, he derived the subject matter for his final large Salon painting.

For the first and last time in his life he was, by virtue of the medal of 1881, exempt from the necessity of submitting his work to the jury. His adversaries could not even let his admission to the Salon under these circumstances go unremarked. Just before the convocation of artists for the election of the jury on March 24 anonymous pamphlets were circulated denouncing the seventeen jurors who had voted Manet his medal. To the credit of the assembled artists, all but four of the seventeen were re-elected to the jury, and Manet's contributions passed without comment.

Of the two paintings, one was a portrait of Jeanne de Marsy, a young actress who had posed for Manet as early as 1875 and whom he now painted in profile against a background of flowers and shrubs (Fig. 36). The painting, which bore the subtitle *Spring,* was intended as the first of four canvases symbolizing the seasons of the year in the guise of beautiful women of his acquaintance. In addition to this painting only *Autumn,* posed by Méry Laurent, was completed.

Before this captivating vision of spring and youth it was hard for even his most determined opponents to remain unmoved. For the most part such persons ignored the canvas and concentrated their attention and attacks on the vulgarity and peculiarities of the *Bar at the Folies-Bergère* (Fig. 39). But there were some generous tributes, among them Maurice Du Seigneur's in *L'Artiste* on June 1:

> Since we are speaking of living flowers, let me introduce you to *Jeanne* by Edouard Manet. She is not a woman, she is a bouquet, truly a visual perfume. Manet's defenders are delirious, his detractors stupefied, and Mlle. Jeanne strolls past them, proud and coquettish, in profile, her eyes alight, her nose turned up, her lips parted, with a winning air. A parasol, long suède gloves, not quite twenty years of age, and a full, fine figure. That describes her.

In the *Bar at the Folies-Bergère* Manet had painted in his studio, from sketches made on the spot, a study of a barmaid standing at

the counter and apparently engaged in conversation with a man whose reflection is seen in the mirror behind her.[11] For the literal-minded spectator there were several puzzling discrepancies in the composition. Although the mirror is apparently parallel with the picture plane, it must be understood as being at an angle to the bar in order to account for the man's position. He, in turn, can only be explained as a reflection of the spectator himself, who is thus obliged to imagine himself in conversation with the barmaid. To the accusation that the painting incorrectly represented the reality for which Manet and the naturalists were striving could be added the charge that the subject was vulgar and inappropriate for the Salon. And following upon the theatrical and almost polemical character of the *Pertuiset* and *Rochefort* of the year before, Manet's choice of subject and more Impressionist technique seemed further evidence that the artist was guilty of a bewildering variety of manners and even a lack of consistency in his point of view. No one thought to point out that the *Bar* was merely the logical result of a tendency, in subject matter and technique, which had commenced with the dark and Dutch tonality of the *Bon Bock* and which led, through the gradual decline of sentiment and increasingly broader brush-work of the café scenes of his exhibition at *La Vie moderne* in 1880, to this final magistral version of the barmaid. In herself she was rooted in Paris and the tradition of Parisian night life. In composition and execution, in the size and brilliance of the work, the subject had been elevated to the rank of Salon historical painting.

There were some who admired the painting immediately. Louis de Fourcaud, who had become one of the painter's close friends and a frequent visitor during his illness, thought the *Bar* even more "significant" than *Jeanne,* for which he had nothing but praise.[12]

11. For a detailed examination of the painting see Raymond Mortimer, *Edouard Manet, Un Bar aux Folies-Bergère* (London, 1943).

12. Louis Boussès de Fourcaud (1853–1914), journalist and critic, contributor to the *Gazette des beaux-arts* and *Figaro*. In 1893 he succeeded Taine as professor of aesthetics and art history at the Ecole des Beaux-arts. He was one of the early enthusiasts for Impressionism and the music of Wagner. Author of several monographs on earlier nineteenth-century artists. For a study of his criticism see S. Roche-blave, "Les Salons de Louis de Fourcaud," *Gazette des beaux-arts*, Series 5, *13* (1926), 37–59.

In the *Gaulois* on May 4 he wrote:

> It is one of the best, the most original, most novel, and most
> harmonious paintings he has produced. . . . For a long time
> the most talented painters have done justice to Manet. The
> time will come when he will be ranked as the Goya of France,
> endowed with some of the virtues of Frans Hals.

Again the suggestion occurs that Manet's painting recalled the
work of the great Dutch and Spanish masters. Those critics were
the more acute who recognized this tendency in work which, so far
as Manet's development was concerned, was emphatically the ex-
pression of his own temperament and personality. The shift in
emphasis from detraction to admiration of the supposedly Spanish
character is a real, if slight, indication that it was possible to iden-
tify the Spanish quality in Manet's work as that reliance on the
total and unadulterated evidence of vision which he shared with
Velasquez. Only habit and prejudice prevented general acknowl-
edgment that a contemporary painter could work this way, and
that this was the way Manet had chosen. As Emile Bergerat re-
marked, on May 10 in the *Voltaire:*

> Here is something seen, sincerely and afresh, and it shakes us
> out of our routine. . . . If Manet were Spanish, and if he were
> called Manetto y Lucientes, you would all exclaim that it was
> a miracle. . . . Alas, he is only a Frenchman!

More than one critic commented upon the novelty of the work,
now not as a quality with which to reproach the artist, but as one
of his important contributions to modern painting. In the *Annuaire
illustré des beaux-arts,* an illustrated handbook of the Salon, Ernest
Chesneau was even more specific on this point:

> The essential quality of the painting consists not in the vulgar
> type of woman but in the accurate vision of things, of their
> coloration, of their luminous vibration, of their fluctuating
> and transient appearance, so fugitive and swift. Therein lies
> Manet's triumph. He does not immobilize forms. . . . he sur-
> prises them in their effective mobility. . . . It is an artistic

formula which is very new, very personal, very piquant, the immediate conquest of the artist over the world of external phenomena, and which will not be lost in the future.

Huysmans was more pleased than he had been the year before, but he was still not entirely satisfied, nor unusually perceptive. In his notes on the Salon, published as an appendix to his book on modern art which appeared in 1883, he wrote:

> The subject is very modern and Manet's idea of thus putting the female figure in its environment is ingenious; but what is the meaning of the lighting? Is it gas or electricity? Or is it perhaps an indefinite out-of-doors light, bathed in pale daylight? From this point of view, everything falls apart. The Folies-Bergère exists and can only exist in the evening. Treated in this adulterated fashion it is absurd. It is truly deplorable to see a man of Manet's talent sacrifice himself to such subterfuges and make his paintings, when all is said and done, as conventional as the others.
>
> I regret it all the more, for even with the chalky color his *Bar* is full of good qualities. The figure is well placed, and the crowd is in lively movement. In spite of everything this *Bar* is certainly the most interesting and most modern in the entire Salon.

Huysmans' reserved admiration of its novelty and modernity is one indication that the *Bar* had to be reckoned with as one of the most important paintings of the year. More convincing evidence of the extent to which Manet had succeeded in imposing his ideas, not alone upon a few progressive critics but even upon the character of the Salon as a whole, came this year from the very organ which during the 1860's had scrupulously ignored him. In the *Revue des deux mondes* of June 1, Henry Houssaye began his lengthy survey of the Salon by facing "the Manet problem" first of all. His confused and bitter attitude shows how the conventional academic insistence on an ideal standard of beauty, which Zola had denounced fifteen years before, was still effective in official circles. Houssaye's criticism of Manet and the Impressionists, whose method and manner he inextricably confused, again suggests how

difficult it was to overcome old habits of vision, even when the subject matter of modern life might partially have been acceptable. His *Salon* began:

> The character of the Salon of 1882 is very significant. It is marked by the intrusion of banal and vulgar scenes of contemporary life into the field of serious painting. It also witnesses, over a wide range, the renewal of technical methods inspired by the little cult in which Manet has been mocked as the pioneer and Bastien-Lepage hailed as the Glorious Apostle. The Salon is both *naturalist* and *Impressionist*.
>
> Will the triumph of these related movements long endure? It already appears that naturalism in literature, having reached the last depths of the gutter, henceforth has no purpose. But for painting the field is still immense. . . . Personally we deplore the lack of interest in serious painting as it once was understood. Not only are we simple enough to believe that one can put a more elevated feeling into a *Descent from the Cross* than into a *Bar at the Folies-Bergère*, and we think that a bit of Greek drapery has more grace and nobility than overalls and overcoats, but we particularly regret the absence of scenes of mythology and ancient history because they are the only subjects suitable for the nude. Besides, we agree with Théophile Gautier that "without the nude and without drapery there can be neither painting nor sculpture in the true sense of the word."

Houssaye went on to accuse the Impressionists of trying to paint modern subjects without a really modern technique: "Impressionist painting, which is derived from the primitive masters and from Japanese prints, is an anachronism." For Houssaye the true study of light and air was part of the whole heritage of Renaissance art, but for better or worse he had to admit that at the Salon there were at least two hundred paintings which showed the influence of Manet and of Bastien-Lepage. Houssaye himself felt that the conjunction of these two names required some explanation.

> The only difference between Manet and Bastien-Lepage is the difference between a painter who does not understand his

trade and a painter who knows his very well and willingly forgets it half the time. There is also the difference between a sincere painter and a clever one. The former, as we said, is a pioneer, the latter is an acknowledged leader. Manet has sown, Bastien-Lepage reaps. If one uses the word masterly only to mean serious painting, Manet is not a master; far from it. But if the word is taken to mean teacher, or rather initiator, the painter of *Olympia* should be hailed as a master. His influence is apparent upon a whole group of contemporary painters. It is he who since 1860 has advocated, preaching by example, the crude effect of diffused lighting, unusually bright coloring, large areas of color taken from Japanese prints, simplified modeling of the flesh, and a general effect easily obtained by parts completely modeled and by parts left in the state of a sketch.

Houssaye's disparaging conclusions contain a hint that he had some doubts as to his own judgment:

Doubtless everyone does not judge this way. How many people see in the new school the renovation and the future of French art? In not admiring the Impressionists we may then be as blind as Kératry who wrote that [Géricault's] *Medusa* dishonored the Salon. Kératry was mistaken but he was honest, just as we ourselves are. If a critic were so hesitant as to fear that some day his judgment would be reproached, he would have to praise everything to the skies on the pretext that everything can be consecrated by posterity. Moreover, in the event that posterity will put Impressionism and Romanticism on the same plane, the painter of the *Medusa* and the painter of the *Olympia*. . . . what assurance is there that posterity will not be mistaken? To have had the nobility of the seventeenth century, all the grace of the eighteenth and the grandeur of the nineteenth, and on the threshold of the twentieth to sink to every triviality, what a consummation for French art!

Houssaye discussed Manet's painting in detail only in the following issue on June 15 where, after an enthusiastic account of John

in the public mind. If Manet had any hopes in
Albert Wolff's comments must have encouraged
the day the Salon opened, Wolff wrote in *Figaro-*

agree with Manet on all counts. His hatred of
and powdered painting often makes him exceed
. But, in the end, he has an individual tempera-
nting is not for everyone; it is the work of an in-
st, but still of an artist. . . . There is no denying
t is entirely his own. He has not borrowed it from
, he has taken it from nature.

day Manet thanked Wolff for his unexpected
the irony of which was shortly to assume a tragic

r the pleasant things you said with regard to my
ut I should be sorry not to read, in my lifetime,
rticle which you will devote to me after my death.

1 8 8 3

1882 had again been spent in the country, at
et painted views of the house and garden and a
es of flowers and fruit. The landscapes of these
s, painted at Bellevue in 1880, at Versailles in
at Reuil, are the most strictly Impressionist, in
, of all his work. Obliged by the circumstances of
ndon large figural compositions, he concentrated
ment of nature immediately before him. The
these last years, devoid of incident and usually
Manet to that place among the Impressionists
vere even then so busily denying him.
inued to fail upon his return to Paris in October.
appearances in public and a few visits to his
winter months, he was from the end of March
arly in April his left leg became gangrenous and
putation was performed from which he failed to

Singer Sargent's *El Jaleo* (Boston, Gardner Museum), he confessed
that:

> We really must mention Manet's contribution since we have
> acknowledged him as a master. It seems that this painting
> represents a bar of the Folies-Bergère; that this violently blue
> dress, surmounted by a cardboard head such as we used to see
> in milliners' windows, represents a woman. . . . We might
> indeed be tempted to pass immediately to another canvas, but
> then it would be said that our criticism is not serious. As if
> Manet's painting were serious! In all honesty must we admire
> the chalky flat face of the bargirl [sic], her flat bust, her of-
> fensive color? Is this painting true? No! Is it attractive? No!
> Well, then! What is it?

Houssaye's question was easily answered. On June 20 the critic of
L'Illustration, Jules Comte, thought that the *Bar* was

> . . . only one more defiance of all the laws of common sense
> and logic. To tell the truth, we had not counted on even men-
> tioning Manet here, and it is with real regret that we devote
> these few lines to his painting, lines which we could have used
> for discussing more serious works. But Manet is hors con-
> cours; Manet has been decorated. Everyone is talking of Manet.
> They want to make him out as the leader of a school. We are
> thus obliged to do as everyone else, and to state once more how
> insincere is this infatuation of a few persons for a painter who
> has not even the elementary qualification of knowing his trade.

Paul Leroi, writing in *L'Art*, stated in no uncertain terms his
distaste for Impressionism, which he characterized as "vandalism"
destroying "everything which constitutes the essence of art." He
heartily disliked the *Bar*, thinking the figures a "complete failure,"
yet at the same time he admired *Jeanne* and used it as a pretext to
suggest that Manet had broken with the Impressionists.

> I do not know a more devastating satire than this *Jeanne*, so
> utterly charming and so well aware of her charm, for the chilly
> foibles of the Impressionists. I strongly suspect that Manet has

entrusted her to intimate to that group that it no longer suits him to pose as their ancestor or to play the part of high priest for this hysterical cult. But why the devil doesn't Manet always paint this way?

Possibly the most interesting statement appeared on June 1 in the *Gazette des beaux-arts* where Manet had for twenty years been consistently belittled or ignored. The review this year was written by none other than Antonin Proust. Since this was the first time Proust had spoken out in print in favor of his friend his remarks are of some consequence for the history of Manet's works. They are also significant as marking, now that Manet had been before the public for twenty years, the extent to which his conquest of contemporary life had achieved semiofficial recognition. In Proust's opening remarks on the character of the Salon we catch the hint of his conversations with Manet, not only through the years but from the days when they were companions in Couture's studio and the youthful friends of Charles Baudelaire who had first opened their eyes to the charms of modern life. In the introduction to his *Salon* Proust reached a conclusion exactly the reverse of Houssaye's:

> The Salon of 1882 will rank among the best of this age. It is distinguished from those which have preceded it by a greater respect for the environment in which we live. And in that there is progress for which one cannot be too grateful. Our century has been, in effect, very slow to reconcile itself to its own appearance. Finding ourselves overdressed or badly dressed, we have for a long time given in to the fantasy of draping ourselves in the antique manner or masquerading in the apparel left us by the past. And even today we are so reluctant to represent ourselves as we are that very recently, when it was a question of a statue destined to decorate the new Hôtel de Ville, there was a serious deliberation as to whether the hat which fashion afflicts upon us should be used.
>
> For my part I am very far from proscribing allegory. I have no intention of underestimating the merit that there may be in retracing scenes of history, saturated with what is called local color, but I confess that I have a pronounced taste for the

representation of th
First, because art sho
search for contemp
seems to me most un
dence of our own ti
Thus a simple inte
preferable to the mo

For almost thirty
studies which are so
honest. I call these
viction, he does no
thing which has bee
stantly experiment w
Among these there a
effects, as indication
those who study the
in our public collect
to the painters who
by the instruction w
simply embellished l
line in our museum:
he is not yet accepte
before the decision i
his more fortunate
was walking, downca
bourg with one of th
asked him what he
plied the painter of
Museum, "that you
could have been mo
should zealously coll
acter, whatever may
. . . The obligation
and not to proscribe
the sentiment of pre

Proust's suggestion tha
the national museums wa

soon be very muc
this direction, eve
him. This time, or
Salon:

> I shall never
> the perfumed
> his intention
> ment. His pa
> complete arti
> it; Manet's a
> the museums

The following
praise in a letter,
cast:

> My thanks fo
> exhibition. F
> the splendid

THE SUMMER O
Reuil where Mar
number of still li
last three summe
1881, and finally
terms of techniqu
his ill health to ab
on the small fra
few landscapes of
of figures, entitle
which the critics

His health con
After a few mor
studio during the
confined to bed.
on the 18th an a

rally. His fever increased daily and his strength ebbed. On Monday, April 30, at seven in the evening, Manet died in the fifty-second year of his age.

Since the gravity of his illness had been known in Paris for some weeks, his death was not unexpected and was the occasion for numerous obituary notices and extended criticisms. On the whole these added little to the character of earlier criticism, since in most cases writers long familiar with his work merely used the opportunity to summarize opinions they had expressed at length elsewhere. Three notices may be taken as representative of the prevailing attitudes toward his work.

Albert Wolff's was among the very first to appear in print. During Manet's lifetime his criticism had been chiefly remarkable for the equivocal attitude he had adopted toward the painter. Now that Manet was dead his tribute was all the more curious for the grudging assent he gave to his work by mentioning only two paintings, and those Manet's most traditional. So Wolff was able to disparage the entire Impressionist accomplishment of the artist's last years. At the head of his article in *Figaro* on May 1 he reprinted Manet's letter of 1882 in which the painter had expressed his regret that he would not be able to read the "splendid article" Wolff would devote to him after his death. The "splendid article" continued:

My poor friend died without my being able, in spite of all the sympathy I felt for him as a man and as an artist, to write the article he wished and which I would have been happy to sign. This was because an understanding was impossible between the critic and the painter, for the reason that Edouard Manet understood art entirely in terms of the principles which he upheld, and which the critic stubbornly could not grant such a high place. . . .

It is certain that Edouard Manet belongs to the history of painting in the last third of this century, and that his name will always be taken into account by those who shall be concerned with this period in art. Manet will leave a lasting trace in this history of French painting.

With Manet one of the most interesting artistic personalities

of our time disappeared. His few superior works, conceived
without regard for any revolutionary preoccupations, born of
pure artistic inspiration, will endure. Manet did not have the
satisfaction of seeing one of his canvases in the Luxembourg.
The future will vindicate him by placing the *Bon Bock* and the
Boy with a Sword in the Louvre. To die at fifty and to leave
behind him two excellent pages worthy of inclusion among the
manifestations of French painting is enough glory for an artist.

As usual Wolff misjudged Manet. The *Boy with a Sword*, so
thoroughly Spanish, and the *Bon Bock,* so completely Dutch, are
witnesses of Manet's preoccupation with the European tradition;
neither is an account of his true contribution to French painting.
And neither entered the Louvre: the first is in the Metropolitan
Museum in New York, the second in the Tyson Collection in the
Philadelphia Museum of Art.

A more honest and more searching estimate of Manet's position
in the light of the academic tradition was published by Jules Comte
on May 12 in *L'Illustration.* His insistence that Manet had neg-
lected the primary artistic truths of drawing, modeling, form, and
interpretation of subject matter may be allowed to stand as the final
accounting from this point of view. These will always be the charges
brought to bear against Manet by those who are opposed to the
realist-Impressionist aesthetic, whether in terms of technique or
subject matter.

> Manet could have followed like others the beaten track; he
> preferred to place himself outside tradition and to seek a new
> path. It is only fair to be grateful for the merit in his effort be-
> fore judging the results which he achieved; he will be forgiven
> much for having dared much.
>
> As for the results, they are unfortunately notorious. To try
> to paint modern life, to claim that a nude woman need not
> necessarily be a goddess or a nymph, to insist, if we are present
> at a bathing scene, that the water should be painted out of
> doors and not in the studio, these are elementary truths which
> no one dreams of disputing, but which taken together should
> not actually comprise a new aesthetic. . . .

An aesthetic, besides, is only valuable in its applications. Now what has Manet accomplished since the day he claimed to have freed himself from the conventions of the studio? What stirring or inspiring scenes, what true paintings has he alone given us? Not one, at least among those which we know. His *Bon Bock* is perhaps the best of his paintings, and that is only an unfinished work. We have often said that it is easy to know how to stop when the going becomes difficult, but that is a talent which should not be developed as a theory nor made to constitute a school. There is no art without imagination, there is no painting without drawing, and even when it is granted that Manet had sometimes lighted upon happy juxtapositions of color, even when it is conceded that he possessed up to a certain point what we may agree to call a feeling for values, it will remain no less true that this theorist, who talked only about nature, never knew how to draw and never painted anything but manikins.

Moreover, a comprehensive exhibition of his work has been announced for the summer. We shall then see, at our leisure, what is the value of theory without technique and what weight the admiration of a few friends carries with the larger public.

To the admiration of a "few friends" whose number, as we have seen, had slowly been increasing with the passing years, was added that of Gustave Geffroy, a young writer who would later become one of the first serious historians of Impressionism.[13] On May 3 he had written in the *Justice:*

What we can insist on, even now, is not the importance of Manet's canvases taken by themselves as museum paintings, but the importance of his position as an innovator from the point of view of art history.

These are the larger consequences of the revolution which he began, of the influence which he had wielded and which he

13. Gustave Geffroy (1845–1926), critic and novelist. His best articles were collected in the eight volumes of *La Vie artistique* (1892–1903). He was a friend of Clemenceau and from 1908 administrator of the Gobelins. His portrait by Cézanne (1895, Paris, Pellerin Collection) is in the succession of Duranty's by Degas (1879, New York, Metropolitan Museum), and Zola's by Manet.

will wield until the day when another original artist shall come again to speak to the exasperated public who will stone him in the name of Manet, whose *Olympia* and *Déjeuner sur l'herbe* will then be in the Louvre.

Geffroy wrote as a historian, not as a partisan. From that point of view he was able to prophesy more accurately than Wolff. *Olympia* entered the Louvre in 1890, the *Déjeuner sur l'herbe* in 1906.

Manet's funeral was held on May 3. The pallbearers were his oldest friends and staunchest champions, Zola, Duret, and Burty; Alfred Stevens, whose long friendship had been maintained in spite of the astonishing dissimilarity, to modern eyes, of their paintings of the world of Parisian femininity; Fantin-Latour, who had earliest proclaimed Manet as a realist in his *Homage to Delacroix* and *Studio at Batignolles,* and whose portrait of Manet remains the most convincing likeness of the painter as a gentleman and *boulevardier;* Claude Monet, who had introduced Manet to the Impressionist doctrine and technique; and lastly, Antonin Proust, who delivered beside the grave in the cemetery in Passy a brief eulogy in which he spoke of his lifelong affection and admiration for Manet as a generous friend and great artist.

WITH 1883 THE criticism of Manet's work as the production of a living artist, contributing annually to the development of French painting, comes to an end. Henceforward the student is concerned with the stages by which his present position as a painter in his own right and in relation to his contemporaries became finally established. Each decade during the half century after his death saw his position more firmly secured, until in 1932 the centenary of his birth was celebrated by a large retrospective exhibition, skillfully organized and installed in the Orangerie in the Tuileries Gardens. Manet had conquered the last stronghold of French conservatism, and however sympathetic or antagonistic the individual critic might henceforward feel toward his work, the historical importance of that work could not be ignored. He had become an integral part of the tradition many of his contemporaries feared he would destroy.

Within a year after his death the first two steps were taken toward assuring Manet his rightful position in French art. Because his last illness had left the immediate family—his wife, his mother, and Léon Koëlla-Leenhoff—in considerable debt, a posthumous sale of the works remaining in his studio was necessary to settle his estate. It was thought that before such a sale an exhibition of his paintings, under the most auspicious circumstances, would be to the benefit of his heirs. Théodore Duret and Antonin Proust were charged with the arrangements and the choice of a hall. Their selection of the Ecole des Beaux-arts, the stronghold of conservative hostility to Manet's painting, would seem foolhardy unless one recalled that in

1882 Proust and Castagnary had prevailed upon the government, through Proust's prestige as a former minister of fine arts and Castagnary's position as minister of education, to open the exhibition halls of the Academy for a retrospective exhibition of the works of Courbet.

Now two years later Proust used his influence again with the premier, Jules Ferry, a countryman of Courbet and long a friend of Manet. Although Ferry disliked Manet's painting he had admired him as a man. He consented to permit the use of the Ecole des Beaux-arts during the month of January 1884. The general supervision of the exhibition was exercised by Proust, Duret, and Koëlla-Leenhoff. Edmond Bazire, a man of republican sentiments like Duret, Thoré, Castagnary, and Zola, had in press a monograph on the artist. Since this would appear in conjunction with the exhibition, Bazire was entrusted with the hanging of the works and the preparation of the catalogue.[1]

The exhibition, which opened January 4 and continued through the 28th of the month, consisted of 116 paintings, seven water colors, thirty-one pastels, twenty-six etchings and lithographs, and thirteen drawings. Of the thirty-eight paintings which Manet had offered to the Salon during his career eight were still unsold at the time of his death and were lent to the exhibition by his widow. These were *Olympia,* the *Balcony,* the *Music Lesson, Argenteuil,* the *Laundress, Chez le père Lathuille,* the portrait of Rochefort, and the *Bar at the Folies-Bergère.* Faure was still the owner of the largest collection of Manet's works in private hands; from his twenty-three he lent the *Absinthe Drinker,* the *Spanish Guitarist,* the three works of the Salon des Refusés, the *Dead Toreador,* the *Fifer,* the *Luncheon,* the *Bon Bock,* the *Opera Ball,* and *In the Conservatory.* Manet's mother lent the early portrait of the artist's parents. Zola and Pertuiset contributed their own portraits; Proust lent his portrait and *Jeanne.* Henri Guérard, the husband of Eva Gonzalès, who had died in childbirth just five days after Manet's death, lent her portrait. From other individuals came the *Young*

1. The catalogue may be consulted in E. Moreau-Nélaton, *Manet raconté par lui-même* (1926), 2, 127–32; see Figs. 338–53 for photographs of the installation of the exhibition.

Woman of 1866, the *Kearsarge and Alabama,* the *Swallows, Le Repos* lent by Duret, the *Chemin de fer* from Durand-Ruel, the water color of *Polichinelle* lent by Mme. Martinet, *Boating,* and the portrait of Desboutin. The only Salon paintings not exhibited were the two religious pictures of 1864 and 1865, the portrait of *Faure as Hamlet, Nana,* and the *Tragic Actor.* The first four were still in the studio; the last had been owned by Durand-Ruel since 1872.

The only significant works mentioned in this account which were not to be seen were the *Execution of Maximilian,* in the artist's estate, and the *Boy with a Sword.* The latter was the first of Manet's larger works to be acquired by an American collector. When Mr. Erwin Davis of New York, who had purchased it from Durand-Ruel in 1880, presented it in 1889 to the Metropolitan Museum, it became the first of Manet's paintings to enter a public museum.

No less than fifty individuals lent works from their private collections, an impressive number considering the prevailing official and popular opinion of Manet. In addition to his old friends Zola, Duret, Proust, and Faure, the lenders included the relatively conservative artists Tissot, Stevens, Fantin-Latour, de Nittis, and Henri Rouart. Although the last two had exhibited with the Impressionists, de Nittis once and Rouart all but once, of the Impressionists proper neither Monet, Renoir, nor Sisley had been able to afford a Manet up to this time. Degas and Manet had exchanged portraits, but later returned them to each other. Manet, disliking Degas' portrait of his wife, had cut the canvas in two. Two collectors, less prominent in 1884 than later, who lent small pictures were Gustave Caillebotte, the faithful patron of the Impressionists, and Paul Gauguin, who had just renounced his business career to become a painter.

The introduction to the catalogue was prepared by Zola at his own suggestion. The tone was very like his articles of 1866, tempered by his reservations of 1879 and 1880. He repeated his first convictions as to the worth of Manet's paintings, recounted the major episodes of his life, and enumerated the more important works in the exhibition. But while Zola reaffirmed the important position which he believed Manet would always occupy in the his-

tory of French painting, he could not resist inserting a few captious remarks about the inadequacy of his technique. Zola could recognize the tremendous change which had occurred in the course of the past twenty years in contemporary painting. He asked the reader to compare the dark, conventionally illuminated canvases of 1863 with the flood of light which had entered the Salons along with a more exclusive preoccupation with contemporary subject matter, and he attributed this to Manet's influence on younger painters. But he never could bring himself to accept completely the apparent willfulness of Manet's technique. Speaking of Manet's unexpected popular success in 1873 he said:

> The *Bon Bock* was praised by everyone. There was a return to the clever composition of the *Boy with a Sword*, only bathed in a more candid light. But he was not always master of his hand, using no set method, having kept the frank naïveté of a schoolboy before nature. When he began a picture, he would never be able to say how it would end. If genius consists of unself-consciousness and a natural gift for truth, he certainly had genius. Consequently he did not again find, doubtless despite all his efforts, the happy balance of the *Bon Bock*, where his original touch was tempered by a dexterity which disarmed the public.

Even his most acute appreciation contained this hesitation:

> It must be added that Manet's personality made the new formula still less acceptable to people who liked the beaten paths. I spoke of his ingenuousness, his departure for the unknown with each white canvas he placed on his easel. Without nature he remained impotent. The subject had to pose, even when he attacked it as a copyist without malice, without any sort of formula, sometimes very deft, at other times deriving charming effects even from his clumsiness. That is the reason for this elegant stiffness for which he has been reproached, these abrupt lacunae which are found in his most finished works. The fingers do not always obey the eye whose precision is marvelous. If he made a mistake it was not from

lack of study as people pretended, because no painter has worked with so much furious obstinacy; it was simply by nature. And not from prejudice; he would have liked to please. He gave his flesh and his blood, and none of us who knew him well dreamed of his being more balanced or more perfect, because he would certainly have lost the best part of his originality, that strident note of light, that truth of value, that vibrating appearance of his canvases which marks them from the rest.

But with Zola's final estimate there can be no cavil:

If you want an accurate realization of the great place which Manet occupies in our art, try and name someone after Ingres, Delacroix, and Courbet. Ingres remains the champion of our school of classical tragedy; Delacroix blazes during all the romantic period; then comes Courbet, a realist in his choice of subjects but classic in tone and execution, borrowing from the old masters their learned trade. Truly, after these great names I am not unaware of some fine talents which have left many works; only I am looking for an innovator, an artist who would have brought a new vision of nature, who would above all have profoundly changed the artistic production of the school; and I am compelled to come to Manet, to this scandalous man so long disowned and whose influence is dominant today.

Zola's reluctance to accept Manet without reserve is a revealing indication of the increasing conservatism in artistic matters which came upon him as he aged. In 1886 occurred the final rupture with Cézanne, precipitated by the publication of Zola's novel *L'Oeuvre*. The principal figure was an unsuccessful painter, Claude Lantier, transparently a characterization of Cézanne, although the descriptions of his paintings were based on Manet's work. Manet's friends might protest Zola's interpretation and they did. But they could not change the point of view of a man who, for all his insistence that art like letters must deal with subjects known to the artist in his own time, was filling his house with the plunder of the past in

objects of Renaissance art typical of the taste of any wealthy member of the middle classes.

If Zola hesitated, Albert Wolff floundered in uncertainty. Possibly to forestall his withering and niggling criticism, Manet's friends had invited him to serve on the committee sponsoring the exhibition. But on the day the exhibition opened he devoted his column in *Figaro* to his opinion of Manet:

> I have been honored by being invited to join the committee. My warm friendship for Manet signaled me out for this choice. But the art critic of *Figaro* does not consider that a reason for blindly subscribing to the enthusiasm of Manet's intimate friends. Personally, I have no ambition of imposing his work in its entirety on the admiration of the centuries to come. . . .
>
> Edouard Manet was only a remarkably gifted man, whose numerous attempts most often remained sterile owing to the lack of an elementary artistic education. . . . I have seen him at work. His family even wanted to send me a portrait which he began and couldn't finish. . . . When he had to develop his painting technically his lack of knowledge was a stumbling block. . . . After the fifteenth sitting, my portrait was no further advanced than on the first day; the model was discouraged and also the painter. . . . Having become the leader of the painters who lack discipline, Manet worked a little for the crowd. His qualities are always great, but the faults take precedence over them. . . . It takes courage to say it, but his work is often ugly. It is discouraging, for the critic would ask for more than to applaud heartily the poor departed. . . . Today the Institute makes amends for its disdain of Manet who enters the sanctuary of official art as one of the most interesting manifestations of modern painting. Ah! if the poor painter could see himself in the Palais des Beaux-arts hung with the national banner, a long procession of carriages at the door! What an unexpected apotheosis!

During the exhibition Edmond Bazire's monograph was published. This first book devoted to the painter was intended by its author solely as a biographical study. He disclaimed any attempt

to establish an aesthetic and contented himself with a circumstantial account of the painter's life and the chronology of his work. Today this volume is principally of interest for its illustrations, profuse for the time, of Manet's drawings and prints. But Bazire sincerely admired his late friend, and in the summation which he added to his last chapter, entitled after Manet's device "Manet et Manebit," he reached a succinct statement of his achievement:

> His career can be summed up as a continuous ascent toward light and truth. It presents this extraordinary circumstance that each revelation of the painter is a step forward, a transition so to speak, toward a new expression of his personal conception. At first he copied, and then he was inspired. He fumbled, he broke away, he found himself, he matured, and still he continued to search. From the beginning he had foreseen his formula. There was then no question of open-air painting. To paint what he saw, not from the imagination, was his program. He had no idea of idealizing reality, and under the pretext of idealism of ceasing to be realistic. He thought of nature as a model in front of him and never believed he had the right to flatter it by interpretation just as he didn't believe he had the right to paint mendacious portraits. He was possessed by the idea that the painter has a supreme and primary duty: fidelity. Why, therefore, fabrications or travesties? He thought of himself as a primitive.

On the whole the exhibition could be considered a success. On the last Sunday the attendance reached 1,567 and a total of 1,100 catalogues had been sold. Such public interest augured well for the auction of the work remaining in the studio which took place on February 4 and 5. The sales catalogue contained a skillful introduction by Théodore Duret in which he described two kinds of artists. The first consisted of the facile technicians who received every honor from a benevolent administration, yet were forgotten as soon as the generation they had tried to please passed away. The other kind Duret described as the "inventors":

> These are the men who have their own particular way of seeing and feeling and, if they are painters, a touch, a color, a way

of drawing, which are absolutely their own. And nothing is easy for them. First of all they have to find themselves, they must succeed in giving form and expression to their obscure and turbulent visions.

Duret then made a relevant distinction between the type of criticism accorded such men before and after their deaths:

At the Salon the artists are faced with literary men who write hasty articles for the papers, and by the crowd which pushes in and out. Yet these literary people in general, and the crowd always, see in painting only the subject, only the motif, only the action represented. . . . However, after death artists are judged by a very different public from that which distributed praise and blame during their lives. . . . Their works henceforward attract only the attention of collectors and of those who understand and love works of art. . . . For them the value, the intrinsic quality peculiar to painting dominates everything else, and the subject is no more than an accessory. . . . All they ask of a painting is that it be painted, in the fullest sense of the word.

He concluded with an appeal to the state to purchase Manet's work for the national museums:

For an artist to be definitely accepted by the connoisseurs it is necessary that his canvases, when placed beside those of his great precursors, should be able to sustain the comparison. In private collections and museums they must hold their own beside the work of the masters. Now Manet's canvases hold their own beside those of any painter whatsoever. . . . Put a Manet beside paintings by Delacroix, Corot, and Courbet, and it will take its natural place among its peers.

In every collection, in every museum where one would like to have examples of all the French masters and to have the complete development of the modern school represented, Manet will necessarily have his allotted place for he has been, as much as anyone else, original and personal, and he has added, with a splendor which has never been surpassed, a

special note to painting, that of bright color, the open air, and full sunlight.

The sale not unnaturally attracted considerable curiosity. For the last time Manet's name awakened old passions, enthusiastic or antagonistic. Although his family and friends took pains to make it a financial success, the more important pictures went for less than the appraised valuations, and in some cases were withdrawn or sold for sums agreed upon beforehand.[2] Of the seven unsold Salon paintings, *Olympia* was withdrawn when it failed to reach 10,000 francs. The *Music Lesson* found no purchaser; Durand-Ruel later bought it for 4,400 francs. Caillebotte paid 3,000 for the *Balcony*. Léon Koëlla-Leenhoff went to 12,500 for *Argenteuil* in an attempt to stimulate the bidding. Durand-Ruel paid only 3,500 for *Faure as Hamlet,* and Duret, by prior arrangement, offered 5,000 for *Chez le père Lathuille.* The highest price was the 5,850 which Emmanuel Chabrier, the composer and friend of the artist, paid for the *Bar at the Folies-Bergère.* But the *Old Musician* had to be withdrawn, and Chabrier acquired *Skating* of 1877 for only 1,670 francs. The "Americans," as one journalist put it, had failed to appear.[3] The total of the sale came to 116,637 francs, a sum which failed to justify the opposition's prediction of a disaster, but not on the whole very considerable, given the quality of the work. The academic faction rejoiced that the Louvre had abstained from buying anything, although the administration had acquired three works at the first Courbet sale of 1881. Six years were still to elapse before *Olympia* would be purchased from Mme. Manet by private subscription for presentation to the nation.

Henceforth Manet's position, although it might be contested, could not be overlooked. In 1889 Antonin Proust took charge of the centennial exhibition of French painting for that year's international exposition. He succeeded, in spite of opposition, in exhibiting fourteen works by Manet, including Salon paintings from

2. The list of paintings, with prices and purchasers, appears in Meier-Graefe, *Edouard Manet* (Munich, 1912), pp. 317–31.

3. Paul Eudel, in *Figaro,* published two lively, somewhat sarcastic accounts of the bidding. The net sum realized for Mme. Manet was 76,907 francs, "little, but more than she had expected," according to Tabarant, p. 502.

1861 through 1882. And at the exposition of 1900 sixteen works were included in a retrospective exhibition of French painting. In 1905 the third Autumn Salon contained a special exhibition of twenty-six works, testifying to Manet's continuing interest for the younger painters of the new century. Meanwhile his work had begun to enter the national collections. After much acrid discussion two of the three paintings bequeathed to the Luxembourg by Gustave Caillebotte in 1894, the *Angelina* of 1865 and the *Balcony*, were accepted by the state. In 1906 Etienne Moreau-Nélaton gave the *Déjeuner sur l'herbe* to the Louvre, although for many years it was hung "provisionally" across the courtyard in the Musée des Arts Décoratifs. In 1907 *Olympia* was transferred from the Luxembourg to the Louvre, thus achieving its final translation from obloquy to honor just forty-three years after the original scandal. In 1911 Count Isaac de Camondo bequeathed to the nation his collection, which contained seven oils by Manet, among them the *Fifer*, two pastels, and a water color.

In 1932 the centenary of the artist's birth was marked by a retrospective exhibition in the Orangerie in the Tuileries, appropriately the place where Manet had walked as a young painter with Proust and Baudelaire. The exhibition was almost as large as that of 1884, with ninety-nine paintings and pastels, and thirty-one water colors and drawings. The authoritative catalogue, prepared by Charles Sterling, included tributes to Manet's genius by Paul Valéry and Paul Jamot. With this exhibition and catalogue Manet's work had finally attained its indisputable position in the history of French painting.

After the second World War all the works in the Louvre by the Impressionists were transferred to the building of the Jeu de Paume in the Tuileries, which was renamed the Musée de l'Impressionisme. Here twenty-four paintings and pastels by Manet may be seen in the appropriate company of masterpieces by his friends and companions, in addition to works by their precursors and more significant followers. There the *Déjeuner sur l'herbe*, *Olympia*, and the *Fifer* recall the scandals of the 1860's. *Lola de Valence* and the *Portrait of Zola*, bequeathed by the writer's widow, testify to Manet's friendship for two great men of letters. The *Balcony*, with

the "bitter elegance" of Berthe Morisot's figure, announces Manet's relations with the Impressionists in the 1870's. If there are no Salon paintings from that decade, his later work is represented by a number of fragrant still lifes and by the exquisite pastel portrait of *Mme. Zola.*

MANET AND HIS ART TODAY

Now that the passions Manet's painting once evoked have cooled, his critics and their opinions, quite aside from the questions raised by their sympathies and antagonisms, may be considered as part of the larger issue of the continuing relationship between the progressive artist and the contemporary public. After so many years it would be idle to scold those who disliked Manet just because we no longer share the point of view which made their positions at least logical in their own times. Undoubtedly there was an element of bitterness in much of the criticism of the academic and conservative factions, but professional reservations would surprise more by their absence than they should by their presence. For us the least useful critics were those who meaninglessly repeated the laughter of the crowd. But even they help us to understand the bewilderment experienced by the simpler members of the public when faced with the most sophisticated paintings of the day. On the other hand it is notable that not one of the serious professional critics of the rank of Castagnary or Thoré failed to recognize the promise of Manet's work. They were disturbed by what seemed to them amateurish craftsmanship and they believed that his apparently slipshod technique could be improved by further study. It is the more remarkable that, when he failed to take their advice, some of these critics felt obliged to modify their own standards in order to account for his. In this way they proved themselves critics of art rather than arbiters of taste—that position toward which the critic is frequently urged by his ambition.

Even hostile critics have their place in this account, for the

passage of time plays strange tricks with opinions. In the act of revealing new forms it may obscure values which were once significant for the creation of those forms. This is particularly so with the art of the later nineteenth century, that art toward which we, after a half century and more, stand in the double attitude of acceptance and rejection. Affection for the fashions of our immediate ancestors has thrown a veil of sentiment over what in actuality was intended for another purpose. Since no one now is horrified by the crude subject matter of the *Déjeuner sur l'herbe* or by its apparent attack on social conventions, we need the protests of shock and outrage with which it was greeted to sense what it meant to those who saw it for the first time. Our interest in Victorian costume lends the *Portrait of Antonin Proust* a special elegance it did not have in 1880. Berthe Morisot in her white dress on the green balcony appears so freshly fashionable we need her own testimony that to the public of 1868 she appeared weird and ugly. Since the use we make of art is not always that for which it was originally intended, we must know how it appeared then if we are to understand more than our own opinion of it now. By rereading the attacks on Manet we do more than point to our own superiority in being able to accept him without qualms. We anchor his art securely within its own time in order that it may have more meaning for ours.

Such criticism also reminds us that the artistic process is not static but dynamic, that art is a continual coming into existence of new forms expressive of new states of feeling. To accept Manet without further consideration as one of the masters of modern painting is to avoid the task of re-examining the artist and his work and so to fail to reach an understanding of the complex issues of modern art. For those willing to make the effort the criticism of his work helps to solve the riddle of the relation of personality to painting, which is one of the constant problems of art history. To those who offer the anonymity of ancient and medieval art as an excuse for subordinating the importance of personality in modern painting, one must answer that the situation is not the same now as it was in the past. Since the Renaissance, the public has demanded evidence of personal intervention in the art object from the presence of signatures through all the other indications that this par-

ticular work was done by that particular man. Psychological discoveries merely persuade us that, when we know something about an individual, we are obliged to take that something into account when examining his work. Who would discard the journals of Delacroix, the letters of Van Gogh, or the life of Gauguin in examining their artistic production? For the men themselves such records of experience must have been intimately related to their pictorial activity.

Yet with Manet the relation between the man and his art is not altogether clear. His personality eludes us. We know more about his outer appearance than about the inner workings of his mind. We know that he was handsome, well dressed, and well mannered, that he moved in a restricted but respectable circle, preferring the company of his social rather than of his artistic equals. His friends were not legion but they were on the whole faithful. We know also that he was stubborn, and that he was sometimes hesitant and unsure of himself. Baudelaire was fearful of the effects of the adverse publicity of 1863. We know that he was sensitive and scornful, as quick to give as to resent affront; he fought a duel with Duranty, insulted Degas, and offended Cézanne. We may suspect that the rancor in some contemporary criticism was not entirely unprovoked. The insistence of the caricaturists that he was a disorderly ruffian suggests that his aristocratic aloofness was resented, that his failure to reciprocate elicited the attacks. Before any of his larger paintings the observer must often have felt a curious withdrawal of the artist from any participation with the spectator in the implications of the subject. Before the *Young Woman of 1866*, the *Old Musician*, even before the *Bar at the Folies-Bergère* one senses an inexplicable element of emotional negation which cannot be resolved in strictly pictorial terms.

We are forced to conclude that Manet's personality cannot be thought of apart from his paintings. Elsewhere the artist as a member of society may occasionally be considered apart from his career as a painter: David voting the death of the king, Courbet involved in radical political activity, Daumier as the critic of society. But in Manet there is scant evidence of a reflective mind, an inquiring intellect, or a participating will. As much, if not more, than Monet

he was the attentive observer of the object before which he set his easel and which he then proceeded to translate into variations of value and color. Who seeks more from him is doomed to the same kind, if not to the same intensity, of disappointment experienced by his contemporaries, who sought in his work the presence of an attitude or the resolution of an action.

It follows that much of the satisfactory criticism from the modern point of view was written by men who knew Manet personally. Baudelaire's few but perceptive comments, Zola's early unequivocal praise, the reticent insight of Théodore de Banville, the oblique references of Mallarmé, and the writings of Goetschy and Duret were all based on knowledge of the man. In the studio they watched the work in progress, they measured intention against performance, and they reached an understanding of his program and accomplishment which was difficult for the journalist and reviewer who knew only one or two works seen for a few weeks in competition with 4,000 other paintings at the Salon. Their accounts of Manet's technical procedures and artistic conceptions, which have never lost their usefulness for understanding his work, were at the time unheeded but inevitable instruments for putting an end to the prejudice of those who could not see, in the literal sense of the verb, what the painter was doing. More tenacious than the dispute over the validity of the contemporary subject was the persistent accusation that Manet could not paint. To the academic critics such paintings looked like childish scribbles. They could not read them as the record of forms in light which they were intended to be.

To innovate is to invent. As Duret said in 1884, the artist must discover for himself the forms which shall express his obscure and turbulent feelings. By the very nature of art all pictorial research precipitates innovations in formal appearances which in turn require adjustments in traditional ways of seeing. This is as true for the inventions of Giotto and Raphael as it was for those of Manet and the Impressionists. The new painting could not appear coherent to eyes that were not prepared to see. With Manet there was neither attitude nor action; the statement of what had been observed must content the spectator.

This circumstance explains much of his position toward tradi-

tional painting and his troubles with the traditionalists. Composition as a formal principle is essentially a reflection upon the significance of forms considered in relation to some aspect of content. Manet was uninterested in content in the traditional sense as the communication of ideas; he was therefore uninterested in composition as a formal exercise. When he felt obliged to create some particularly complex figural arrangement he placed the figures side by side without regard for the formal harmony which might be derived from their juxtaposition, as in the *Old Musician,* or he relied upon some compositional device near at hand in the work of the masters of the past or present, as in the *Déjeuner sur l'herbe,* the *Balcony,* and in the later café-concert scenes derived from Degas. The spectators of 1863 were outraged by what they considered the immorality of the action depicted in the *Déjeuner sur l'herbe.* They could have held their peace, for neither here nor elsewhere had Manet's characters come together for any purpose other than their existence as objects to be painted. The proof of this lies in the fact that the further woman, the landscape, and the still life in the foreground were not united within a single pictorial space with the major figures. Each object and each area of the painting contributed its own effect to the picture but without anecdotal or psychological relation to any other. Consequently in another painting which contained the most explicitly dramatic possibilities, the *Execution of Maximilian,* there was a total lack of drama. Neither the soldiers nor the Emperor and his companions were conscious of the reasons which had brought them together at that particular moment. The tragedy existed only in the title. Castagnary was aware of the condition, if not of the reasons for it, when he complained that in the *Balcony* he could not fathom the significance of the woman drawing on her gloves, and asked whether she were arriving or departing. Neither he nor anyone else would ever know or need to know, because action is not a component element of such designs. The paintings are still here and, as Zola said, "continue to look at us with solemn, proud disdain."

It was inevitable that Manet should on the whole have achieved his earliest popular understanding with single figures rather than with groups, and still more so with landscapes and still lifes than

with figures. The paintings which now seem most incontrovertibly his own are just those in which the single figure like an icon dominates the whole painted surface and lingers as an irresistible image in the memory. Such is the quality of the *Fifer*, the *Street Singer*, the *Young Woman of 1866*, the *Bon Bock*, and the barmaid of the *Folies-Bergère*. We also remember certain seascapes of small black boats scudding over a bright green sea, a still life of a sprig of lilac or a silver knife. They contain not only the secret of his genius but the meaning of his art. Motionless, we might even say emotionless before the object, his eyes sought only to record the visual experience in the fewest material terms. The effort to achieve simplicity involved the elimination of multiple intermediate tones; their suppression left a scale of values rather closely restricted within the oppositions of black and white as well as a similar restriction of the range of local colors to a selection of cool colors, principally lavender, lemon, and olive.

One may even think that there was perhaps some physiological basis for Manet's selectivity. This is not to say that he was in any degree color-blind, but rather that his sensitivity to color and light operated within certain definable limits as personal to him as were the predilections of Renoir, Cézanne, and Van Gogh for harmonies preponderantly red, blue, or yellow. Each of us has preferences in color which oblige him to see certain hues and to remain oblivious to others. In such terms we might explain Manet's reluctance to adopt the brilliance of the Impressionist palette. Not habit or intention led him to retain a black base even in his latest landscapes, but his tendency to see a few colors in relation to a dominant dark ground.

These comments are offered not as limitations to Manet's accomplishment but toward the fuller understanding of his work. Had he been otherwise, emotionally, intellectually, or physiologically, his art would have been other than it was. As it is, this eye concerned only with seeing and this taste restricted to certain aspects of society and certain areas of nature were so penetrating and perceptive that the images they directed the hand to fix upon the canvas are among the most compelling of his time. Together with the greatest masters of Impressionism, Monet, Sisley, and Pissarro

in landscape, Degas and Renoir in figure painting, Manet succeeded in creating forms to communicate his attitude toward his times which are unexcelled in sensitivity and discrimination. For the unselective and often vulgar realism of Courbet he substituted his carefully chosen subjects, at first marked, as Baudelaire suggested, with a touch of romanticism. Quickly he sloughed off the last traces of that essentially interpretative attitude. As early as the *Fifer* he had found his own way. Although, as Zola suggested, in the paintings of 1866 the simple outlines and broad areas of pure color were taken from Japanese prints, there was no Japanese look comparable to the Spanish appearance so conspicuous a few years before. And only a year or two later the *Balcony*, based upon a composition by Goya, awakens no suggestions of Spain. What Manet had discovered, what he had introduced into art, was that element of modern elegance, incisive yet detached, which marked all his work henceforward.

As much as any French painter of the later nineteenth century Manet succeeded in creating the conditions of an art which can be called modern in the sense that Baudelaire intended. If Manet's genius could be reduced to a formula, it might be stated as his gift for extracting from the undifferentiated visual whole of everyday life just those aspects which we see and feel are qualitatively "modern" rather than chronologically "contemporary." In these terms the solemn and disdainful figures in his canvases are representations of modern man whose sensibility has set him apart from the restricted emotional responses of that mob which comes only to jeer at such art. Manet did more than paint distinguished pictures of daily life. That would have been much, but not enough for the twentieth century which has not been especially interested in such scenes. As man became more dissociated from the sources of action in the modern world, as his emotions became more intensely objects of cultivation in and for themselves, the way was prepared for the destruction of the natural appearances which it had been the business of the Impressionists so scrupulously to record. The process is evident in much of the later work of the Impressionists themselves. Just as Monet and Sisley abolished figures from their canvases in order that the study of nature might not be

affected by any evidence of human participation, so Degas avoided compromising his taste by refusing to consider the emotions of his characters. How often they turn their backs or avert their faces so that we shall not be obliged to consider their response to their environment. This process was carried further by Cézanne in his *Card Players*, who lean forever over a game which neither will win. And in his *Bathers* this divorce of the figure from action and emotion becomes even more acute, to the point where the bathers seem not only to have no faces but scarcely any sex. If the next step in the gradual dematerialization of the human figure was the cubist analysis of Picasso and Braque, just as certainly neither their work nor Cézanne's can be conceived without the preliminary propositions of Manet. A cubist Harlequin fragmentarily disengaging himself from a network of planes has as his formal and spiritual predecessors not only the carnival figures of Cézanne but also the *Fifer* of Manet. Not the painting of manners, not the invention of a particularly enchanting scheme of color and value, not a lifetime of protest and the assertion of the individual's right to create in his own way—none of these phases of his work, however valuable, comprises Manet's claim to our attention now. Rather it is that aspect of any artist's work which secures for him his greatness, the invention of forms which dominate not only the visual experience of his own day but even that of times still to come.

BIBLIOGRAPHY

A selection of books on Manet, and of articles on his Salon paintings, published since 1945.

Ackerman, Gerald M. "Gérôme and Manet." *Gazette des beaux-arts.* 6th pér. 70 (September 1967): 163–76.

Boime, Albert. "New Light on Manet's 'Execution of Maximilian.' " *Art Quarterly* 36 (Autumn 1973): 172–208.

Cachin, F., Moffett, C. S., and Melot, M. *Manet, 1832–1883.* Metropolitan Museum of Art (exhibition catalogue). New York, 1983.

Callen, Arthur. "Faure and Manet." *Gazette des beaux-arts.* 6th pér. 83 (March 1974): 157–78.

Clark, Timothy J. *The Painting of Modern Life: Paris in the Art of Manet and His Followers.* New York, 1985.

———. "Preliminaries to a Possible Treatment of 'Olympia' in 1865." *Screen* (Spring 1980): 18–41.

Collins, Bradford R. "Manet's 'Luncheon in the Studio': An Homage to Baudelaire." *Art Journal* 38 (Winter 1978–79): 107–13.

Davidson, Bernice F. " 'Le Repos': a Portrait of Berthe Morisot by Manet." *Rhode Island School of Design Bulletin* 46 (December 1959): 5–10.

Edouard Manet and the Execution of Maximilian. Department of Art, Brown University (exhibition catalogue). Providence, 1981.

Farwell, Beatrice. "Manet's 'Espada' and Marcantonio." *Metropolitan Museum of Art Journal* 2 (1969): 197–207.

Gay, Peter. *Art and Act. On Causes in History: Manet, Gropius, and Mondrian.* New York, 1976.

Hadler, Mona. "Manet's 'Woman with a Parrot' of 1866." *Metropolitan Museum of Art Journal* 7 (1973): 115–22.

Hanson, Anne Coffin. *Manet and the Modern Tradition.* New Haven, 1977.

Hofmann, Werner. *Nana: Mythos und Wirklichkeit.* Cologne, 1973.

Johnson, Lee. "A New Source for Manet's 'Execution of Maximilian.' " *Burlington Magazine* 119 (August 1977): 560–64.

Kovacs, Steven. "Manet and His Son in 'Déjeuner dans l'atelier.' " *Connoisseur* 181 (November 1972): 196–202.

Leiris, Alain de. "Edouard Manet's 'Mlle. V. in the Costume of an Espada': Form-Ideas in Manet's Stylistic Repertory: Their Sources in Early Drawing Copies." *Arts Magazine* 53 (January 1979): 112–17.

———. "Manet and El Greco: The Opera Ball." *Arts Magazine* 55 (September 1980): 95–99.

Mauner, George. *Manet Peintre-Philosophe: A Study of the Painter's Themes.* University Park, Penn., 1975.

Needham, Gerald. "Manet's 'Olympia' and Pornographic Photography." *Art News Annual* 38 (1972): 81–99.

Nochlin, Linda. "A Thoroughly Modern Masked Ball." *Art in America* 71 (November 1983): 188–201.

Peters, Susan Dodge. "Examining Another Source for Manet's 'The Balcony.' " *Gazette des beaux-arts.* 6th pér. 96 (December 1980): 215–16.

Reff, Theodore. *Manet and Modern Paris.* National Gallery of Art (exhibition catalogue). Washington, D.C., 1982.

———. "Manet's 'Portrait of Zola.' " *Burlington Magazine* 117 (January 1975): 34–44.

———. *Olympia.* New York, 1976.

Roos, Jane Mayo. "Edouard Manet's 'Angels at the Tomb of Christ': a Matter of Interpretation." *Arts Magazine* 55 (April 1984): 55–83.

Rouart, Denis, and Wildenstein, Daniel. *Edouard Manet, Catalogue raisonné.* 2 vols. Lausanne, 1975.

Selkin, David, "Philibert Rouvière: E. Manet's 'L'Acteur tragique.' " *Burlington Magazine* 117 (November 1975): 702–09.

Wilson, Mary G. "Edouard Manet's 'Déjeuner sur l'herbe,' an Allegory of Choice: Some Further Considerations." *Arts Magazine* 54 (January 1980): 132–34.

INDEX OF PAINTINGS BY MANET

GENERAL INDEX

About, Edmond, 53 and n., 68 n.

Academies, 2, 3, 83

Academy, French, in Rome, 12

Academy, Royal, of Painting and Sculpture (1663), 9

Academy of Fine Arts, *see* Paris, Académie des Beaux-arts

Agoult, Claire Christine d', *see* Sault

Ambre, Emilie, 248

André, Edmond, 179

Andrée, Ellen, 232

Argenteuil, 44, 176, 177

Arnoux, Charles Albert d', *see* Bertall

Art: academic, 2, 27, 55, 112–3, attacked by Zola, 86–7; classic, 49; Dutch, 48, 163 n.; Flemish, 48; Italian Renaissance, 23; religious, 47, Manet's, 55–6; modern, 1, 2, 16, 17, 18, 30, 31, 48, 51, 152, 153, 165, 171, 226, 275, 280–1; Spanish, 25 n. *See also* Goya, El Greco, Murillo, Ribera, Velasquez

Art dealers, 11, 28. *See also* Durand-Ruel, Fèvre, Martinet

Art schools, *see* academies

Astruc, Zacharie, 45, 46 and n., 68–9, 105, 141, 144; his *La Fille des îles,* 68–9 and n.

Autumn Salon, *see* Paris, Salon d'Automne

Baignères, Arthur, 214–5

Balzac, Honoré de, 70 n.

Banville, Théodore de, 37, 160, 180 and n., 277; criticism (1872) 155, (1873) 172

Barbey d'Aurevilley, Jules, 158–60

Barbizon, painters of, 16, 47, 65, 109, 155

Barye, Antoine-Louis, 210

Bastien-Lepage, Jules, 218, 235, 253, 254

Baudelaire, Charles, 19, 25, 56, 64, 93, 147, 171, 216, 246, 256, 272, 278; criticism by, 29, 31 and n., 37, 277; death of, 36; discussed by de Banville, 37, 172, by Barbey d'Aurevilley, 159; friendship with Manet, 29–30, 34–6, 160; influence on Manet, 29–31, 78–80, denied by Zola, 94; lampooned by Leroy, 32–4; letters by, 35, 52 and n., 62–3; opinion of Manet, 18, 35–6, 62–3, 66, 152–3, 276; verse, 29–30 and n., 32, 40 n., Fleurs du mal, 25, 30, 37, 78, 79, 80, 94 n., 172, quotations from, 30, 40 n., 78, 79, 80

Baudry, Paul, 12 n., 13, 82 n., 198, 207

Bazire, Edmond, 264, 268–9

Beauty, defined by Zola, 92

Beauverie, Charles-Joseph, 241

Bellot, Emile, 163

Bergerat, Emile, 208–9, 226, 245, 251

Bernard, Claude, 95

Berne-Bellecour, Etienne-Prosper, 226

Bernhardt, Sarah, 226

Bernier, Camille, 13

Bertall, 17, 70 n.; caricatures (1865) 70, (1869) 132, 149, (1873) 163, (1874) 178, (1875) 189; criticism (1870) 142, (1876) 197–8, (1879) 212–3, (1880) 230

Bida, Alexandre, 13

Bins, Paul, *see* Saint-Victor

Blanc, Charles, 17, 82 n., 207

Boldini, Giovanni, 226

287

ILLUSTRATIONS

1. *The Absinthe Drinker* (1859), 69⅞ × 40½ in. Rejected at the Salon of 1859

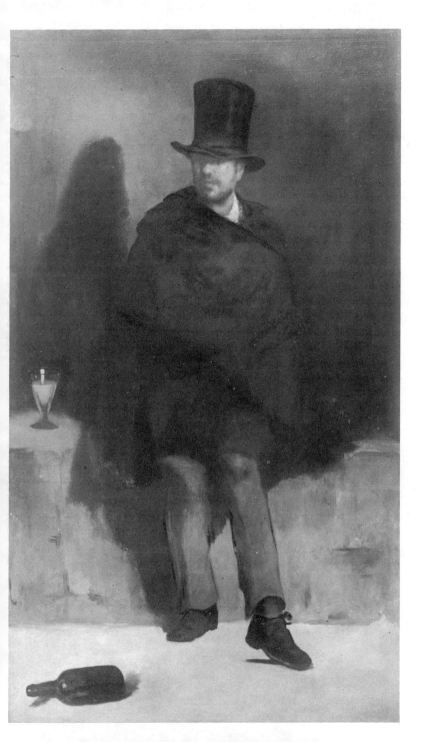

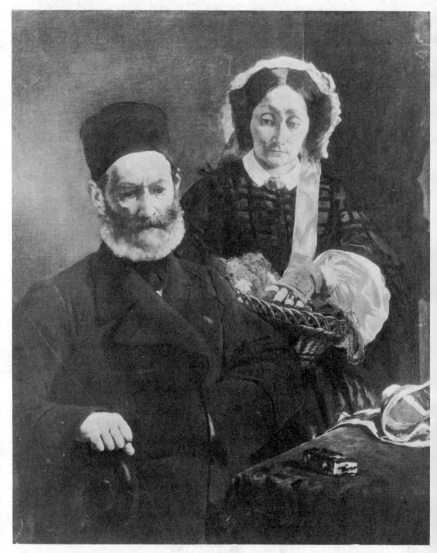

2. *Portrait of the Artist's Parents*, dated 1860, 43¼ × 35⅜ in. Salon of 1861

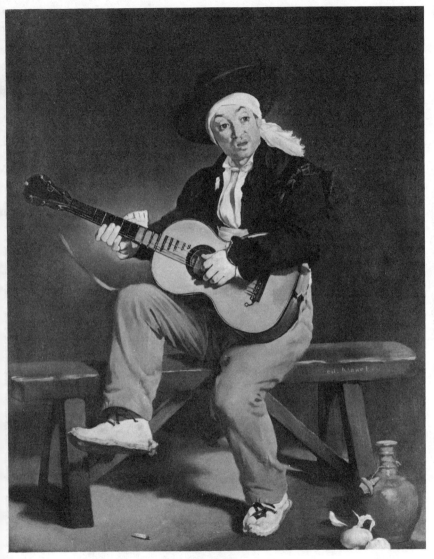

3. *The Spanish Singer or Guitarrero,* dated 1860, 58 × 45 in. Salon of 1861

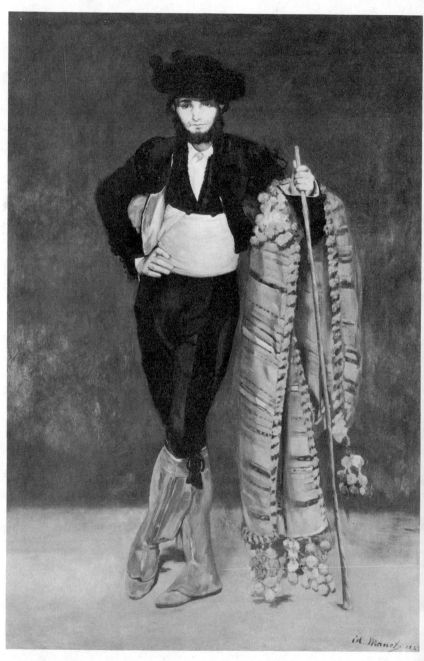

4. *Young Man in the Costume of a Majo,* dated 1862, 74 × 49⅛ in. Salon des Refusés, 1863

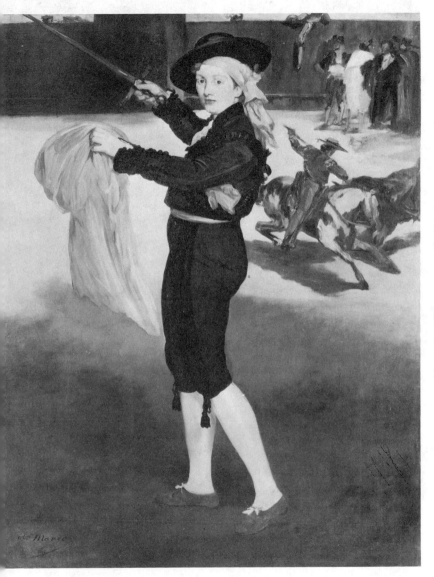

5. *Mlle. V. in the Costume of an Espada* (1862), 65 × 50¼ in. Salon des Refusés, 1863

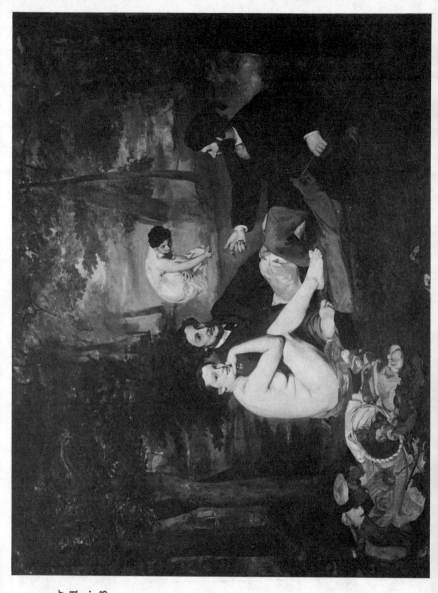

6. *Le Déjeuner sur
l'herbe (Le Bain)*, dated
1863, 81⅞ × 104¼ in.
Salon des Refusés, 1863

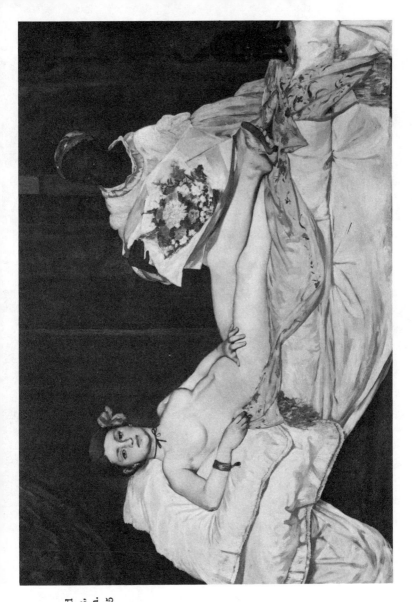

7. *Olympia*, dated
1863,
51⅛ × 74¾ in.
Salon of 1865

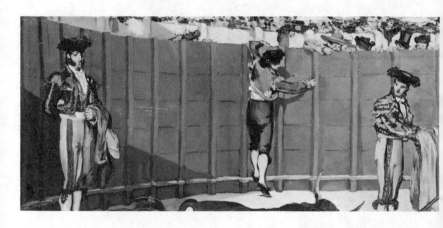

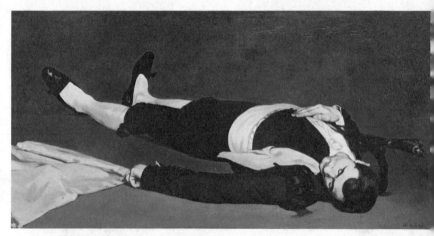

8a. Above. *Bullfight*, 18⅞ × 42¾ in. Salon of 1864

8b. Below. *The Dead Man (The Dead Toreador)* (1864), 29⅞ × 60⅜ in. Salon of 1864

(These two fragments from Manet's *Incident in the Bull Ring* are not reproduced at the same scale. The *Bullfight* is approximately half the size of the *Dead Toreador*)

a.

b.

c.

d.

a. Cham's caricature of the *Incident in the Bull Ring* in *Charivari,* May 22, 1864: "Since he had to complain to his paint seller, Manet has decided to use only his inkwell."

b. Cham's caricature of *Argenteuil* in *Charivari,* May 9, 1875: "N.B. Since Manet seems subject to a painterly indisposition in the spring, he ought to take a good purgative about this time of year."

c. Cham's caricature of *Faure as Hamlet* in *Charivari,* May 23, 1877: "Hamlet, gone mad, has had himself painted by Manet."

d. Cham's caricature of Manet in *Charivari,* April 27, 1879: "Manet himself, overcome by an attack of nerves at the sight of the independent painting."

10. *Punchinello,* water color (1873), 13⅜ × 9¼ in. Salon of 1874

11. *The Tragic Actor (Portrait of Philibert Rouvière)* (1866), 73¾ × 42½ in. Rejected at the Salon of 1866

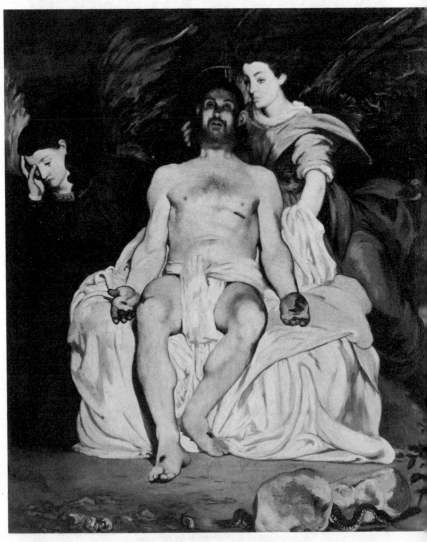

12. *The Dead Christ with Angels* (1864), 70⅝ × 59 in. Salon of 1864

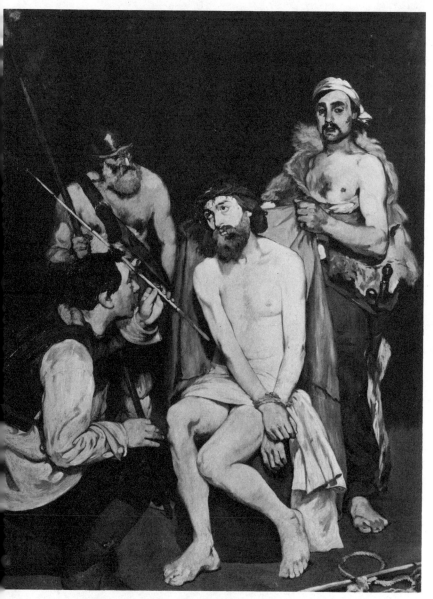

13. *Jesus Mocked by the Soldiers (Christ Scourged)*, dated 1865, 75⅛ × 58⅜ in. Salon of 1865

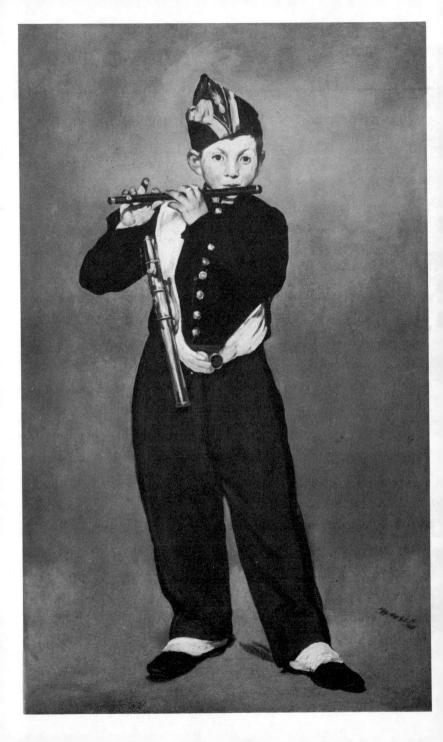

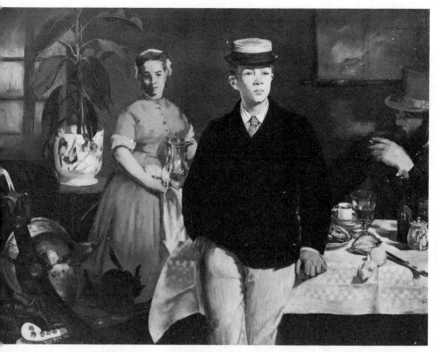

15. *The Luncheon (The Luncheon in the Studio)* (1868–69), 47¼ × 60¼ in. Salon of 1869

14. *The Fifer* (1866), 63⅜ × 38⅛ in. Rejected at the Salon of 1866

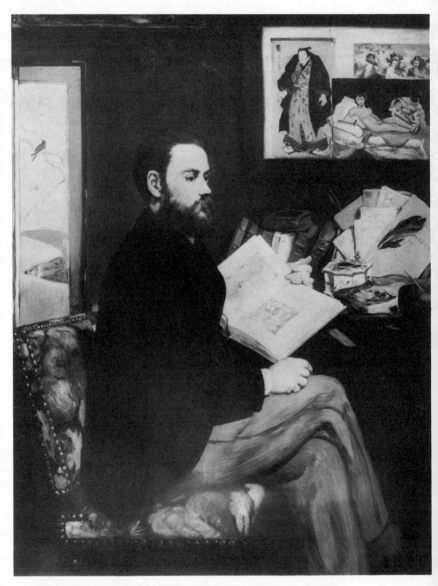

16. *Portrait of Emile Zola* (1868), 57½ × 44⅞ in. Salon of 1868

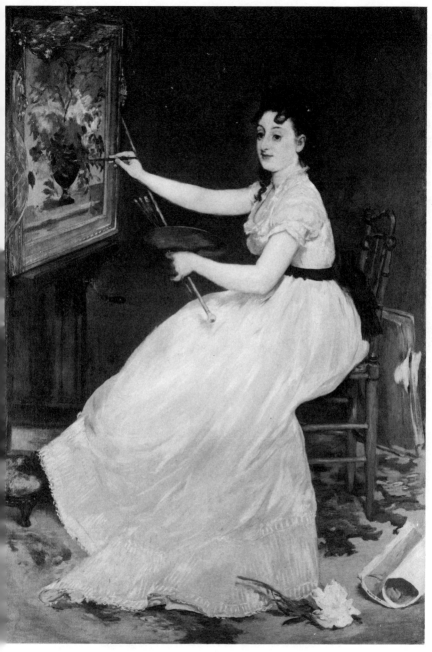

17. *Portrait of Eva Gonzalès (Portrait of Mlle. E. G.)* dated 1870, 75¼ × 52½ in. Salon of 1870

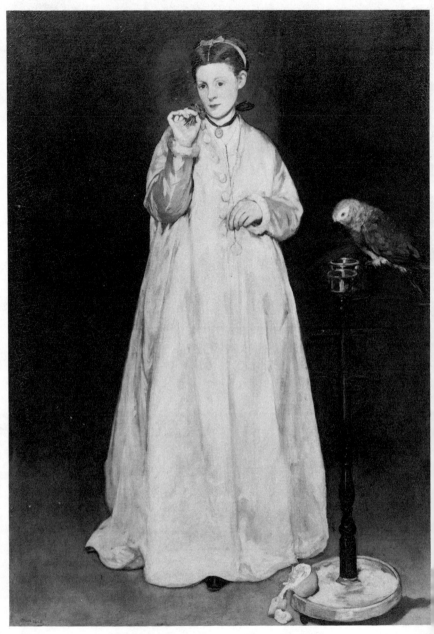

18. *Young Lady in 1866 (Woman with a Parrot)* (1866), 72⅞ × 50⅝ in. Salon of 1868

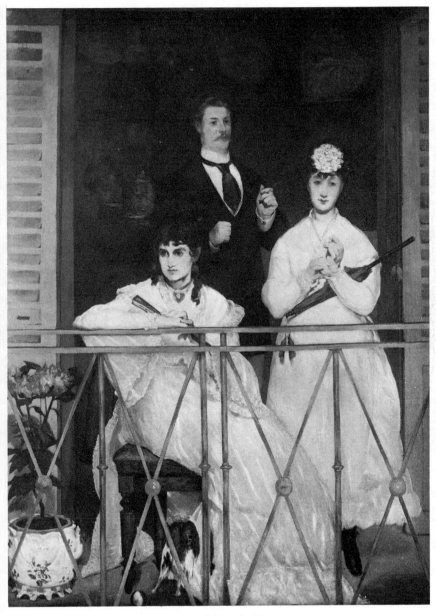

19. *The Balcony* (1869), 66⅞ × 49 in. Salon of 1869

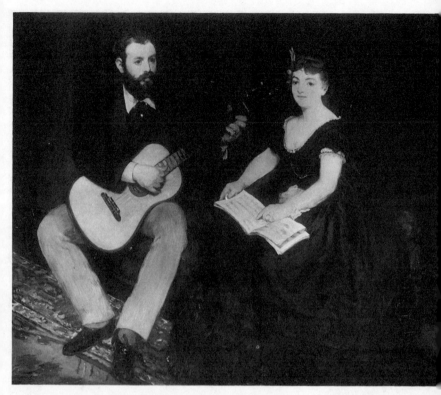

20. *The Music Lesson* (1870), 55⅛ × 68 in. Salon of 1870

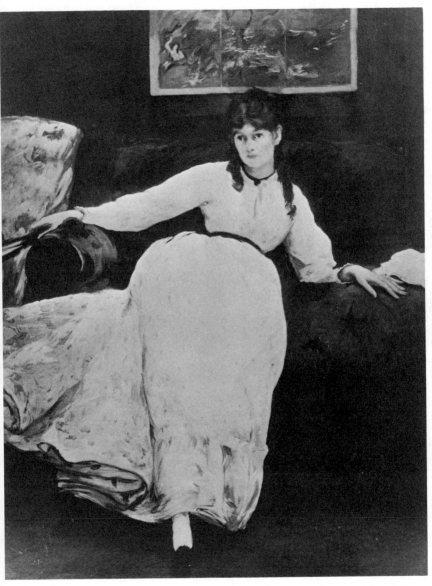

21. *Le Repos (Repose: Portrait of Berthe Morisot)* (1870), 58⅛ × 44⅛ in. Salon of 1873

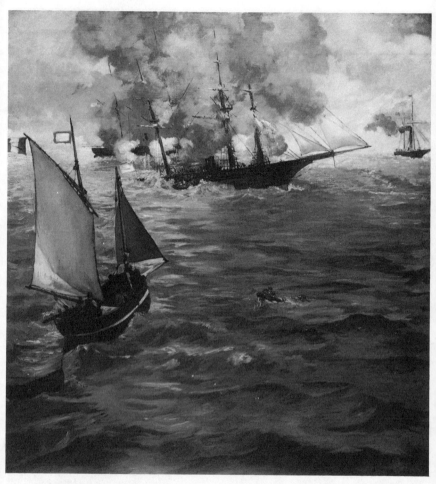

22. *Combat between the Kearsarge and the Alabama* (1864), 54⅝ × 51⅛ in.
Salon of 1872

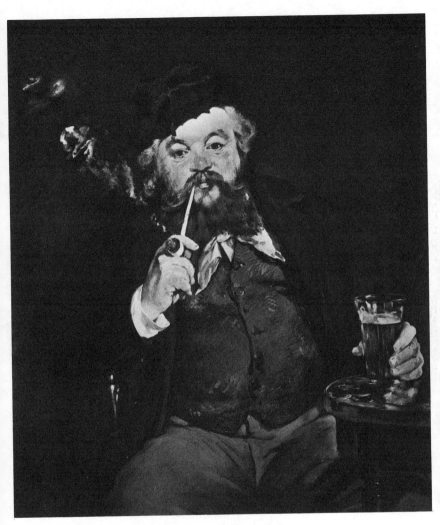

23. *Le Bon Bock,* dated 1873, 37 × 32⅝ in. Salon of 1873

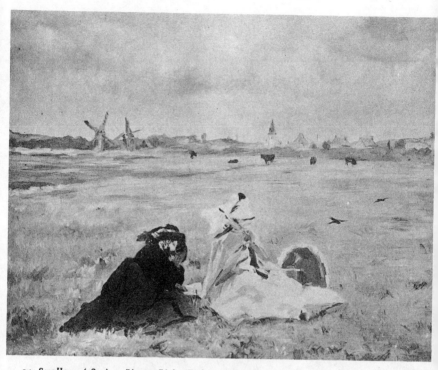

24. *Swallows* (1873), 25⅝ × 31⅞ in. Rejected at the Salon of 1874

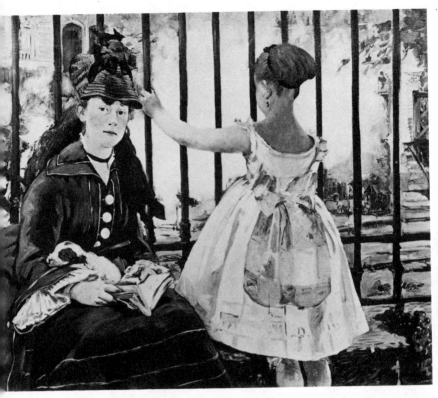

25. *The Railway* (1873), 36¾ × 45⅛ in. Salon of 1874

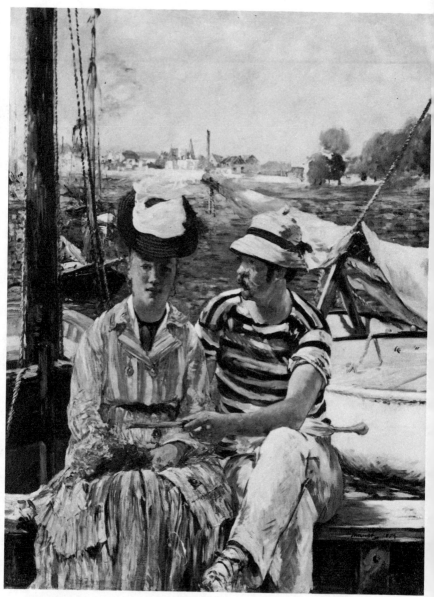

26. *Argenteuil,* dated 1874, 57⅞ × 44½ in. Salon of 1875

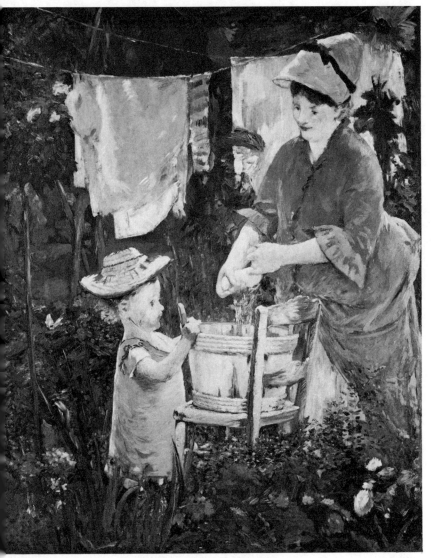

27. *The Laundress (The Laundry)* (1874), 57⅛ × 45¼ in. Rejected at the Salon of 1876

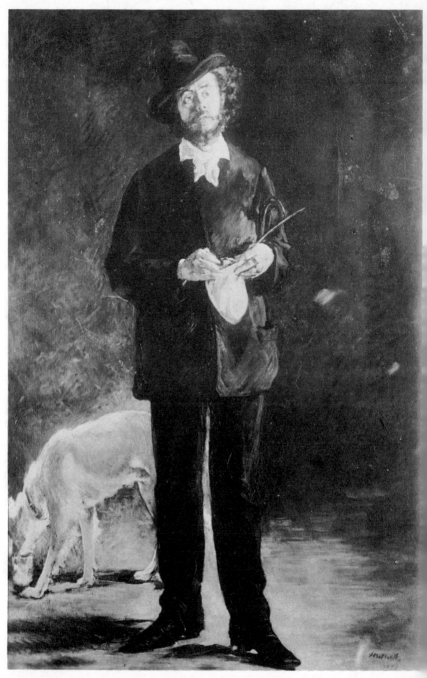

28. *The Artist (Portrait of Marcellin Desboutin)*, dated 1875, 75⅜ × 48⅜ in
Rejected at the Salon of 1876

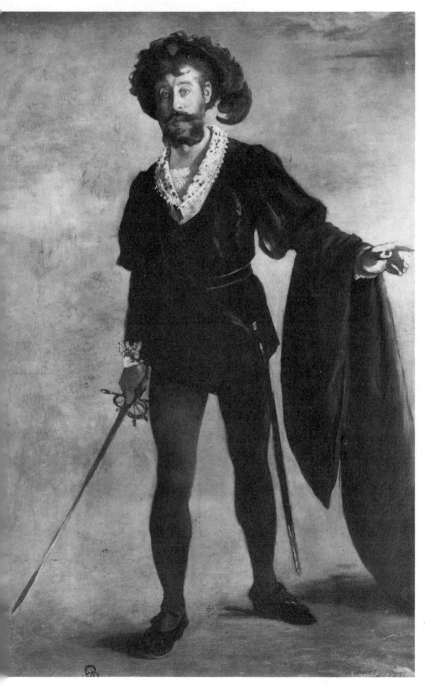

29. *Portrait of Faure as Hamlet,* dated 1877, 76 × 51¼ in. Salon of 1877

30. *The Opera Ball
(Masked Ball at the
Opera)* (1873), 23⅝ ×
28¾ in. Rejected at
the Salon of 1874

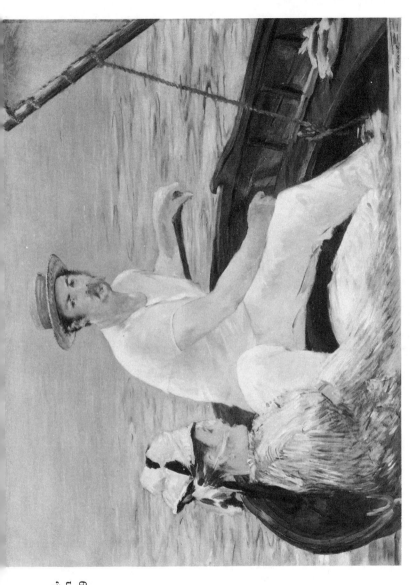

31. *Boating*, 1874,
38¼ × 51¼ in. Salon
of 1879

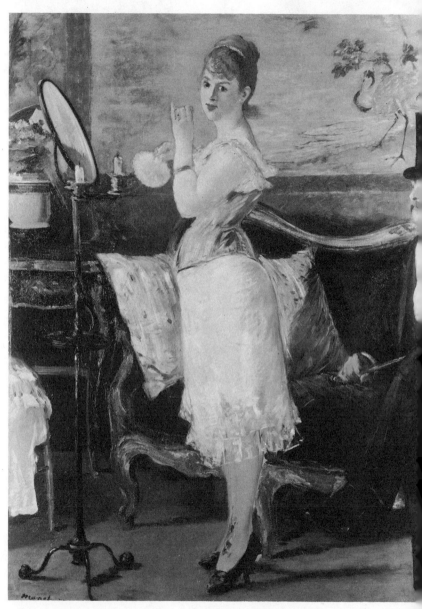

32. *Nana,* dated 1877, 59 × 45⅝ in. Rejected at the Salon of 1877

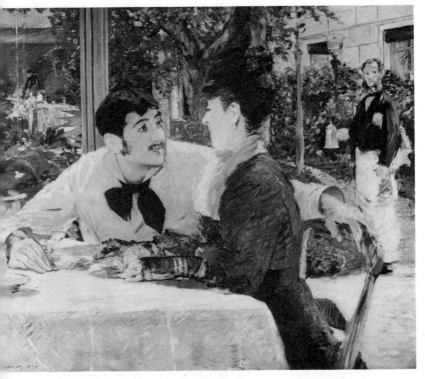

33. *Chez le père Lathuille,* dated 1879, 36¼ × 44⅛ in. Salon of 1880

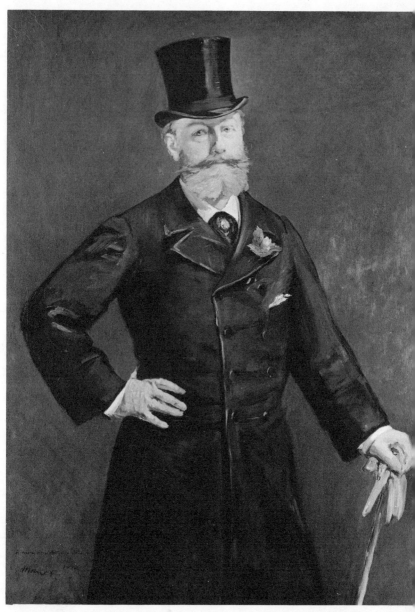

34. *Portrait of Antonin Proust,* dated 1880, 51½ × 38¼ in. Salon of 1880

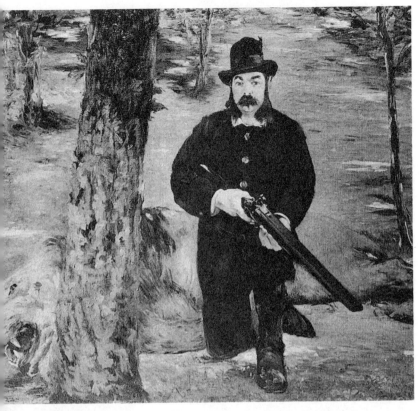

35. *Portrait of Pertuiset, the Lion Hunter,* dated 1881, 59⅛ × 66⅞ in. Salon of 1881

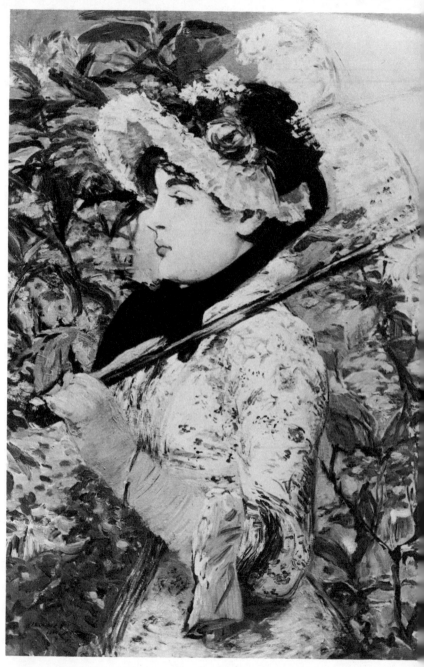

36. *Jeanne (Spring)*, dated 1881, 28¾ × 20⅛ in. Salon of 1882

37. *Portrait of Henri Rochefort,* dated 1881, 32 × 26⅛ in. Salon of 1881

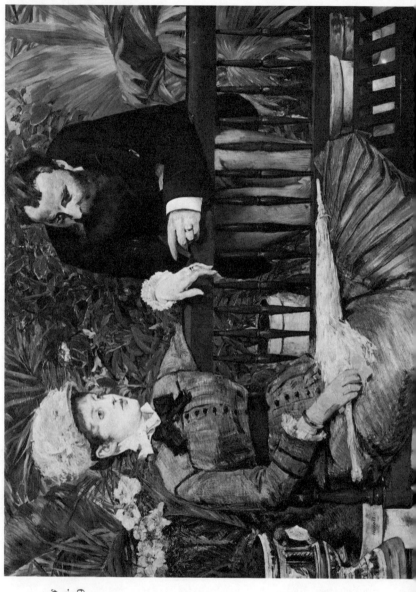

38. *The Conservatory*
(1878), 45¼ × 59 in.
Salon of 1879

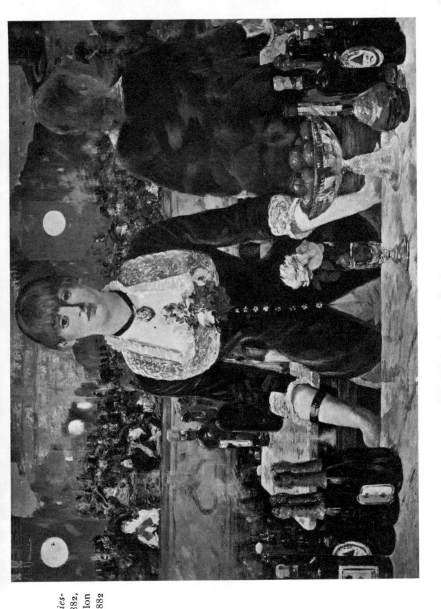

39. *The Bar at the Folies-Bergère*, dated 1882, 37¾ × 51⅛ in. Salon of 1882